ADVENTURES IN MODERN ART
THE CHARLES K. WILLIAMS II
COLLECTION

INNIS HOWE SHOEMAKER

WITH CONTRIBUTIONS BY JENNIFER T. CRISS,
KATHLEEN A. FOSTER, JOHN ITTMANN, AND MICHAEL R. TAYLOR

PHILADELPHIA MUSEUM OF ART

Published on the occasion of the exhibition
Adventures in Modern Art: The Charles K. Williams II Collection, Philadelphia Museum of Art,
July 12–September 13, 2009

The exhibition was generously supported by
The Kathleen C. and John J. F. Sherrerd Fund for
Exhibitions at the Philadelphia Museum of Art and
The Pew Charitable Trusts.

The catalogue was made possible by The Andrew
W. Mellon Fund for Scholarly Publications.

Front cover/jacket: Joseph Stella, *Tropical Floral,*
detail, c. 1928 (pl. 91)
Back cover/jacket: Thomas Hart Benton, *The Apple
of Discord,* 1949 (pl. 12)
Frontispiece: Charles Williams's living room,
Philadelphia, 2006

Produced by the Publishing Department
Philadelphia Museum of Art
Sherry Babbitt
The William T. Ranney Director of Publishing
2525 Pennsylvania Avenue
Philadelphia, PA 19130
USA
www.philamuseum.org

Editorial coordination by Sarah Noreika
Edited by Fronia Simpson
Production by Richard Bonk
Designed by Jenny 8 del Corte Hirschfeld,
Franck Doussot, and Mischa Leiner of
CoDe. New York, Inc.
Color separations, printing, and binding by Conti
Tipocolor S.p.A., Florence, Italy

**Library of Congress Cataloging-in-Publication
Data**
Shoemaker, Innis H.
Adventures in modern art : the Charles K. Williams
II collection / Innis Howe Shoemaker ; with
contributions by Jennifer T. Criss . . . [et al.].
 p. cm.
Published on the occasion of an exhibition
held at the Philadelphia Museum of Art,
July 12–Sept. 13, 2009.
ISBN 978-0-87633-215-3 (PMA cloth)—
ISBN 978-0-87633-216-0 (PMA paper)—
ISBN 978-0-300-14978-4 (Yale cloth)
1. Modernism (Art)—United States—Exhibitions.
2. Modernism (Art)—Europe—Exhibitions. 3. Art,
American—20th century—Exhibitions. 4. Art,
European—20th century—Exhibitions. 5. Williams,
Charles K., 1930—Art collections—Exhibitions.
6. Art—Private collections—United States—
Exhibitions. I. Shoemaker, Innis Howe. II. Criss,
Jennifer T. III. Philadelphia Museum of Art.
IV. Title. V. Title: Charles K. Williams II collection.
N6494.M64S56 2009
709.73'07474811—dc22 2009009569

Notes to the Reader
The entries and checklist have been organized
alphabetically by artists' last names and chrono-
logically thereafter.

Dimensions are given in both inches and centimeters,
with height preceding width. Dimensions and
mediums of works designated as "Collection of
C. K. Williams, II," and "Promised gift of C. K.
Williams, II," are by sight; signatures and
inscriptions on the versos of these works have
not been confirmed.

Provenance records, exhibition histories, and
references for each work have been verified.
In the few instances in which verification was not
possible, the information bears the designation
"possibly" or "probably." If no exhibition history
or reference is given for a work, none is known.

D

ADVENTU ART

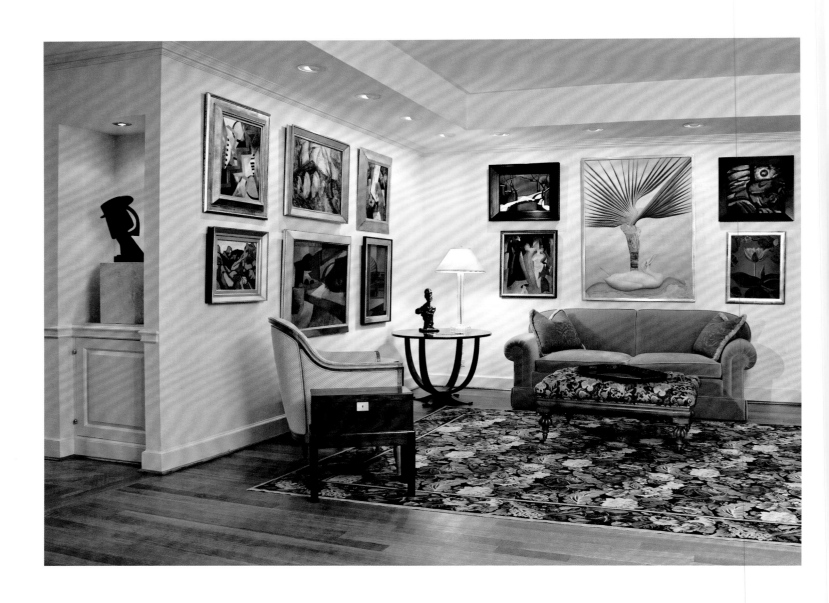

IN MEMORIAM
ANNE D'HARNONCOURT
SEPTEMBER 7, 1943–JUNE 1, 2008

TABLE OF CONTENTS

FOREWORD

The renowned holdings of the Philadelphia Museum of Art have been described as "a collection of collections." Indeed it is impossible to imagine the Museum without the glorious Italian and Northern European Renaissance paintings in the John G. Johnson Collection, the spectacular collection of arms and armor given by Carl Otto Kretzschmar von Kienbusch, the sculptures of Auguste Rodin bequeathed by Jules E. Mastbaum, or the Indian sculptures and folk art collected by Stella Kramrisch, to name just a few of the benefactors whose passion for art has made this Museum one of the world's greatest.

In the field of modern art, Charles K. Williams II is joined by a number of venerable collectors without whose generosity this Museum's astonishing holdings would have been markedly diminished. Our unparalleled collections of works by Marcel Duchamp and Constantin Brancusi, as well as masterpieces by other giants of modernism, were the magnificent gift of Louise and Walter Arensberg. Pablo Picasso's *Three Musicians* and Fernand Léger's *The City* were among the iconic treasures that came to the Museum as part of the A. E. Gallatin Collection, and wonderful works by such American masters as John Marin, Marsden Hartley, Georgia O'Keeffe, and Arthur Dove were given by O'Keeffe in her capacity as executor of the great collection amassed by her husband, Alfred Stieglitz.

While museums continue to build and refine their collections by making strategic purchases here and there, they must increasingly rely on gifts from generous collectors to make major inroads. So, above all else, we wish to express here our deepest gratitude to Charles for carrying on the grand tradition of wanting to share with others the remarkable collection that he has assembled with such enthusiasm and intelligence.

The wisest collectors, Charles included, have sought the advice of knowledgeable dealers and museum professionals in their pursuit of the finest, all the while making their own decisions and marking their collections as their own. Innis Howe Shoemaker, The Audrey and William H. Helfand Senior Curator of Prints, Drawings, and Photographs, has delighted in her association with Charles and in their continuing conversations about art. To her, we owe this wonderful narrative documenting the origins, evolution, and character of the Williams collection. That narrative has been informed by Innis's breadth of knowledge, her consummate connoisseurship, and the same astute observations that Charles must have appreciated when he consulted her about a potential purchase.

We also want to acknowledge here the scores of Museum staff in all departments who helped make possible this exhibition and catalogue. Their singular commitment to excellence, whether they are engaged in scholarly pursuits or making visitors feel welcome in our galleries, underlies everything we do. We are also exceedingly grateful to have received funding for the exhibition from The Kathleen C. and John J. F. Sherrerd Fund for Exhibitions at the Philadelphia Museum of Art and The Pew Charitable Trusts, and for this catalogue from The Andrew W. Mellon Fund for Scholarly Publications.

Alice Beamesderfer
Associate Director for Collections and Project Support and Interim Head of Curatorial Affairs

Gail Harrity
Chief Operating Officer and Interim Chief Executive Officer

ACKNOWLEDGMENTS

The great pleasure of working on Charles Williams's collection has been exploring the background and context of the works of art that, over the past fifteen or so years, I have had the wonderful opportunity to see soon after they joined the others on his walls. Discussing Charles's purchases with him—those made as well as those not pursued—also provided endless hours of fun for me, as well as for Anne d'Harnoncourt, who encouraged me to propose this exhibition to Charles and whose delight in the evolution of his collection most definitely equaled mine. It is still unimaginable to realize that she is not here to cheer us on as the work on the exhibition and catalogue nears its conclusion.

Charles's own detailed records on each work in the collection provided the starting point for all research, particularly that of Jennifer T. Criss who tirelessly assembled research files and created the checklist during her tenure as the Carl Zigrosser Fellow in the Museum's Department of Prints, Drawings, and Photographs. I am especially appreciative of her work, as it took place during the closing and move of the Museum's library, necessitating many trips to the University of Pennsylvania as well as numerous requests for books through interlibrary loan. The Museum's library staff, including Danial Elliott, Lilah Mittelstaedt Knox, Evan Towle, Jesse Trbovich, and Mary Wassermann, deserves special thanks for its help during those months as well as after the library's reopening.

The number of individuals who provided research materials and answered countless questions far exceeds the number of works included in this catalogue. I would like to single out with particular gratitude the following: Kathy Fonda, Addison Historical Society, Maine; Karen Shafts, Boston Public Library; Kevin Grace, Archives and Rare Books Library, University of Cincinnati; Royal Academy of Arts Library, London; Chris Bastock, Tate Research Centre, London; Nancy Kuhl, Beinecke Rare Book and Manuscript Library, Yale University, New Haven; Kathleen Kienholz, American Academy of Arts and Letters, New York; Michelle Harry, The Museum of Modern Art Archives, New York; The Solomon R. Guggenheim Museum Archives, New York; Kristen Leipert and Sarah O'Holla, Frances Mulhall Achilles Library, Whitney Museum of American Art, New York; Cheryl Leibold, Pennsylvania Academy of the Fine Arts Archives, Philadelphia; Amey Hutchins, Rare Book and Manuscript Library, University of Pennsylvania, Philadelphia; Megan E. Peacock, University of Washington Libraries, Seattle; IBM Corporate Archives, Somers, New York; Marisa Bourgoin, Archives of American Art, Smithsonian Institution, Washington, DC; National Gallery of Art Library, Washington, DC; and the Smithsonian American Art Museum/National Portrait Gallery Library, Washington, DC.

I am also grateful for the assistance of colleagues at many fellow art institutions, including Alexandra Keiser, The Archipenko Foundation, Bearsville, New York; Kathleen Bettis, Boise Art Museum, Idaho; Nora Donnelly, The Institute of Contemporary Art, Boston; Erin L. McCutcheon, Museum of Fine Arts, Boston; Nancy Weekly, Burchfield-Penney Art Center, Buffalo, New York; Miriam Stewart, Harvard Art Museum/Fogg Museum, Cambridge, Massachusetts; Angie Morrow, Smart Museum of Art, University of Chicago; Mark Cole, The Cleveland Museum of Art; Mike Martin, Flint Institute of Arts, Michigan; Edward G. Russo, Wadsworth Atheneum Museum of Art, Hartford; Jon Evans and Sarah Shipley, The Museum of Fine Arts, Houston; Karen Jenkins, The Demuth Museum, Lancaster, Pennsylvania; Thom Hall, Arkansas Arts Center, Little Rock; Ted Greenberg, Los Angeles County Museum of Art; Sarah Quimby, Minneapolis Institute of Arts; Robin Jaffee Frank and Suzanne Greenawalt, Yale

University Art Gallery, New Haven; Catherine Heroy, The Metropolitan Museum of Art, New York; Robert Parks, The Morgan Library and Museum, New York; Marshall Price, National Academy Museum and School of Fine Arts, New York; Ted Mann, The Solomon R. Guggenheim Museum, New York; Anita Duquette, Barbara Haskell, and Sasha Nicholas, Whitney Museum of American Art, New York; Robert Cozzolino, Pennsylvania Academy of the Fine Arts, Philadelphia; Joann Potter, The Frances Lehman Loeb Art Center, Vassar College, Poughkeepsie, New York; Cassandra Smith, San Antonio Museum of Art; Jane Glover, Fine Arts Museums of San Francisco; Barbara Buhler Lynes, Georgia O'Keeffe Museum, Santa Fe; Robert Yarber, Morris Graves Foundation, Seattle; Patti Junker and Marta Pinto-Llorca, Seattle Art Museum; Julie McMaster and Nicole Rivette, Toledo Museum of Art; Amy Marshall and Larry Pfaff, Art Gallery of Ontario, Toronto; Jason Stieber, National Museum of Women in the Arts, Washington, DC; and Sara Anderson and Karen Schneider, The Phillips Collection, Washington, DC.

Indispensable to the research for this catalogue have been owners and staff of the many art galleries who have generously provided provenance information, photographs, and exhibition histories for almost every work in the collection. For their efforts in response to innumerable inquiries I thank Thomas McCormick, Thomas McCormick Gallery, Chicago; Christian Torner, Galerie Gmurzynska, Cologne; Neelon Crawford, Polar Fine Arts, Fort Washakie, Wyoming; Dr. Ewald Rathke, Kunsthandel, Frankfurt; Sally Preslar, Midtown Payson Galleries, Inc., Hobe Sound, Florida; Richard Nathanson, London; Sandy Shin, Leslie Sacks Fine Art, Los Angeles; Marissa G. Boyescu, Marissa G. Boyescu Arts, Miami; ACA Galleries, New York; Barbara Mathes Gallery, New York; Edward DeLuca and Sandra Paci, DC Moore Gallery, New York; Deedee Wigmore, D. Wigmore Fine Art, Inc., New York; Nicola Lorenz, Forum Gallery, New York; Francis M. Naumann, Francis M. Naumann Fine Art, New York; Reagan Upshaw and Stephanie Wezowicz, Gerald Peters Gallery, New York; M. P. Naud, Hirschl & Adler Galleries, Inc., New York; Lillian Brenwasser and Martha Fleischman, Kennedy Galleries, Inc., New York; Martha Parrish, Martha Parrish & James Reinish, Inc., New York; David McKee, McKee Gallery, New York; Susan E. Menconi and Claudia Sanchez, Menconi & Schoelkopf Fine Art, LLC, New York; Meredith Ward, Meredith Ward Fine Art, New York; Michael Rosenfeld, Michael Rosenfeld Gallery, LLC, New York; Achim Moeller, Moeller Fine Art Ltd., New York; Owen Gallery, New York; Jon Mason, Pace Wildenstein, New York; Sarah Arnett and Caitlin Fitzgerald, Salander-O'Reilly Galleries, New York; Jodi Spector, Spanierman Gallery, LLC, New York; Andrew Dintenfass, Terry Dintenfass, Inc., New York; Kara Gillam, Washburn Gallery, New York; Jonathan Spies, Zabriskie Gallery, New York; Abigail Joseph, Newman Galleries, Philadelphia; Schwarz Gallery, Philadelphia; and Sam Berkovitz, Concept Art Gallery, Pittsburgh.

Several individuals also gave essential support of many kinds to this project as the publication took shape. I am deeply grateful to Hon. Morris Fish, Russell Goings, Leslie Goldman, William D. Hamill, Irma B. Jaffe, Elaine Kilmurray, Joseph Koerner, Jack Levine, Bruce MacEvoy, Norma Marin, William S. Moye, Richard Ormond, Shari Payson, Marshall Potamkin, Stephanie Sacher, Margo Pollins Schab, Jonathan Shahn, Patterson Sims, John Tancock, Roberta Tarbell, Michael and Sue Vanderwoude, and Peggy Zorach.

At the Philadelphia Museum of Art I have had the support of talented colleagues from many departments. In the Department of Prints, Drawings, and Photographs, I have relied upon the

formidable organizational skills of Rita M. Gallagher and Rhonda V. Davis, as well as three curatorial fellows, Sarah Cantor, Kevin Kriebel, and John Vick. I also extend thanks to Suzanne F. Wells and Zoë Kahr, of Special Exhibitions, Elie-Anne Chevrier, of the Office of the Registrar, and Conna Clark, of Rights and Reproductions.

Paper conservators Nancy Ash and Scott Homolka have answered complicated questions about the mediums of drawings and watercolors, while the conservator of furniture and woodwork, Behrooz Salimnejad, made valuable observations about the wood sculptures. It has been a special pleasure to discuss many of the paintings and their frames with paintings conservator Suzanne Penn, whose love and knowledge of early-twentieth-century American painting have added great joy to this project, not only for me but also for Charles Williams.

Working with the Museum's publishing staff is always a reassuringly enjoyable workout as their standards are impeccably high. Chief among them is publishing director Sherry Babbitt, working with production manager Richard Bonk. They have been joined by a sequence of editors, initially Beth Huseman and independent editor Fronia Simpson, and Ellen Adair, who scrupulously checked all quotations. Sarah Noreika, the newest member of the Museum's publishing team, merits special mention for meticulously seeing the book through its final stages. I am particularly delighted to recognize the splendid work of the book's designer, Mischa Leiner of CoDe, New York. Will Brown, who was commissioned by Charles to photograph the works in his apartment, is responsible for the outstanding quality of the plates in this catalogue. I am, as always, very grateful to the Museum's own fine photographers, including Graydon Wood, Andrea Nuñez, and Lynn Rosenthal, who were responsible for the photography of the works stored at the Museum. Jennifer Vanim worked her way through the intricacies of photography permissions with her characteristic proficiency. Deserving of exceptional thanks are my busy colleagues Kathleen A. Foster, John Ittmann, and Michael R. Taylor, as well as my former assistant Jennifer Criss, for their willingness to write for this catalogue in areas where they have special expertise.

The final and most heartfelt salute is to Charles Williams for his generosity, for his wonderful eye, and for his desire to share his collection with visitors to the Philadelphia Museum of Art now and in the future.

Innis Howe Shoemaker
The Audrey and William H. Helfand Senior Curator of Prints, Drawings, and Photographs

March 2009

ADVENTURES IN MODERN ART

INNIS HOWE SHOEMAKER

It was my good luck that Charles Williams was collecting prints and had just begun to build a collection of watercolors in 1992, the year Professor David Brownlee of the University of Pennsylvania's History of Art Department brought Charles to the Philadelphia Museum of Art's Department of Prints, Drawings, and Photographs. A year later, Charles might well have been taken to meet a curator of paintings, for his interests quickly shifted as he became concerned about leaving vulnerable water-colors exposed to the light on his walls. Still, as an accomplished watercolorist himself (fig. 1), Charles has never really stopped acquiring watercolors. Indeed, those in his collection by Joseph Stella (pl. 92), Charles Demuth (pls. 32–33, 36–37), Charles Burchfield (pls. 23–25), George Grosz (pls. 49–50), Max Weber (pl. 98), and Emil Nolde (pl. 71) form a marvelously diverse array of approaches that show his innate appreciation for the miraculous range of effects watercolor can achieve.

As a result of that fortuitous meeting in 1992, I have watched with enormous pleasure and fascination the remarkable develop-ment of Charles Williams's collection of paintings, sculptures, watercolors, drawings, and still occasionally prints, which becomes ever more ambitious in strength and quality even though the market yields fewer and fewer works of the kind that he seeks. His professed focus has continued to be American art of the first half of the twentieth century, but that has never prevented excursions into European modernism. Take, for example, Giorgio de Chirico's *Portrait of Carlo Cirelli* (pl. 28), recently given to the Museum in a desire to achieve a more rigorous concentration on American art as well as to provide an empty spot on his wall, or the sparkling *Head of an Oriental with a Short Beard*, by Giovanni Battista Tiepolo (fig. 2), a drawing bought in a moment of enthusiasm at auction one winter (which is displayed on his wall among the American moderns), or the dark, richly textured relief print *Self-Portrait #1* by Chuck Close (fig. 14). However, such digressions are excep-tions that add zest to a thoughtfully formed collection, which is neither a dry, didactic accumulation nor an encyclopedic survey of American modernism, although the collection does cover most of the movements of American modern art, including Regionalism (Thomas Hart Benton, Grant Wood); American Scene painting (Isabel Bishop, Kenneth Hayes Miller,

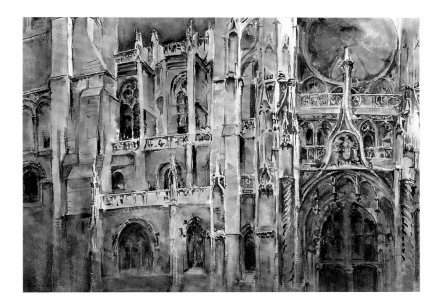

Paul Cadmus); Synchromism (Morgan Russell, Hugo Robus); Precisionism (Charles Sheeler, Charles Demuth, Ralston Crawford); Social Realism (William Gropper, Ben Shahn); Magic Realism (Jared French, George Tooker, Henry Koerner); and the Stieglitz circle (John Marin, Arthur Dove, Marsden Hartley, Georgia O'Keeffe).

Knowing what one does about Charles Williams's training as an architect and his distinguished scholarly career as an archaeologist, teacher, and author, it is fascinating to observe how his collection seems primarily to reflect the eye of an artist rather than an academic, showing an instinctive, often unpredictable attraction to formal elements such as sumptuous color and brushwork, strong compositions, and arresting images. His selections show no aversion to representing a painter by an uncharacteristic work, such as the early *Portrait of Theresa Lewensohn* by Philip Guston (pl. 51). Humorous, satirical, eccentric, or even what he jokingly calls "sick" images also attract—these varied traits bring to mind paintings such as Jack Levine's *Woodstock Pastorale* (pl. 57), William Gropper's *Shouting Senator* (pl. 48), Henry Koerner's

The Arcades (pl. 56), and Alton Pickens's *Game of Pretend* (pl. 73). Certainly there are clear favorites, like Charles Demuth, Joseph Stella, and Oscar Bluemner, each represented by several wonderful paintings and works on paper; Georgia O'Keeffe and Marsden Hartley, equally distinguished, whose work the collector does not particularly favor, make cameo appearances, respectively, in a small but very important early watercolor (pl. 72) and in an unusual totally abstract composition (pl. 52).

A significant but not immediately evident strength of this collection reflects a deeply held conviction about the importance of Philadelphia in the birth of American modernism. Among the artists in the Williams collection are those who spent their careers as great teachers in the city's art schools: Hugh Henry Breckenridge, Arthur B. Carles, and Earl Horter; and others who studied in Philadelphia and moved on to play a major role in the New York art world of the early decades of the twentieth century, such as Charles Demuth, Ralston Crawford, Morton Schamberg, Charles Sheeler, and John Marin. Still another area of special emphasis in the collection is

Fig. 1: **Charles K. Williams II**
American, born 1930
Senlis Cathedral, c. 1993
Watercolor on paper, 13 x 19 inches (33 x 48.3 cm)
Collection of C. K. Williams, II

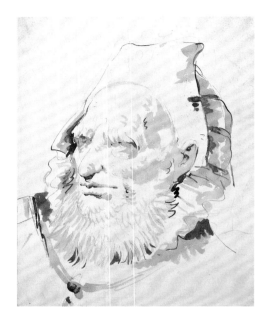

collection of paintings, sculptures, and works of art on paper will exert an extraordinary and wide-ranging influence at the Philadelphia Museum of Art. As an example, the Museum owns prints and drawings by many of the artists in the Williams collection, but none of their paintings. Among the most notable instances of such lacunae are George Bellows, Oscar Bluemner, Ralston Crawford, Jan Matulka, Morgan Russell, Max Weber, and Grant Wood, in addition to sculpture by John Storrs. There is also a significant group of paintings by American realist artists of varied stripes, such as Paul Cadmus, Jared French, George Tooker, Kenneth Hayes Miller, Henry Koerner, and Alton Pickens—artists more valued today than by earlier collectors—whose work is either not represented in the Museum at all or only by prints. Most striking in terms of impact is the case of John Marin, whose unparalleled master collection of prints and etching plates is at the Museum, as well as a rare early drawing of Independence Hall, and thirty-one watercolors, but no paintings—a strength that will be marvelously expanded by Charles Williams's three early oils. Many more of the works of art by other artists in his collection promise to transform, enhance, or resonate with the Museum's existing collections in an endless variety of ways.

The collection is still growing, and Charles continues to prune judiciously as he searches for new acquisitions, consulting with the Museum before he "deaccessions." And although work has become increasingly hard to find on the market, he has also become more selective as the collection has acquired an increasingly definite shape. Indeed, as his walls have filled with more and more pictures, Charles seems concerned that his collection is getting too distinct a "look" and struggles with the question of whether to add work that will diversify or change or stand out from what is already there. In any case, while he never fails to consider the impact an acquisition might have on the Museum's collection, we delight in the fact that Charles continues to follow his own bent, and that many of his recent acquisitions rank among his most significant and transforming: Philip Guston's incomparable *Portrait of Theresa Lewensohn* (pl. 51), Pavel Tchelitchew's monumental *Pierrot* (pl. 95), and William Zorach's superb *Yosemite Falls* (pl. 102). May this grand adventure continue for many years to come!

the influence of Futurism and Fauvism on American painters like Joseph Stella, the Synchromist Morgan Russell, and Hugo Robus. A small but varied group of sculptures has been added slowly and selectively because of limited space, most notably the rare wood model for John Storrs's bronze *Study in Form (Forms in Space)* (pl. 94), the haunting late bronze *Chiavenna Bust I* by Alberto Giacometti (pl. 46), and the splendid golden *Wounded Stag* by Elie Nadelman (pl. 69), whose companion piece, *Recumbent Stag*, is in the Museum's Henry P. McIlhenny Collection.

Most exciting for the Philadelphia Museum of Art in presenting Charles Williams's collection is his magnanimous plan to bequeath the works of art that he has not yet given or promised to the Museum, which offers the opportunity here to consider the two collections together. Notwithstanding our well-known and spectacular holdings of modern art from the estate of Alfred Stieglitz (1949) and the legendary gifts from Louise and Walter Arensberg (1950), A. E. Gallatin (1956), Louis E. Stern (1963), and Samuel S. White 3rd and Vera White (1967), this

Fig. 2: **Giovanni Battista Tiepolo**
Italian, 1696–1770
Head of an Oriental with a Short Beard, n.d.
Black chalk, pen and brown ink, and brown wash on paper,
9 ⅝ x 7 ⅝ inches (24.4 x 19.4 cm)
Collection of C. K. Williams, II

COLLECTING ART

CHARLES K. WILLIAMS II

An article on Business—Your Money, in the *International Herald Tribune*, on January 27–28, 2007, stated, "There are three beauties in some sense in art, the beauty of the object; the joy of collecting and meeting with people and talking with people and the excitement of the hunt; and there is the diversification potential of art in a portfolio." This statement can be weighted variously, but if art in any of its forms excites the mind when one first turns the pages in an art book, it is at that time, most likely, that one is attracted by the beauty of the object. The early years of collecting, almost everyone admits, are the formative ones; but as years pile up and diverse experiences force a broader view of life, many early impressions turn out to be oversimplifications.

In my case, being aware of labor strikes, witnessing daily discomforts, and watching WPA laborers laying pipes for water and sewage were all part of growing up in the Great Depression. Daily life in the 1930s and 1940s put a sharp edge to my earliest view of "the best of all possible worlds." In fact, growing up in the Depression made it easy, if not necessary, to appreciate the message of the Thomas Hart Benton lithograph *Mine Strike*; of the oil and tempera down-and-out (*The Club*) by Isabel Bishop; and of the *Game of Pretend* by Alton Pickens. The Charles Burchfield watercolor *Stormy November Day* of 1946, although he augmented it in 1959, has the same feel. Living through the 1930s and 1940s also gave added meaning to the graphics of Käthe Kollwitz (*Self-Portrait*) and Emil Nolde (*Frauenkopf III*). That early conditioning probably even heightened my appreciation for the Charles Sheeler tempera painting of 1944, *Water*.

Although forming a set of aesthetics may have stimulated my youth, subsequent education and wider exposure certainly broadened my ken. Education fortified me with reasons to react against the concept of beauty in nature as you find it. Once I realized that pure beauty, or even a mysterious cityscape, cannot be improved on by making a portrait of it, just as one cannot fully appreciate a pet by preserving it for posterity, then it was easy to abandon the search for Ruskinian principles of beauty. Instead, the search was on for other qualities, the sound of a foghorn or the essence of a freight car. In collecting,

one cannot always get exactly what one wants, but I think that I have acquired the essence of backlighting in *Frozen Pool at Sunset*, thanks to Arthur Dove, and a glimpse into the inner order of life via Precisionists such as George Ault.

I find that grouping artists' paintings on my walls in different ways can stimulate surprisingly varied responses. Each time I move a painting, I get new stimuli and make new observations. For example, different combinations of works by Joseph Stella certainly provoke the mind as well as the eye. *Palm Tree and Bird* is radically different in aesthetic approach from either *Golden Fall* or *Study for "Battle of Lights."* The contrasts always make me wonder, What, exactly, was Stella not capable of? Similar questions can be asked of a number of other experimental artists painting in the first half of the twentieth century. Take, for example, Charles Demuth, who executed *Jazz (Jass)* as an abstraction, *Gloucester—Sails and Masts* in the Precisionist style, and his watercolor *Straw Flowers* more naturalistically. Grouping works by a single artist can raise even more questions, with the chronology of his or her life becoming a major theme. Differences in the dates of execution, the origin of the inspiration for the works, or knowledge of whether the works were homegrown or influenced from abroad are all valid questions. Take as an example Hugo Robus's *The Accordionist*. It is fueled by a Futurist aesthetic that the artist experienced in Paris in 1912, but it was painted in New York about 1917. For me date and context add much to my appreciation of a work, but then, I was trained as an archaeologist, with dating and contexts playing a major part in that discipline. To underline my point about date, I cite here Max Weber's *Four Figures (Sisters)*, painted in a loose Cubist style, which was executed in 1912 before the style burst on the American scene via the New York Armory Show of 1913.

Usually, when I pick a painting or piece of sculpture, I do so because of its special appeal or message, even if the work may not fit tidily into my collection. *Voice I* by George Tooker is such a piece, displaying a Surrealist quality with a worrisome message. Stronger still is Ben Shahn's *Melancholia*, which I bought to hang above my computer so that, in case the computer goes down, I can look up and see someone unhappier than I am. That is close to impulse buying, in which I don't indulge myself very often. There are times, however, when impulse does strike. The Giorgio de Chirico *Portrait of Carlo Cirelli* is an example. In no way does the painting belong in my collection of American artists of the first half of the twentieth century, but it has a strong presence that I could not ignore.

This leads to a final point that I would make as a collector. One may buy to please the eye, but one collects with the mind. I have tried to focus my interests so that I can better understand the area in which I collect. Collecting within specific demands adds discipline to the hunt, although flexibility and experimentation should never be disregarded in the chase, and I have found it especially valuable to solicit outside expertise to joggle the mind before I make a purchase. A second, different point of view makes contemplation of the purchase just that much more exciting.

Continuing in this vein, I have Jonathan Greenberg, now at Sotheby's in New York, to thank for helping me cut my eyeteeth as I started collecting etchings and lithographs and was at the bottom of the learning curve. I could not have assembled many of the oils and watercolors that I now own without the help of dealers, mainly from the isle of Manhattan; some I cannot thank warmly enough for their time, help, and interest, one or two others for the lessons they served up. Marissa Boyescu has been indispensable in my hunting sorties and definitely has improved the quality of what hangs on my walls. I also thank the lively minds of people at the Philadelphia Museum of Art and Innis Howe Shoemaker, singled out fairly or not, who has endeavored, whenever asked, to balance my purchase plans with rational ideas.

Philadelphia, February 2007

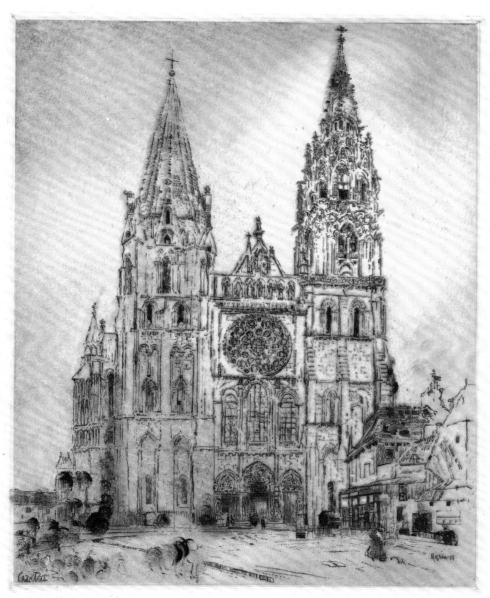

Fig. 3: **John Marin**
American, 1870–1953
Chartres Cathedral, 1910
Etching, unique proof with monotype inking; plate 11 5/16 x 9 inches (28.7 x 22.9 cm)
Philadelphia Museum of Art. Gift of C. K. Williams, II. 2001-169-8

IN PURSUIT OF PRINTS

JOHN ITTMANN

Charles Williams's love of art found its earliest expression in the paintings, drawings, and prints that he made himself. He had the good fortune to attend a boarding school where etching was taught, a graduate school where he was introduced to the traditional methods of Chinese brush and ink painting, and throughout his school years he often found time to paint with watercolors and oils. After completing an initial phase of graduate studies required to become an architect, Williams had a change of heart and embarked instead on a long and distinguished career as a classical archaeologist, devoting himself to the excavation of lost cities rather than the building of new ones.

In the early 1980s Williams discovered print collecting as a new outlet for his deepening interest in art, and within a few years he assembled a highly personal collection of more than 150 major and minor masterpieces by some sixty nineteenth- and twentieth-century European and American artists. Now largely dispersed, the collection eventually included prints by the grand and famous as well as the obscure and overlooked, from Édouard Manet (fig. 4) and Grant Wood (fig. 5) to Julian Alden Weir (fig. 6) and Eugen Kirchner (fig. 7), along with such touchstones of American printmaking as Winslow Homer's etching *Perils of the Sea* (1888) and George Bellows's lithograph *A Stag at Sharkey's* (1917).

A computer database that Williams compiled in 1989 traces the gradual growth of the collection and reveals a medley of themes in play throughout it: architecture, landscape, portraiture, and Social Realism. The collection had begun in earnest five years earlier in 1984 with the purchase of seventeen prints from two art galleries on Fifty-seventh Street in New York, Associated American Artists and Kennedy Galleries. Both establishments enjoyed well-deserved reputations as dealers in prints as well as paintings and sculpture, and Williams quickly formed a rewarding and lasting relationship with Jonathan Greenberg, who was the director of Kennedy's print department from 1983 to 1993.

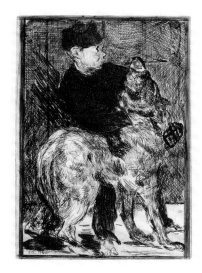

4

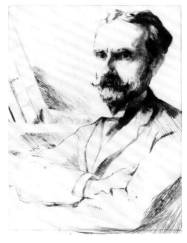

6

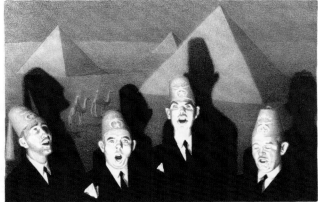

5

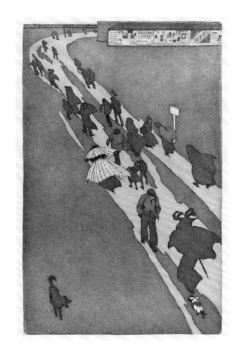

7

Fig. 4: **Édouard Manet**
French, 1832–1883
Boy with Dog, 1862
Etching and aquatint, state iii/iii; plate 8 x 5 ⁹/₁₆ inches (20.3 x 14.1 cm)
Proof before first edition of *Huit gravures à l'eau-forte par Édouard Manet*, 1862
Ex-collection: Henri Guérard (French, 1846–1897)
Philadelphia Museum of Art. Gift of C. K. Williams, II. 2006-131-10

Fig. 5: **Grant Wood**
American, 1891–1942
Shrine Quartet, 1939
Lithograph; image 7 ¹⁵/₁₆ x 11 ⅞ inches (20.2 x 30.2 cm)
Philadelphia Museum of Art. Gift of C. K. Williams, II. 2001-169-15

Fig. 6: **Julian Alden Weir**
American, 1852–1919
Portrait of Dr. Robert F. Weir, 1891
Etching and drypoint, state ii/vi (unique proof); sheet (cut within plate mark)
7 ¹⁵/₁₆ x 5 ¹³/₁₆ inches (20.2 x 14.8 cm)
Philadelphia Museum of Art. Gift of C. K. Williams, II. 2006-131-11

Fig. 7: **Eugen Kirchner**
German, 1865–1938
November, 1896
Etching and aquatint, printed in brown ink; plate 12 ⅝ x 7 ⅞ inches (32.1 x 20 cm)
Philadelphia Museum of Art. Gift of C. K. Williams, II. 2001-169-16

Perhaps not surprisingly, among the first prints to catch his eye were works that reflected his own experience as a tentative teenage etcher and lifelong student of architecture. Four of the first eight prints that Williams purchased were by recognized masters of the etched architectural view: a French Gothic cathedral by John Taylor Arms, an Egyptian mosque by David Young Cameron, quayside buildings in Paris by Charles Meryon, and a Venetian canal scene by James McNeill Whistler.

As would become his frequent practice, Williams sought out multiple examples of favorite artists' work. In due course, he owned four etchings by Cameron, six by Meryon, and fifteen by Whistler; however, the finicky perfectionism of Arms's architectural views failed to hold his attention, and he bought no more prints by him. Meryon's and Whistler's lasting influence on European and American printmakers can be clearly seen in two pairings of prints in the collection. Meryon's moonstruck evocation of medieval Paris etched in 1850 (fig. 8) resonates with a Manhattan street scene executed by Armin Landeck nine decades later (fig. 9), while Whistler's method of leaving a hand-wiped film of ink on the plates of his etchings of Venice's back canals no doubt served as inspiration for an experimental proof of Chartres Cathedral by John Marin (fig. 3), which is dappled with the artist's own inky fingerprints.

Print collecting gave Williams the opportunity to develop and pursue several avenues of interest simultaneously. During the first year alone he demonstrated his strong affinity for American Scene painters of the early twentieth century by acquiring prints by Thomas Hart Benton, Isabel Bishop, Edward Hopper, Jack Levine, Reginald Marsh (fig. 10), and Kenneth Hayes Miller, a marked preference that would ripen into the splendid collection of paintings, drawings, watercolors, and sculptures presented in this catalogue. In time Williams was able to add four more of Hopper's etchings, including a rare early state of *Bay Window* printed in green ink (fig. 11).

The purchase in 1984 of a single landscape etching by Peter Moran (1841–1914) was soon followed by etchings by two other members of the Anglo-American Moran family of artists, Thomas Moran (1837–1926) and his wife, Mary Nimmo Moran (1842–1899). By the end of the decade Williams had extended his collection of prints by pre–World War I American artists to include one or more etchings by Frank Duveneck (1848–1919), John Austin Monks (1850–1917), Stephen Parrish (1846–1938), Joseph Pennell (1857–1926), Charles Adams Platt (1861–1933), and John Henry Twachtman (1853–1902).

In similar fashion, an exhibition held in February 1985 at Associated American Artists of prints by French painters of the Barbizon School, which yielded a clutch of etchings by Jean-Baptiste Camille Corot (1796–1875), Jean-François Millet (1814–1875), and Pierre-Étienne-Théodore Rousseau (1812–1867), prompted Williams to pick up an additional Millet from the William Weston Gallery in London during a stopover on the way to Greece the very next month.

By making a visit to Weston's print gallery a regular habit whenever he was in London, Williams was able to expand his collection in a new direction with the addition of the first of three self-portraits by the great German printmaker Käthe Kollwitz, culminating in a proof impression of the 1934 lithograph of the careworn artist at the age of sixty-seven (fig. 12). During the next several years Weston would be Williams's source for a number of portrait and self-portrait prints by various fin de siècle and early-twentieth-century European artists, such as Kollwitz's fellow German Emil Nolde and the French painters Paul Helleu (1859–1927), Georges Rouault (1871–1958), and James-Jacques-Joseph Tissot (1836–1902). That the penetrating portrait in any medium continues to hold a special place in Williams's affections is made evident by the collector's understandable inability to resist adding two particularly arresting portrait prints to his holdings when he was no longer buying prints in the other favored categories: in 2004 he succumbed to Chuck Close's *Self-Portrait #1* and in 2006 to Nolde's *Frauenkopf III* (figs. 13, 14).

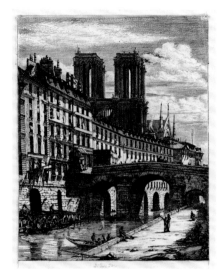

8

9

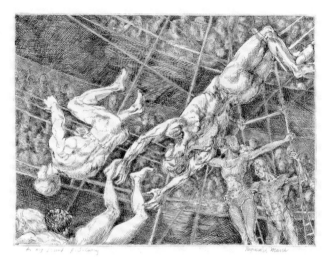

10

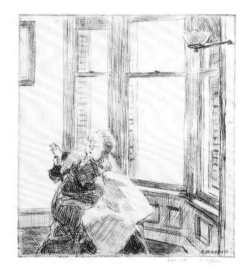

11

Fig. 8: **Charles Meryon**
French, 1821–1868
Le Petit Pont, Paris, 1850
Etching and engraving, proof on India paper, state vi/ix;
plate 10 1/8 x 7 3/8 inches (25.7 x 18.7 cm)
Philadelphia Museum of Art. Gift of C. K. Williams, II. 2003-62-2

Fig. 9: **Armin Landeck**
American, 1905–1984
11 West 11th Street, 1939
Drypoint; plate 12 11/16 x 9 7/8 inches (32.2 x 25.1 cm)
Philadelphia Museum of Art. Gift of C. K. Williams, II. 2006-131-2

Fig. 10: **Reginald Marsh**
American, born Paris, 1898–1954
Flying Cancellos, 1936
Etching; plate 7 7/8 x 9 7/8 inches (20 x 25.1 cm)
Inscribed by the artist in graphite: *for my friend J. S. Curry*
Philadelphia Museum of Art. Gift of C. K. Williams, II. 2001-169-10

Fig. 11: **Edward Hopper**
American, 1882–1967
Bay Window, 1915–18
Etching, printed in green ink; plate 6 7/8 x 5 7/8 inches (17.5 x 14.9 cm)
Inscribed in graphite: *2nd State*
Philadelphia Museum of Art. Gift of C. K. Williams, II. 2001-169-6

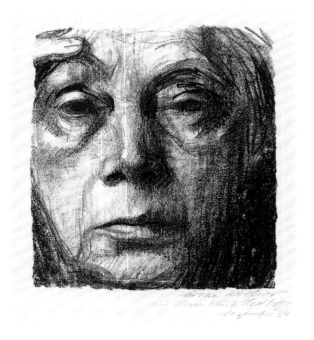

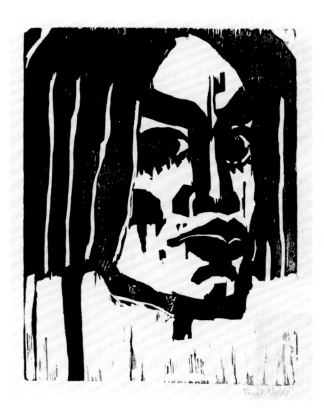

Fig. 12: **Käthe Kollwitz**
German, 1867–1945
Self-Portrait, 1934
Lithograph; image 8 1/8 x 7 3/8 inches (20.6 x 18.7 cm)
Inscribed by the artist in graphite: *für Herrn Kurt Hedloff / Dezember 34*
Collection of C. K. Williams, II

Fig. 13: **Emil Nolde**
German, 1867–1956
Frauenkopf III, 1912
Woodcut, state iii/iii; block 11 13/16 x 8 7/8 inches (30 x 22.5 cm)
Collection of C. K. Williams, II

Fig. 14: **Chuck Close**
American, born 1940
Self-Portrait #1, 1999
Relief print with embossment printed on blue-gray Twinrocker handmade paper;
block 20 x 15 ¼ inches (50.8 x 38.7 cm)
Collection of C. K. Williams, II

ALEXANDER ARCHIPENKO

FIGURE IN MOVEMENT
1913

I found that technically collage is the most adequate medium for the spontaneous sketchy arrangement of compositions. In spite of the subject matter, the abstract element in the work of art appears inevitable, because the metaphysical side of art can be expressed more effectively through symbolic abstraction. Abstraction cannot exclude harmony, balance and rhythm, for without these abstraction becomes total emptiness. Technically these three elements are more easily and quickly obtained by arranging or rearranging patterns of cut colored paper than by painting, particularly in spontaneous sketches. Beside technical facility, the natural quality of different materials adds a much more vital effect to the collage than would an ordinary painted pattern in colors.[1]

Ukrainian-born Alexander Archipenko (1887–1964) is rarely mentioned as one of the earliest practitioners of collage, yet he was making them in 1913, a year after Pablo Picasso and Georges Braque had created the first such works. However, unlike their pasted pictures, Archipenko's were conceived as studies for sculpture, as is readily apparent in his commanding *Figure in Movement*, which has been described as "Archipenko's most powerful, extant early composition on paper."[2] In 1913 Archipenko was living in Paris, where he had been exhibiting his work since 1910; in 1911 and 1912 he had shown his work with the Cubists, and he was a member of the group led by the Duchamp brothers who met regularly in Puteaux.[3] Thus Archipenko was well aware of the Cubist collages of Picasso and Braque; perhaps theirs may have triggered the idea for Archipenko, but it is difficult to believe that they were more than a superficial precedent, since the appearance and rationale of Archipenko's collages are entirely different.[4]

Archipenko's paper collages are now very rare, but he is known to have made many of them.[5] Of the few that survive, *Figure in Movement* is the most simplified, for it is composed of only six cut paper shapes. Color and texture are minimal; shape, volume, and movement predominate. Each piece is cut to have both straight and rounded profiles, and each is shaded in pastel over graphite to give a sense of volume. The artist connected the cutout shapes by drawing crossing arcs and ruled lines that

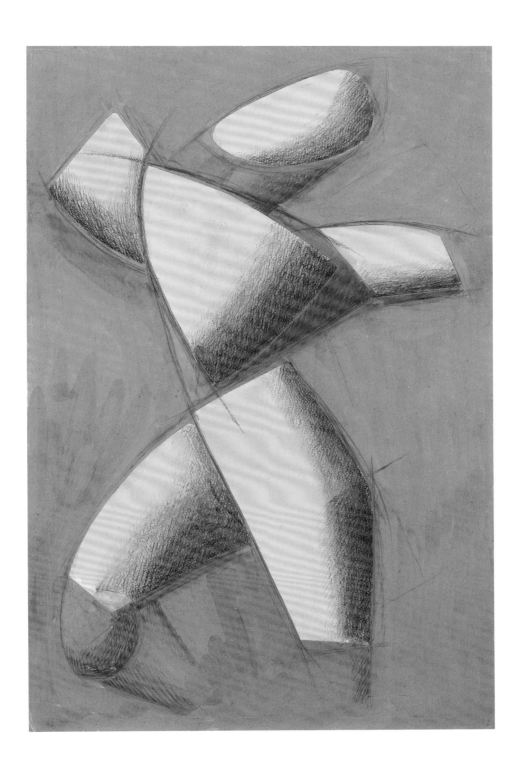

Plate 1
Alexander Archipenko
American, born Ukraine, active Paris, 1887–1964
Figure in Movement (Figure), 1913
Collage, graphite, and pastel on paper, 18 ³/₄ x 12 ¹/₄ inches (47.6 x 31.1 cm)
Collection of C. K. Williams, II

trace and extend the boundaries of the shapes, adding energy to the strong movement of the figure. In fact, though the collage is modest in size, it seems large because of the forceful motion of the powerfully modeled figure whose movements and countermovements fill the entire sheet from top to bottom and side to side.

Attempts have been made to link this work with specific sculptures, but there are no one-to-one instances of such a connection. The most apparent relation is with Archipenko's plaster *Hero* (1912–13), which displays a similar chiastic configuration of truncated arms and legs as well as an upturned head,[6] but despite the formal similarities, *Hero* is closed and monolithic. A less obvious but conceptually more convincing analogy to this work has been observed in *Geometric Statuette*, a plaster of 1914, which is conceived as a series of joining and overlapping parts rather than as a unified mass.[7] Whether any specific collage was its source, this sculpture clearly shows Archipenko's development of the medium into three dimensions.

1. Archipenko, quoted in Alexander Archipenko and Fifty Art Historians, *Archipenko: Fifty Creative Years, 1908–1958* (New York: Tekhne, 1960), p. 64.
2. Donald Karshan, *Archipenko: The Sculpture and Graphic Art, Including a Print Catalogue Raisonné* (Tübingen: Ernst Wasmuth Verlag, 1974), p. 43.
3. Katherine Jánszky Michaelsen, *Archipenko: A Study of the Early Works, 1908–1920* (New York: Garland, 1977), pp. 44–45. Among the artists in the Puteaux group, in addition to Jacques Villon, Raymond Duchamp-Villon, and Marcel Duchamp, were Albert Gleizes, Jean Metzinger, Fernand Léger, Juan Gris, Roger de La Fresnaye, Francis Picabia, and Robert Delaunay.
4. Karshan, *Archipenko*, p. 43, suggests that Léger's 1913 drawings and gouaches could have been influences, although they do not employ collage. Referring to his constructions, Archipenko wrote, "the collage as it was developed in the second decade of this century by other artists I found useable only as a preliminary sketch." See Archipenko and Fifty Art Historians, *Archipenko*, p. 64.
5. Karshan, *Archipenko*, p. 43, says that Archipenko's first solo exhibition at the Galerie Der Sturm, Munich, in 1913 included several collages. A photograph of his exhibition in Germany in 1921 shows a large number of framed works of art on the walls, though the images cannot be made out. According to Michaelsen, *Archipenko*, p. 12, the artist left many of his early Paris works behind when he moved to the United States in 1923, which must have included other examples of his collages. Four collages of 1913, including *Figure in Movement*, are reproduced in Katherine Jánszky Michaelsen and Nehama Guralnik, *Alexander Archipenko: A Centennial Tribute*, exh. cat. (Washington, DC: National Gallery of Art; Tel Aviv: Tel Aviv Museum, 1986), nos. 8–11; a fifth is reproduced in Archipenko and Fifty Art Historians, *Archipenko*, pl. 271.
6. *Hero* has been dated as early as 1910; the date 1912–13 is proposed by Michaelsen, *Archipenko*, pp. 92–93; repro. no. S35.
7. Michaelsen and Guralnik, *Archipenko: A Centennial Tribute*, p. 24.

ALEXANDER ARCHIPENKO

HEAD: CONSTRUCTION WITH CROSSING PLANES

Late 1950s

Sometimes I sculpt a new version of the same statue after considerable time has elapsed. Of course, in modeling the same problem the forms are not as mathematically exact as if they were cast from the same mold. However, on all versions I prefer to keep the date of the first, since I want to conserve the chronology of the idea. The particular stylistic and creative approach I use equally in all versions unless changes are purposely made.[1]

This statement, written in 1960, partially clarifies the complication surrounding the history of this small bronze, *Head: Construction with Crossing Planes*. Cast in an edition of unknown number from a plaster on plywood model made in the United States in the late 1950s,[2] the bronze is inscribed with a date of 1913, which is the date of the sculpture on which the artist apparently based it. This claim was made by Alexander Archipenko (1887–1964) in 1960, when he wrote that *Head: Construction with Crossing Planes* was a sketch for his seven-foot-high construction *Woman in Front of a Mirror*, an assemblage of wood, glass, metal, and mirror, which is known only from a photograph published in 1914.[3] However, other than Archipenko's statement in 1960, no earlier documentation exists for a 1913 *Head: Construction with Crossing Planes*. Because of that, current opinion holds that the bronze is a sculpture of the late 1950s.[4]

Until the uncertainty of the date of *Head: Construction with Crossing Planes* emerged in 1975, this piece was heralded as "the earliest known constructed head with open, planar design,"[5] an innovation that still may be attributed to Archipenko's lost *Woman in Front of a Mirror* (1914), as the open, intersecting planes of the head are evident in the early photograph despite its poor quality.[6] Even though the bronze was created at a later date, *Head: Construction with Crossing Planes* is a small yet powerful statement that documents one of Archipenko's most revolutionary sculptural achievements in the second decade of the twentieth century.

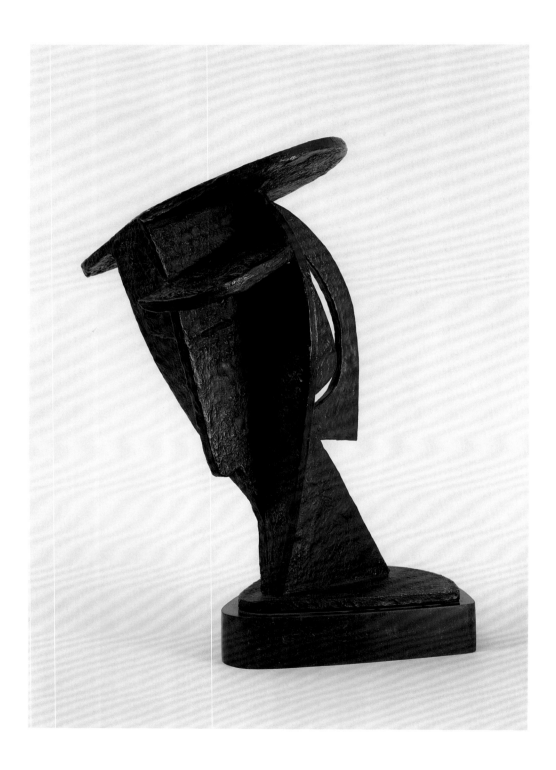

Plate 2
Alexander Archipenko
American, born Ukraine, active Paris, 1887–1964
Head: Construction with Crossing Planes (Sketch for "Woman in Front of a Mirror"
***[Étude pour femme à la toilette])**, late 1950s
Bronze, height 15 1/16 inches (38.2 cm)
Collection of C. K. Williams, II

1. Archipenko, quoted in Alexander Archipenko and Fifty Art Historians, *Archipenko: Fifty Creative Years, 1908–1958* (New York: Tekhne, 1960), caption to pl. 141.

2. This information was provided by Alexandra Keiser, research curator of the Archipenko Foundation. As of February 2007 the Archipenko Foundation has catalogued eleven bronze casts of *Head: Construction with Crossing Planes*. In *Alexander Archipenko: A Memorial Exhibition, 1967–1969*, exh. cat. (Los Angeles: UCLA Art Galleries, 1967), p. 65, no. 15, an undocumented statement is made that *Head* was "made from original wood construction of 1913."

3. Archipenko and Fifty Art Historians, *Archipenko*, caption to pl. 182. A photograph of *Woman in Front of a Mirror* was published in *Les soirées de Paris* (June 15, 1914), p. 309.

4. This is the opinion of the Archipenko Foundation. Katherine Jánszky Michaelsen, *Archipenko: A Study of the Early Works, 1908–1920* (New York: Garland, 1977), p. 123, was the first to make this claim, citing the opinion of Mrs. Archipenko that the bronze was made in 1957. Ibid., p. 123 n. 1, also believes that *Seated Geometric Figure* (1913) was made in the 1950s.

5. Donald Karshan, *Archipenko: The Sculpture and Graphic Art, Including a Print Catalogue Raisonné* (Tübingen: Ernst Wasmuth Verlag, 1974), pp. 29, 32.

6. The best reproduction of the photograph is in ibid., p. 20.

GEORGE AULT

LOFT BUILDINGS, NO. 1
1922

THE MACHINE
1922

The career trajectory of George Ault (1891–1948) is different from that of most of his American modernist contemporaries who rebelled against their conservative art school training, frequented Alfred Stieglitz's gallery 291, were galvanized by the work they saw at the Armory Show in 1913, and exhibited their work in the 1916 *Forum Exhibition of Modern American Painters*. Ault was born in Cleveland into a well-to-do family, which in 1899 moved to London, where the young artist received a traditional training in several art schools. When Ault returned with his family in 1911 to a New Jersey suburb of New York, he was working in a quasi-Impressionist style, and he remained unaffected by developments in avant-garde art taking place in the city. His inauspicious entrance into the New York art world was in 1920, when he exhibited his conservative work in the fourth exhibition of the Society of Independent Artists.[1] However, it must have been no time at all before he immersed himself in the work of his modernist contemporaries, for by 1921 his painting *A New York Skyline*[2] sported a group of simplified, blocklike black buildings against a night sky, their facades dotted with abstract grids of brightly lit windows. Soon afterward, Ault's life seems to have transformed, too, as he quickly asserted his independence of his conservative suburban family, spending the summer in the art colony of Provincetown, Massachusetts, and moving to Manhattan in 1922, though supported by a stipend from his father. That year his artistic transformation became complete when he showed his work, including *Loft Buildings, No. 1*, at the Salons of America. In this painting, he rendered the juxtaposed forms of Manhattan buildings as pure, simplified blocks of flat color applied uni-formly against an unrelieved bright blue sky.[3] There is no modeling in *Loft Buildings, No. 1*—only shifts in juxtaposed planes of flat color that minimally suggest a source of light; it is one of Ault's purest and most severe early paintings. The work is also unusual in that he generally preferred night scenes lit by the moon or electric lighting; in Ault's night paintings, gradations of color denote shadows, unlike the flat planes of unmodulated color seen here.

Ault also painted *The Machine* in 1922 during an unhappy period when his father persuaded him that he should be employed at his New Jersey printing ink plant. Ault's approach

to his subject is just the opposite of the bright, shadowless *Loft Buildings, No. 1*, for in *The Machine*, he introduces a complex system of light and shade evocatively rendered by a limited range of colors—uniformly grayed shades of yellow, blue, and violet—no doubt inspired by his immediate surroundings. Ault also may have known Paul Strand's cool, close-up photographs of wheel-driven machinery, in which clear geometric shapes of light surround the mechanical forms.[4] Although machinery was famously the subject of the Dada creations of Marcel Duchamp and Francis Picabia and inspired the Americans Morton Schamberg, Joseph Stella, and others, Ault's monochromatic painting of the wheels and gears partially obscured by an open doorway strangely combines detailed observation with a mysterious quality that is foreign to the paintings of machines by other artists.

It is obvious from the up-to-date urban and industrial subject matter and the immaculate style of Ault's paintings in the 1920s that he was aware and part of the art and interests of his contemporaries. Throughout that decade he showed his work at some of the important venues for Precisionist art, the Whitney Studio Club, the Bourgeois Galleries, and the Downtown Gallery, though he was never associated with the Daniel Gallery, which regularly featured Precisionist work by Charles Demuth, Preston Dickinson, Niles Spencer, and Charles Sheeler. Ault's friends were the artists who showed at the Bourgeois and Downtown galleries, such as William and Marguerite Zorach, Reuben Nakian, Yasuo Kuniyoshi, and Vincent Canadé.[5] Yet few specific details provide any flavor of his relationships, influences, enthusiasms, or interests in the early 1920s—the time when the most radical transformation of his style occurred. For example, there is little sense of how much he shared in the vibrant spirit of the New York art world—felt so strongly in the 1920s by those artists who were striving to define an indigenous American artistic style. This perception in part derives from the fact that Ault left no papers that shed light on his shift to a modernist style. The principal sources of information about his early career are the writings and correspondence of his second wife, Louise, whom he did not meet until 1935, after he had succumbed to alcoholism and his career was on the wane.[6] Her account of

Ault's early career largely narrates where he was when, where he exhibited, and what he painted, but gives little information about his personal connection to the world in which he lived, such as whose work he admired, what he thought of European modernism or of the exhibitions he must have seen in New York during the late 1910s and 1920s, and, most important, what inspired him in 1922 to thoroughly embrace and create his own version of the emerging Cubist-Realist style.[7]

1. Biographical information comes largely from Susan Lubowsky, *George Ault*, exh. cat. (New York: Whitney Museum of American Art, 1988), pp. 7–12.
2. Reproduced in ibid., p. 10, pl. 4.
3. The work of Charles Sheeler, exhibited at the Daniel Gallery in April 1922, must have been a source of inspiration for the radical new style of Ault's paintings of skyscrapers at this time. A review of that exhibition states that Sheeler's paintings "are chiefly views of skyscrapers, painted in flat tones and angular in pattern. . . . The color in 'New York' and 'Skyscrapers' is remarkable for the strength, purity and fine design it makes in the various masses." *American Art News*, vol. 20 (April 1, 1922), p. 6.
4. See, for example, Strand's *Wheel Organization* (1917), reproduced in Karen Tsujimoto, *Images of America: Precisionist Painting and Modern Photography*, exh. cat. (Seattle: University of Washington Press, for the San Francisco Museum of Modern Art, 1982), pl. 42.
5. Biographical and Vita Information, George C. Ault Papers, Archives of American Art, Smithsonian Institution, Washington, DC, reel D247.
6. See Louise Ault's voluminous writings and correspondence regarding her husband's work in Louise Ault Writings—MSS, Biographical and Vita Information, ibid.
7. The best source of information about Ault's friends, interests, and formative sources is a series of questions and answers posed to Louise Ault at an unknown date after the artist's death. Biographical and Vita Information, ibid.

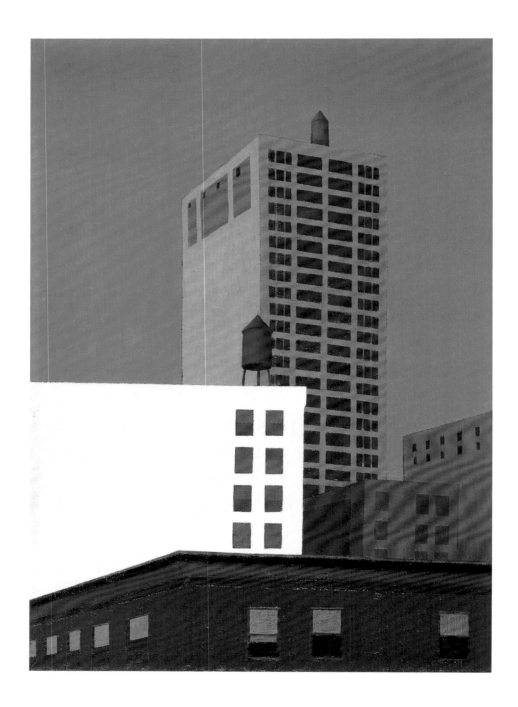

Plate 3
George Ault
American, 1891–1948
Loft Buildings, No. 1, 1922
Oil on canvas, 20 x 14 inches (50.8 x 35.6 cm)
Collection of C. K. Williams, II

Plate 4
George Ault
American, 1891–1948
The Machine (The Engine), 1922
Oil on canvas, 26 ¼ x 16 inches (66.7 x 40.6 cm)
Collection of C. K. Williams, II

GEORGE AULT

TREE STUMP
1934

In 1934 George Ault (1891–1948) severed his ties with the Downtown Gallery, where he had shown his work regularly since 1927. He had been unhappy with the gallery's owner, Edith Halpert, feeling that she was pressing him too hard to produce.[1] Ault had been depressed and recalcitrant since the late 1920s, largely due to the death of his difficult and domineering father and the suicides of two of his brothers following the 1929 stock market crash. Until that time, Ault's career had been quite successful; he was showing his work not only at the Downtown Gallery but also at the Bourgeois Galleries and the Whitney Studio Club. Unfortunately, the downturn in his artistic career was largely self-inflicted, as Ault began to drink heavily, turning away from his friends and from the art world in general, and exhibiting his work less and less. When he painted *Tree Stump* in 1934, Ault was spending his summers in Woodstock, New York, participating in the federal government's New Deal art projects; in 1937 he left New York City and moved to Woodstock permanently. Woodstock inspired him to paint landscapes and to make fewer of the urban subjects that had dominated his work in New York; frequently he drew and painted single trees, but few of them are charged with the odd hyperclarity and desolation of *Tree Stump*, which was shown in the Second Whitney Biennial exhibition in late 1934, only months after its completion.

A strange, almost surreal quality entered Ault's work in 1924, soon after he returned to New York from a trip to Paris. His paintings began to show the influence of Giorgio de Chirico, especially in oddly lit night scenes of empty streets and industrial buildings, such as *Sullivan Street Abstraction* and *Factory Chimney*.[2] But Ault was never a Surrealist; rather, he portrayed an uneasy reality.[3] In *Tree Stump* the intensity of his focus on the subject produces its alien feeling: the large, solitary, amputated tree trunk bounded by the clear shapes of floating clouds in a bright blue sky exudes the air of a portrait. Every detail of this lonely, hulking presence is minutely observed: the uneven top of the trunk seems broken off, suggesting that its core is decayed; the ringed stumps of the severed lower branches appear to

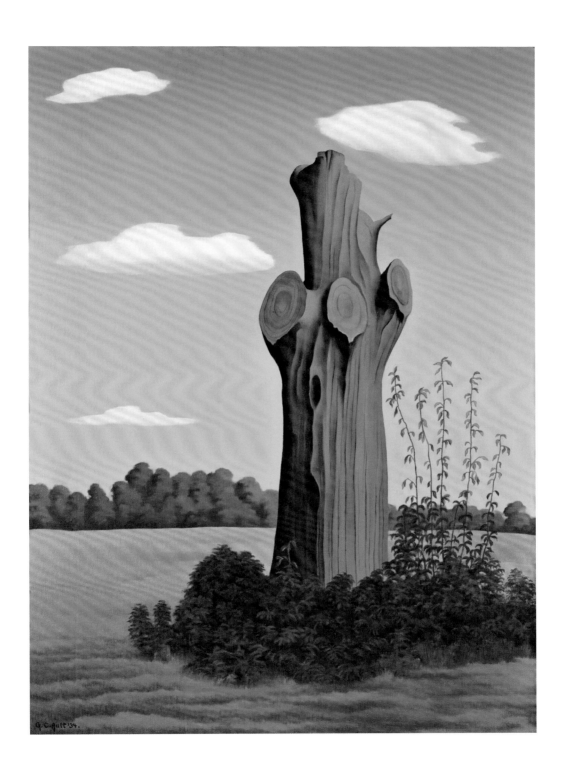

Plate 5
George Ault
American, 1891–1948
Tree Stump, 1934
Oil on canvas, 28 x 20 inches (71.1 x 50.8 cm)
Collection of C. K. Williams, II

have been sawn off mechanically. Tall, leafy shoots rise from the ground at the base of the trunk, encircled by foliage, evidence that the tree's roots are not entirely dead.

There is no indication that Ault attached symbolic meanings to his paintings, though the focused, portraitlike character of the severed tree's remains certainly lends itself to interpretation. In a publication that postdates Ault's death, his widow, Louise, described *Tree Stump* as a reflection of the artist's family relationships, which appears to be her own reading of the picture rather than that of Ault himself:

> During those Woodstock summers he produced other landscapes that harked back to the English countryside. His "Tree Stump" of 1934 was romantic, the gray chestnut stump large and dominant in a landscape of green field and blue sky with four white clouds. At the foot of the stump, five green tendrils cluster around it as lovingly as had the five Ault children around the parental figures. A romantic landscape, yes, although the silvery central form, the stump, again is a tree severely amputated.[4]

1. Biographical information included here is from Susan Lubowsky, *George Ault*, exh. cat. (New York: Whitney Museum of American Art, 1988), pp. 24–27.
2. Ibid., figs. 14–15.
3. While the surrealist aspect of Ault's art and the influence of de Chirico have long been recognized, he has also been called a magic realist. Jeffrey Wechsler, "Magic Realism: Defining the Indefinite," *Art Journal*, vol. 45, no. 4 (Winter 1985), p. 297, finds Ault's work to be "just shy" of magic realism.
4. Louise Ault, *Artist in Woodstock, George Ault: The Independent Years* (Philadelphia: Dorrance & Company, 1978), p. 72.

GEORGE AULT

NIGHT AT RUSSELL'S CORNERS

1946

I do not at all try to "copy" nature—I make order out of nature and "crystalize" [sic] its beauty—or, rather, my "reactions" or "feelings" about nature. That is all that matters—what I—The Artist—feels. G.C.A.[1]

During the last five years of his life, George Ault (1891–1948) made four evocative paintings of Russell's Corners in Woodstock, New York, a meeting of country roads by red and white barn buildings.[2] They are among his strongest works in a career that had focused continuously on the revelation of architectural structures by night lighting, whether moonlight or electric power. Even before he left England at the age of twenty in 1911, Ault painted the night.[3] In paintings and drawings of city and country, as his style evolved, he repeatedly found new ways of representing the effect of nocturnal lighting on his subjects. From the glowing windows of New York skyscrapers in the thickly impastoed *New York Skyline* (1921) to the lean Precisionist clarity of factory buildings in *Construction Night* (1922), to the surreal orange glow of a walkway over a deserted street in *Sullivan Street Abstraction* (1924), and to the bizarre and haunting night clouds in *Greenwich Village Nocturne* (1934),[4] one may follow nearly every twist and turn of Ault's stylistic development before he abandoned Manhattan for Woodstock in 1937, where Russell's Corners became his focus from 1943 to 1948, the year of his death.

The paintings of Russell's Corners seem to be such faithful renderings of the dark crossroads lit by a single streetlight that Ault's widow and biographer, Louise, felt it necessary to describe his method to make clear that they were artistic creations and not literal representations of the site. She wrote that the artist took nightly walks around Russell's Corners, slowly contemplating it, then made the paintings in his studio using the "visual memory training" he had received as a student at the Slade School in London. But, lest anyone confuse his process with copying, Louise stated emphatically: "I knew that this artist painted, not the scene before him, but his vision of that scene as translated by his emotions; his painting of a scene was a creation, not a duplication."[5]

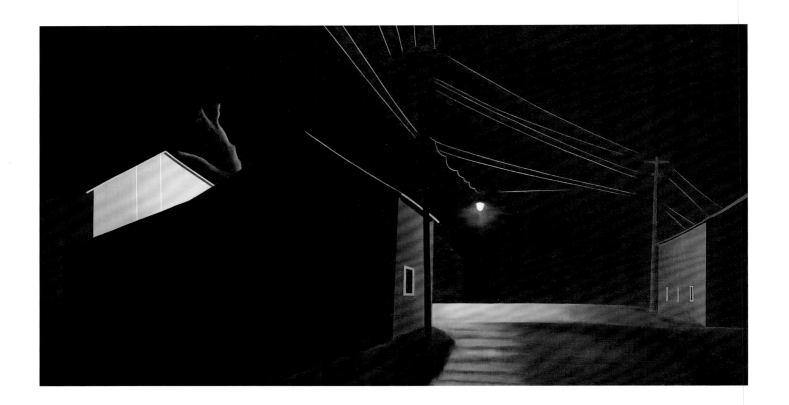

Plate 6
George Ault
American, 1891–1948
Night at Russell's Corners, 1946
Oil on canvas, 16 x 30 inches (40.6 x 76.2 cm)
Collection of C. K. Williams, II

In fact, the clarity and precision of Ault's paintings of Russell's Corners could easily lead to the conclusion that he was making accurate copies, but scrutiny of details of each picture in the series shows that he took liberties with the placement of the buildings and the streetlight, as well as the configuration of the power lines to enhance the quiet drama each one conveys in a different way. From the first to the last of the series, the lighting becomes progressively dimmer as the artist moves closer and closer to the subject. The earliest painting, *Black Night: Russell's Corners* (fig. 15), is the starkest and simplest in composition; the brightly lit buildings are disposed frontally, their forms clearly revealed against the black sky. Third in the series, *Night at Russell's Corners* is muted and the streetlight is suspended in isolation. Here, the compositional structure derives less from the shapes of the buildings than from receding patches of light on the pavement and the complex intersection of power lines overhead. In both of these paintings, the same leafless tree bends toward the white building, yet it is futile to try to establish precise spatial relationships between the buildings and the lighting in these two compositions. For, indeed, Ault was not making literal copies of the place. As he said, he was making "order out of nature," or, as one critic aptly put it: "Ault is trying to paint exactly what he sees, and he goes beyond reality simply by conveying a sense of how clear painting can be and of how intense the concentration is which achieves it."[6]

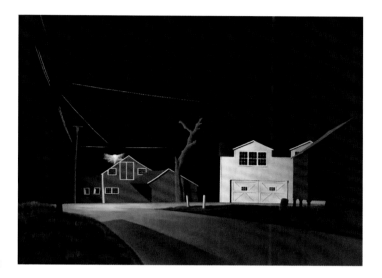

1. Undated handwritten note by George Ault on p. 332 of *The Arts* (December 1928), in the George C. Ault artist file, Library and Archive, Smithsonian American Art Museum, Washington, DC. Emphasis in original.
2. Known as the Russell's Corners Nocturne Series, the other paintings are *Black Night: Russell's Corners* (1943; Pennsylvania Academy of the Fine Arts, Philadelphia), *Bright Light at Russell's Corners* (1946; Smithsonian American Art Museum, Washington, DC), and *August Night at Russell's Corners* (1948; Joslyn Art Museum, Omaha).
3. Susan Lubowsky, *George Ault*, exh. cat. (New York: Whitney Museum of American Art, 1988), p. 8.
4. The paintings are reproduced in ibid., pls. 4, 1, 15, and 26, respectively.
5. Louise Ault, *Artist in Woodstock, George Ault: The Independent Years* (Philadelphia: Dorrance & Company, 1978), pp. 89–90.
6. Roberta Smith, "Reviews," *Artforum*, vol. 12, no. 7 (March 1974), p. 74.

Fig. 15: **George Ault**
American, 1891–1948
Black Night: Russell's Corners, 1943
Oil on canvas, 18 x 24 ¹/₁₆ inches (45.7 x 61.2 cm)
Pennsylvania Academy of the Fine Arts, Philadelphia. John Lambert Fund.
1946.3

MILTON AVERY

RED NUDE

1955

Milton Avery (1893–1965) was a thinker, an observer, and a reader, not a talker. A largely self-taught artist, though always looking carefully at the art of others, he developed his own method of working and a style that uniquely straddles representation and abstraction. Although his paintings at first may appear naive in their compositions of simple, flat, interlocking shapes, they are highly evolved results of Avery's penetrating visualization of form and surface and his finely tuned sense of color. As Adelyn Breeskin observed, "He developed a style of his own, with no predecessors whose work closely resembled his, and also with no direct followers."[1] Yet Avery did not come out of nowhere. His acknowledged influences were Albert Pinkham Ryder and Henri Matisse; he was part of a circle in New York that included Marcel Duchamp, Francis Picabia, and Jacques Villon; he worked in artists' retreats such as Gloucester and Provincetown, Massachusetts, and Woodstock, New York; and close friends in later years were Mark Rothko and Adolf Gottlieb.

Avery's working process was clearly charted; he found what worked for him and did not stray from it even as his style developed. He began his paintings by making sketches from nature, attending sketch classes and drawing from live models throughout his life until poor health prevented it; from sketches he proceeded to watercolors, where the format of a painting emerged, but he did not begin to paint until he had mostly worked out the composition in his head. He then painted quickly to maintain the freshness of his vision, maintaining flexibility only to improvise in the choice of colors.[2] Avery painted thinly, using transparent washes to give emphasis to the flatness of the canvas; contours were sometimes created by simple juxtapositions of colors.

Avery painted nudes frequently throughout his career. Between the 1930s and early 1940s, his nudes displayed flattened bodies with slight indications of shading, but by the late 1940s his forms as well as his colors had moved farther from reality.[3] The nudes Avery created during his last decade show his ultimate integration of simplified shapes and forms. Contours and details such as hair, breasts, or fingers (if they are indicated

Plate 7
Milton Avery
American, 1893–1965
Red Nude, 1955
Oil on canvas, 22 x 50 inches (55.9 x 127 cm)
Collection of C. K. Williams, II

at all) were drawn with uneven, hair-thin lines that waver and occasionally disappear, so that changes of color alone suggest boundaries. Many of Avery's nudes of the 1950s, such as *Red Nude*, were painted in a single flat color with little modulation of tone, showing his inclination during that decade to eliminate anything that seemed extraneous. In fact, *Red Nude*, which is composed of a severely limited range of reds, rose, hot pink, and orange, may be his most minimal, most sophisticated handling of the subject, for few other works have the same spectral glow.[4] In *Red Nude*, small hints of light surround the figure's torso, so that the image nearly disappears in an overall radiance.

1. *Milton Avery*, introduction by Adelyn D. Breeskin, exh. cat. (Washington, DC: National Collection of Fine Arts, Smithsonian Institution, 1969), n.p.
2. Robert Hobbs, *Milton Avery: The Late Paintings*, exh. cat. (New York: Harry N. Abrams, in association with the American Federation of Arts, 2001), p. 71.
3. See, for example, *Blue Nude* (1947), in the Metropolitan Museum of Art, New York.
4. See, for example, *Sailfish in Fog* (1959), reproduced in Barbara Haskell, *Milton Avery*, exh. cat. (New York: Whitney Museum of American Art, in association with Harper & Row, 1982), pl. 91.

ROMARE BEARDEN

TROMBONE PLAYER

c. 1986

Reared in Harlem by parents who counted among their friends the artists, writers, and intellectuals of the Harlem Renaissance, Romare Bearden (1914–1988) continued to live and work in New York for the greater part of his life. After graduating in 1935 from New York University, where he had been a cartoonist for the university's monthly magazine, he studied with George Grosz at the Art Students League. He also frequented the Harlem nightclubs, and although jazz musicians did not become part of his artistic repertoire until later, a close friendship with the artist Stuart Davis in the late 1930s introduced him to a new way of thinking about the connection between painting and jazz: "And from then on, I was on my way. I don't mean to imply that I knew where I was going. But the more I just played around with visual notions as if I were improvising like a jazz musician, the more I realized what I wanted to do as a painter, and how I wanted to do it."[1]

Bearden made his first collage about 1956, first reusing fragments of his earlier watercolors and drawings and later employing cut-up magazines and newspapers. By the 1960s collage had become his favorite medium, and he continued to work with it for the rest of his life, progressively replacing photographic images with flat colored papers, fabric, foils, and found materials, attached to canvas or fiberboard.[2] In the 1970s collages of New York music clubs and musicians became predominant themes in Bearden's work, highlighted in *Of the Blues*, a 1975 exhibition at his New York gallery, Cordier and Ekstrom. *Trombone Player*—a late collage of about 1986— shows that Bearden continued to favor jazz as a subject for the rest of his career.

Ruth Fine discusses the difficulty of assigning dates to much of Bearden's work, a situation that exists not only because many of his works are undated, but also because he often would later repeat an earlier subject or process.[3] The single trombone player may have appeared first in Bearden's 1979 *Solo Flight*, one of a series of brilliantly colored six-by-nine-inch collages that Bearden made in St. Martins,[4] where he had built a house in 1973; a similar profile of a trumpet player also occurs in Bearden's 1985 design for Wynton Marsalis's disc

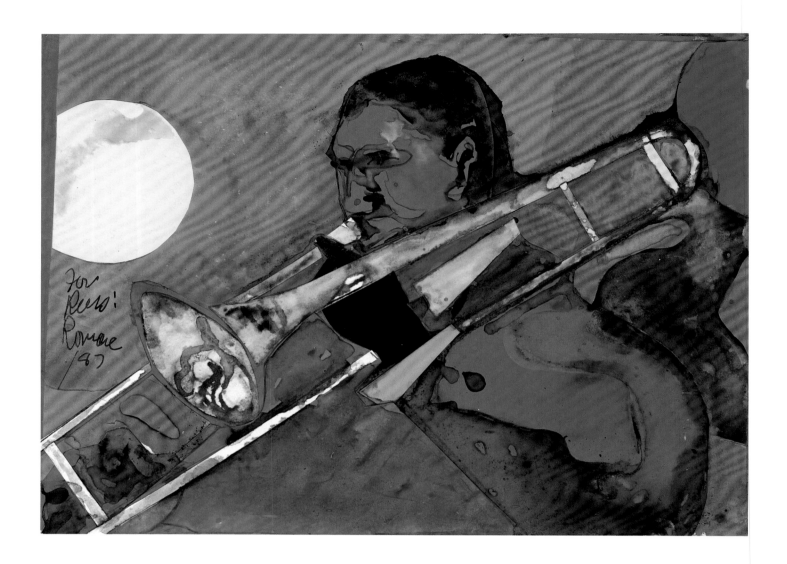

Plate 8
Romare Bearden
American, 1914–1988
Trombone Player, c. 1986
Paper collage and gouache on board, 8 x 11 inches (20.3 x 27.9 cm)
Collection of C. K. Williams, II

album *J Mood*, showing the close connection that existed between his art and his commercial work.[5] The present collage portrays Russell Goings as a trombone player, a close friend of the artist whom he occasionally used as a model for his work.[6] Bearden also dedicated the collage to Goings in 1987 and gave it to him. A former National Football League player for the Buffalo Bills who had held the first black-owned seat on the New York Stock Exchange, Goings spent a great deal of time with Bearden during his final illness, taping discussions with him about his work, keeping a diary of their conversations, preserving his correspondence, and forming a collection of his art.[7]

Bearden died in 1988, and he worked up to the last months of his life, with no deterioration of his creative abilities. Goings suggests that Bearden made *Trombone Player* about 1986, when he was making small collages,[8] and indeed it displays many of the hallmarks of Bearden's small, brilliant collages of that period, which he called "collage paintings."[9] In them, he basically painted all the elements of the composition, including the background and the large and small collage elements, to which he applied additional color. In *Trombone Player*, he laid down a painted orange background and dominant areas of blue, including a yellow sun and a blue moon, but he also applied a wide range of colors to even the smallest collaged pieces, such as the long, thin slide of the trombone and the dazzling rosette of variegated colors within the horn. Bearden was also using a bleaching agent like Clorox or hydrogen peroxide in this period, poured over flat areas of paint to produce fluid, lighter patches of color.[10] This can be seen in several areas of *Trombone Player*, such as in the puddles of lighter blue within the musician's jacket and in the area behind his shoulder.

1. Bearden, quoted in Jerald L. Melberg and Milton J. Bloch, eds., *Romare Bearden: 1970–1980,* exh. cat. (Charlotte, NC: Mint Museum, Department of Art, 1980), p. 23.
2. Ruth Fine, *The Art of Romare Bearden*, exh. cat. (Washington, DC: National Gallery of Art, 2003), pp. 27ff., provides the best analysis of the evolution of Bearden's collages and their materials.
3. Ibid., p. 19.
4. *Solo Flight* is reproduced in Myron Schwartzman, *Romare Bearden, His Life and Art* (New York: Harry N. Abrams, 1990), p. 275.
5. Fine, *The Art of Romare Bearden*, p. 81.
6. Russell Goings in a telephone conversation with the author, January 30, 2007.
7. See Samuel Freedman, "An Artist Talked and a World Listens," *New York Times*, December 28, 2004.
8. Goings says that after Bearden took on André Thibault/Teabo as his assistant in late 1986, he began to concentrate on making large collages.
9. Fine, *The Art of Romare Bearden*, p. 105.
10. Ibid., p. 107.

GEORGE WESLEY BELLOWS

THE BEACH, NEWPORT

1919

Though devoted to using geometric and scientific systems to govern the compositional structure and colors of his paintings, George Wesley Bellows (1882–1925) exhibited such natural virtuosity with paint that it defeated any limitations such schemes might impose. Whatever the system, palette, subject, or style, Bellows's luscious paint surfaces stand as his most evident and extraordinary achievement, arguably surpassing his mastery in graphic art. Bellows's talents were discovered early, and he developed quickly as an artist after his arrival in New York from Columbus, Ohio, in 1904 to enter William Merritt Chase's New York School of Art, where he became the best pupil of the American Realist Robert Henri. Physically tall and imposing, Bellows developed a bold, dynamic style that earned him membership in the Ashcan School as its youngest member as well as election to the National Academy of Design in 1909. After his marriage in 1910, Bellows and his wife, Emma, spent summers on Long Island and Monhegan Island, Maine; in 1918 and 1919 he and his family vacationed in Middletown, near Newport, Rhode Island, where he painted *The Beach, Newport (In the Sand)*.

According to contemporary sources, Bellows's prodigious memory nearly eliminated his need to make preliminary drawings for his paintings,[1] though he drew constantly and excelled as a lithographer. Thus, the existence of two drawings for the painting *The Beach, Newport* (showing Third Beach, Newport, Rhode Island, where a pair of city folk has flung themselves fully dressed on a dune near other more appropriately dressed boaters and bathers)[2] presents an unusual and interesting glimpse into Bellows's artistic practice. The first in the sequence of drawings is a small graphite sketch (fig. 16), apparently swiftly set down on the site. Here, the sleeping pair seems proportionately larger than they do in the painting, and they are flanked on either side by figures in rowboats. Looming abstract shapes that rise just behind the couple suggest that some figures might be standing silhouetted against the sky. Executed after the rapid sketch, probably in the artist's studio, is a finished crayon drawing (fig. 17), more than six times the size of the sketch, in which the sleeping couple, though smaller in scale, becomes the center of attention, with all subsidiary details pushed far to each side.

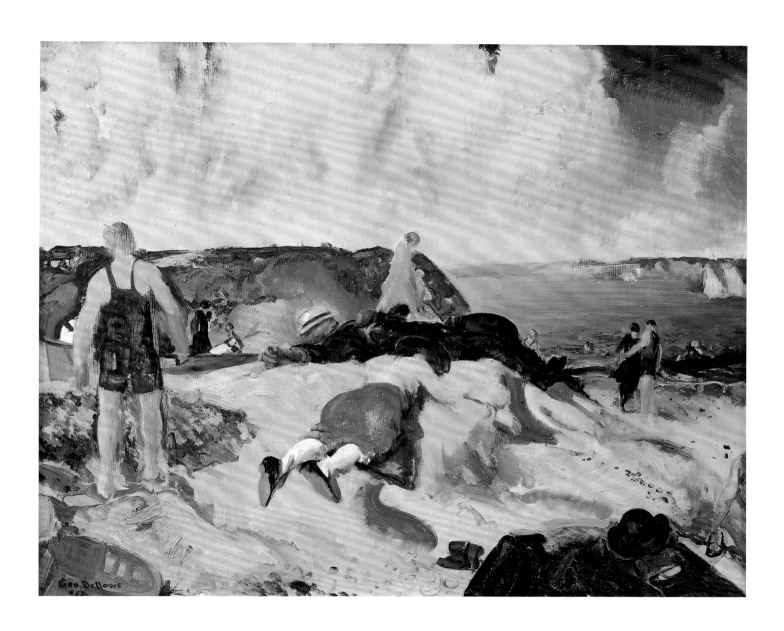

Plate 9
George Wesley Bellows
American, 1882–1925
***The Beach, Newport (In the Sand)**, 1919*
Oil on panel, 26 x 32 inches (66 x 81.3 cm)
Collection of C. K. Williams, II

 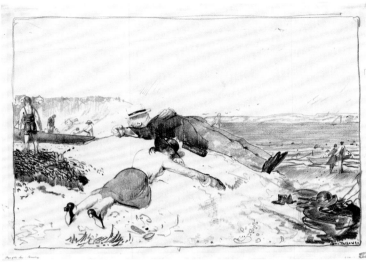

As might be expected, the painting differs from the drawing in several details, most notably with the addition of a girl, dressed in pink, striding across the center of the composition; a youth in a purple bathing suit, standing stiffly in the sand to the left, receives greater prominence than in the drawing. It has been recently proposed that Bellows constructed the composition of the finished preliminary drawing for *The Beach, Newport* using "a loose division of space according to the golden section."[3] The imposition of such a system had the result of making the poses of the figures seem more isolated and stilted than in the earlier sketch, and Bellows transferred that effect to the painting. As in all of his systematized compositions, however, his handling of paint mitigates any sense of rigidity. *The Beach, Newport* displays the somewhat subdued palette he was using in his summer landscapes of 1918–19, which replaced the intense, unmixed colors he had previously preferred.[4] Apparent here is his fondness for juxtaposing color opposites, such as purples and yellows, which creates a somewhat dissonant note in the midst of the bright expanses of white sand, green dune grasses, and deep blue sea beneath towering clouds, applied with Bellows's characteristic bravura.

Bellows was an accomplished lithographer, and in 1920 he began working with the printer Bolton Brown. Several of the first prints he produced with Brown were based on earlier paintings,[5] but his 1921 lithograph *Legs of the Sea* is an exception. Instead of following, in reverse, the composition of *The Beach, Newport*, Bellows returned to develop the details of his early graphite sketch, perhaps preferring its more successful integration of the figures into the setting.

1. Robert Conway, *The Powerful Hand of George Bellows: Drawings from the Boston Public Library* (Washington, DC: Trust for Museum Exhibitions, in cooperation with the Boston Public Library, 2007), pp. 92, 141 n. 48.
2. According to a former owner of the painting, the two figures on the dune are the artist's wife, Emma, and her father, William E. Story, of Montclair, New Jersey.
3. Conway, *The Powerful Hand of George Bellows*, p. 36. The golden section is a system in which the sides of a rectangle are subdivided based on the ratio of 1:1.618.
4. Michael Quick, "Technique and Theory: The Evolution of George Bellows's Painting Style," in *The Paintings of George Bellows*, exh. cat. (New York: Harry N. Abrams, in association with Amon Carter Museum, Fort Worth, and Los Angeles County Museum of Art, 1992), p. 57.
5. Jane Myers and Linda Ayres, *George Bellows: The Artist and His Lithographs, 1916–1924* (Fort Worth: Amon Carter Museum, 1988), pp. 74, 81.

Fig. 16: **George Wesley Bellows**
American, 1882–1925
***The Beach (Study for "Legs of the Sea")**, 1919
Graphite on wove paper, 6 5/8 x 8 1/8 inches (16.8 x 20.6 cm)
Boston Public Library

Fig. 17: **George Wesley Bellows**
American, 1882–1925
***The Beach (Legs of the Sea)**, 1919
Crayon on wove paper, 14 1/4 x 20 11/16 inches (36.2 x 52.6 cm)
Boston Public Library

THOMAS HART BENTON

SUGAR CANE
c. 1938–43

SUGAR MILL
1946

Thomas Hart Benton (1889–1975) drew and drew. Throughout his career, drawing played an important and specific role in his artistic practice. A great many of his drawings were made during long, wandering trips he took through many parts of the United States. Fascinated by the diverse characteristics of each place he visited, he recorded the life and work of ordinary people in rapid pencil sketches. Because the pencil frequently smudged as he carried his drawings around, he usually went over them in pen and ink. Next to the southern Midwest, where he was born, Benton loved to travel through the South, which he visited first on a sketching trip in 1924; he continued his explorations there well into the mid-1940s. Probably during a trip in 1938, Benton recorded the activities of gathering, loading, and processing sugar cane in Louisiana, where most of the country's sugar cane was grown at the time. The trip was taken with James Fitzgerald, who taught watercolor at the Kansas City Art Institute: "The two started their trip in New Orleans, then went west to the boom-town of Disney, Oklahoma, cut back through southern Missouri, and then ranged through Tennessee and North Carolina. 'I made about forty pictures,' Benton told a reporter."[1] The present undated drawing and the related watercolor of 1946 belong to a group of sugar cane pictures, which includes two 1943 paintings of the harvesting of sugar cane, two undated drawings (including the present one), depicting the loading of sugar cane onto a wagon, the present watercolor, dated 1946, showing the sugar cane being unloaded and carried into the mill for crushing under rollers and boiling, and a preparatory drawing for it (fig. 18).[2] The production of sugar cane before the introduction of mechanization that Benton recorded in these pictures involved harvesting with machetes and loading, transport, and processing of sugar cane by hand in the mill—work that required cheap, abundant labor by poorly paid field hands.

Taken together, the paintings, watercolor, and drawings of the sugar cane industry reveal Benton's detailed and analytical approach to his subjects. The two paintings show that if he were satisfied with a composition, he would repeat it in a nearly identical second version, changing only minor details of the setting, but leaving every major aspect of the subject

Plate 10
Thomas Hart Benton
American, 1889–1975
Sugar Cane, c. 1938–43
Pen and ink over graphite on paper, 14 x 20 inches (35.6 x 50.8 cm)
Collection of C. K. Williams, II

Plate 11
Thomas Hart Benton
American, 1889–1975
Sugar Mill (Syrup Mill), 1946
Watercolor on paper, 20 x 29 inches (50.8 x 73.7 cm)
Collection of C. K. Williams, II

exactly as it was in the first. In the three drawings of sugar
cane, of which there must have been more, we can follow
Benton as he literally moves around his subject, recording the
role of each worker and the specific details of his labor. In one
drawing, the mule-driven cart is led around a track while
bales of cane are lifted onto the cart by a hand-operated
system of ropes and pulleys attached to poles. In the present
drawing, Benton moved closer to the cart and in front of the
mill; here, the cart is piled high with cane, and the effort of
operating the ropes has increased as the heavy bales must
be raised higher and higher.

The details of the background of the present drawing,
particularly the mill and its antiquated smokestack, are identi-
cal to those in the watercolor, though Benton's viewpoint is
more distant and farther to the right; in the watercolor, the
focus changes to the mill and the activity in and around it. Here,
as well as in Benton's preparatory drawing for the watercolor,
the subject is the hauling of heavy loads of cane by hand into
the mill. In the drawing, he observes the backbreaking effort
in the face of one worker who struggles under the weight of
the cane; another tries with difficulty to manage an armload of
cane as he moves it toward a third man operating the crusher.
The finished watercolor shows how Benton added color to
emphasize the fiery heat in the mill, the blast of smoke, and the
red-streaked sky, silhouetting the smokestack and the man
struggling to operate the ropes and pulleys against it. Benton
created meticulously organized compositions from his many
drawings, seen here in the masterfully composed sequence of
opposing diagonals formed by the sheaves of cane, the hauling
apparatus, and the mill itself, as well as by the movement of
the workers advancing toward the mill. Benton adds to this
organization his characteristic picturesque handling of details
such as the toppling old smokestack and the animated arch of
smoke that lands as though on two feet on the mill's sweltering
roof. By the late 1930s and 1940s, Benton had to travel deep
into the country to find the kind of hand labor he recorded in
this series of pictures; unlike his documentary travel studies
of the 1920s, he was now recording with sympathy and some
nostalgia an America that was fast disappearing.

1. Henry Adams, *Thomas Hart Benton: Drawing from Life*, exh. cat. (Seattle:
Henry Art Gallery, University of Washington, published by Abbeville Press,
1990), p. 177.
2. One of the paintings, *Sugar Cane* (1943) is in the estate of the artist. See
J. Richard Gruber, *Thomas Hart Benton and the American South* (Augusta, GA:
Morris Museum of Art, 1998), p. 46. A variant of the painting *Untitled (Sugar
Cane)* was formerly listed on the website of the Spanierman Gallery, LLC, New
York. A drawing *Loading Sugar Cane* was reproduced in *Benton's America:
Works on Paper and Selected Paintings*, introduction by Douglas Dreishpoon,
exh. cat. (New York: Hirschl & Adler Galleries, 1991), p. 39, nos. 26, 52. The
location of the preparatory drawing for the watercolor is unknown, but it is
reproduced in *Benton Drawings: A Collection of Drawings by Thomas Hart
Benton* (Columbia: University of Missouri Press, 1968), no. 72 (as *Sugar Mill A*).

Fig. 18: **Thomas Hart Benton**
American, 1889–1975
***Sugar Mill**, c. 1938–46
Medium unknown, 10 ½ x 15 inches (26.7 x 38.1 cm)
Location unknown

THOMAS HART BENTON

THE APPLE OF DISCORD
1949

In spite of the shift of the art world away from representational paintings, which was so marked a characteristic of the late forties and all of the fifties, I continued to make and sell such works. When they possessed human content, however, this factor began to be placed, not in a Regionalist present, but largely in the past. In dealing with the activities of people, I became more and more a painter of history.[1]

The years following World War II were filled with difficulty for Thomas Hart Benton (1889–1975). With the death of Grant Wood in 1942 and John Steuart Curry in 1946, Benton was the last remaining member of the trio of Regionalist painters who had achieved positive recognition in the 1930s. In 1946 Horst W. Janson wrote a virulent attack on Regionalism in *The Magazine of Art*, condemning it as fascist art. Benton, who had been largely unsuccessful in working on advertising commissions for corporate America in the early 1940s, ended up blaming advertising for the downfall of Realist art.[2] As Benton stated above, he never retreated from representational art, though his direction changed as he more or less abandoned roving the country for indigenous subject matter; people had become more suspicious and less welcoming of unannounced strangers after the war, and Benton himself was no longer the wandering youthful sketcher he had been. As the 1940s progressed, he turned more frequently to historical subjects and to those inspired by his intimate surroundings. Still, his new direction had many links to his earlier art.

In subject as well as in style, *The Apple of Discord* was a direct descendant of the two infamous paintings Benton had made a decade earlier: *Susannah and the Elders* (1938), based on the Apocrypha, and *Persephone* (1938–39), each presented as shockingly realistic contemporary scenes of nude women ogled and lusted after by men.[3] This was a subject with an even earlier history in Benton's development, going back to his encounter at age seventeen with a painting of a nude in a barroom in Joplin, Missouri, which was not unlike the images in these paintings: "Across from the bar hung a big painting. This was a famous painting in the locality. It depicted a naked girl with a mask on her face. She was lying across a sort of

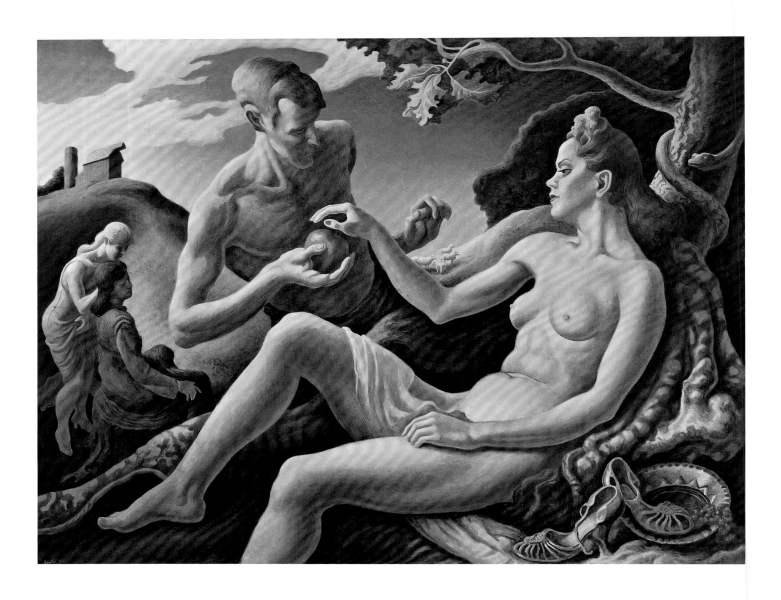

Plate 12
Thomas Hart Benton
American, 1889–1975
The Apple of Discord, 1949
Tempera glazed with oil on gessoed mahogany panel, 33 ½ x 43 ¼ inches (85.1 x 109.9 cm)
Philadelphia Museum of Art. Promised gift of C. K. Williams, II

bed and appeared to be dying from a knife wound. In the background was a young man in fancy costume." Ironically, this event had deeper significance, for Benton claimed that it was the origin of his decision to become an artist;[4] in 1971 he made a painting of it to commemorate that moment.[5]

The Apple of Discord is a fanciful conflation of the Greek myth of the Judgment of Paris and the biblical story of Adam and Eve and the serpent.[6] Benton seems to have relished the ambiguity caused by his artful blending of two tales in which the giving and receiving of an apple unleash a disastrous chain of events. Key details from each narrative are readily apparent—at right, Eden's serpent coils around a tree trunk as witness to original sin; at left, Hera and Athena, the two goddesses rejected by Paris in favor of Aphrodite, appear to be comforting each other, while Paris's sheep gather on a distant hill. Most confounding of all are the gestures of the two protagonists, which succeed in leaving open to question who is giving and who is receiving the apple. Benton brings both events squarely into the present day, for the narrative takes place on a rural American farm; Eve/Aphrodite is a forties beauty queen, complete with high-heeled shoes and up-to-date coiffure; and Adam/Paris is a timid, skinny, shirtless farmhand.

Nowhere more than in his monumental biblical and mythological paintings of nudes did Benton display his deep knowledge of old master painting. In bringing two ancient tales into the present day in *The Apple of Discord*, he followed a tradition familiar in Renaissance narrative cycles where events were frequently set in recognizable surroundings, with local participants in contemporary costume. Notably, however, Benton's painting differed from those scenes in one crucial aspect, for the modern-day figures in Renaissance paintings were only witnesses to the principal event—they were never the central figures, as they are here. In placing contemporary figures in the starring roles of two well-known stories and emphasizing the grandeur and significance of their attitudes, Benton's intention was clearly to shock. The noble curve of Eve/Aphrodite's long neck gives her a queenly demeanor, while her intense gaze and slow, languid gesture acquire a symbolic significance similar to that of Adam being brought to life in Michelangelo's *Creation of Adam*, an image that, in fact, it brings to mind; Adam/Paris's pose is more mannered, but seems equally charged with meaning. While cupping the apple in one hand, he raises his other hand as though to touch his intended partner's breast on which he rests his gaze. Every detail, whether from the natural or material world, is recorded with the precision of an early Netherlandish painting, making all the more flamboyant Benton's merging of the two familiar subjects.

1. Thomas Hart Benton, *An Artist in America*, 3rd ed., rev. (Columbia: University of Missouri Press, 1968), pp. 329–30.
2. Henry Adams, *Thomas Hart Benton: An American Original* (New York: Alfred A. Knopf, 1989), pp. 320–24. Adams quotes Benton on p. 324: "It is perhaps questionable whether any serious publicly directed art of a realistic nature can permanently sustain itself in America as long as the advertising trade in its present form exists."
3. *Persephone* and *Susannah and the Elders* are reproduced in Matthew Baigell, *Thomas Hart Benton* (New York: Harry N. Abrams, 1973), pls. 105 and 106, respectively.
4. See Benton, *An Artist in America*, pp. 18–20, at 18, 19: "I must have got sufficiently absorbed in this masterpiece to attract attention, . . . I turned around to meet a line of grinning fellows and a barrage of kidding. . . . In desperate defense of my position, I stated that I wasn't particularly interested in the naked girl but that I was studying the picture because I was an artist and wanted to see how it was done. . . . By a little quirk of fate, they made a professional artist of me in a short half-hour." After telling them he was out of a job, one of the men took him to the local newspaper, where he made a sketch and became an artist for the paper.
5. *Young Tom Benton at the House of Lords in Joplin, Missouri*, 1906, oil sketch, 1971. Reproduced in Victor Koshkin-Youritzin, "Thomas Hart Benton: 'Bathers' Rediscovered," *Arts Magazine*, vol. 54, no. 9 (May 1980), p. 101, fig. 13.
6. Karal Ann Marling, *Tom Benton and His Drawings: A Biographical Essay and a Collection of His Sketches, Studies, and Mural Cartoons* (Columbia: University of Missouri Press, 1985), p. 178, no. 16-2, mentions that Benton made several versions of *Judgment of Paris*, which has also been suggested as the title of this painting.

GEORGE BIDDLE

SELF-PORTRAIT

1933

In this small self-portrait of 1933, George Biddle (1885–1973) painted himself dressed for the outdoors in a coat with a high fur collar. His very pink cheeks suggest that he is out in cold weather, as is confirmed by his appearance in a larger and more detailed version of the same portrait, also dated 1933 (fig. 19), in which the artist is seated in front of a stand of leafless birch trees, perhaps somewhere on the property he owned near Croton-on-Hudson, New York.[1] That the smaller version is not a sketch for the larger picture is documented by a letter Biddle wrote on September 7, 1934: "It is a recent self portrait, a large duplicate of which was exhibited last winter at the Whitney Museum of American Art and the Philadelphia Fairmount Park Museum."[2]

Biddle painted his self-portraits in the same year he wrote to his former schoolmate, President Franklin D. Roosevelt, proposing the establishment of a government program to sponsor art in public buildings, which resulted in the Public Works of Art Program and the Works Progress Administration. This is perhaps the most dramatic example of the independence and creative thinking of this artist, who was born into one of Philadelphia's most prominent families. Having studied art since an early age in Philadelphia, Biddle went on to Groton and Harvard, graduated from the Harvard Law School, passed the Pennsylvania bar, and forthwith moved to Paris to pursue his art studies at the Académies Julian and Colarossi. On his return to Philadelphia, Biddle studied at the Pennsylvania Academy of the Fine Arts, where his imagery and style showed the strong influence of Mary Cassatt and Edgar Degas, whom he had known in Paris. Thereafter, Biddle left Philadelphia for good, although he maintained a strong relationship with friends and relatives in the city. A sculptor, printmaker, world traveler, and author of several books on art and artists, Biddle held important art advisory positions in the United States government during and after World War II and was generally an influential citizen in and out of art circles.[3]

By the 1930s, when he painted this self-portrait, Biddle's style had evolved far from that of Cassatt and Degas. On the one hand, he painted satiric views of the frivolous side of American

Plate 13
George Biddle
American, 1885–1973
Self-Portrait, 1933
Oil on canvas, 14 x 10 inches (35.6 x 25.4 cm)
Collection of C. K. Williams, II

life, even as he made proposals for grandly conceived murals of laboring workers for projects in Washington and Philadelphia. Most distinctive in all his work were the fine wavering outlines that trace the contours of forms—a mannerism he picked up in Paris in the 1920s, when he worked closely with Jules Pascin. Biddle's portraits are among his strongest works, and he often enlivened them by including descriptive surroundings, such as in *Portrait of William Gropper*, in which Gropper is surrounded by sketches, and *Portrait of Man Ray*, which shows the artist seated near various Surreal accoutrements.[4] He seems to have made several self-portraits in the 1930s, including a lithograph of 1932, the painting *Self-Portrait with Skis* (1936),[5] as well as the present work and its larger counterpart.

1. The small *Self-Portrait* was donated by Biddle to the Endowment Collection of the Museum of Fine Arts, Houston, in 1934; it was sold by that institution in 1973. The larger version is in the Philadelphia Museum of Art.
2. George Biddle to an unnamed recipient, September 7, 1934, archives, The Museum of Fine Arts, Houston.
3. See *Philadelphia: Three Centuries of American Art*, exh. cat. (Philadelphia: Philadelphia Museum of Art, 1976), pp. 540–41.
4. The portraits of Gropper and Man Ray are reproduced in *Paintings from Europe and the Americas in the Philadelphia Museum of Art: A Concise Catalogue* (Philadelphia: Philadephia Museum of Art, 1994), pp. 325–26.
5. Reproduced in *Art Digest*, vol. 12, no. 3 (November 1, 1937), p. 21.

Fig. 19: **George Biddle**
American, 1885–1973
Self-Portrait, 1933
Oil on canvas, 31 ⅛ x 25 ¼ inches (79.1 x 64.1 cm)
Philadelphia Museum of Art. Bequest of Margaretta S. Hinchman. 1955-96-1



ISABEL BISHOP

THE CLUB
1935

I think these men felt a certain cohesiveness to each other. Groups of them met in certain parts of the Square like a club and they would notice who wasn't there and who was.[1]

Trained at the Art Students League with Kenneth Hayes Miller in the 1920s, Isabel Bishop (1902–1988) shared with her teacher a fondness for portraying the interaction of the diverse ordinary population of New York City: shopgirls, office workers, clerks, idlers, and so forth, yet she always treated her subjects with greater human interest than Miller, focusing on the telling expression or gesture. At home in suburban Riverdale, Bishop was married to a successful physician, but she commuted each day to her studio in Manhattan, leading the daily life of an independent artist, an unusual circumstance that she took in her stride, eschewing any feminist agenda. Hailed in 1936 as "one of the most important woman painters in America today,"[2] Bishop spent her long career as the sensitive observer of daily life, working in the mediums of drawing, etching, and painting, which she approached with the painstaking method of the old masters.

In 1934, the year she married, Bishop moved to a new studio at 857 Broadway, with its windows facing the northwest side of Union Square. In earlier years at a nearby location on West Fourteenth Street, her work already concentrated on the life of the square, but now it lay spread before her window, allowing for endless hours of contemplating and sketching the passing scene. *The Club*, which she completed in 1935, is one of her best-known paintings of the Union Square "bums," as she called the unemployed men who gathered in the square, reading, musing, napping, and talking, and here shown congregating around the base of the equestrian statue of George Washington. While Bishop would often sit in the square and sketch, she also would invite some of the people who interested her to visit the studio: "I got to know them as I had a series of them come up here. They would bring each other and they would take anything they could lay their hands on."[3] This statement is telling of her essentially detached attitude toward the misfortune of her subjects, for she considered them picturesque characters that were readily available to draw. As she

Plate 14
Isabel Bishop
American, 1902–1988
The Club, 1935
Oil and tempera on pressed board, 17 x 20 inches (43.2 x 50.8 cm)
Collection of C. K. Williams, II

explained in an interview in 1974: "I've been interested in bums and so on for years. I was interested because I could get them. They were available, and they were very beautiful to draw. . . . I didn't feel they were victims exactly, but that their lives were largely a matter of choice."[4] Neither sympathetic nor particularly critical, Bishop's view of her subjects seems to be motivated more by aesthetic response than by a spirit of condescension.

Bishop worked very slowly on her paintings, as she employed an exceedingly laborious preparatory process. She not only made many sketches, but she also made etchings, turning to a new plate each time she made a change; she also made photographic enlargements of etchings to use for reference as she composed her paintings. *The Club* was preceded by what must have been many sketches of individual figures and groups, which were followed by a highly finished compositional drawing in wash, chalk, and oil that is nearly identical to the painting.[5] This procedure, consisting of initial sketches of individual figures and groups, followed by a painterly compositional study, is the same preparatory method as that of the old masters from the late fifteenth century onward. Rembrandt and Rubens were special favorites of Bishop's, the former for his humanity and the latter for the transparency and luminosity of his oil sketches.

The Club is remarkable for its nearly monochromatic palette and its luminous transparency, which must have evolved from the oil glazes Bishop is known to have favored. The figures are enveloped by a yellowish gray light—almost a haze—that obscures the figures in the distance but reveals more of the semicircular group of men in the foreground. Artfully yet naturally arranged, they are described in varying degrees of detail, but the focus of attention is the man in the center of the foreground, whom she drew with great precision. Huddled in his coat and deep in thought, he is clearly a portrait of someone Bishop knew.[6]

1. Bishop, quoted in Cindy Nemser, "Conversation with Isabel Bishop," *Feminist Art Journal* (Spring 1976), p. 18.
2. Emily Genauer, in *New York World Telegram*, quoted in Helen Yglesias, *Isabel Bishop* (New York: Rizzoli, 1989), p. 17.
3. Nemser, "Conversation with Isabel Bishop," p. 18.
4. Quoted in James M. Dennis and Kathleen M. Daniels, "A Modern American Purgatory: Isabel Bishop's *Dante and Virgil in Union Square*, 1932," in *Between Heaven and Hell: Union Square in the 1930s*, exh. cat. (Wilkes Barre, PA: Sordoni Art Gallery, Wilkes University, 1996), p. 10.
5. Karl Lunde, *Isabel Bishop* (New York: Harry N. Abrams, 1975), figs. 73–74, reproduces two pen and ink sketches for figures in the painting. Fig. 75 reproduces the compositional drawing in wash, chalk, pencil, and oil, in the Phoenix Art Museum; its dimensions are only about three inches smaller than the painting.
6. *Phoenix Art Museum: Collection Highlights* (New York: Harry N. Abrams, 2002), p. 39, no. 20 (entry by Betsy Fahlman). The man in the foreground is identified by Fahlman as Walter Broe, who modeled for Reginald Marsh and Raphael Soyer and who was the subject of a drawing by Bishop in 1935 (location unknown). However, the man in Bishop's painting does not have Broe's distinctive long, thin face.

ISABEL BISHOP

OUT TO LUNCH
1953

Isabel Bishop (1902–1988) claimed that the laborious process she used for preparing her paintings made it hard for her to hold onto the initial spark that had inspired it in the first place, yet the transparency of her paintings' surfaces and her method of enlivening them with fine, unsystematically applied horizontal and vertical lines give her images an immediacy and sparkle that belie her arduous preparation; she kept using the same method throughout her career. In the upper right of *Out to Lunch*, one glimpses the random horizontal gray stripes that the artist initially applied to the panel covered by many layers of gesso, creating a vibrating environment for the figures. Over these lines she drew the figures, varnished, blotted, and finally began to paint: "Tone upon tone was then overlaid on this tacky ground, the striped underpainting remaining visible through the layers of oil."[1] Finally, she applied a veil of fine, random lines to the painted surface, seen most clearly in the lower right of the present work. Although Bishop's painting technique never altered, her palette changed from the pale, almost monochromatic paintings of women in the 1930s to the brilliant reds, greens, and yellows she used in *Out to Lunch*, which has an overall shimmering golden tonality, giving the impression that we glimpse the scene through a plate-glass window.

Out to Lunch perpetuates a subject Bishop had pursued since the 1930s: ordinary young women, individually or in pairs, going about the routines of daily life, such as walking, talking, dressing, eating, and reading. During the 1950s she drew, etched, and painted many variants of the image of a young woman seated on a stool at a counter, about to bring a glass to her lips.[2] Often, these women of the 1950s were not dressed in business attire, as they had been in the 1930s. Instead, their garments are less formal, rumpled and unruly, suggesting that these are not working girls on lunch break but that they are out enjoying some leisure activity. In this painting, the woman's puffed-sleeve peasant blouse slips from her shoulder, and a high-heeled anklestrap shoe rests on a rung of her stool. Another woman stands to her left with her back to the viewer; less distinct figures and shapes evoke a crowded bar. Alone in a crowd, perhaps, the women do

Plate 15
Isabel Bishop
American, 1902–1988
Out to Lunch, 1953
Oil and tempera on gessoed panel, 24 ¼ x 16 ¼ inches (61.6 x 41.3 cm)
Collection of C. K. Williams, II

not interact with each other. We catch the stolid, immobile woman on a stool between sips, lost in thought, and momentarily unaware of her surroundings.

1. Helen Yglesias, *Isabel Bishop* (New York: Rizzoli, 1989), p. 18.
2. Numerous drawings and etchings of a young woman seated on a barstool are reproduced in Karl Lunde, *Isabel Bishop* (New York: Harry N. Abrams, 1975), figs. 127–30. The major paintings of this subject, besides the present one, are *Snack Bar* (c. 1954) and *Pause to Refresh* (1955) (ibid., figs. 131–32). All three paintings display a similar warm, bright palette.

OSCAR BLUEMNER

HARLEM RIVER FROM
MORRIS MANSION
1914

MOTIF MILLTOWN
1915

Oscar Bluemner (1867–1938) was born in Germany and studied architecture at Berlin's Royal Technical Academy in 1892 but moved to New York that same year and eventually abandoned architecture for painting.[1] In 1908 he discovered Alfred Stieglitz's Little Galleries of the Photo-Secession, known as 291, where he forged a friendship with Stieglitz kindled by their common German heritage and education as well as their mutual disdain for commercialism. Bluemner's blossoming interest in painting, which he had practiced as a sideline to architecture in Germany, was inspired by Stieglitz and the work he saw at 291. Especially attracted to the expressive brushwork of Vincent van Gogh and the formal structure and color of Paul Cézanne's work, by 1911 Bluemner turned exclusively to painting. He was nothing if not methodical, in part due to his disciplined training in architectural draftsmanship; his passion for an orderly analytical approach carried over not only into his art practice but also into his ideas about art, which he expounded in extensive personal notes as well as in published articles. Once he determined to pursue a career as a painter, Bluemner decided to study modern art in a systematic fashion, and in 1912 he made an extended trip to Europe, where he was exposed to most of the current European modernist styles. Most important, he attended the international exhibition of the Sonderbund in Cologne, an immense survey of contemporary painting and sculpture that left him better prepared than most New Yorkers for the Armory Show, which opened just after he returned from his travels, and in which five of his own works were included.

Bluemner radically altered his style when he returned from Europe in 1912, turning to a simplified, geometrically ordered treatment of forms, again rendered in bright, highly saturated colors. His style was always more dynamic than his subject matter, for he focused not on striking urban views or picturesque country scenes but on the bleak, industrial towns of northern New Jersey, devoid of people. He increasingly simplified the forms of buildings, bridges, roads, and trees, rendering them expressionistically and using deep colors as well as stark black and white. Indeed, color was the defining element of Bluemner's art. As he stated again and again, art was an expression of the artist's inner consciousness, not the

Plate 16
Oscar Bluemner
American, born Prussia, 1867–1938
Harlem River from Morris Mansion; verso: ***Study Sketch***, 1914
Charcoal and ink on paper, 4 ½ x 8 inches (11.4 x 20.3 cm)
Collection of C. K. Williams, II

portrayal of external appearance, and because he believed that color possessed expressive and symbolic powers, it became the principal agent of Bluemner's powerful feelings and artistic style. Not that he worked in color alone, for the great majority of his works were the hundreds of drawings in black and white with which he prepared his paintings according to a carefully prescribed process.

The double-sided sketch *Harlem River from Morris Mansion* is typical of the drawings with color notations that Bluemner made in the landscape. These were the first in a long sequence of studies that preceded his final painting. Neither of the sketches on this sheet seems to have resulted in a painting, but each provides information about the elements the artist found to be of interest in the initial stages of his working process. According to the artist's inscription in the center of the lower margin, the drawing on the recto depicts the view looking down from what is now known as the Morris-Jumel Mansion on Mount Morris overlooking the Harlem River, with a railroad bridge and factory buildings on the riverbank. The inscription "S 10-14" at the far left appears to be the date, September 10, 1914,[2] followed by the time of day, 5:30 p.m.; in the lower right corner, the weather is described as a clear day [*klares Tag*]. Bluemner identified the trees in the right margin as acacia and tulip, with the note "not too dark foliage." He wrote his inscriptions in ink, using both German and English; additional inscriptions in pencil were added in English by another hand.[3] The clear, geometric forms of the buildings and the abstract shapes that stand for the foliage are characteristic of Bluemner's drawing style about 1914–15, which coincides with the date indicated by the inscription.

The drawing on the verso is not as precisely documented, but like the drawing on the recto, it is probably a first sketch made in the landscape. An illegible inscription in the lower left refers to figures [*Figuren*], but none is included in the drawing. The remaining inscriptions are color notes, again mixing English with German color names. While it is more sketchy and not as detailed as the drawing on the recto, Bluemner's handling of

the clear, geometric forms of the buildings and the simplified shapes of the foliage is also comparable to his other preliminary sketches of about 1914.

Motif Milltown, dated 1915, is an example of just one of the kinds of preparatory drawings Bluemner made. Typically he would begin with a charcoal sketch on the site, as in *Harlem River from Morris Mansion*, followed in the studio by more sketches in black and white or color. Just before painting, he created a full-scale charcoal and wash study on tan paper, known as a "notan,"[4] which he often followed with watercolors in half scale. *Motif Milltown* cannot be connected with any of Bluemner's paintings, but its abstract style identifies it as one of the small drawings made in the studio "to mass and set the large dividing lines."[5] Its composition of simplified planar buildings combined with geometrized, leaf-laden branches bending over them are comparable to the forms in some of the eight paintings Bluemner exhibited in November–December 1915 in his first solo exhibition in America at Stieglitz's 291 (fig. 20). However, most notable in this small drawing is the uneven grid of ruled lines that crisscross parts of its surface— lines that are largely absent from the paintings, though traces of crossing ruled lines appear in the skies and foregrounds of some of them and their preparatory studies.[6]

1. The most recent and complete biographical information on Bluemner may be found in Barbara Haskell, *Oscar Bluemner: A Passion for Color*, exh. cat. (New York: Whitney Museum of American Art, 2005), from which most of this summary is drawn.
2. Bluemner dated other drawings in this way, with the day followed by a dash and the last two numerals of the year.
3. The pencil inscription incorrectly adds "Schuyler" to the name of the mansion; in the upper right, a pencil inscription provides information about the railroad bridge.
4. Bluemner took this term from his study of the writings of the artist Arthur Wesley Dow. *Notan* is a Japanese word meaning "dark, light" and "refers to the amassing of tones of different values." See Haskell, *Oscar Bluemner*, p. 42.
5. Bluemner, quoted in Jeffrey R. Hayes, *Bluemner on Paper*, exh. cat. (New York: Barbara Mathes Gallery, 2006), p. 7.
6. See, for example, *Motive of Space and Form—a New Jersey Village (Montville)* and *Expression of a Silktown, New Jersey (Paterson Centre)*, reproduced in Haskell, *Oscar Bluemner*, figs. 42, 46.

68

Plate 17
Oscar Bluemner
American, born Prussia, 1867–1938
Motif Milltown, 1915
Graphite on paper, 3 ⁵/₈ x 5 ³/₈ inches (9.2 x 13.7 cm)
Collection of C. K. Williams, II

Fig. 20: **Oscar Bluemner**
American, born Prussia, 1867–1938
***Form and Light, Motif in West New Jersey (Beattiestown)**, 1914*
Oil on canvas, 30 x 40 inches (76.2 x 101.6 cm)
Hunter Museum of American Art, Chattanooga, Tennessee. Gift of the Benwood Foundation

OSCAR BLUEMNER

RED PORT IN WINTER, MORRIS CANAL
1922

RED PORT IN WINTER
1922

Oscar Bluemner (1867–1938) made few paintings in the early 1920s. Instead, he filled diaries with observations that included such things as notes on color theory and sketches of Asian and early Renaissance art, which he admired and studied as part of an ardent quest to define their aesthetic properties and, through them, to create a set of formal artistic principles. His goal was to establish a set of universal standards for art, which were founded on his passionately held belief that art sprang from the inner consciousness rather than from records of external appearance. Bluemner's work was not selling, and this hiatus was in part brought on by his inability to afford painting materials as well as a need to justify and define (in his ponderous, searching way) the work that was bringing him so little financial success. Between 1919 and 1923 the Bourgeois Galleries represented Bluemner's work, and its owner, Stephan Bourgeois, had become a friend who shared many similar interests, most significantly a belief that art proceeded from one's inner awareness and an admiration of Asian art.[1]

What attracted Bluemner to Asian art was its flatness, differentiated from Western art by its lack of modeling, fore-shortening, and perspective rendering of space. While maintaining the primacy of expressive color, Bluemner aimed to create pictorial unity based on the flatness of Asian art. *Red Port in Winter* (1922)[2] demonstrates as well as any of Bluemner's written theories the kind of formal continuum he was striving for. Here he maintains all forms—both angular architectural forms and the curving forms of nature—in one plane, eliminating shadows and using colors of a very high key. Color, indeed, plays the dominant role—not descriptive, but emotionally charged colors set starkly against one another. Minimal shifts in tone barely hint at the existence of planes, but their volume is always denied, as may be seen where the planes of the red walls are brought back to the surface by the broad band of black outlining them. The curving trees form a flat network of lines that lies over the angular shapes.

The changes that took place between *Red Port in Winter* and the small preparatory watercolor, *Red Port in Winter, Morris Canal*,[3] which contains virtually all of the major elements of

the final composition, spell out exactly how Bluemner manipulated the forms of nature to create what he called "Simplicity: Total flat."[4] Having already settled on the composition's overall color scheme, he made only minor alterations in the forms, methodically simplifying and defining each of them so that they move farther from nature, becoming flatter, more patterned, more abstract. The snow on the bank receives scalloped edges; the snowy path receding toward the red building in the watercolor bounces back to the surface in the painting with the addition of a flat, spreading profile. In *Red Port in Winter* Bluemner successfully blended geometric architectural shapes with the flowing forms of nature to achieve the flat, simple unity he was seeking. But, as he intended, color plays the dramatic role in this still, smooth landscape: the blazing red buildings, pink bridge, and fiery sky with the bare, black branches, and ruffled patches of pure white snow.

1. The most recent analysis of this period of Bluemner's career is given by Barbara Haskell, *Oscar Bluemner: A Passion for Color*, exh. cat. (New York: Whitney Museum of American Art, 2005), pp. 74–83, on which most of this summary is based.

2. The date of 1922 for the painting is confirmed by the date of January 31, 1922, on a sketch for the painting, entitled *Das Problem Rot*. The drawing is published in *Oscar Bluemner: American Colorist*, exh. cat. (Cambridge, MA: Fogg Art Museum, 1967), no. 34, fig. VIII. The first owner of this painting was Edward Bruce, another painter at the Bourgeois Galleries. It would appear from two handwritten pages in Bluemner's papers that Bruce may have ordered the painting as early as 1917: "Red House & Snow ordered by Mr. Bruce . . . 15x20 Upson panel W.L.—oil in 1917." In three places in the text that follows, however, there are references to dates in 1922. See Oscar Bluemner Papers, Archives of American Art, Smithsonian Institution, Washington, DC, reel 340, frames 53–54.

3. The title of the watercolor identifies the site of the landscape as the northern New Jersey canal that extends 102 miles from Phillipsburg to Jersey City.

4. This is how he described what he achieved in *Evening South River, New Jersey (Old Bridge)*, a painting of 1911 that he revised in 1922. Quoted in *Oscar Bluemner: A Retrospective Exhibition*, exh. cat. with an essay by Jeffrey R. Hayes (New York: Barbara Mathes Gallery, 1985), n.p.; no. 10 (repro.).

Plate 18
Oscar Bluemner
American, born Prussia, 1867–1938
Red Port in Winter, Morris Canal, 1922
Watercolor and graphite on paper, 5 ¼ x 6 ⅞ inches (13.3 x 17.5 cm)
Collection of C. K. Williams, II

Plate 19
Oscar Bluemner
American, born Prussia, 1867–1938
Red Port in Winter, 1922
Oil on panel, 14 ¾ x 19 ¾ inches (37.5 x 50.2 cm)
Collection of C. K. Williams, II

OSCAR BLUEMNER

MOONSHINE FANTASY

1928–29

In the late 1920s Oscar Bluemner (1867–1938) turned to a new, more inward and spiritual kind of expression. Sinuous, curving shapes painted in glowing, modulated tones replaced the crisply defined colored forms of *Red Port in Winter* (pl. 19). Subject matter, though still focused on landscape, was treated more dramatically: instead of silent, lonely expanses, landscapes became sharply compressed spaces dominated by turbulent skies or by a sun or moon surrounded by shimmering rings. Color was still the artist's chief means of expression, but now the color appeared transparent and luminous rather than flat and static. Part of this change of style and expression was brought about by the circumstances of Bluemner's life. In 1926 his wife, Lina, died, and he moved with his son and daughter to Braintree, Massachusetts. Wracked by grief and unrelenting poverty, he was nonetheless able to work, and he produced a series of twenty paintings in oil on panel, which were exhibited at the Whitney Studio Galleries in New York in November 1929.[1]

Moonshine Fantasy is a small watercolor study that Bluemner made in preparation for the painting of that title in the Whitney Studio exhibition (fig. 21). As was his custom, he used a clearly mapped and laboriously executed preparatory process. His desire for a transparent effect caused him to choose a gessoed academy board, smoothed to a gleaming finish, which he cemented to a three-ply fir panel. The painting's composition was determined first in a finished watercolor study, such as this one, which was followed by a full-scale drawing in charcoal that he transferred by a complicated process to the surface of the panel. After perfecting the underdrawing, he began to paint in thin glazes of color suspended in oil or resin, making sure that each layer was dry before adding the next one. Several months would pass before the finished painting received a coat of varnish.[2]

Bluemner's handwritten notes about *Moonshine Fantasy* indicate that a sketch for the painting was "recolored," but unfortunately his illegible handwriting and convoluted shorthand terminology make it impossible to tell if the changes refer to the present watercolor or another one, or if the recoloring

Plate 20
Oscar Bluemner
American, born Prussia, 1867–1938
Moonshine Fantasy, 1928–29
Watercolor on paper, 7 ½ x 5 inches (19.1 x 12.7 cm)
Collection of C. K. Williams, II

was a change that he made on the panel. Most likely, it was the latter, for an arrow drawn on a small pen sketch in Bluemner's notes points out that the "revised tonality" occurred in the sky, which is exactly the area in which the painting and the watercolor differ most.[3] In fact, the composition of the watercolor remains unchanged in all other parts of the finished painting. Another new aspect of Bluemner's landscapes of this period was a tendency to combine images from different times and locations: "By returning to New Jersey, especially Bloomfield, where Lina had died, the artist immersed himself in a sense of place based on a plumbing of psychological depths rather than on immediate observation."[4] Indeed, his notes show that this was true of the images in *Moonshine Fantasy*, for he describes the scene as "a red shack on green hill at Brookdale, New Jersey. . . . [and a] moon thus seen in Braintree 1928."[5]

1. *Exhibition of Twenty New Oil Paintings on Panels by Oscar Bluemner*, exh. cat. (New York: Whitney Studio Galleries, 1929).
2. *Oscar Bluemner: A Retrospective Exhibition*, exh. cat. with an essay by Jeffrey R. Hayes (New York: Barbara Mathes Gallery, 1985), n.p.
3. Oscar Bluemner Papers, Archives of American Art, Smithsonian Institution, Washington, DC, reel 340, frame 1849.
4. Roberta Smith Favis, "The Art of Oscar Bluemner (1867–1938)," *American Art Review*, vol. 16, no. 1 (2004), p. 111.
5. Oscar Bluemner Papers, reel 340, frame 1849.

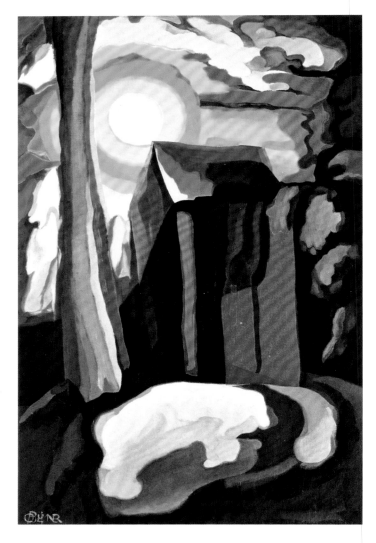

Fig. 21: **Oscar Bluemner**
American, born Prussia, 1867–1938
Moonshine Fantasy, 1928–29
Oil on panel, 22 ³/₈ x 15 inches (56.7 x 38.1 cm)
Private collection

OSCAR BLUEMNER

COMPOSITION FOR
COLOR THEMES

1932

The hyperintensive purity of color in this small watercolor by Oscar Bluemner (1867–1938) surpasses even the vividly contrasted hues of *Red Port in Winter, Morris Canal* (pl. 18) and the bright radiance of *Moonshine Fantasy* (pl. 20), signaling the last phase of his lifelong search for an art based on emotion expressed primarily through color. In the 1930s, although his subject matter showed little change, Bluemner's interpretation of forms and colors became ever more personal, complex, and intensely felt as he expanded the range of aesthetic equivalents he needed his art to evoke. Bluemner claimed that "all landscape is human theater,"[1] and the landscape forms he depicted now became performers, acquiring analogies in his mind to human anatomy and movement; colors, now distilled to their purest essence, assumed specific emotional identities resulting from a renewed study of color theory;[2] the emotion evoked by his paintings now found equivalents in the music of favorite composers such as Bach, Beethoven, Brahms, Schubert, Liszt, Scriabin, and Schoenberg.[3] In addition, Bluemner concocted a new, durable waterbased painting medium at this time, incorporating casein, formaldehyde, and other materials to reproduce the hard, glowing surfaces of old master panel paintings.

Since it was customary for Bluemner to make small, finished watercolors in preparation for his paintings, the present work was probably created for a painting that is either lost or never executed.[4] In any case, its title connects it with a group of paintings of varied scale and tonality that Bluemner produced between 1932 and 1934, which were exhibited in his last retrospective in January 1935 at the Marie Harriman Gallery in New York and later that year at the Arts Club of Chicago.[5] The present watercolor coincides exactly with the subject matter and coloring of many of the paintings in that exhibition, nearly all of which had titles referring to color.[6] Here, as in many of Bluemner's late "psychological landscape[s]," a vivid interplay of red, green, and blue was selected as the means to render the "simplest setting of simplest Forms of our surroundings in dramatic Tension."[7] The blocklike buildings are lit with an eerie, unreal light; shadows and reflections assume stylized shapes that have

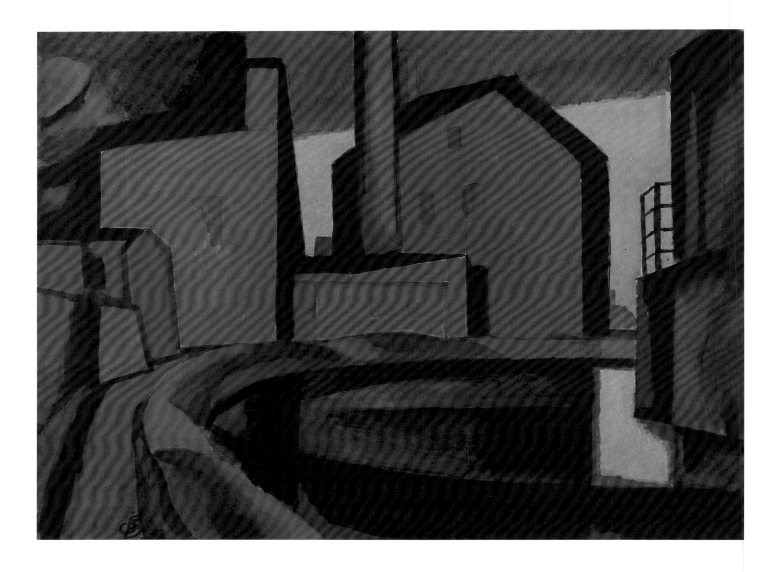

Plate 21
Oscar Bluemner
American, born Prussia, 1867–1938
Composition for Color Themes, 1932
Watercolor on paper, 7 ³/₄ x 10 ¹/₂ inches (19.7 x 26.7 cm)
Collection of C. K. Williams, II

nothing to do with a realistic light source; and the broad, black outlines surrounding the brilliantly colored shapes give the overall effect of a stained-glass window.

1. Quoted in Barbara Haskell, *Oscar Bluemner: A Passion for Color*, exh. cat. (New York: Whitney Museum of American Art, 2005), p. 144.

2. Judith Zilczer, *Oscar Bluemner: The Hirshhorn Museum and Sculpture Garden Collection* (Washington, DC: Smithsonian Institution Press, 1979), p. 11.

3. Jeffrey R. Hayes, *Oscar Bluemner: Landscapes of Sorrow and Joy*, exh. cat. (Washington, DC: Corcoran Gallery of Art, 1988), p. 72.

4. See Richard York Gallery, *An American Gallery, Vol. 7*, exh. cat. (New York: Richard York Gallery, 1992), no. 28.

5. *New Landscape Paintings by Oscar F. Bluemner: Compositions for Color Themes*, exh. cat. (New York: Marie Harriman Gallery, 1935).

6. Titles of some of the paintings were *Azure*, *A Situation in Yellow*, and *In High Key*. As the entire Harriman exhibition had the title *Composition for Color Themes* and the paintings in the checklist had individual titles, it is possible that this watercolor was preparatory for one of the exhibited paintings that has not been identified and that the watercolor's correct title has therefore been lost.

7. Bluemner, quoted in *Bluemner on Paper*, exh. cat. with an essay by Jeffrey R. Hayes (New York: Barbara Mathes Gallery, 2006), p. 13. Bluemner wrote this in reference to another work in which he used the same three colors.

HUGH HENRY BRECKENRIDGE

ABSTRACTION WITH BOUQUET

c. 1930

A highly successful artist during his long career in Philadelphia, Hugh Henry Breckenridge (1870–1937) is little known today, despite the recent surge of interest in collecting the work of American modernists. One of a trio of painters in Philadelphia who were united by their passion for color during the 1920s and 1930s, Breckenridge, along with Henry McCarter and Arthur B. Carles, taught at the historically conservative Pennsylvania Academy of the Fine Arts, an institution that nonetheless harbored a strain of sympathy for modern art in all its forms. The painters' zeal was shared by a lively group of Philadelphians consisting of other artists as well as collectors, architects, and musicians (including Philadelphia Orchestra conductor Leopold Stokowski). The formidable collector Dr. Albert Barnes, though never a part of the group, made his collection available to them by offering classes that many of them eagerly joined.[1]

Breckenridge is best characterized as a natural teacher and an ardent colorist—traits that sometimes came into conflict in his art, which may help to explain the wane in his reputation. His pedagogical side led to an almost scholarly analysis of the purpose of art, which he communicated to generations of admiring students: he preached the importance of beauty and orderliness in art; the primacy of color in the perception of painting; and the need to maintain a lifelong search for problems and their solutions.[2] Breckenridge's passion for color emerged early through his admiration of the paintings of George Inness, of whom he said: "Nature spoke to him in terms of color, and even at the very beginning of my student days, I felt the same urge."[3] This urge persisted despite his academic training at the Pennsylvania Academy and in 1892–93 at the Académie Julian in Paris, where he studied with William Bouguereau, Gabriel Ferrier, and Lucien Doucet. On his return to Philadelphia from Paris, Breckenridge's work displayed the free brushwork and strong color of the Impressionists, suggesting that he had been exposed to their work. Always the scholar, Breckenridge also began to study the theory and chemistry of color.

Breckenridge's dual nature also appears in the two styles in which he worked. Part of his success as an artist came from painting portraits, which he pursued in a traditional style that

Plate 22
Hugh Henry Breckenridge
American, 1870–1937
Abstraction with Bouquet, c. 1930
Oil on canvas, 28 ¼ x 32 ¼ inches (71.8 x 81.9 cm)
Collection of C. K. Williams, II

won him many commissions. In his other, more experimental, avant-garde work, which changed and developed over the years, he consistently employed a palette of brilliant color, in styles that ranged from the broken brushwork of Impressionism in the 1890s, through Fauvism, to near- and finally complete abstraction about 1922.[4] Following Cézanne, who became a major influence in the early 1920s, still life became a preferred subject: "It has no story to tell, other than a story of line, form and color, and always this is the painter's real story."[5] To Breckenridge, modernism meant freedom—of color, of brush-work, and of design, but he never completely abandoned tradition. *Abstraction with Bouquet* shows the extent to which he maintained yet transformed established subjects with a literal riot of color that surrounds and dominates a conventionally rendered vase of flowers on a table. Abstract color shapes, modeled to suggest volume, surge around, above, and behind the bouquet, while traces of a blue floor and brown woodwork suggest a ground separating the table and bouquet from a nearby scattering of fruit over another surface. Yet space and compositional structure seem not to be the point. A reviewer of Breckenridge's solo exhibition at the Pennsylvania Academy in 1934 put a finger on the elusive relation of color and form in his compositions: "It [the color] is unusual in that it is bound principally to temperature—it gives us a sensation of warmth and coolness rather than of distance or nearness. Form, when it appears, is utilized by the painter only as it offers shapes to color areas of contrasting temperatures."[6]

1. See Innis Howe Shoemaker with Christa Clarke and William Wierzbowski, *Mad for Modernism: Earl Horter and His Collection*, exh. cat. (Philadelphia: Philadelphia Museum of Art, 1999), pp. 26–29; and Sylvia Yount and Elizabeth Johns, *To Be Modern: American Encounters with Cézanne and Company*, exh. cat. (Philadelphia: Museum of American Art of the Pennsylvania Academy of the Fine Arts, 1996).
2. Gerald Carr, "Hugh Henry Breckenridge: A Philadelphia Modernist," *American Art Review*, vol. 4 (May 1978), p. 97. Breckenridge taught and followed these precepts not only at the Pennsylvania Academy but also at two schools he founded: the first with William Anschutz between 1909 and 1937 in Darby and Fort Washington, Pennsylvania; the second, the Breckenridge School of Art, in East Gloucester, Massachusetts, during the summers between 1920 and 1937. He also became director of the Department of Fine Arts of the Maryland Institute in Baltimore in 1919. Among his most famous students were Charles Demuth and Ralston Crawford.
3. Breckenridge, quoted in ibid., p. 94.

4. Breckenridge was the only Philadelphia modernist painter whose work was not included in the 1921 *Exhibition of Paintings and Drawings Showing the Later Tendencies in Art* at the Pennsylvania Academy, which was organized by seven Philadelphia and New York artists, led by Academy alumnus William H. Yarrow. It would appear that it was only after his transition to abstraction that Breckenridge was included. His work was represented in two later exhibitions of modern art: the *31* exhibition in Philadelphia in 1923 and *Exhibition of Paintings by Seven Philadelphia Painters* at the Wildenstein Gallery in New York in 1927.
5. Breckenridge, quoted in Carr, "Hugh Henry Breckenridge," p. 98.
6. Weldon Bailey, quoted in ibid., p. 121.

CHARLES BURCHFIELD

WATERFALL
1916

AUGUST NOON
1916

When I was much younger, I liked to imagine that I was largely self-taught. . . . Perhaps it is a common attitude of extreme youth.[1]

For many years, the understanding of the environment in which the art of Charles Burchfield (1893–1967) developed eluded scholars, thanks in large part to the artist's own extensive writings, which as Nannette Maciejunes observed, made it possible to explain almost any aspect of his work with his own words.[2] Only recently has it been recognized that Burchfield's apparent uniqueness and artistic isolation were a myth perpetrated for decades by the artist himself. During his lifetime Burchfield endorsed the publication of essays characterizing him as a solitary anomaly, almost totally ignorant of European art and, before 1918, unaware of Asian art. One example is the following statement made by Alfred Barr in 1930: "It is impossible to discover any external influence upon Burchfield's art. . . . One can only conclude that we have in this period [1916–18] of Burchfield's development one of the most isolated and original phenomena in American art."[3]

Recent investigation of the milieu in which Burchfield received his education at the Cleveland School of Art between 1912 and 1916, however, has shown that it was culturally and intellectually far richer than has previously been recognized, and reveals that there were many opportunities for him to discover not only Asian art, but also contemporary trends in modern American and European painting.[4] The present watercolors, both executed in 1916, confirm the accuracy of a statement Burchfield made nearly fifty years later about his work of that year: "Gradually, I turned to painting watercolors of a highly decorative nature, working out my own set of abbreviations, or conventions, of natural effects. I was told later by many people that these watercolors showed a strong Japanese influence. Small wonder, for I admired greatly the work of Hokusai and even more, that of Hiroshige."[5]

Waterfall, also known as *Untitled, January 1916*, was painted during the winter before Burchfield graduated from the Cleveland School of Art. Having entered the school with the intention of studying to become a commercial illustrator, he discovered

Plate 23
Charles Burchfield
American, 1893–1967
***Waterfall (Untitled, January 1916)**, 1916*
Watercolor and graphite on paper, 13 ⅞ x 10 inches (35.2 x 25.4 cm)
Collection of C. K. Williams, II

that art was a means for exploring and expressing his mind's inner spirit, and he decided to become an independent artist. By the time of his graduation, Burchfield had already developed a unique expressive style with which he could capture the essence of specific moments in nature. In *Waterfall*, one of Burchfield's most abstract watercolors of 1916, his debt to Japanese prints is clear, strongly suggesting that his source was Katsushika Hokusai's famous series A Tour of Waterfalls of Various Provinces. The composition portrays a rushing torrent landing with a dramatic splash of white foam against a brown boulder, dispersing finally in broken trails of froth on a dark pool. The flattening and stylization of natural forms

surely call to mind Hokusai's vibrant woodblock prints (fig. 22), but Burchfield also makes expressive use of the fluidity of watercolor in his depiction of the subject. Remarkably, he somehow evokes the sound of the place as well as the conditions of weather, in this case a bright, cold day where the cascade's continuous splashing breaks the silence of the woods where the shadows of bare branches make pale outlines on the snowy ground.

August Noon was painted during the summer after Burchfield graduated from the Cleveland School of Art. Depicting more than noontime on a later summer day in the artist's backyard garden in Salem, Ohio, it presents a vivid metaphor for the feeling of the garden at this time of day. As was typical of his work in this early stage of his career, he began by drawing the design in pencil and then colored in and around the pencil outlines. Here, as in several of his watercolors of 1916, he put the color around the exterior of the outlines (as opposed to within them), leaving small, irregular, white shapes scattered all over the composition—sunlit leaves silhouetted against darker foliage. One feels that the bleaching noonday sun directly overhead makes every plant and insect shimmer and dance all over the garden. Burchfield even surrounds sunflower blooms with white haloes, visually likening them to the aura around the sun. The abstract, jagged, curving lines that hover erratically above the garden are explained by his inscription: "Yellow butterflies and flies darting among the garden plants which glitter with white sunlight—the insects move so swiftly that they appear to the slow human eye as continuous zigzags (butterflies) or waving streaks (flies)." The inscriptions on the backs of Burchfield's early watercolors describe his feelings about them and provide a ready source for their interpretation, often helping to overromanticize the uniqueness of his artistic vision.

The influence of Ando Hiroshige's prints upon *August Noon* is apparent in the flat, stylized, allover pattern of outlined plant forms with which Burchfield covered the surface of the composition, especially in details such as the decorative handling of the trees, whose flat, spreading branches are silhouetted against

Fig. 22: **Katsushika Hokusai**
Japanese, 1760–1849
Yoshitsune's Horse-washing Falls at Yoshino in Yamato Province, 1833
From the series A Tour of Waterfalls of Various Provinces
Color woodcut, 15 1/16 x 10 1/16 inches (38.2 x 25.6 cm)
Philadelphia Museum of Art. Gift of Mrs. Anne Archbold. 1946-66-70

Plate 24
Charles Burchfield
American, 1893–1967
***August Noon (Butterflies and Black Barn)**, 1916*
Watercolor and graphite on paper, 20 x 14 inches (50.8 x 35.6 cm)
Collection of C. K. Williams, II

patterns of leafy foliage. According to William Robinson, Henry
Keller, Burchfield's teacher at the Cleveland School of Art
(whose work was exhibited in the Armory Show during the
time Burchfield was studying with him), collected and exhibited
Japanese prints, while Burchfield's own journal for the autumn
of 1915 records that he read *The Heritage of Hiroshige*.[6]

1. Burchfiled, quoted in William H. Robinson, "Native Sons: Burchfield and the
Cleveland School of Art," in Nannette V. Maciejunes and Michael D. Hall, *The
Paintings of Charles Burchfield: North by Midwest*, exh. cat. (New York: Harry N.
Abrams, in association with the Columbus Museum of Art, 1997), p. 70.
2. Maciejunes, "Burchfield on Burchfield: An Artist's Journal Reconsidered,"
in Maciejunes and Hall, *The Paintings of Charles Burchfield*, p. 108.
3. Alfred H. Barr, Jr., introduction to *Charles Burchfield: Early Watercolors,
1916–1918*, exh. cat. (New York: The Museum of Modern Art, 1930), p. 6.
4. See Maciejunes and Hall, *The Paintings of Charles Burchfield*, esp. essays by
Robinson, Hall, M. Sue Kendall, Maciejunes, and Henry Adams.
5. Charles Burchfield, *His Golden Year: A Retrospective Exhibition of Watercolors,
Oils and Graphics by Charles E. Burchfield*, exh. cat. (Tucson: University of
Arizona Art Gallery, published by the University of Arizona Press, 1965), p. 17.
6. Robinson, "Native Sons," pp. 65, 71 n. 30.

CHARLES BURCHFIELD

STORMY NOVEMBER DAY
1946/1959

For Charles Burchfield (1893–1967), many things in life remained constant: he lived in few places for many years with only brief interruptions in between, and the subjects of his pictures stayed close to home as well; most of his early works (1915–21) were painted in Salem, Ohio, and his later ones (1925–66) were largely done in and around Gardenville, New York. Burchfield's artistic vision also changed little: his whole life he was fascinated with the changing moods of nature—the weather, the seasons, and the effects of these on familiar places. Stylistic changes occurred in his work over many years, but they formed a regular pattern of swings between intense, emotionally charged works, which departed from reality by including abstract forms and incorporating an expressive use of color, and straightforward realistic depictions of places, either domestic or industrial, whose appearance was always subject to a specific mood of weather. During the 1930s he favored the latter style, but he generally persisted in working in both manners. Burchfield himself perpetuated the idea that he was given to epiphanies that brought about changes in his style, which resulted in the division of his work into neatly defined phases. More recent assessments of his career, however, have concluded that his work should be viewed as a whole; this more expansive approach has shown Burchfield to be more constant in his vision, as was also true of his life.[1] *Stormy November Day*, for example, shows that Burchfield never abandoned a realistic approach to subject matter even though at the same time he was also painting pictures in a highly expressionist style.

Stormy November Day was begun in 1946, a time when Burchfield was turning away from painting realistic industrial scenes to return to his earlier expressionistic renderings of landscape. In his new works, tree branches are treated like curling flames, dots and flecks of colors skim wildly like will-o'-the-wisps through the branches, and shapes resembling bat wings hover against the sky; in others, strange flowers and insects glow in the night, the dark sky is inhabited by repeated fluttering shapes, and fairy-tale houses with dark circular windows are hidden among towering flower stalks.[2] At the same time he was painting in this manner, Burchfield

Plate 25
Charles Burchfield
American, 1893–1967
Stormy November Day, 1946; augmented 1959
Charcoal, watercolor, and gouache on paper board, 29 ¾ x 37 inches (75.6 x 94 cm)
Collection of C. K. Williams, II

made *Stormy November Day*, a scene whose location
has not been identified; most likely it is a house and barn
rising above a culvert in or near Gardenville, New York,
where Burchfield lived and worked continuously after 1925.
The subject is typical of winter scenes that Burchfield
painted throughout the 1930s, with a gray sky looming over
bare tree branches and a straightforward treatment of
architectural structures. In *Stormy November Day*, only the
agitated brushstrokes that appear in the sky, around the
tree branches, and through the grasses differ from the
smoother, less emotional approach to the winter scenes
Burchfield painted during the previous decade. In this
respect, the brushwork more closely resembles the restless-
ness of his contemporaneous expressionist landscapes.

Stormy November Day was completed in 1959, a time
when Burchfield reworked a number of early pictures.
He wrote: "The Summer of 1959 was very fruitful. . . . my
mind worked unusually well and my physical state was
excellent. For every unfinished or unsolved picture I got
out and looked at, the solution became instantly clear
and I had the stamina to bring them to successful con-
clusions."[3] His desire to resolve, improve, or complete
earlier pictures had started in the early 1940s. He saved
every scrap of his work and began a practice of "recon-
structing" pictures from the 1910s by pasting them to
boards of a larger dimension and adding strips to the edges
to enlarge their formats. By the mid-1940s, however, he
seems to have abandoned the "reconstructions," as he
called them, but he persisted in revisiting earlier compositions
for the rest of his career, as may be seen in his method of
dating them by recording their beginning and ending years.
It is not possible to tell precisely which parts Burchfield
added to *Stormy November Day* in 1959, but it might have
been in the upper right area of the sky behind the cupola
of the house, where traces of tree branches appear to have
been obliterated by white gouache; touches of black on
the tree branches in the same location and around the
windows of the house and barn are more difficult to identify
confidently as later additions.

1. A summary of Burchfield's participation in the categorization of his artistic
career and the new interpretation of his career as an entirety is given by
Nannette V. Maciejunes and Michael D. Hall, introduction to *The Paintings of
Charles Burchfield: North by Midwest*, exh. cat. (New York: Harry N. Abrams,
in association with the Columbus Museum of Art, 1997), pp. 15–17.
2. This characterization, which is generally true of Burchfield's expressionist
style in 1946, is based on two paintings: *Tree* and *The Sphinx and Milky Way*,
which are reproduced in ibid., pls. 137 and 55, respectively.
3. Charles Burchfield, *His Golden Year: A Retrospective Exhibition of
Watercolors, Oils and Graphics*, exh. cat. (Tucson: University of Arizona Art
Gallery, published by the University of Arizona Press, 1965), p. 81.

PAUL CADMUS

POLO SPILL
1935

Polo Spill is a small sketch that Paul Cadmus (1904–1999) made in preparation for one of four large panels he submitted to the Treasury Relief Art Project (TRAP) for a 1936 commission to make murals in the U.S. post office of the affluent Long Island suburb of Port Washington, New York. The subject of the series was Aspects of Suburban Life, and TRAP doubtless intended the murals to celebrate the pastoral quiet of the suburbs, where well-to-do commuters escaped each evening from the dirt, noise, and stress of the city. What they received were four biting satires of leisure-obsessed suburbanites strutting the town's Main Street, overweight middle-aged golfers, a crowd of weekend fishermen struggling like Laocoön with a monstrous eel, and overdressed spectators recoiling in exaggerated horror at a polo accident (fig. 23). Port Washington had already been immortalized by F. Scott Fitzgerald in *The Great Gatsby* as East Egg, a place where the town's inhabitants "drifted here and there unrestfully wherever people played polo and were rich together."[1] Though painted ten years later than Fitzgerald's novel was published, Cadmus's four panels might be seen as visual equivalents of Gatsby's East Egg. Not surprisingly, they were rejected by TRAP, which revoked the commission and returned one of the panels to the artist.[2] The small sketch for *Polo Spill* remained in the possession of the artist, who later gave it to his companion of thirty-five years, Jon Anderson.

Cadmus was born in New York City and left high school at fifteen to begin his formal art training with nine years at the National Academy of Design. While working at a New York advertising agency between 1928 and 1931 he took classes at the Art Students League, where he met the painter Jared French, who became a decisive influence on his future career and encouraged him to adopt a painting style that was influenced by the old masters. French persuaded Cadmus to abandon commercial work and become a full-time painter, and in 1931 they traveled to Europe together, eventually settling in Puerto de Andraitx, a Mallorcan fishing village, before returning to America in October 1933. Back in New York, Cadmus became one of the earliest members of the government-sponsored Public Works of Art Project (PWAP). His first painting for the project in 1934, *The Fleet's In!*[3] flaunted a frieze of unruly

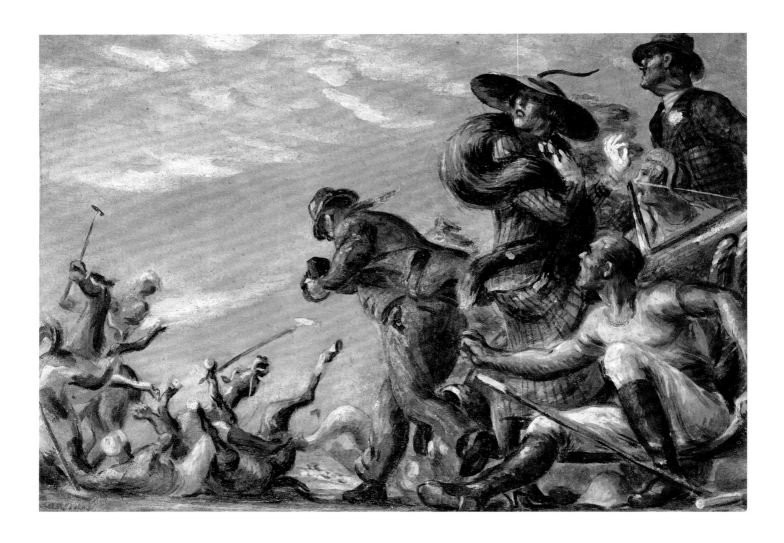

Plate 26
Paul Cadmus
American, 1904–1999
Preliminary Study for "Aspects of Suburban Life: Polo Spill," 1935
Mixed technique (oil and tempera) on paper, 5 1/8 x 7 3/8 inches (13 x 18.7 cm)
Collection of C. K. Williams, II

sailors on shore leave cavorting with female companions. It was to be exhibited in Washington's Corcoran Art Gallery but was withdrawn at the request of the assistant secretary of the navy for its insulting portrayal of American sailors. Though this event publicly labeled Cadmus an enfant terrible, he nonetheless received the commission from TRAP for the Port Washington murals, which suffered a similar fate.

The panels Cadmus submitted to TRAP for the murals were executed on pressed wood boards in a mixed oil and tempera technique; he used the same mixed technique, though on paper, for the smaller sketches, such as the present one. Cadmus had been using this medium for only about a year, and he virtually abandoned painting in oil on canvas in 1935 in its favor, as it imitated the brilliant, glossy surfaces of Renaissance egg tempera panel paintings.

Of the four compositions, *Polo Spill* was perhaps the least grotesquely satirical, as its mockery is directed mostly at the horrified expressions of two female spectators sporting elaborate hats, furs, and jewels rather than at the main subject. Comparison of the panel and the sketch shows that Cadmus altered many minor details to make them more vivid: he changed the colors of costumes; sharpened and further dramatized the facial expressions; and modified the treatment

of the accident itself. While in the sketch the fallen horses, riders, and equipment are silhouetted clearly against the sky, in the large panel the accident becomes a chaotic tangle.

In *Polo Spill*, Cadmus turned to the Italian Renaissance for his visualization of the narrative by employing a dramatic device first used by Raphael in the Vatican frescoes of the Stanza dell'Incendio. There, as here, the main event is relegated to the background, whereas the reactions to it are highlighted in the actions and expressions of the larger spectators in the foreground. Especially Raphaelesque in conception is the large polo player in the right-hand foreground of *Polo Spill* reaching out toward the accident. He occupies the same position and dramatic role as the river god who gestures toward the central figures of Raphael's *Judgment of Paris*, an image well known from Marcantonio Raimondi's celebrated engraving after it (fig. 24).

1. Quoted in Elizabeth N. Armstrong, "American Scene as Satire: The Art of Paul Cadmus in the 1930s," *Arts Magazine*, vol. 56, no. 7 (March 1982), p. 123. **2.** *Golf*, *Polo Spill*, and *Public Dock* were sent to the billiard room of the U.S. Embassy in Ottawa and later transferred by the U.S. Department of State to the National Arts Collection of the Smithsonian Institution; *Main Street* is now in the Regis Collection, Minneapolis. See Lincoln Kirstein, *Paul Cadmus*, rev. ed. (New York: Chameleon Books, 1996), pp. 34–35. **3.** Reproduced in ibid., p. 25.

Fig. 23: **Paul Cadmus**
American, 1904–1999
Aspects of Suburban Life: Polo Spill, 1936
Mixed technique (oil and tempera) on pressed wood panel,
31 ⁵⁄₈ x 45 ³⁄₄ inches (80.3 x 116.2 cm)
Smithsonian American Art Museum, Washington, DC. Transfer from the
U.S. Department of State. 1978.76.3

Fig. 24: **Marcantonio Raimondi**
Italian, c. 1480–c. 1530
After Raphael (Italian, 1483–1520)
The Judgment of Paris, c. 1517–20
Engraving, 11 ½ x 17 inches (29.2 x 43.2 cm)
The Art Institute of Chicago. Mr. and Mrs. Potter Palmer Collection. 1919.2533

ARTHUR B. CARLES

RECLINING NUDE

1927–35

For Arthur B. Carles (1882–1952), visits to France in the first years of the twentieth century provided the stimulation for his early development of a passion for modernism in all its forms. In the spring of 1910 he joined John Marin, Marsden Hartley, and others in a group exhibition at Alfred Stieglitz's New York gallery 291, which was followed two years later by a solo exhibition there. Carles never moved to New York, however, preferring to work in his native Philadelphia. He became an influential teacher at the Pennsylvania Academy of the Fine Arts, where he himself had studied, punctuated by long periods spent abroad, mostly in France. Henri Matisse and Édouard Manet were the most important early influences, though later on he was attracted more by the Cubism of Pablo Picasso and Georges Braque. In Philadelphia in the early 1920s, Carles was the leader of a coterie of artists, architects, musicians, and collectors; he organized exhibitions of modern art at the Academy and elsewhere, joined fellow artists in classes at the Barnes Foundation, and encouraged his students to pursue modernist art. His impassioned pursuit of modernism at the Academy, combined with bouts of alcoholism, led to his dismissal in 1925.[1]

In his own work, Carles employed increasingly free brushwork and an idiosyncratic abstract use of color that at times foreshadowed the Abstract Expressionists. He was infatuated with color, and he thought, wrote, and spoke about it analytically as well as empirically, often referring to colors as though they had personalities.[2] However, it is always dangerous to deduce from Carles's art a straight line of development. Never predictable, he treated some of his subjects in a relatively controlled, traditional manner at the same time that he was painting vigorous near-abstractions; this fluctuation continued throughout all of his work. For this and other reasons it is nearly impossible to establish a precise chronology of Carles's work. In addition to his changeable style, he rarely dated his paintings, and he stuck to the same repertoire of subjects throughout his career: principally nudes, still lifes, flowers, and occasional landscapes, to which he usually assigned generic titles.

Plate 27
Arthur B. Carles
American, 1882–1952
Reclining Nude, 1927–35
Oil on canvas, 18 x 22 inches (45.7 x 55.9 cm)
Collection of C. K. Williams, II

Still, a few generalizations may be made about Carles's paintings of the nude over the course of his career. Most often his models strike flamboyant poses: arms and heads are flung back or to the side; faces are often obscured or not painted at all; backgrounds often consist of broadly painted swaths of colored drapery in dramatic arrangements. His nude figures of the 1910s display fairly traditional shading and modeling; flesh was sometimes painted a stark white, which was high-lighted against dark, almost black backgrounds. As the 1920s progressed, however, Carles's nude models were treated with increasing freedom in less representational colors—modeling was sometimes abandoned altogether and the backgrounds became more abstract and colorful. By 1930 he painted a nude figure that almost disappeared within bright prisms of surrounding color divided by slashing strokes of black[3]—a work that is difficult to see as roughly contemporaneous with *Reclining Nude*, which is thought to date between 1927 and 1935. Nonetheless, this is how Carles worked, and there are other comparable nudes of the 1930s, such as *Reclining Nude* in the Hirshhorn Museum and Sculpture Garden in Washington, DC, which is datable to 1931–35.[4]

Among the many nudes Carles painted over the course of his career, *Reclining Nude* is an unusually peaceful composition of a model sleeping on a sofa or cushions in front of a fire-place. Drama and energy emanate here from the loose, brushy handling of a wide and dynamically applied range of colors: touches of green on the model's thigh, patches of vivid red, broad areas of white, and black outlines that appear and disappear. Brushed in light dashes and daubs over the entire canvas, Carles's colors remarkably not only convey the weight of the figure sinking into the cushions but also give a firm sense of her placement in the surrounding space.

1. See Barbara A. Wolanin, *Arthur B. Carles (1882–1952): Painting with Color*, exh. cat. (Philadelphia: Pennsylvania Academy of the Fine Arts, 1983); and *The Orchestration of Color: The Paintings of Arthur B. Carles*, exh. cat. (New York: Hollis Taggart Galleries, 2000). On Carles and his modernist colleagues in Philadelphia, see Innis Howe Shoemaker with Christa Clarke and William Wierzbowski, *Mad for Modernism: Earl Horter and His Collection*, exh. cat. (Philadelphia: Philadelphia Museum of Art, 1999), pp. 26–29.

2. Wolanin, *Arthur B. Carles*, p. 111: "But color for Carles was not a scientific matter. Each hue expressed its own personality for him."
3. *Nude* (1930, Wadsworth Atheneum, Hartford, Connecticut). See ibid., p. 100, cat. 78, which is compared with one of Willem de Kooning's paintings of 1950–51.
4. Ibid., p. 128, fig. 30.

GIORGIO DE CHIRICO

PORTRAIT OF CARLO CIRELLI

1915

During the 1910s Giorgio de Chirico (1888–1978) created enigmatic works of art in which he used a clear, sharp painting style to evoke a troubling dream reality, infused with illogical images, bizarre spatial configurations, and a pervasive melancholic mood. De Chirico called these thinly painted, luminous works "metaphysical," meaning "beyond the physical," and with them he hoped to destabilize the meaning of everyday objects by making them symbols of fear, alienation, and uncertainty. In the paintings he made before his career was disrupted by the outbreak of World War I, de Chirico created an instantly recognizable world of statues, trains, clocks, and smokestacks, all situated within a deeply shadowed and eerily silent urban square whose mysterious empty spaces are suffused with an atmosphere of premonition and foreboding. Indeed, by the time he completed this memorable portrait in 1915, the artist had created an impressive body of work that would later exert a profound impact on the Surrealists, who viewed his metaphysical paintings as powerful forerunners of their own efforts to create art from dreams and the unconscious.

Although better known for his mysterious paintings of empty, sun-drenched piazzas and brooding mannequins, de Chirico also painted a large number of portraits and self-portraits throughout his early career, including important paintings of family members, friends, and prominent members of the Parisian avant-garde. *Portrait of Carlo Cirelli* was painted in October 1915 in the Italian city of Ferrara, where the artist was stationed in the 27th Infantry Regiment, also known as the Pavia Brigade, during World War I. The twenty-seven-year-old artist and his brother Andrea, a painter and composer who worked under the pseudonym Alberto Savinio, enlisted together in the Italian army in May 1915, shortly after Italy had declared war on Austria-Hungary. Although assigned to the 27th Infantry Regiment, the two brothers were allowed to sleep and eat in the small, furnished apartment of their mother, Gemma de Chirico, who had moved to Ferrara in June 1915 to be near her sons. This unusual arrangement allowed de Chirico to continue to paint and write poetry, as well as correspond with the friends he left behind in Paris, such as the noted poet, playwright, and critic Guillaume Apollinaire and the art

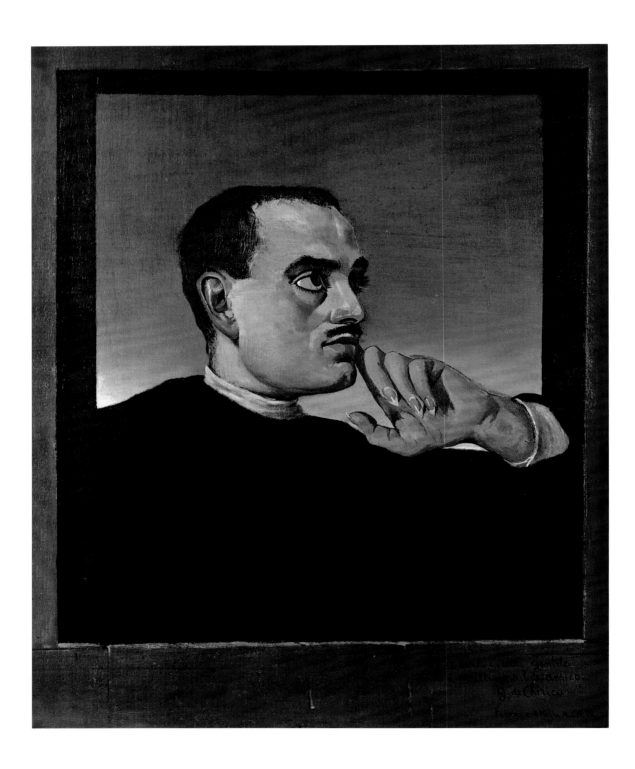

Plate 28
Giorgio de Chirico
Italian, born Greece, 1888–1978
Portrait of Carlo Cirelli, 1915
Oil on canvas, 29 ½ x 24 ½ inches (74.9 x 62.2 cm)
Philadelphia Museum of Art. Partial and promised gift of C. K. Williams, II. 2008-111-1

dealer Paul Guillaume, whose gallery in Paris had represented his work since 1914. It seems highly probable, therefore, that de Chirico painted *Portrait of Carlo Cirelli* in his mother's rented apartment at 24 Via Montebello in Ferrara.

Carlo Cirelli was a corporal in the Italian army who befriended de Chirico during his military service in Ferrara. At the time of the painting, the artist and his brother had recently been reassigned to desk jobs as bookkeepers at the regiment's depot headquarters in Poggio Renatico, after the painter suffered from heat exhaustion while drilling with his fellow soldiers in the humid July weather.[1] It was probably at that time that de Chirico came into contact with this highly cultivated young officer, who was the son of Ettore Cirelli, a prominent landowner in Ferrara and financial backer of the *Gazzetta Ferrarese* news-paper, which he used as a propaganda vehicle to defend his conservative views on land reclamation in the Emilia-Romagna region, as well as his staunch opposition to foreign investment in the Ferrarese agricultural economy.[2] As Paolo Baldacci has argued, the 27th Infantry Regiment was a classic "hideaway" place where soldiers from wealthy backgrounds or with politically powerful or influential parents, such as Cirelli, the de Chirico brothers, and fellow artist Luigi Tibertelli, who worked under the name Filippo de Pisis, could carry out their military service without any danger of facing the enemy.[3]

In his memoirs, the artist recalled that Cirelli

> was a highly original boy. He would sit in the storeroom of the depot, among pyramids of shoes, gaiters, cloaks, jackets, etc., and carry out, with the patience of a medieval châtelaine, the most beautiful and complicated embroidery. He had long finger-nails, which were lustrous and extremely well cared for; his hands often felt hot and then he would raise his arms over his head and move his hands, like certain dancers performing in the aesthetic style.[4]

According to de Chirico, Cirelli was obsessed with cleanliness and order, and his behavioral patterns denote a nervous disposition that was not unlike the artist's own.[5] Throughout his military service, de Chirico had been plagued with intestinal disorders, heat exhaustion, and other maladies that ensured that he never saw combat duty, despite the fact that he remained in the Italian army until the end of the war.

In April 1917 the painter was sent to convalesce at the Military Reserve Hospital at the Villa del Seminario, a hospital special-izing in neurological disorders on the outskirts of Ferrara, where he was treated for physical and mental exhaustion. Even before he was hospitalized, de Chirico was given an extraordinary amount of freedom, thanks to the indulgent staff major who had given the artist and his brother desk jobs as clerks in the regiment's headquarters. While other soldiers received their combat training, de Chirico was free to paint again, as well as to roam the streets of Ferrara, especially the Jewish quarter with its celebrated pastry shops that sold exotic delicacies, as he later recalled in his memoirs:

> I began to paint again. The appearance of Ferrara, one of the most beautiful cities in Italy, had impressed me, but what struck me most of all and inspired me on the meta-physical side, the manner in which I was working then, were certain aspects of Ferrara interiors, certain windows, shops, houses, districts, such as the ancient ghetto, where you could find certain sweets and biscuits with remarkably metaphysical and strange shapes.[6]

One of the first works he completed in Ferrara was the portrait of his new friend that he inscribed with the following dedication in his highly distinctive vertical handwriting: "A Carlo Cirelli gentile / mio e multisensibile amico. / G. de Chirico / Ferrara Ottobre MCMXV." The painting looks back to the artist's celebrated self-portrait of 1911 (private collection, Lugano, Switzerland),[7] in which he rests his head in his hand in a pose derived from the well-known photograph of his intellectual hero Friedrich Nietzsche, who was himself adopting the philo-sophical thinker's traditional pose of meditation in which the head is cradled in the hand. Both portraits feature the same pictorial device of a frame within a frame, in which the sitter is shown wearing dark clothing, with a white collar and cuffs,

against a blue-green sky that is often found in de Chirico's paintings, the color of which he called "Veronese" green.[8] The connections between the two works suggest a possible self-identification with Cirelli, a man of rare sensitivity, intelligence, and exquisite taste, who after the war became a successful dealer in Italian furniture and antiques.[9]

There are, however, several important differences between the two portraits. To begin with, Cirelli's hand does not support his head, as de Chirico's did, but rather lightly touches his face with an open-fisted gesture that allowed the artist to focus on the young corporal's carefully manicured fingernails, which look as if they were made of ivory or mother-of-pearl. In the portrait these long, glossy fingernails are tapered like the sharpened points of fountain pens, which give the young man a decadent and slightly threatening appearance, although it should be noted that sharply pointed fingernails were highly fashionable among the upper classes in Italy at that time. In a contemporaneous letter to Paul Guillaume, de Chirico wrote that his friend's face possessed "the never-ending nostalgia of the Italian Middle Ages," which may explain why Corporal Cirelli is not shown in profile, but rather in a three-quarter view that emphasizes the upturned gaze of his large brown eyes.[10] With his shiny, daggerlike fingernails, languid posture, and contemplative expression, Cirelli looks more like a priest or a poet than a soldier in the Italian army. As such, the work appears to be far closer to *Portrait of Paul Guillaume*, completed shortly before the artist left Paris in May 1915, in which the young French art dealer is shown in a similarly pensive mood.[11]

In an important essay on de Chirico, published in *La critica d'arte* in November 1949, the Italian art historian Carlo L. Ragghianti argued that *Portrait of Carlo Cirelli* was indebted to the nineteenth-century German painting that the artist was exposed to during his early training at the Academy of Fine Arts in Munich from 1906 to 1908, where he first discovered the work of Arnold Böcklin, Franz von Stuck, Hans von Marées, Hans Thoma, and his own painting instructor, Carl von Marr.[12] James Thrall Soby, the most perceptive writer on the artist's work during his lifetime, agreed with Ragghianti that the

painting was "rather reminiscent of the Germanic sources which had so interested de Chirico during his youth at Munich," before going on to argue that "the influence of Franz [von] Stuck is particularly strong."[13] However, these critical responses to the work miss the immediate context in which the painting was made, namely, the city of Ferrara, with its proud tradition of painting and artisanship. I would argue instead that the completed portrait reflects de Chirico's interest in the work of Dosso Dossi, Benvenuto da Garofalo, and other Italian painters who worked for the highly cultivated Este court in Ferrara during the Renaissance. Its splendid execution, seen especially in the skillful modeling of the face, is quite unlike de Chirico's earlier work in Munich and Paris, in which he sought to adapt the Romantic vision of von Stuck and other German painters to the classical world.

A painting of intense emotionality despite the utter austerity of its pictorial means, *Portrait of Carlo Cirelli* looks instead to Dosso Dossi's early portraits, which are characterized by their simple, unadorned presentation. This reading is supported by the artist's letter to Guillaume, dated November 1, 1915, in which he told his friend that he was reliving at this time "the joys of the artisans of the sixteenth century," after the recently completed portrait of Cirelli had gone on public display, in a richly adorned frame, in the shop window of an antique dealer in Ferrara, where a large number of people had seen it.[14] Indeed, such was the spectacular success of the painting's debut that de Chirico gleefully informed his dealer that he was "already a celebrity in Ferrara where I am called 'il pittore' (the painter)."[15]

Portrait of Carlo Cirelli thus foreshadows de Chirico's famous renunciation of modern art in 1919, following a revelation in front of a painting by Titian at the Villa Borghese in Rome, in favor of a return to the techniques and classicizing subject matter of the Italian old masters. In an effort to develop a new personal painting style that placed special emphasis on technical dexterity, de Chirico began making copies of Italian Renaissance paintings by such artists as Raphael, Lorenzo Lotto, and Dosso Dossi. By the early 1920s he had absorbed

the lessons of these celebrated predecessors and began making mythological landscapes inspired by Dossi, whose paintings he had seen in abundance during his military service in Ferrara, and whose presence is keenly felt in this compelling portrait of Cirelli, his refined and "highly sensitive" new friend.

Michael R. Taylor

1. Giorgio de Chirico, *The Memoirs of Giorgio de Chirico*, trans. Margaret Crosland (London: Peter Owen, 1971), pp. 79–80.

2. Sandro Zanotto, *Filippo de Pisis ogni giorno* (Vicenza: Neri Pozza Editore, 1996), p. 74.

3. Paolo Baldacci, *De Chirico: The Metaphysical Period, 1888–1919*, trans. Jeffrey Jennings (Boston: Bulfinch Press / Little, Brown and Company, 1997), p. 342.

4. De Chirico, *The Memoirs of Giorgio de Chirico*, pp. 81–82.

5. De Chirico discovered Cirelli's fanatical obsession with cleanliness on a visit to his home in Ferrara, where "the bedroom floor was so highly polished with wax, so smooth and gleaming, that you had to walk on tiptoe and spread out your arms in order to keep your balance, like a tightrope-walker or someone learning to skate. If you did not take this precaution you were in danger of falling down at every step and ending up flat on the floor." Ibid., p. 82.

6. Ibid., p. 80.

7. For a reproduction, see Baldacci, *De Chirico*, p. 107.

8. See, for example, the 1914 *Portrait of Guillaume Apollinaire*, which was described by the artist as a "numismatic profile, which I stamped onto the Veronese sky of one of my metaphysical paintings." See Giorgio de Chirico, "Guillaume Apollinaire," *Ars nova*, December 1918; reprinted in Maurizio Fagiolo dell'Arco, ed., *Giorgio de Chirico: Il meccanismo del pensiero; Critica, polemica, autobiografia, 1911–1943* (Turin: Giulio Einaudi, 1985), p. 59 (author's translation).

9. In his memoirs, de Chirico remembered Cirelli purchasing "from an antique dealer an old bed, an historic bed, which he had covered with a baldachin and with heavy, expensive hangings." De Chirico, *The Memoirs of Giorgio de Chirico*, p. 82. This early interest in antique furniture would turn into a full-blown career after the war, when Cirelli bought numerous items of furniture and furnishings, mainly from the sixteenth and seventeenth centuries, including tables, chairs, sideboards, and linen chests, and sold them to local collectors and institutions in Ferrara and the surrounding Po River valley region. See Lucio Scardino and Antonio P. Torresi, eds., *Antichi e moderni: Quadri e collezionisti ferraresi del XX secolo* (Ferrara: Liberty House, 1999), p. 48.

10. De Chirico to Paul Guillaume, November 1, 1917, in Giuliano Briganti and Ester Coen, eds., *La pittura metafisica*, exh. cat. (Vicenza: Neri Pozza Editore, 1979), p. 117 (author's translation).

11. For a reproduction, see Baldacci, *De Chirico,* p. 290.

12. Carlo L. Ragghianti, "Il primo De Chirico," *La critica d'arte*, 3rd ser., vol. 8, no. 4, fasc. 30 (November 1, 1949), p. 326.

13. James Thrall Soby, *Giorgio de Chirico*, exh. cat. (New York: The Museum of Modern Art, 1955), p. 108.

14. De Chirico to Guillaume, p. 117 (author's translation).

15. Ibid.

RALSTON CRAWFORD

BOAT AND GRAIN ELEVATORS

1942

Ralston Crawford (1906–1978) was born in St. Catherine's, Ontario, and studied briefly at the Otis Art Institute in Los Angeles in 1927, but he was exposed to his first formative influences in Philadelphia. In the fall of 1927 he entered the Pennsylvania Academy of the Fine Arts, the historically conservative institution that two years before had dismissed from its faculty its most ardent proponent of modernism, Arthur B. Carles. Henry McCarter and Hugh Henry Breckenridge remained, however, to encourage an interest in modern art among the Academy's students. Although he was not specially drawn to modernism, Crawford worked primarily with Breckenridge, a colorist who advocated the importance of orderliness for the artist, which may have laid the foundation for Crawford's lifelong contempt for excessive feeling and his pursuit of order and discipline in his art.

While at the Academy he also spent two seasons attending classes taught by Dr. Albert Barnes in nearby Merion, where Barnes's collection of Post-Impressionist paintings shaped Crawford's style as much or more than the lectures; there, he developed an enduring love for the art of Paul Cézanne, particularly admiring its clarity of structure. Crawford also visited other modern art collections in Philadelphia, such as that of Earl Horter, who owned spectacular paintings and drawings by Charles Sheeler, as well as the collection of Samuel S. and Vera White, who had several of Charles Demuth's architectural watercolors.[1]

After initially making traditional landscapes with barns, figure paintings, and still lifes influenced by Cézanne, Crawford ultimately found beauty in the industrial landscape, especially shipyards, grain elevators, bridges, highways, tanks, and the like. In about 1934–35 he began to treat those subjects as large, simplified shapes, which he painted as sharp-edged planes of broad, smooth areas of color. These paintings and those that followed in the early 1940s caused critics to associate Crawford with the Precisionists Sheeler, Demuth, and Morton Schamberg, former students at the Pennsylvania Academy, who had introduced the simplified planar style in 1916–17, nearly twenty years earlier.

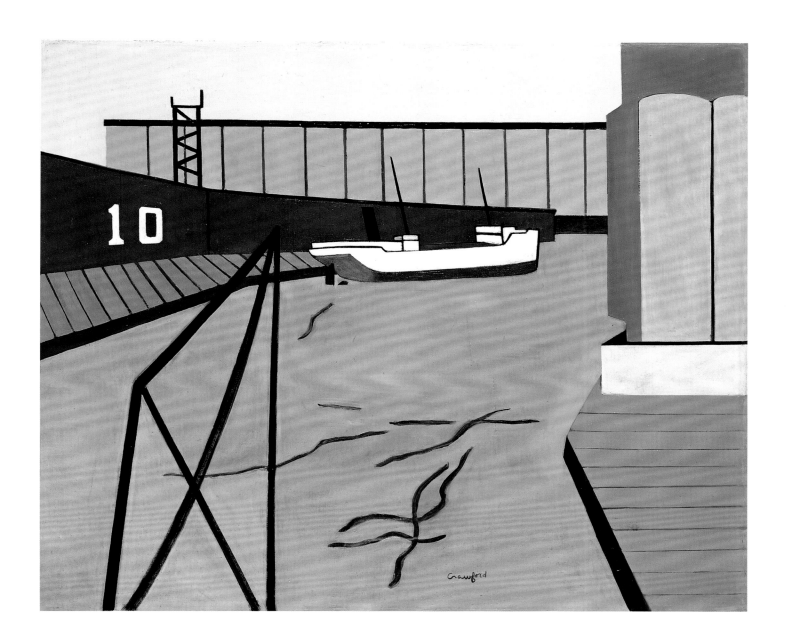

Plate 29
Ralston Crawford
American, 1906–1978
Boat and Grain Elevators, 1942
Oil on canvas, 30 x 36 inches (76.2 x 91.4 cm)
Collection of C. K. Williams, II

Boat and Grain Elevators is a subtly structured composition of curved and angled planes that recede gently toward a compact row of grain elevators silhouetted against a gray sky. All of the elements in the picture are recognizable, and yet Crawford treats them as abstract planes and flattened forms. This composition was made precisely at the time when the artist moved away from composing plunging perspective renderings of roads and bridges[2] and replaced them with more abstract compositions dominated by large, flattened forms placed right on the picture plane.[3] In *Boat and Grain Elevators* Crawford used a receding perspective construction, but instead of sharp recession from foreground to background, many shapes, curves, and angles intrude and interrupt.

A drawing for *Boat and Grain Elevators* (fig. 25) shows how Crawford simplified the composition of the painting, even as he made its structure more complex by making minute changes in individual shapes and relationships between forms. By eliminating the shading and strong outlines that occur in the drawing, the forms in the painting appear flattened; the addition of the broad black borders along the docks in the painting emphasize that there is no straight line of progression between foreground and background. These and other subtle adjustments, calculated irregularities, and juxtapositions suggest that *Boat and Grain Elevators* is an important transitional work in which Crawford complicated his plunging perspectives and moved toward greater abstraction of form.

1. For the influence of Philadelphia collections on Crawford, see William C. Agee, *Ralston Crawford* (Pasadena, CA: Twelve Trees Press, 1983), p. 6; and Barbara Haskell, *Ralston Crawford*, exh. cat. (New York: Whitney Museum of American Art, 1985), pp. 14–17. Horter owned eight paintings and drawings by Sheeler, notably *Pertaining to Yachts and Yachting* (1923) and *Church Street El* (1920). The Whites' collection included nine Demuth watercolors, including *Bermuda Trees* (1916), *Red Roofed Houses* (1917), *Bermuda Houses* (1917), and *Red Chimney* (1920).
2. See *Overseas Highway* (1939), in Haskell, *Ralston Crawford*, p. 53, pl. 51.
3. See *Grain Elevators from the Bridge* (1942), in ibid., p. 57, pl. 55.

Fig. 25: **Ralston Crawford**
American, 1906–1978
Study for "Boat and Grain Elevators," c. 1942
Graphite on paper, 9 x 11 ³/₄ inches (22.9 x 29.8 cm)
Colby College Museum of Art, Waterville, Maine

JEAN JOSEPH CROTTI

CUBIST LANDSCAPE

1923

I am a vagabond. Few have understood my work; few have grasped my thinking. As opposed to my peers who have all carved out a niche, their own niche, in the minds of their con-temporaries without considering that by carving it out, they were engraving it in their own minds, and that little by little this niche would take over gray matter. I was a vagabond in thought.[1]

The reputation of Jean Joseph Crotti (1878–1958) as an artist suffered because of his "vagabond" tendency to work simul-taneously in a wide variety of styles—a difficulty he openly acknowledged in later life. He was an artist of enormous talent and inventiveness, but could never maintain one stylistic direction at a time, although certain images, such as heads of women, appeared consistently throughout his work. Indeed, Francis M. Naumann has declared that "Crotti might have been ranked among the best-known abstract painters of his generation, but he was aesthetically restless, simply incapable of embracing a singular style."[2]

Crotti's life story betrays his restlessness and introspective nature. Born in Bulle, the canton of Fribourg, in French-speaking Switzerland, he was the youngest of three children. After two years at the university in Fribourg, he left to become an apprentice to his father, a painting contractor. Art studies in Munich and Marseilles and later at the Académie Julian in Paris were also short-lived, as he resisted the academic approach of his teachers, preferring to work in isolation. Despite his inclination for solitude, however, Crotti became part of the art world in Paris, and by 1907 his work was included in the Salon d'Automne. It was probably in 1913, the year when Crotti was named a Sociétaire of the Salon d'Automne, that he met the Duchamp brothers, Albert Gleizes, Francis Picabia, and others at the famous Dîners des Artistes de Passy, banquets sponsored by Henri Martin Barzun's journal, *Poème et drame*, and the Puteaux Cubists.

In September 1915, preceded by Marcel Duchamp and Picabia and encouraged by his surgeon brother who lived in Columbus, Ohio, Crotti and his wife, Yvonne, moved to the United States and settled in New York; that fall and winter Crotti and Duchamp

Plate 30
Jean Joseph Crotti
French, 1878–1958
***Cubist Landscape (Paysage cubiste)**, 1923*
Oil on canvas, 24 x 18 inches (61 x 45.7 cm)
Collection of C. K. Williams, II

shared a studio and became close friends. Between 1915 and 1920, working with Duchamp and Picabia, Crotti embraced Dadaism. In addition to the now-lost wire and metal construction, *Portrait of Marcel Duchamp*,[3] his work included paintings of irreverent machine forms and obscure, provocative Dada inscriptions, and occasionally bore titles with religious associations such as *Dieu* or *Il créa le ciel et la terre*. Yet, as was his wont, Crotti continued to paint abstractions, heads, and other subjects alongside his Dada works. Finally, between 1921 and 1922, with his second wife, Suzanne (Duchamp's artist-sister), he entered an intense period of work that he called Tabu, an offshoot of Dada that was intended to create art that would "express the Mystery,"[4] particularly that of God's existence. Crotti's cosmic Tabu paintings, often brilliant in color, were composed of circles, arcs, curved lines, letters, arrows, and words through which he strove to embody the feeling of infinity. He wrote, "We no longer wish to produce an art for the body but for the mind. We wish through forms, through colours, through [*sic*] it matters not what means, to express the mystery, the divinity of the universe, including all mysteries."[5]

In 1923, when he painted *Cubist Landscape*, Crotti was moving away from the powerful spirituality of Tabu, though not its penchant for mystery. This dynamic composition consists of triangular forms tumbling downward like pieces of shattered glass, which resemble *Formes pointues*, his paintings of 1921.[6] In the present painting, however, the Cubist shapes part near the center of the canvas to reveal paneled doors opening onto a view of the distant sea. A pale gray arc with a darker underside just above the opening may suggest that we glimpse the water beneath the arch of a bridge. In this aspect, the painting resembles Crotti's contemporaneous *Bridge over the Seine* in which curtains are pulled aside to expose a bridge's arcade beyond a window.[7] In both works, the falling angled shapes are painted in somber browns, tans, grays, and blues, overlaid by hovering, lightly brushed, white triangles that are nearly transparent. But while *Bridge over the Seine* presents a close-up view through a window, *Cubist Landscape*, with its view onto a faraway sea, is deeply mysterious, almost surreal—as though Crotti (and the viewer) were looking through the broken Cubist planes of the painting into the water's infinite depths. As Naumann speculates, the painting might look "both backward (to his Cubist past) and forward (to whatever the future holds)."[8]

1. Crotti, quoted by Francis M. Naumann and translated from French by Molly Stevens, The Art of Translation, New York, in the English typescript for Naumann's preface in Jean Carlo Bertoli, *Jean Crotti: L'oeuvre peint, 1900–1958; Catalogue raisonné* (Milan: 5 Continents Editions, 2007), pp. 13–23. Emphasis in original. The passage cited is from Crotti's handwritten notes in the Papers of Jean Crotti and Suzanne Duchamp, Archives of American Art, Smithsonian Institution, Washington, DC, reels 2394–95. Naumann kindly gave the author a copy of the typescript.
2. Ibid.
3. Reproduced in *Tabu Dada: Jean Crotti and Suzanne Duchamp, 1915–1922*, ed. William A. Camfield and Jean-Hubert Martin, exh. cat. (Bern: Kunsthalle Bern, 1983), p. 93, fig. 1.
4. Jean-Hubert Martin, "Tabu: Artistic Movement or Religion?" in ibid., p. 83.
5. Quoted in ibid., p. 86.
6. *Formes pointues* are reproduced in Bertoli, *Jean Crotti*, p. 124, nos. 21-10–21-11.
7. *Bridge over the Seine (Pont sur la Seine)* is reproduced in ibid., p. 146, no. 23-10.
8. In an e-mail message from Francis M. Naumann to the author, November 6, 2008, Naumann suggested that *Cubist Landscape* might be positioned somewhere between Cubism and Surrealism: "There can be no question that, at that time, Crotti realized that the years he spent in New York sharing a studio with Duchamp was the more important phase of his career, so he might have envisioned this view across the sea as a look backward. . . . It would be tempting to speculate that Duchamp saw this painting before making his *Door 11 rue Larrey*, since it opens and closes a space at the same time, and Crotti's painting looks both backward (to his Cubist past) and forward (to whatever the future holds)."

STUART DAVIS

COMPOSITION 1863

1932

From 1915 through the 1940s Stuart Davis (1892–1964) drew and painted the rugged coastline and busy harbor of Gloucester, Massachusetts. Never interested in its picturesque aspects, as were such nineteenth-century painters as Fitz Hugh Lane, Winslow Homer, and Childe Hassam, Davis preferred Gloucester's gritty side: the fishing schooners, lobster traps, derricks, gas pumps, and smokestacks, as well as the drama of houses hanging from precipitous cliffs, the assortment of towers and steeples, and the immense boulders lining the sea at Bass Rocks. After toting his painting equipment over the rocky terrain for a time, Davis began to carry small sketchbooks and a fountain pen, which provided him with a convenient way to record motifs and views that he later reworked and transformed in his studio.[1] Motifs in his drawings and paintings, such as harbor detritus, often do not reveal their specific location, though titles occasionally identify a particular site. Davis progressively reduced his images to simple lines and colored shapes, but he never gave way to pure abstraction; instead, he developed a unique manner of treating American subjects in an abstract style.

An important breakthrough occurred for Davis in the early 1930s, especially in Gloucester during the summer of 1932, when he found a means for bringing diverse objects seen from different perspectives into a single focus by rendering their planes as thick black lines intersecting at angles. He determined that the angle is the point where planes change direction, and he abandoned color for a time in an effort to concentrate on the juxtaposition of planes.[2] Typically he began with sketches made in nature, and he combined, arranged, and rearranged them into a unified, flat, yet inevitably animated composition of motifs viewed from multiple perspectives.

Produced during the summer of 1932,[3] *Composition 1863*, alternatively (and more properly) named *Factory by the Sea*,[4] is one of the "angle pictures" that Davis undertook in his search for creating logical relationships of objects in space. Its subject is the rambling red factory that is still a landmark at the entrance to Gloucester Harbor (fig. 26), where copper paint was once produced to protect the city's fleet of fishing

Plate 31
Stuart Davis
American, 1892–1964
***Composition 1863 (Factory by the Sea)**, 1932*
Gouache and traces of graphite on paper, 22 ¼ x 30 ¼ inches (56.5 x 76.8 cm)
Collection of C. K. Williams, II

schooners. Faded white letters along its harbor side even now proclaim "Gloucester Sea Jackets / Marine Paints / Manufactory / Established 1863." Abbreviated, regularized, and reconfigured in Davis's complex diagram of interlocking black and white lines and colored shapes, the factory rises over what is apparently the sea and shipyard, its roof jauntily labeled "1863 paint." Irregular areas of color are interwoven into the strictly linear arrangement—not intruding, but enlivening and giving further definition to its compact structure. Colors are not necessarily descriptive, though the curlicues in a wave of yellow along the top are clearly smoke, while the curving panels of yellow over blue to the right may stand for a spit of land that projects beyond the factory into the water.

1. See Karen Wilkin, "The Place I've Been Looking For," in *Stuart Davis in Gloucester*, exh. cat. (West Stockbridge, MA: Hard Press, 1999), pp. 32–77.
2. John R. Lane, *Stuart Davis: Art and Art Theory* (New York: Brooklyn Museum, 1978), p. 23.
3. Ani Boyajian and Mark Rutkoski, eds., *Stuart Davis: A Catalogue Raisonné*, vol. 2 (New Haven: Yale University Art Gallery, in association with Yale University Press, 2007), cat. no. 1174, confirm the date from a note in the artist's account book and list two related works: *Drawing for "Composition (1863)"* from Sketchbook 14-4 (cat. no. 533) and a gouache, *Gloucester Sunset* (1955; cat. no. 1298).
4. Ibid., cat. no. 1174, lists alternative titles, including *Composition*, *Composition with 1863*, *1863*, and *Gloucester Copper Paint Factory*.

Fig. 26: Paint factory, Gloucester, Massachusetts, 2006

CHARLES DEMUTH

STRAW FLOWERS

c. 1916

Maintaining close ties with his family in Lancaster, Pennsylvania, and having many friends in the United States and abroad, Charles Demuth (1883–1935) nonetheless spent his most creative hours alone and always saw himself as someone different. The only child of a well-to-do manufacturer of snuff and tobacco, Demuth spent a coddled and isolated childhood owing to a hip ailment that left him an invalid for a time and gave him a lifelong limp and fragile self-image. But though Demuth was delicate he was not weak, and he soon learned to mask his marginality with the image of an aesthete and a dandy, sporting a cane and affecting an air of indifference. As an art student he studied first at the Drexel Institute of Art, Science, and Industry in Philadelphia and took classes at the Pennsylvania Academy of the Fine Arts, to which he eventually transferred in 1905. Although he was exposed to modern art in classes with Henry McCarter and Hugh Breckenridge, spent time in Paris in 1907 in contact with artists like John Marin, Arthur B. Carles, and Edward Steichen, and was aware of the work of Paul Cézanne, Pablo Picasso, and the Fauves, it was not until after his second European trip of 1912–14 that Demuth's own work began to show evidence of modernism. On that trip he traveled with Marsden Hartley and became part of the social milieu of Americans in Paris. When he returned home, Demuth joined the Daniel Gallery in New York, which gave him a solo exhibition of landscape watercolors and exhibited his work nearly every year until 1925.[1]

Demuth's watercolors of flowers appeared first in 1915, and they quickly became his most popular work, though they were far from his only subjects. Initially, he drew his floral compositions in pencil, then wet the paper, and proceeded to cover the entire sheet with profusions of blossoms whose forms alternately merge with and spring forth from surrounding spots and blots of color. His earliest flower compositions are light and airy, forming unstructured, allover patterns. Increasingly, however, he concentrated on groups of single blossoms, though he continued to cover the entire sheet with a surrounding color. Demuth's early flowers are highly energetic and expressive; nothing about them seems arranged (though they clearly were), and they pulsate with a life that has been interpreted as sinister or sexually charged.

Plate 32
Charles Demuth
American, 1883–1935
Straw Flowers, c. 1916
Graphite and watercolor on paper, 8 1/8 x 10 5/8 inches (20.6 x 27 cm)
Collection of C. K. Williams, II

Unlike many of the floral compositions of this date, the blossoms in *Straw Flowers* are not arranged in a bouquet, seeming instead to explode over the sheet in different directions. The red, yellow, and white flowers are drawn together, but not fettered, by trailing diagonal stalks that converge at the center, providing a kind of structure to the disorder. The red and yellow petals are applied in small, precise brushstrokes, but the white ones are formed by the white of the paper with their petals drawn in pencil. A dark blue "background" (for it is not really a background) is carefully controlled around the edges of the white blossoms;[2] areas of the blue are also blotted to give the mottled effect of light penetrating a cloudy sky. While some of Demuth's floral watercolors justifiably invite deeper interpretation, *Straw Flowers* evokes pure joy and demonstrates his remarkable early powers of expression with the watercolor medium.

1. For biographical information, see Barbara Haskell, *Charles Demuth*, exh. cat. (New York: Whitney Museum of American Art, 1987), chap. 1.
2. According to Betsy Fahlman, *Chimneys and Towers: Charles Demuth's Late Paintings of Lancaster*, exh. cat. (Fort Worth: Amon Carter Museum, 2007), p. 106: "He would give a hard edge to his washes by employing something with a firm side to stop the flow of watercolor and concentrate his color." Demuth's use of this technique is evident here in the white edges around many of the blossoms where the surrounding blue wash was clearly stopped out.

CHARLES DEMUTH

NANA BEFORE THE MIRROR

1916

In the same year that he started making floral watercolors such as *Straw Flowers* (pl. 32), Charles Demuth (1883–1935) began a series of literary illustrations. These were not commissioned works, nor were they ever published with their texts; they seem to have been made to satisfy the artist's own interests and concerns. It is not surprising that Demuth would turn to illustration. Not only did he have a deep personal interest in writing (in 1914 he still described himself as a writer as well as an artist), but his training in Philadelphia linked him to the city's long tradition of book illustration. Creating images that support or portray a text would have had a natural fascination for him.[1]

Begun in 1915–16, Demuth's first and most extensive series of illustrations was for Émile Zola's scandalous novel *Nana*, which had been published in 1880. The tale revolves around Nana, a beautiful courtesan descended from a long line of drunkards in the suburbs of Paris, whose irresistible sexual attractions wreaked havoc among Parisian aristocrats who flocked to garner her favors. Most disastrous of all was her effect on the pious Count Muffat, whose downfall is the central episode in the story. Demuth's eleven illustrations of *Nana* do not follow Zola's text systematically; instead, they present a lively series of impressions that sometimes conflate parts of different events into a single image. More interesting and indeed revealing of Demuth's own psychology is his rollicking theatrical interpretation of a plot that concerns the inevitably catastrophic results of all-consuming sexual pleasure. The dilemma faced by the doomed Count Muffat who abandoned religious piety in favor of unbridled passion seems to have mirrored Demuth's own conflicted feelings, for the artist's strict Lutheran upbringing cast a menacing shadow over the decadent life he was enjoying in the demimonde cafés, cabarets, and Turkish baths of Greenwich Village—subjects he also portrayed in watercolors at this time.[2] Demuth's illustrations of *Nana* combine a happy mixture of irony, nonchalance, boredom, exhibitionism, theatricality, and joyful abandon, with a dash of romanticism, which not surprisingly recalls the attitudes of the fin de siècle aesthetes Oscar Wilde and Aubrey Beardsley, as well as the style of Henri de Toulouse-Lautrec, each of whose work Demuth admired.

Plate 33
Charles Demuth
American, 1883–1935
Nana before the Mirror, 1916
Graphite and watercolor on paper, 8 x 10 inches (20.3 x 25.4 cm)
Collection of C. K. Williams, II

Nana before the Mirror[3] is one of three of Demuth's illustrations of *Nana* that were not purchased by Dr. Albert Barnes from the Daniel Gallery in 1922. In 1929 Demuth appears to have sent it to Alfred Stieglitz, as a letter exists in which Demuth describes it as a drawing of Nana nude.[4] That this is the drawing mentioned is confirmed by the fact that it is the only *Nana* illustration not purchased by Barnes in which the subject appears unclothed.[5] At some point Stieglitz must have returned the work to the artist, as it ended up in the collection of Robert Locher who inherited the watercolors from Demuth's estate.

The image illustrates the following text from Zola's *Nana*:

> "A mirror stopped her, and as of old she lapsed into oblivious contemplation of her nakedness. But the sight of her breast, her waist, and her thighs only doubled her terror, and she ended by feeling with both hands very slowly over the bones of her face.

> "'You're ugly when you're dead,' said she in deliberate tones.

> "And she pressed her cheeks, enlarging her eyes and pushing down her jaw, in order to see how she would look. Thus disfigured she turned towards the Count:

> "'Do look! my head'll be quite small, it will!'

> "He fancied he saw her in a grave, emaciated by a century of sleep, and he joined his hands and stammered a prayer.

> "The joints of his fingers used to crack, and he would repeat without cease these words only: 'My God, my God, my God!'"[6]

Demuth portrays the scene brilliantly by punctuating it with symbols unmentioned in the text. Here, Nana's face reflects, not a disfigured image, but a skull, creating a modern *vanitas*,[7] pausing to admire her figure. The count kneels with hands clasped over his eyes, perhaps melodramatically contemplating his own fate as much as hers, as his rosary (the symbol of his abandoned piety) lies cast on the ground. The details of their

poses and gestures are equally illuminating: the curvaceous nude reveling in her beauty with her toe delicately pointed; the stricken count, kneeling humbly in his underwear as though in prayer. Demuth's graphite drawing of figures and props is sure and incisive, but the surroundings are executed in energetic loops and scribbles overlaid with touches of hot red, warm brown, black, and golden yellow that blend atmospherically into one another, producing a swirling, smoky aura that reminds one of stage lighting. Masterfully juxtaposed in a single image, the preening femme fatale and the theatrically anguished count are mirthful symbols of the central theme of Zola's novel even as they may suggest something of the artist's own inner unrest.

1. Barbara Haskell, *Charles Demuth*, exh. cat. (New York: Whitney Museum of American Art, 1987), p. 97, observed that attempts to have one art form give expression to another were more common between music and painting: "Demuth's preoccupation paralleled comparable efforts being made within the music world between 1890 and 1920 by composers . . . experimenting with the formal properties of music and its potential for conveying a narrative."
2. See *Negro Jazz Band* (1916), *Turkish Bath* (1915), and *Vaudeville Comediennes* (1917), reproduced in ibid., figs. 19, 21, 23.
3. The inscription on the watercolor has been variously interpreted as "Te Nana," "Ta Nana," or "To Nana." Most recently, Jean-Max Guieu, "Les illustrateurs des romans d'Emile Zola aux Etats-Unis," *Les cahiers naturalistes*, vol. 38, no. 66 (1992), pp. 216–17, has suggested that the inscription reads "For Nana." Guieu inexplicably cites the location of *Nana before the Mirror* as the Regis Collection, Minneapolis.
4. Pamela Edwards Allara, "The Water-color Illustrations of Charles Demuth" (Ph.D. diss., Johns Hopkins University, 1970), p. 101.
5. The others not purchased by Barnes are the *Scene after George Stabs Himself with the Scissors* (second version) in the Museum of Fine Arts, Boston, and *Nana, Seated Left, and Satin at Laure's Restaurant* in the Museum of Modern Art, New York.
6. Quotation taken from the translation in Andrew Carnduff Ritchie, *Charles Demuth*, exh. cat. (New York: The Museum of Modern Art, 1950), p. 41.
7. Haskell, *Charles Demuth*, p. 99.

CHARLES DEMUTH

GLOUCESTER—SAILS AND MASTS
1919

Charles Demuth (1883–1935) began to explore Cubism while in Bermuda with Marsden Hartley in 1917, concentrating primarily on architectural subjects to introduce a new planar style. Hartley, as well as Albert Gleizes, who was also in Bermuda at the time, certainly influenced this development, but as Barbara Haskell observed, Demuth's new direction was also inspired by the watercolors of Paul Cézanne, which showed a way of merging organic with angular forms and integrating untouched areas of the white paper ground into an overall compositional structure.[1] Initially, Demuth continued to work in watercolor, often blotting or scraping away lines in certain areas; his colors were generally pale and delicate. In addition to buildings, the masts, sails, and riggings of schooners also became important subjects at this time, first in Bermuda and later that year in Gloucester, Massachusetts. The schooners' erect, crisscrossing forms were perfect vehicles for a style based on angular planes overlapping in space. As Demuth's new approach developed, he began to extend the ruled lines of planes to the edges of the composition, often nearly eliminating color as the lines moved toward the borders, so that the greatest concentration of colored forms remained, almost floating, in the center. In one early marine composition, *Sail in Two Movements* (1917),[2] Demuth introduced a rhythmic motion into the overall structure, recalling Futurism's "lines of force," but that was a feature he did not continue, and he replaced it with a more delicate movement of light over limpid, gently shifting planes.

During the summer of 1919, Demuth continued his series of boat and harbor paintings in Gloucester, often including glimpses of nearby buildings. Following the precedent of Marcel Duchamp and Francis Picabia, he gave a few of them whimsical names, or titles borrowed from literature, such as *Sailboats (The Love Letter)*, *Rise of the Prism*, or *In the Key of Blue*.[3] The marine paintings are larger in format than his earlier watercolors, averaging about fifteen by nineteen inches, and most of them are executed in tempera on board rather than watercolor.[4] In these compositions, as in *Gloucester—Sails and Masts*, Demuth applied the tempera in small parallel strokes, keeping precisely within the borders of ruled lines. Interestingly, when using this opaque

Plate 34
Charles Demuth
American, 1883–1935
Gloucester—Sails and Masts, 1919
Graphite and tempera on board, 20 x 15 ½ inches (50.8 x 39.4 cm)
Collection of C. K. Williams, II

medium, Demuth continued to strive for a transparent effect that is similar to watercolor washes; he achieved this by using an infinite number of shades of a small number of colors. The palette of *Gloucester—Sails and Masts* is limited to blue, brown, and black, which change in shade as they intersect each other, thereby producing an effect of shifting transparent planes that never completely come to rest. Only the distinct areas of white in the painting seem impenetrable.

Demuth's marine pictures, such as *Gloucester—Sails and Masts*, are among his most abstract works. This is in part because, unlike his paintings of architecture, they depict clearly defined but relatively unstable forms that move gently in response to the surrounding air; the shifting planes of the masts and sails may also at times resemble shafts of light. Demuth further heightened the abstract effect of *Gloucester—Sails and Masts* by giving the composition an irregular form, as its lower border rests precariously on the small blue tip of an (irregular) inverted triangle. As often occurs in Demuth's Cubist works, the ruled lines of the masts continue in outline to the picture's bottom boundary.

Gloucester—Sails and Masts was virtually unknown until it appeared on the market in 1985, as it had always been in private hands. Since 1921, just two years after its execution, it had belonged to the renowned historian, philosopher, art historian, and curator Ananda Kentish Coomaraswamy (1877–1947), who is said to have acquired it from the artist. It is certainly possible that Demuth and Coomaraswamy knew each other personally. In 1921, when Coomaraswamy acquired the picture, he was close to the artist Stella Bloch, whom he married the following year.[5] They kept an apartment in New York and were interested in the contemporary art world, as evidenced by an article they published jointly in 1923, "The Appreciation of Art," which deals with the entire spectrum of art from ancient to contemporary times, including abstract art.[6] As a curator at the Museum of Fine Arts, Boston, Coomaraswamy may have been drawn to Demuth's painting of the schooners in nearby Gloucester.

1. Barbara Haskell, *Charles Demuth*, exh. cat. (New York: Whitney Museum of American Art, 1987), p. 126.
2. Reproduced in Alvord L. Eiseman, "A Study of the Development of an Artist: Charles Demuth" (Ph.D. diss., New York University, 1975), p. 171, no. 91.
3. Ibid., p. 130 and n. 15, identifies the source of *In the Key of Blue* as the title of an essay by John Addington Symonds. There are about six 1919 tempera paintings of marine subjects set in Gloucester. In addition to the present *Gloucester—Sails and Masts* and the three works mentioned in the text, others include *Gloucester or Mackerel 35 Cents a Pound* and *Backdrop of East Lynne*.
4. Different reasons have been offered to explain Demuth's use of tempera, and later oil, and any and all of them may be correct. He made the change because watercolor was always considered a medium of importance secondary to oil and tempera (Andrew Carnduff Ritchie, *Charles Demuth*, exh. cat. [New York: The Museum of Modern Art, 1950], p. 14); tempera allowed Demuth to create cleaner edges of forms in his immaculate planar compositions (Nancy E. Green, *American Modernism: Precisionist Works on Paper*, exh. cat. [Ithaca, NY: Herbert F. Johnson Museum of Art, Cornell University, 1986], n.p.); and/or tempera was a medium easier to control than watercolor, and Demuth adopted it at the time that his health began to deteriorate (Eiseman, "A Study of the Development of an Artist," p. 328).
5. I am grateful for this information provided by Darielle Mason, Stella Kramrisch Curator of Indian and Himalayan Art, Philadelphia Museum of Art.
6. Ananda Coomaraswamy and Stella Bloch, "The Appreciation of Art," *Art Bulletin*, vol. 6, no. 2 (December 1923), pp. 61–64.

CHARLES DEMUTH

JAZZ
1921

Jazz is an anomaly in the oeuvre of Charles Demuth (1883–1935),[1] though it was not the first time he had painted the subject. Indeed, *Jazz* represented a return to a theme that Demuth had portrayed in his 1915–17 watercolors of the dancers and jazz bands performing at Marshall's, a black-owned jazz club in New York.[2] In those earlier works he captured the riotous atmosphere of the dancers' angular gestures, the pulsing diagonals of banjo necks, the circular shapes of cymbals and drums, the intense concentration of players, and the jumble of heads in the audience. But in *Jazz*, instead of painting the performance, Demuth painted the *feeling* of jazz, striving to give visual form to the sensation evoked by its sound, an approach that parallels Wassily Kandinsky's painted translations of music. In its combination of flat, brightly colored patterns, zigzags, and mottled swirls of color, *Jazz* resembles Fernand Léger's paintings of 1919–20 (fig. 27), though the latter's compositions are more static.[3] As in Léger's paintings, some of the forms and patterns in *Jazz* appear to make reference to real objects, such as the striped "piano keyboard" at the right and the blue fretted shapes at the left that look like banjo tuners.

Demuth did not return either to this abstract style or to this kind of expressive subject matter in any of his other paintings.[4] In fact, *Jazz* is absent from nearly all the literature on Demuth, which is surprising, given its unusual role in his oeuvre. This omission may be explained by the fact that he did not show it but kept it at his home in Lancaster, Pennsylvania. It was not among the paintings Alfred Stieglitz showed in 1925 in the *Seven Americans* exhibition at the Anderson Galleries, where he premiered Demuth's first three portrait posters of Charles Duncan, Georgia O'Keeffe, and Arthur Dove, as well as another equally anomalous painting, *Spring* (1922; The Art Institute of Chicago), which displayed a group of overlapping samples of shirting material arranged against a flat background. Nor was *Jazz* one of the paintings Demuth left to O'Keeffe at his death. It passed instead to the artist's mother and her heir, Robert Locher, and then to Locher's attorney in Lancaster. *Jazz* was exhibited for the first time in 1966, and a reproduction of it was not published until 1971.

Plate 35
Charles Demuth
American, 1883–1935
Jazz (Jass), 1921
Oil on canvas, 20 x 16 inches (50.8 x 40.6 cm)
Collection of C. K. Williams, II

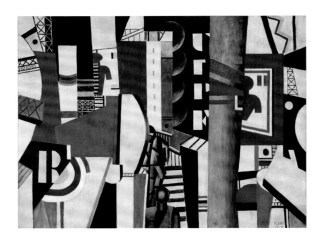

Jazz was painted in the year that Demuth began to work in oil, so its uniqueness might be simply attributed to his experimentation with a different medium. But there may be other reasons for its unusual style and subject, for in 1921 Demuth was grappling with the question of how to create an indigenous American style. That same year Demuth withdrew his work from the Daniel Gallery and transferred responsibility for his oil paintings to Alfred Stieglitz,[5] an event that occurred in August, just before he departed for what would be his final trip to Europe. Returning to Lancaster in ill health in November, having been diagnosed with diabetes, Demuth wrote Stieglitz, with a certain regret, that (like Stieglitz) he had at last become convinced that America, rather than Paris, was the new center of modernism: "Marcel [Duchamp] and all the others, those who count, say that all the 'modern' is to us, and of course they are right, but it is so hard. . . . What work I do will be done here; terrible as it is to work in this 'our land of the free.'"[6] Given the state of his health, it is doubtful that Demuth accomplished much painting after his return to Lancaster in the final months of 1921, but *Jazz*—of all of his paintings of that year—coincides with Demuth's newfound alignment with Stieglitz's quest for an indigenous American modernism: What could be a more American subject than jazz? But while *Jazz* is a quintessentially American subject, Demuth turned to French Cubism for its expression. It is possible that he may have decided

later that this was not the way he wanted to communicate his American subjects, for he never repeated the style. His other oil paintings of 1921 were cool, precisely rendered architectural subjects, but after Demuth regained his strength in 1924, he began his series of poster portraits, using the bold language of billboard advertisements as the vehicle for his new American style.[7] But whatever the reason *Jazz* remained hidden in Lancaster for many years. As an abstract rendering of jazz music it is a pioneering work, predating not only Stuart Davis's abstract paintings of the subject but also Arthur Dove's works of the later 1920s based on the music of George Gershwin, Louis Armstrong, and Irving Berlin.

1. In the inscription on the reverse of the painting Demuth spelled the title of the painting *Jass*, an early spelling of the now familiar "jazz." We use *Jazz* as the title at the request of the Demuth Museum, Lancaster, Pennsylvania.
2. Marshall's was located in the basement of the Marshall Hotel on West Fifty-third Street under the Sixth Avenue El. See Emily Farnham, "Charles Demuth: His Life, Psychology and Works" (Ph.D. diss., Ohio State University, 1959), vol. 2, p. 669, no. 664. Demuth attended performances often in the company of Marcel Duchamp. As Barbara Haskell writes: "It was primarily to its Americanness that vaudeville owed its popularity among artists in the Arensberg clique: witness Picabia's 1913 watercolors of black jazz players, Gleizes' versions of the same subjects of 1915, and De Zayas' illustrations of entertainers for the 1914 book *Vaudeville*. Demuth and Hartley were sufficiently enthralled with the genre to generate a rumor about their future collaboration on an illustrated book on the topic." Haskell, *Charles Demuth*, exh. cat. (New York: Whitney Museum of American Art, 1987), pp. 53–54.
3. He may well have known Léger in Paris through Léger's dealer Léonce Rosenberg, who took some of Demuth's work during his 1921 trip to Paris. Demuth could also have seen Léger's recent work in 1921 at Rosenberg's gallery. See Bruce Kellner, ed., *Letters of Charles Demuth, American Artist, 1883–1935* (Philadelphia: Temple University Press, 2000), p. 33, Charles Demuth to Augusta Demuth, October 15, 1921.
4. The authenticity of *Jazz* seems to have been called into question, prompting a long letter of April 18, 1981, from Demuth scholar Emily Farnham to Sydney D. Brener of Lancaster, Pennsylvania. In her detailed analysis of the painting, Farnham claims that the image includes a dancing stick-figure; she concludes, "I feel that there can be no doubt that *Jazz*, though certainly atypical, is an original Demuth painting." The letter was brought to the Museum's attention by the Demuth Museum. A copy of the letter is in the author's possession.
5. Sarah Greenough, *Modern Art and America: Alfred Stieglitz and His New York Galleries*, exh. cat. (Washington, DC: National Gallery of Art, 2000), p. 364.
6. Demuth to Stieglitz, November 28, 1921, in *Letters of Charles Demuth*, pp. 37–38.
7. For an exhaustive interpretation of Demuth's search for an American style, the poster portraits, and Demuth's relationship with Stieglitz, see Wanda M. Corn, *The Great American Thing: Modern Art and National Identity, 1915–1935* (Berkeley: University of California Press, 1999), pp. 193–237.

Fig. 27
Fernand Léger
French, 1881–1955
The City, 1919
Oil on canvas, 91 x 117 ½ inches (231.1 x 298.4 cm)
Philadelphia Museum of Art. A. E. Gallatin Collection. 1952-61-58

CHARLES DEMUTH

TUBEROSES
1922

Charlie once said on reviewing this picture . . . that he thought it as good as anything he had ever done.[1]

The poet William Carlos Williams, the first owner of *Tuberoses* and lifelong friend of Charles Demuth (1883–1935), admired it so much that he wrote a poem about it. More has been written about the relationship between Williams's poem and the water-color than about Demuth's work itself, which deserves its own notice, for it is unusual among his many floral watercolors[2] and is justifiably "as good as anything he had ever done." Most striking is the silhouetting of the blossoms, white touched with yellow, against the leaves and pots behind them, their stark, unmodulated brilliance coming close to the appearance of a photographic negative. Isolating and floating a colored image within a surrounding white space of paper, as seen here, is not unusual in Demuth's work in the early 1920s, nor is the reserve of untouched paper for the flowers. What is different is that the blossoms and their stems exist right on the picture surface, growing not from the pots but out of the white emp-tiness at the composition's base. The flowerpots, leaves, and stems behind the flowers, colored in shades of rose, yellow-green, and brown, are drawn with particular clarity and firmness, and each flowerpot is placed in an unambiguous diagonal relationship to the other, receding into depth. Every part of the colored image is clear, but the overall image floats. The almost surreal beauty of this composition springs from the startlingly vivid combination of uncompromising formal clarity and pale, floating emptiness.

Williams's book *Spring and All* (1923), in which the poem "The Pot of Flowers" appears, was dedicated to Demuth,[3] who was undergoing treatment for diabetes at the time. In June 1922 he had entered the Physiatric Institute in Morristown, New Jersey, for a month, where he was placed on a near-starvation diet intended to extract the sugar from his system.[4] As the clinic was near Williams's home in Rutherford, New Jersey, he and his wife saw Demuth and followed his difficult progress.[5] It is no wonder that Williams dedicated a book to Demuth at this time, for he was well aware of his friend's precarious state. It has been suggested that Demuth painted

Plate 36
Charles Demuth
American, 1883–1935
Tuberoses, 1922
Graphite and watercolor on paper, 13 x 10 ½ inches (33 x 26.7 cm)
Collection of C. K. Williams, II

Tuberoses while he was at the clinic, where he spent the spring of 1922 and painted several watercolors of flowers.[6] Sometime during these months, Williams acquired the watercolor and was inspired to write "The Pot of Flowers":

Pink confused with white
flowers and flowers reversed
take and spill the shaded flame
darting it back
into the lamp's horn

petals aslant darkened with mauve

red where in whorls
petal lays its glow upon petal
round flame green throats
petal radiant with transpiercing light
contending
 above
the leaves
reaching up their modest green
from the pot's rim
and there, wholly dark, the pot
gay with rough moss.[7]

"The Pot of Flowers" is no more "a literal rendering into poetry of Demuth's watercolor"[8] than *Tuberoses* is a literal depiction of the flowers and pots that Demuth drew. As James Breslin correctly pointed out, "what the poem does do is to recreate in words many of the effects of Demuth's watercolor,"[9] an observation he carries much further in an exhaustive line-by-line analysis of the poem in relation to each form in Demuth's picture, which confuses rather than clarifies. A third reading by William Marling takes a broader look at poem and picture, observing *how* the poet addressed the visual image and what he did with it. Like Breslin, Marling concludes that the poet did not create a literal rendition of the watercolor, and he perceptively adds that Williams approached it in a methodical yet creative way. Beginning by looking at the top and working down through the visual image, the poem "in part . . . takes its cues from the painting, . . . Now his practiced hand sets

down what his eye sees in its instantaneous 'vision' and he frames a poetic line that either continues or stops according to the next action of the eye."[10] This wedding of the poet's vision of the watercolor to the poem's structure seems to come closest to defining its relationship to Demuth's "transpiercingly" radiant image.

1. William Carlos Williams, quoted in Emily Farnham, "Charles Demuth: His Life, Psychology and Works" (Ph.D. diss., Ohio State University, 1959), vol. 2, p. 582, no. 432.

2. An example of a similar work may be found in Demuth's *Orange Tree and Primrose* (1920) in the Carnegie Museum of Art, Pittsburgh, an image of which may be found on the museum's website.

3. "I met him [Demuth] almost at once when I went down to Penn in my Freshman year and we became at once lifelong friends. The men I met in those years I have clung to forever; that's the way I felt about it from the first, that it would be forever, and that's the way it has turned out. With *Spring and All*, it was his turn for a dedication and tribute." Williams's dedication is quoted in William Marling, *William Carlos Williams and the Painters, 1909–1923* (Athens: Ohio University Press, 1982), p. 187.

4. It was not until he returned to the clinic in March 1923 that Demuth was treated with insulin, which showed positive effects within a month. See Barbara Haskell, *Charles Demuth*, exh. cat. (New York: Whitney Museum of American Art, 1987), p. 139. More recently, Betsy Fahlman, *Chimneys and Towers: Charles Demuth's Late Paintings of Lancaster*, exh. cat. (Fort Worth: Amon Carter Museum, 2007), pp. 71–78, 80–81, has published additional information about Demuth's stay at the Physiatric Institute from correspondence between Demuth and Dr. Albert Barnes in the Barnes Foundation Archives, Merion, Pennsylvania.

5. See interview with William Carlos Williams, January 10, 1956, in Farnham, "Charles Demuth," vol. 3, p. 989.

6. Alvord L. Eiseman, "A Study of the Development of an Artist: Charles Demuth" (Ph.D. diss., New York University, 1975), p. 475. Fahlman, *Chimneys and Towers*, pp. 76, 80, documents Demuth's work on watercolors of flowers made during his stay at the clinic.

7. Quoted from Marling, *William Carlos Williams and the Painters*, p. 191.

8. Bram Dijkstra, *The Hieroglyphics of a New Speech: Cubism, Stieglitz, and the Early Poetry of William Carlos Williams* (Princeton: Princeton University Press, 1969), p. 172.

9. James E. Breslin, "William Carlos Williams and Charles Demuth: Cross-Fertilization in the Arts," *Journal of Modern Literature*, vol. 6, no. 2 (April 1977), p. 251.

10. Marling, *William Carlos Williams and the Painters*, p. 192.

CHARLES DEMUTH

THREE SAILORS ON THE BEACH

1930

The watercolors of homoerotic encounters by Charles Demuth (1883–1935) have brought about several extensive analyses of his homosexuality.[1] He lived in a time when it was necessary to keep his preference camouflaged, which he appears to have done with relative success.[2] However, Demuth did not hesitate to portray homosexual subjects in his art at two separate times in his life, the first about 1915–18, when he was living in bohemian New York and was part of a crowd that embraced sexual permissiveness and, later, in 1930, when illness kept him largely confined to his home in conservative Lancaster, Pennsylvania. In each case, the watercolors were not displayed to the public, though he seems to have shown them to intimate friends.[3] The watercolors of 1930, of which *Three Sailors on the Beach* is perhaps the best known, differ from those Demuth made in 1915–18 in that they are not scenes based on innuendo but are instead blatant portrayals of homosexual liaisons. Demuth's earlier watercolor scenes, which portrayed men in Turkish baths or sailors dancing, rely on exchanged glances, touching hands and feet, nude figures with backs turned to the viewer, or towels masking physical contact, but in *Three Sailors on the Beach* there is no need to guess what is going on. The two sailors are turned full front, their hand and eye contact and their erect phalluses are exposed; the third sailor, with back turned, flexes his muscles like a boxer as he removes his clothes. As Barbara Haskell observes, there is nothing gentle about this later work; it is an aggressive, rough depiction of public sex, which is far removed from the understated, secret signs that Demuth depicted in the 1910s.[4]

Much speculation has focused on whether the escapades portrayed in Demuth's homoerotic watercolors are real or imagined. In either case, Demuth clearly intended to implicate himself, for in one work in both the earlier and the later group he inserted himself into a scene: in *Turkish Bath* of 1915 (fig. 28), he seems to have included himself as the dark mustachioed figure standing among the group of men, while in *Three Sailors* his initials are tattooed in a heart on the arm of the standing man who exposes himself. Haskell speculates that in each instance Demuth's "homosexual adventures were

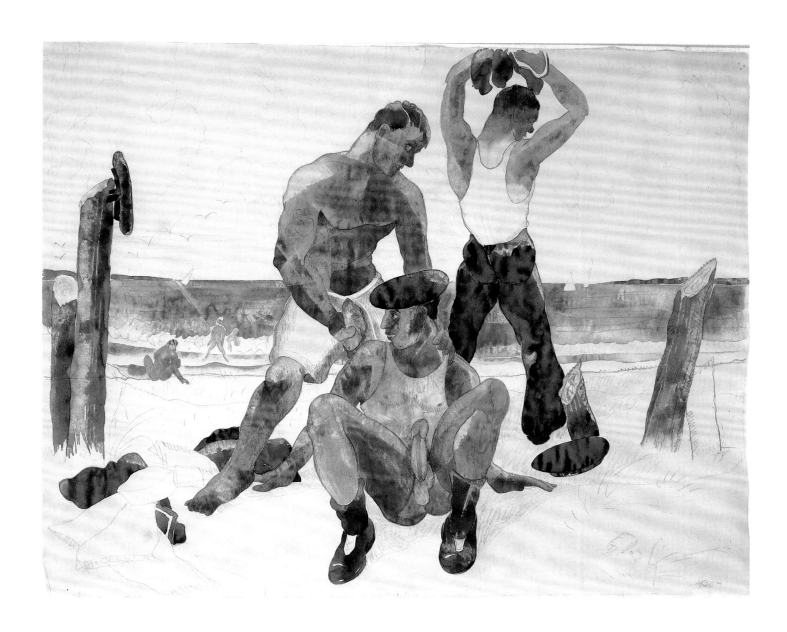

Plate 37
Charles Demuth
American, 1883–1935
Three Sailors on the Beach, 1930
Graphite and watercolor on paper, 13 ½ x 16 ½ inches (34.3 x 41.9 cm)
Collection of C. K. Williams, II

lived out more in his imagination than through actual encounters . . . [and that] these internalized fantasies would have found an outlet in his art."[5] She concludes that the later watercolors were "fantasies rather than chronicles of actual encounters."[6] In another, more exhaustive study of Demuth's homosexuality, Jonathan Weinberg also doubts that the watercolors portray actual events and interprets them as the artist's way of defining himself as homosexual at a time when society demanded that they remain underground: "If for Demuth they served the purpose of recapturing the memory of sexual escapades lived or dreamed, for us they provide rare visual evidence of how many homosexuals found intimacy during the period between the wars. The illicit sexual meetings that made up so much of gay life were designed to be invisible. Demuth's paintings upset that design."[7]

Demuth's ironic wit was one way that he kept people at a distance. In the many interviews recorded by Emily Farnham with those who knew him, there was little agreement about his emotional temperament, for while Demuth was gregarious, witty, always impeccably turned out, and a favorite guest at parties, he kept his real self hidden and often escaped to his home and mother in Lancaster, where he remained secluded with his work. Clearly his homosexuality was part of his cloak of aloofness, but one thing Demuth did not keep hidden was his disdain for Lancaster's provincialism, even though his home was a needed haven from the social worlds of New York, Philadelphia, Provincetown, and Paris. By 1930 Demuth was confined to Lancaster almost full time by diabetes, which required a strict diet and regular insulin injections. Much of the time he felt debilitated, as his correspondence shows; after 1921 Demuth was never able to return to Europe, and his escapes to New York or Provincetown were of short duration. Why did Demuth return to the homoerotic subjects he had abandoned in 1918? Other reasons, joining those advanced above, may be that he was frustrated by his illness and confinement in conservative Lancaster, by the reality of middle age and loss of physical attraction, and probably also by the awareness that his life would be short. Another possible

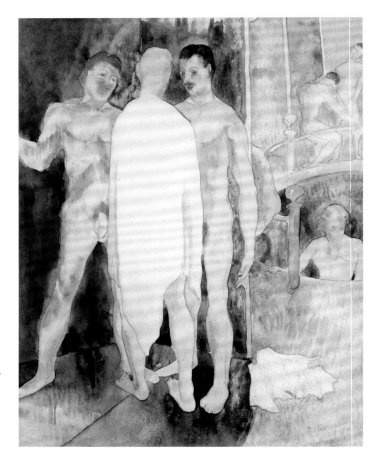

cause may have been the likelihood that in 1930 Demuth had a liaison with Darrell Larsen,[8] who arrived in Lancaster that year to direct the Green Room Theater at Franklin and Marshall College and traveled with Demuth to Nantucket that summer. This alliance may have brought home to Demuth all of these frustrating realities and inspired his renewed interest in erotic subjects. Certainly Larsen awakened the artist's earlier memories, for Demuth gave him *Turkish Bath*, in which he appeared as the attractive, youthful suitor.[9]

Fig. 28: **Charles Demuth**
American, 1883–1935
Turkish Bath, 1915
Graphite and watercolor on paper, 10 ½ x 8 inches (26.7 x 20.3 cm)
Location unknown

1. See Emily Farnham, "Charles Demuth: His Life, Psychology and Works" (Ph.D. diss., Ohio State University, 1959); Barbara Haskell, *Charles Demuth*, exh. cat. (New York: Whitney Museum of American Art, 1987); and Jonathan Weinberg, *Speaking for Vice: Homosexuality in the Art of Charles Demuth, Marsden Hartley, and the First American Avant-Garde* (New Haven: Yale University Press, 1993).

2. Haskell, *Charles Demuth*, p. 58.

3. Weinberg, *Speaking for Vice*, pp. 89–90.

4. Haskell, *Charles Demuth*, p. 206.

5. Ibid., p. 58.

6. Ibid., p. 206, bases this conclusion on the theory that Demuth may have feared impotence as a result of his severe diabetes and became obsessed with virility.

7. Weinberg, *Speaking for Vice*, p. 113.

8. Larsen's interview in 1958 with Farnham, "Charles Demuth," vol. 3, pp. 994–95, is the briefest and least revealing of all those she conducted.

9. Weinberg, *Speaking for Vice*, p. 24: "Darell [*sic*] Larsen . . . who obtained the work directly from Demuth, supposedly kept the picture in a closet because he felt its subject was too explicit for mixed company." Alvord L. Eiseman, *Charles Demuth* (New York: Watson-Guptill Publications, 1982), p. 22, makes the puzzling and undocumented statement, "The year 1930 was the last year Demuth did his so-called 'pornographic' works, many of French sailors. Apparently, the remainder of his total work in this genre was done on order for Professor Darrell Larsen."

PRESTON DICKINSON

STILL LIFE, NO. 3

c. 1924

His new still lifes have a grace, a precision, and an elegance that are remarkable. In modern art it is rare to see so high a finish carried out with complete gusto to the end.[1]

During the 1920s Preston Dickinson (1891–1930) enjoyed considerable success, although he was constantly challenged by financial difficulties because of his peripatetic inclinations, nervous temperament, and excessive lifestyle. Born in Greenwich Village, the son of an interior decorator and sign painter, he was subsidized by a patron for study at the Art Students League (1906–10) and travel to Europe (1910/11–14).[2] Talent as well as charm, good looks,[3] and perhaps an entrepreneurial nature also led to Dickinson's early sponsorship by future New York gallery owner Charles Daniel, who purchased some of the young artist's work even before he left on his trip abroad. Daniel included Dickinson among his stable of artists after he opened his gallery in 1913. Dickinson was far from immune to the spectacular impact of modern art in Paris on American artists during the teens, although he would always claim that the art in the Louvre was his most important influence. Like many of his contemporaries in Paris, he studied at the Académie Julian and in 1912 exhibited his work at the Salon des Indépendants and the Salon des Artistes Français. While he was not among the Americans who frequented the salon of Gertrude and Leo Stein, he was a friend of Charles Demuth, whose distinctive profile he included in a drawing.[4] Among the moderns, Paul Cézanne and Juan Gris were Dickinson's particular favorites, but his interests were wildly eclectic, ranging from Japanese prints and Persian miniatures to German Expressionism and American Synchromism—styles that were in tune with his enduring fascination with pattern and design and his unusual sense of color.

Still-life subjects gave Dickinson a golden opportunity to revel in his penchant for complex compositional construction, diverse objects, detailed patterning, as well as odd combinations of color. *Still Life, No. 3* is one of a group of handsome undated pastels he made about 1924. Typically, he included a rectangular element, such as a picture frame or, as here, a chair back, which functions as a backdrop for an arrangement of fruit, dishes,

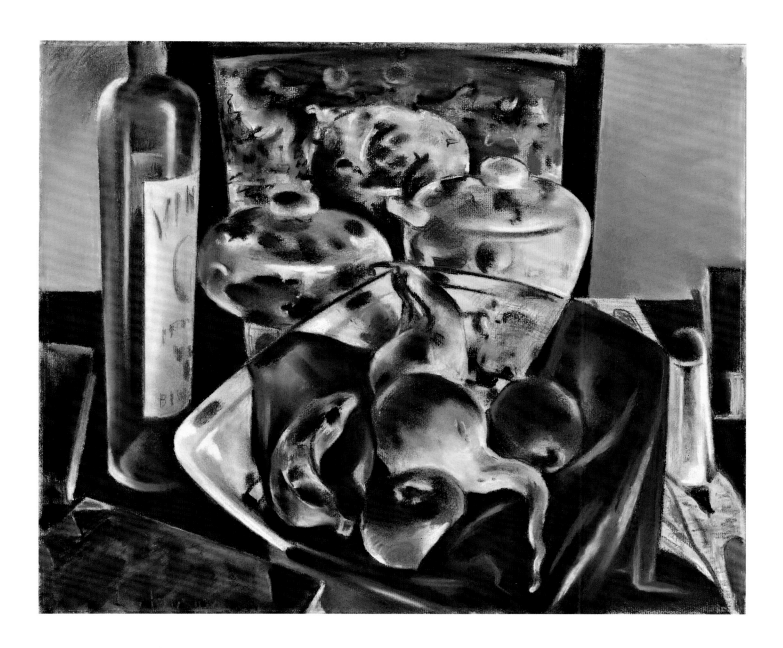

Plate 38
Preston Dickinson
American, 1891–1930
Still Life, No. 3, c. 1924
Pastel and graphite on paper adhered to board; sheet 14 ³/₈ x 17 ⁵/₈ inches (36.5 x 44.8 cm)
Philadelphia Museum of Art. Gift of C. K. Williams, II. 1999-114-1

and books on a tabletop. The flat, cropped book covers intruding at angles along the left edge of the composition imitate a device frequently seen in Japanese prints. However, the spatial arrangement of objects derives from Cubism, particularly the still lifes of Gris, though Dickinson never achieved Gris's compositional clarity. Often, Dickinson employs more than one vantage point for his still-life arrangements:[5] here, the tabletop, plate of fruit, books, and salt shaker are viewed from above, while the bottle of wine, the chair back, and the two covered vessels in front of it are presented frontally. More complex is the way that objects are combined and merged, such as the white vessel whose right profile appears to extend into the plate in front of it, while the darker vessel to the left seems to float above a tiny triangular piece of tablecloth that becomes an extension of the blue cloth draped over the plate of fruit. Seen as a whole, the spatial and formal ambiguities of this picture seem oddly unified by the busy visual patterning created by the variegated surfaces of the objects—all of them rendered in soft, mottled patches of blues, browns, purples, and yellows.

Through his association in the 1920s with the Daniel Gallery, which championed Precisionism, Dickinson's quasi-abstract, quasi-Cubist style has traditionally been linked with the Precisionists, including Charles Sheeler, Charles Demuth, Niles Spencer, and Peter Blume, with whom he showed at the Daniel Gallery. Like them, Dickinson focused on views of industrial complexes, city- and landscapes, and still lifes, only rarely including figures in his work. But in Dickinson's hands, those subjects often lost the proud, robust spirit that characterizes Precisionism. Rather than using hard-edged, simplified forms and color, Dickinson's works can often seem soft and insubstantial, his compositions and colors decorative and overwrought, at times exuding a feeling of coldness, detachment, and even empty superficiality.[6] Still, his work enjoyed generally positive critical reception; seventeen of his works, including *Still Life, No. 3*, were acquired by Ferdinand Howald, the distinguished collector of modern art and an important client of the Daniel Gallery.[7]

1. Henry McBride, "Notes and Activities," *New York Sun*, April 26, 1924, sec. 6, p. 3.
2. There is little biographical information about Dickinson. The principal publication on him is Ruth Cloudman, *Preston Dickinson, 1889–1930*, exh. cat. (Lincoln: Sheldon Memorial Art Gallery, in collaboration with the Nebraska Art Association, 1979).
3. Ibid., p. 18, quotes Charles Daniel on Dickinson's appearance: "when he left [for Paris] he was the handsomest boy I ever saw in my life."
4. *Café Scene with a Portrait of Charles Demuth* (1912–14) is now in the Philadelphia Museum of Art. It is reproduced in ibid., p. 68, no. 3.
5. Abraham A. Davidson, *Early American Modernist Painting, 1910–1935* (New York: Harper & Row, 1981), p. 208.
6. In 1931, the year after Dickinson's death, Samuel M. Kootz published a severe critique of his work that concluded: "The record he has left us is of an undigested, impersonalized glimpsing of the exterior of a very important movement in art." See Kootz, "Preston Dickinson," *Creative Art*, vol. 8 (May 1931), pp. 339–40, at 340.
7. Howald gave the pastel to the Columbus Museum of Art in 1931; it was sold by the museum in 1980.

ARTHUR DOVE

GEAR

c. 1922

And his work brings the shy interior life of things, most often familiar humble things: cattle, old wood, rusty pieces of farm machinery; the things as they perhaps exist for themselves.[1]

In 1923 Alfred Stieglitz photographed Arthur Dove (1880–1946) in front of his recent painting *Gear* (fig. 29), a close-up, cropped image of a well-used piece of wood and metal machinery silhouetted against a blank light gray ground; it was used as an illustration for the essay on the artist in American journalist Paul Rosenfeld's *Port of New York: Essays on Fourteen American Moderns*.[2] While not particularly typical of Dove's principally nature-based work, *Gear* was a logical choice as the background for the portrait, because the image is easier to read than the compositions of abstracted natural forms that made up the majority of his work at the time. When Dove painted *Gear* in about 1922 he had recently emerged from a nine-year hiatus in his work, and he was experimenting with different subjects. Although he did not abandon nature as his principal source of inspiration, in 1921 and 1922 he also painted subjects with titles such as *Harlem River Boats*, *Machinery/ Mowing Machine*, *Tanks and Snowbank*, *Lantern*, and *Gear*— themes that seem to respond to his stated quest to achieve heightened reality in his art, as he expressed to Stieglitz in August 1921: "have five or six drawings for paintings that are almost self-portraits in spite of their having been done from outside things. They seem to me more real than anything yet." Dove went on to state his preference for "stronger things" than the beautiful scenery surrounding him in Westport, Connecticut, and he described an image he was working on that resembles (though not exactly) the object he depicted in *Gear*: "A sluice gate for instance of rusty used iron, warm grey weathered wood . . . which I have been at this morning."[3]

Machine imagery was hardly unusual in the art of the early 1920s, for the Dada machines of Marcel Duchamp and Francis Picabia had cast a spell over American artists such as Morton Schamberg, Joseph Stella, Charles Demuth, and others. Dove's *Gear* has been said by some to be influenced by Dada imagery because of its similarity to Picabia's *Machine tournez vite* (1916);[4] indeed, Dove was interested in Dada, and its effect

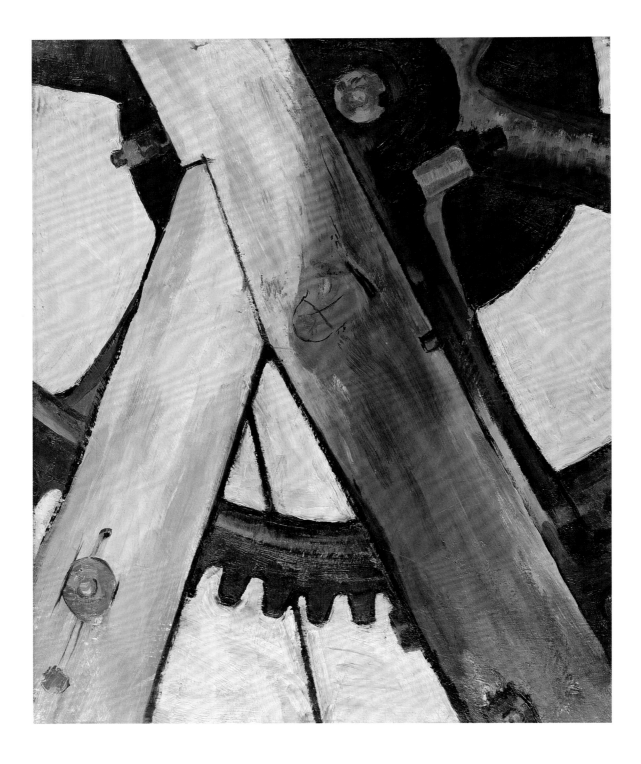

Plate 39
Arthur Dove
American, 1880–1946
Gear, c. 1922
Oil on canvas, 22 x 18 inches (55.9 x 45.7 cm)
Philadelphia Museum of Art. Promised gift of C. K. Williams, II

1. Paul Rosenfeld, *Port of New York: Essays on Fourteen American Moderns* (New York: Harcourt, Brace and Company, 1924), p. 171.

2. In a letter to Dove of July 18, 1923, Stieglitz wrote: "There is a full face might be used for the book. The first shot we made with your painting as 'background.' It just misses fire. Is photographically very fine." See Sarah Greenough, *Alfred Stieglitz, the Key Set: The Alfred Stieglitz Collection of Photographs*, vol. 2, *1923–1937* (Washington, DC: National Gallery of Art; New York: Harry N. Abrams, 2002), p. 508, no. 855.

3. Ann Lee Morgan, ed., *Dear Stieglitz, Dear Dove* (Newark: University of Delaware Press; London: Associated University Presses, 1988), p. 75.

4. Jan Thompson, "Picabia and His Influence on American Art, 1913–17," *Art Journal*, vol. 39, no. 1 (Autumn 1979), p. 21. *Machine tournez vite* is in the National Gallery of Art, Washington, DC.

5. On seeing Dove's assemblages in 1926, Katherine Dreier, the American patron of the arts, called Dove "the only American Dadaist." See Francis M. Naumann with Beth Venn, *Making Mischief: Dada Invades New York*, exh. cat. (New York: Whitney Museum of American Art, 1996), p. 207.

6. Sherrye Cohn, *Arthur Dove: Nature as Symbol* (Ann Arbor, MI: UMI Research Press, 1985), p. 102.

7. Sherwood Anderson, "Alfred Stieglitz," *New Republic*, vol. 32 (October 25, 1922), p. 217.

8. Ann Lee Morgan, *Arthur Dove: Life and Work, with a Catalogue Raisonné* (Newark: University of Delaware Press; London: Associated University Presses, 1984), p. 49.

9. Dove's 1926 exhibition signaled his official "coming out" after the hiatus that had occurred in his work following his 1912 exhibition at Stieglitz's 291. Between 1912 and 1926 he had exhibited in group shows only occasionally, repeatedly showing earlier work. While there is no checklist of works for Dove's 1926 exhibition at Stieglitz's Intimate Gallery, a review of the show in the *New Yorker* almost certainly refers to *Gear*: "The Dove show, fortunately for us plodders, holds many of his best things. . . . the derrick wheel." *New Yorker*, January 23, 1926, pp. 25–26. The exhibition is known to have included Dove's recent assemblages, but it did not contain only his most recent work. A listing of the exhibition on p. 5 of the same issue of the *New Yorker* describes the contents of the exhibition as including "some old paintings and some experiments that may shock you."

may be felt in the assemblages he later created in 1924.[5] But his straightforward depiction of a mechanical object in *Gear*—without humor or heroics—seems more logically to be "a response to the critics' appeal for an indigenous art based on the artist's relation to his own locale and the objects of his immediate environment," as Sherrye Cohn astutely put it.[6] Moreover, the worn yet commanding presence of *Gear* falls in line with the thinking of Dove's mentor Stieglitz, who in 1922 was applauded by Sherwood Anderson for his fight "to make machinery the tool and not the master of man."[7] Visually, *Gear* has more in common with the work of Dove's fellow artists in the Stieglitz circle, such as Paul Strand's similarly cropped, close-up views of mechanical objects (though his are shiny, hard-edged tools and mechanisms rather than the softer, weathered machinery in Dove's painting).[8] Stieglitz must have particularly admired *Gear*, not only because he used it in his photographic portrait of the artist, but also because he included it with some of the artist's earlier works in the solo exhibition he presented in 1926 at the Intimate Gallery, which was Dove's first since 1912.[9]

Fig. 29: **Alfred Stieglitz**
American, 1864–1946
Arthur G. Dove, 1923
Gelatin silver print, 9 7/16 x 7 1/2 inches (24 x 19.1 cm)
Philadelphia Museum of Art. From the Collection of Dorothy Norman.
1967-285-49

ARTHUR DOVE

FROZEN POOL AT SUNSET
1933

THE BARN NEXT DOOR
1934

In July 1933 Arthur Dove (1880–1946) and Helen Torr Dove (known as "Reds") moved from their houseboat, the *Mona*, which was moored near Manhattan, to Geneva, in upstate New York, where Dove had spent his childhood. His mother had died in January, leaving several properties on which taxes were owed; Dove and Reds remained in Geneva until 1938 to settle the estate, visiting New York City only once and keeping in touch through the mail with Alfred Stieglitz at An American Place, where Dove showed his work each year. While the years in Geneva were difficult on many levels, they were productive ones for Dove's painting; the farmlands there offered fresh opportunities for him to develop a deeper and more complex mixture of natural imagery with his increasing inclination toward abstraction. The two present paintings show the range of approaches he used during his first two years in Geneva, from the recognizable imagery of trees bending over water in *Frozen Pool at Sunset* to *The Barn Next Door*, in which he completely transformed a mundane barn and its surrounding yard into a spirited, quasi-zoomorphic group of colorful bulbous shapes in a simplified landscape.

The winter of 1933 seems to have been exceptionally cold, or so it seemed to Dove, who was working outdoors on his watercolors. By mid-November, Dove wrote to Stieglitz, "8° above 0 this A.M. Ink and watercolors froze while working. Had to keep breathing on pen & brush."[1] Watercolors made outdoors were the first step in Dove's creation of a painting, and the now-lost watercolor on which he based *Frozen Pool at Sunset* surely was created under these circumstances. Still, the luminosity of the painting suggests that a cold winter sun must have made the edges of the speckled tree trunks glow, for Dove surrounds them with an aura of light. His palette is limited to variations of brown, blue, and green; he allows the forms of trees, pool, and bank to retain their recognizable local colors. The overall compositional arrangement of *Frozen Pool at Sunset* is one that Dove repeated in several paintings of trees he made in Geneva in 1933, each of which is composed of large, intersecting tree trunks and branches arranged in splayed diagonals across the picture surface.[2] He would soon replace this type of design with the lighter, more organic, and occasionally whimsical shapes that appear in *The Barn Next Door*.

Dove had difficulty putting into words what he was trying to achieve in his paintings. Mostly he wrote about trying to simplify motifs to their essence, to make them "real in themselves,"[3] so that they could stand on their own independently of their original use or function. About 1930 Dove developed a regularized working process, and he began to use small watercolors or drawings made outdoors as preparatory studies for his paintings. These small works on paper served as his initial contact with a motif, which he would transform in the painting he took from it, attempting to distill its essence. Dove wrote to Stieglitz in 1931 about what he hoped to achieve when progressing from the preparatory drawing to a painting: "To express an emotion in the colored drawings is one thing, but to take that and make every part of it do all that, keep its feeling, and exist in its own space is another."[4] To aid in the transfer of the small watercolor to canvas, Dove began to use a pantograph, a device that allowed him to enlarge the watercolor composition mechanically and trace it onto the painting surface.[5]

Seen together, *The Barn Next Door* and its corresponding watercolor (fig. 30) reveal more clearly than Dove was able to describe the kind of transformation he wrought on a motif after he drew it in nature. While the watercolor is loosely drawn and the forms are somewhat distorted, there is no doubt that it depicts a barn in a grassy yard flanked by a tree on each side. The composition generates a feeling of inner life and organic growth, which derives from meandering black ink lines that connect the trees, barn, and surrounding landscape. It was these lines that Dove transferred with the pantograph to the canvas; they are nearly identical in both compositions. However, when it came to painting on the canvas, Dove intensified the colors and simplified the forms by using broader brushstrokes, altering their relationships to create a new, quasi-abstract composition from the linear design he had traced from the watercolor. Gone are the barn and its small, spreading, leafy tree. In their place are two rounded, overlapping brown and blue-gray shapes, which have certain resemblances to a pair of animals.[6] Dove's desire to simplify forms to their essence was not entirely earnest, and he would sometimes bestow whimsical interpretations on his motifs, transforming boats,

houses, or barns into humorous animal-like shapes. Still, some details in the painting keep their original form, such as the flamelike tree and the curving side of the barn at the right. Moreover, Dove retained the low horizon and ground line, thereby preserving the composition's identity as a landscape.

Helen Torr Dove's diary for January 19, 1934, records that "Arthur painted 'Grey Building against Grey Sky' almost finished it in one day. Very exciting and handsome."[7] This may well refer to *The Barn Next Door*, which was certainly completed by early April, when it was sent to New York for Dove's exhibition at An American Place that month; the collector Duncan Phillips purchased it from the gallery, along with its corresponding watercolor.[8] It had become Phillips's custom since 1930 to take several of Dove's works on approval and eventually to purchase some of them; this provided Dove with a small monthly stipend, which, though welcome, meant that a number of his works were unavailable for long periods of time to be purchased by others. Dove had sent Stieglitz about fifteen new oils and about sixty watercolors for the exhibition, which opened on April 17, from which Stieglitz selected eight oils and ten watercolors to show. Whether *The Barn Next Door* and its watercolor were among those Stieglitz included in the exhibition is unknown.[9]

1. Ann Lee Morgan, ed., *Dear Stieglitz, Dear Dove* (Newark: University of Delaware Press; London: Associated University Presses, 1988), p. 288.
2. See Ann Lee Morgan, *Arthur Dove: Life and Work, with a Catalogue Raisonné* (Newark: University of Delaware Press; London: Associated University Presses, 1984): *Nearly White Tree* (no. 33.2), *Tree and Covered Boat* (no. 33.7), and *Two Brown Trees* (no. 33.8).
3. Quoted in William C. Agee, "Arthur Dove: A Place to Find Things," in Sarah Greenough et al., *Modern Art and America: Alfred Stieglitz and His New York Galleries*, exh. cat. (Washington, DC: National Gallery of Art, 2001), p. 436.
4. Morgan, *Dear Stieglitz, Dear Dove*, pp. 230–31.
5. See Ann Lee Morgan, "Toward the Definition of Early Modernism in America: A Study of Arthur Dove" (Ph.D. diss., University of Iowa, 1973), pp. 67–68. Dove's use of a pantograph is mentioned in the diaries of Helen Torr Dove.
6. The one on the left has a brown striped tail and upright ears, an eye, and a nose overlapping the back of an unidentifiable hump-backed creature burrowing a pointed snout in the ground.
7. Helen Torr Dove Papers, 1. Diaries, 1930–1939, Archives of American Art, Smithsonian Institution, Washington, DC, reel 38. The titles given in the diaries do not always correspond to the published titles of Dove's paintings.

Plate 40
Arthur Dove
American, 1880–1946
Frozen Pool at Sunset, 1933
Oil on canvas, 16 x 20 inches (40.6 x 50.8 cm)
Collection of C. K. Williams, II

Plate 41
Arthur Dove
American, 1880–1946
The Barn Next Door, 1934
Oil on canvas, 20 x 28 ½ inches (50.8 x 72.4 cm)
Collection of C. K. Williams, II

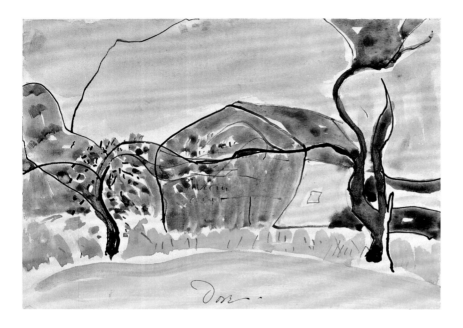

8. Elizabeth Hutton Turner, *In the American Grain: Arthur Dove, Marsden Hartley, John Marin, Georgia O'Keeffe, and Alfred Stieglitz; The Stieglitz Circle at The Phillips Collection*, exh. cat. (Washington, DC: Counterpoint, in association with The Phillips Collection, 1995), p. 180, entry for April 17, 1934.
9. Morgan, *Dear Stieglitz, Dear Dove*, pp. 302–4. The checklist for the exhibition has not been located; see Anne Cohen DePietro, *Arthur Dove and Helen Torr: The Huntington Years*, exh. cat. (Huntington, NY: Heckscher Museum, 1989), p. 37 n. 73.

Fig. 30: **Arthur Dove**
American, 1880–1946
The Barn Next Door, 1934
Watercolor and ink on paper, 5 x 7 inches (12.7 x 17.8 cm)
The Phillips Collection, Washington, DC, acquired 1934

LYONEL FEININGER

NIGHT HAWKS

1921

Lyonel Feininger (1871–1956) was born and spent his childhood in New York and Connecticut but moved to Hamburg, Germany, in 1887. As a child he was always drawing, with particular attraction to boats and trains—images that would appear frequently in his later work. Feininger's musician parents hoped he would become a violinist, but although he never gave up his music, in 1888 he decided to become a painter. His parents acceded, and he passed the examination for the Berlin Royal Academy (Königliche Akademie). Even Feininger's student drawings displayed his exceptional flair for joining humor with expressive line; while still in his twenties he began a career as a cartoonist and illustrator, with work published in the German satirical magazine *Simplicissimus* as well as *Ulk*, the supplement to the *Berliner Tageblatt*, and *Lustige Blätter*. By the turn of the century Feininger was Germany's foremost political cartoonist, but he soon found it more satisfying to make drawings with subjects of his own invention, some of which appeared in the Viennese publication *Der Liebe Augustin*; these stimulated his dream of becoming an independent artist. When he began to make studies after nature about 1906, the conflict emerged that would absorb him for the rest of his artistic career. Feininger's writings show his engagement in an ongoing struggle to resolve the dichotomy he perceived between observed nature and the images that lived in his own rich fantasy world.[1] Indeed, it would seem that Feininger, more than most artists, harbored a wealth of internalized images that repeatedly made their appearance in his art.[2] These images often were broadly defined themes with many variations that he transformed stylistically as his art developed over six decades.

Night Hawks,[3] a dark but luminous painting of figures promenading through a shadowy street, is a 1921 variation on a theme that appeared in Feininger's work at least as early as 1908 and reemerged in different guises until about 1917. The earliest renditions of the subject are pen and ink drawings of well-dressed people with slender, angular silhouettes striking distinctive poses and paintings of carnival characters cavorting along roads that are often bordered by tall buildings.[4] After his encounter with Cubism in Paris at the Salon des

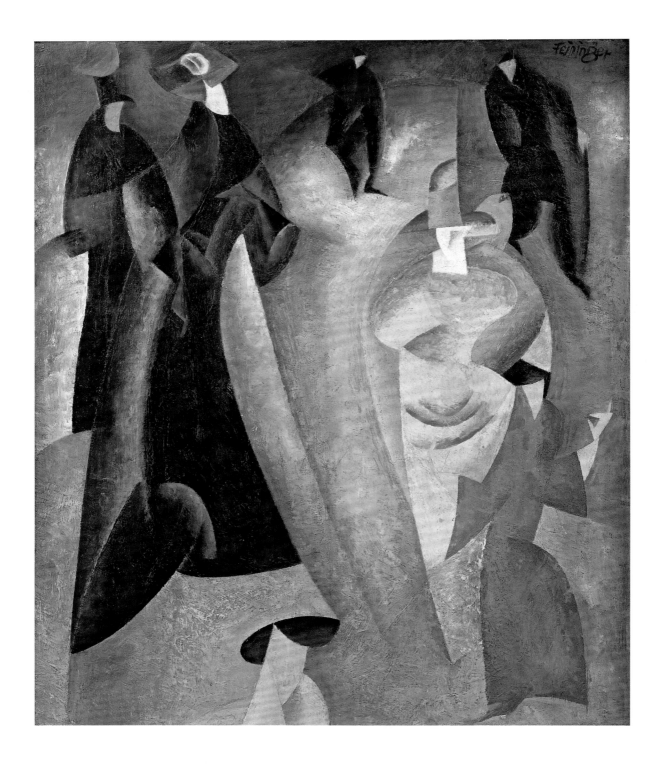

Plate 42
Lyonel Feininger
American, 1871–1956
Night Hawks (Nachtfalken, also ***Nachtvogel)***, 1921
Oil on canvas, 23 ⅝ x 19 ⅝ inches (60 x 49.8 cm)
Collection of C. K. Williams, II

Indépendants in 1911, Feininger's paintings of figures in the street lost their carnival aspect, becoming increasingly simplified into shapes composed of intersecting planes. As his pursuit of Cubist construction developed, Feininger made fewer and fewer paintings of human figures, finding it more difficult to break up the planes of human forms than those of inanimate objects.[5] It was not until 1921–22, when Feininger was teaching at the Bauhaus in Weimar, that figures reappeared briefly in a small number of paintings, including *Night Hawks*, a work in which the Cubist planes of the figures have become translucent, penetrated by light. Large, sweeping planes define the spaces between the figures, perhaps suggesting the beams of street-lights; line no longer creates the boundaries between forms, which now are designated by the juxtaposition of colors. Yet the steep perspective and the stylized poses and gestures of the walking men and elegant women with their simplified faces composed of inverted triangles are characteristics of a familiar idea embedded in Feininger's imagination and trans-posed into his current style. Perhaps the vague, dreamlike quality of *Night Hawks*, with its notable absence of emotion and human interaction, is in part the result of the image having lived so long in the artist's memory.

1. Hans Hess, *Lyonel Feininger* (New York: Harry N. Abrams, 1961), p. 42, quotes the following from a 1924 letter from the artist to his wife, Julia: "What one sees must undergo an *inner transformation*, must be crystallized." Emphasis in original.
2. Ulrich Luckhardt, *Lyonel Feininger* (Munich: Prestel-Verlag, 1989), p. 34.
3. The complicated history of this painting is discussed in Petra Werner, *Der Fall Feininger* (Leipzig: Koehler und Amelang, 2006), pp. 177–81.
4. Many variations of people promenading in the street were made in drawings and paintings dating between about 1908 and 1917. See, for example, *Untitled (Lady and Clerics)* (1908), reproduced in *Lyonel Feininger*, exh. cat. (New York: Marlborough-Gerson Gallery, 1969), p. 103, fig. 88; *Figures, Dusk* (1909), reproduced in Hess, *Lyonel Feininger*, p. 251, no. 40; *Pedestrians* (1912), ibid., p. 254, no. 72; and *The Green Bridge II* (1916), ibid., p. 263.
5. Hess, *Lyonel Feininger*, p. 59.

LYONEL FEININGER

OLD STONE BRIDGE
1943

In the work of Lyonel Feininger (1871–1956), one of the most repeated views in his repertoire of subjects is that of the old bridge over the Ilm River, linking southern Weimar with Oberweimar, Germany. *Old Stone Bridge* is probably Feininger's last painting of the bridge, a subject he had begun sketching in 1906 and continued in many more drawings; most notable is a series of six paintings, numbered 0 through V, which traversed the full range of his development of a Cubist style between 1912 and 1919.[1] The first painting, *Bridge 0* (1912), executed hard on the heels of Feininger's introduction to Cubism in 1911, shows the bridge populated by anglers and pedestrians but includes hints of fractured planes in the bridge's structure that do not break up its formal integrity. In subsequent paintings in the series changes of mood as well as style occur—some are dynamic while others are more static. The series culminates in *Bridge V* (1919) (fig. 31), the most radical of all, in which the bridge has been totally shattered into an explosion of interpenetrating transparent planes rendered in shades of gray and yellow-green.

Feininger continued to draw and paint bridges and viaducts until about the mid-1920s, at which time he temporarily eliminated them from his repertoire of images, only to resurrect them later, a practice he seems to have followed frequently. Such is the case with *Old Stone Bridge* (1943), painted after his move to New York in 1937, which he based on a watercolor, *Bridge at Oberweimar*, that he had made at the site nearly twenty years earlier.[2] Feininger often returned to previous subjects during the early 1940s, as Hans Hess observed, frequently imbuing them with hints of nostalgia.[3] By 1943 he had abandoned his Cubist treatment of the bridge in favor of a style that relied more heavily on line and freely applied color. The straightforward depiction of the site in the watercolor, which Feininger followed quite closely in the painting, shows his use of delicate, spindly outlines that define the pointed profile of the bridge and its arches, the tree branches, and the houses. In the painting, however, he emphasizes a series of abstract elliptical shapes formed by the arches of the bridge and their reflections in the water. He covers the canvas in thin, atmospheric washes of yellows,

Plate 43
Lyonel Feininger
American, 1871–1956
***Old Stone Bridge (Alte Steinbrücke)**, 1943*
Oil on canvas, 20 ½ x 27 ¾ inches (52.1 x 70.5 cm)
Collection of C. K. Williams, II

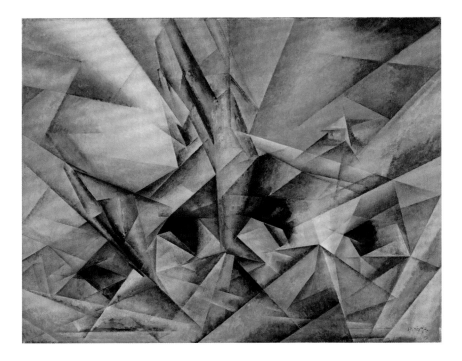

purples, grays, and blues that do not adhere to the network
of thin lines that define the compositional structure, this time
transforming his oft-repeated image into something almost
fragile and ephemeral.

1. The six paintings in the *Bridge* series are reproduced in Hans Hess, *Lyonel
Feininger* (New York: Harry N. Abrams, 1961), p. 254, no. 75 (*0*); p. 256, no.
100, pl. 7 (*I*); p. 259, no. 127 (*II*); p. 264, no. 174, pl. 18 (*III*); p. 265, no. 191 (*IV*);
p. 266, no. 195 (*V*).
2. *Bridge at Oberweimar* (1924) is reproduced in Ulrich Luckhardt and Martin
Frass, with the assistance of Felix Krämer, *Lyonel Feininger: Die Zeichnungen
und Aquarelle*, exh. cat. (Cologne: Dumont, 1998), pp. 124 (repro.), 217, no. 89.
3. Hess, *Lyonel Feininger*, pp. 150–53, discusses Feininger's return to old
themes in 1943 and the mood of nostalgia in works of this period.

Fig. 31: **Lyonel Feininger**
American, 1871–1956
***Bridge V**, 1919*
Oil on canvas, 31 ⅝ x 39 ½ inches (80.3 x 100.3 cm)
Philadelphia Museum of Art. Purchased with the Bloomfield Moore Fund. 1951-31-2

LYONEL FEININGER

MID MANHATTAN
1952

*I am beginning to surprise myself in this ability to innovate. . . .
I have a few charcoal compositions for oil paintings that will
come later. . . . They are spatial depictions of the architecture in
Manhattan, in which I want to try to achieve what others pass
over, namely, working without "symbolism," only with the
structure and interpenetration, abstract dematerialization, the
exclusion of anything that is episodic.*[1]

For Lyonel Feininger (1871–1956), moving to New York in 1937
inspired an important new image for his art, the first in many
years. More than for most artists, the introduction of new
subject matter was of enormous significance, for Feininger's
customary practice was to work repeatedly on a limited
repertoire of themes, varied chiefly in his stylistic treatment of
them. During his difficult first years in New York, Feininger
frequently returned to earlier subjects, even basing paintings
on drawings made many years before, such as the painting
Old Stone Bridge (pl. 43). But even as he endured a "difficult
period of acclimatization,"[2] Feininger began soon after he
arrived in New York to be riveted by the towering modern sky-
scrapers of Manhattan[3]—a new, entirely American subject that
he soon portrayed again and again in drawings, watercolors,
paintings, and prints. Feininger had always been attracted to
the architecture of his surroundings as a subject for his art,
but the New York skyscrapers offered visual challenges quite
different from the irregular pointed roofs and church steeples
of the German villages he had thus far favored. What he found
fascinating in the skyscrapers was the inherent abstraction
of their design:[4] the spatial relations between the juxtaposed
towers, with their surfaces covered by abstract grids of
windows, and the light and atmosphere enveloping their
soaring forms. Modern skyscrapers needed no transformation
into abstraction; Feininger instead concentrated on capturing
and interpreting their placement in space and their demateri-
alization by light and atmosphere.

By 1952, when Feininger made *Mid Manhattan* at the age of
eighty-one, he had portrayed New York skyscrapers over and
over, and his goal remained the same as it had been in 1943:
to "resolve them in atmospheric space."[5] In fact, this late work

Plate 44
Lyonel Feininger
American, 1871–1956
Mid Manhattan, 1952
Ink, charcoal, pastel, and watercolor on paper; 18 ³/₄ x 12 ½ inches (47.6 x 31.8 cm)
Collection of C. K. Williams, II

may serve as an example of Feininger's way of retaining, yet constantly building on, the technical, formal, and stylistic methods he had developed over many decades. Unchanged since his illustrations of the 1890s is the fine ink border surrounding the composition of *Mid Manhattan*; another familiar preference is the thin, laid paper with a texture that shows through the layers of wash and charcoal, while the uneven rubbing of pigment into the paper surface repeats a method Feininger developed at least as early as the 1910s to create variations of light. In *Mid Manhattan* Feininger also used his well-established graphic style, drawing the skyscrapers with spare, ruled ink lines and adding watercolor in and around their forms, then selectively applying a layer of charcoal. He appears to have intentionally smudged the charcoal in places by using a wet brush to move it around the paper surface, creating the rapid parallel lines that cover the left border and areas at the right and center of the composition. Nonetheless, even in his latest works Feininger continued to develop new methods. In *Mid Manhattan* and other watercolors of the 1950s he added an unusual pattern of active parallel white lines that cover the sky and the upper reaches of the skyscrapers. The actual technique he used to produce this effect is uncertain, but it would seem that he abraded the paper surface with a tool like an eraser to represent effectively the shimmering movement of light penetrating and dematerializing the soaring towers.[6]

1. Feininger to Alois Schardt, November 5, 1940, translated in Ulrich Luckhardt, *Lyonel Feininger* (Munich: Prestel-Verlag, 1989), p. 46.
2. Hans Hess, *Lyonel Feininger* (New York: Harry N. Abrams, 1961), p. 147.
3. Several of Feininger's drawings and watercolors of Manhattan architecture were made as early as 1937. See *Manhattan from the Earle*, *Manhattan II B*, *Untitled (Manhattan at Night)*, and *Manhattan IV B*, reproduced in Ulrich Luckhardt and Martin Fraas, with the assistance of Felix Krämer, *Lyonel Feininger: Die Zeichnungen und Aquarelle*, exh. cat. (Cologne: Dumont, 1998), pp. 162–65, nos. 125–28.
4. Hess, *Lyonel Feininger*, p. 155.
5. Lyonel Feininger to Lux Feininger, March 31, 1943, quoted in ibid., p. 153.
6. I am indebted to Nancy Ash and Scott Homolka, Conservators of Works of Art on Paper at the Philadelphia Museum of Art, for their observations of Feininger's technique.

JARED FRENCH

WOMAN

1941

This painting is one of a vast series of Forty-nine Aspects of Man launched by Jared French (1905–1988) in the 1940s but never completed. The series marked a transition toward a unique brand of symbolism in the work of an artist who, since the early 1930s, had made fairly realistic paintings of contemporary figurative subjects, using early Italian Renaissance and ancient art as the basis for an idiosyncratic style. French exhibited his work widely but was intensely secretive about his life and the meaning of his work (at the end of his life he refused to sell any of his paintings and tried to buy back many of them).[1] However, French's critical stance toward society's repressive attitude about sexuality, his own bisexuality, and some small clues about his literary sources in the writings of Carl Jung and William Butler Yeats have permitted some interpretations to develop around the riveting strangeness of his paintings. French worked closely with Paul Cadmus, whom he met at the Art Students League; in 1931 they traveled together to Europe, finally settling in Mallorca until 1933. When they returned to New York, they worked for the Public Works of Art Project and the Works Progress Administration. In 1937 French married Margaret Hoenig, and with Cadmus they spent summers on Fire Island, where French often made photographs of them and other friends striking stilted poses on empty beaches—images that directly or loosely inspired some of his paintings, including the present one.

Woman is not the only painting in which French painted repeated identical figures in a single composition;[2] in *Crew* (1941–42) he presented a disquieting line of nine matching rowers wearing the empty smile of archaic Greek kouroi.[3] In *Crew* and *Woman*, he silhouetted the figures against a nearly unrelieved background color. The four identical figures in *Woman* stand motionless and serene on a narrow, empty strip of sand, turned like department store mannequins in different directions.[4] None of them looks at one another, nor does any of them directly face the viewer. The nude women assume a rigid stance with arms slightly bent at each side and one leg advancing in front of the other; they wear the vacant smile of the rowers in *Crew*. But *Woman* is more complicated and disturbing than *Crew*, because the figures display the pose

Plate 45
Jared French
American, 1905–1988
Woman, 1941
Egg tempera on gessoed panel, 17 ½ x 15 inches (44.5 x 38.1 cm)
Collection of C. K. Williams, II

and nudity of archaic male kouroi—not archaic female korai, which are always clothed. French's preparatory drawing for *Woman* also shows that the figures initially wore the long locks typical of kouroi, flowing straight down the back and bound by a headband. In the painting, however, French arranged the hair in a neat roll around the heads—the exact style worn by his wife Margaret in photographs.[5]

The complexity of this painting and, indeed, of French's oeuvre in general still remains to be analyzed fully. However, *Woman* was painted right at the time when French identified a transition in his work: "Gradually I began to represent aspects of [man's] psyche, until in 'The Sea' (1946) and 'Evasion' (1947) I showed quite clearly my interest in man's inner reality."[6] Jeffrey Wechsler suggested that an important source for French's new interest was spurred by Jung's *Archetypes of the Collective Unconscious*, which was translated into English in 1939, though the artist never acknowledged it publicly.[7] Jung theorized that the mind contains inherited "archetypes" that recur in its unconscious states (sometimes assuming a human form)—a concept that was especially important for French's imagery. In his paintings, the archaic Greek statues, which were the major prototypes for his figures in the 1940s, became the visual equivalents of Jung's "archetypes"—his images of "man's inner reality."

Nancy Grimes may well be correct in suggesting that French's depiction of *Woman* "suggests Jung's idea of the anima—a man's repressed feminine aspect."[8] Certainly the figures' static, dreamlike appearance evokes the unconscious—a quality closely linked to Jung's concept of the anima (an individual's inner self), as opposed to the persona (the exterior mask an individual presents to the world). Yet *Woman* appears to confound straightforward interpretation; there are more questions than there are answers. For example, to counter Grimes, since the subject is Woman, would it perhaps be equally possible for this picture to portray woman's repressed male aspect? And what about the portrayal of Woman as the artist's wife? To explain this painting in purely Jungian terms seems incomplete,[9] for there is too much to be resolved in

this hauntingly serene image of dualities: woman (and wife) presented as the archetypal man (kouros), not to mention a quartet of them.

1. Greta Berman and Jeffrey Wechsler, *Realism and Realities: The Other Side of American Painting, 1940–1960*, exh. cat. (New Brunswick: Rutgers University Art Gallery, Rutgers, State University of New Jersey, 1981), p. 93.
2. The present painting is the first of two versions of *Woman*. The second, in tempera and casein on paper, was painted in 1947; its current location is unknown. See Mark Cole, "Jared French (1905–1988)" (Ph.D. diss., University of Delaware, 1999), p. 384.
3. Reproduced in Nancy Grimes, *Jared French's Myths* (San Francisco: Pomegranate Artbooks, 1993), pl. 6.
4. Piero della Francesca seems to have used the device of showing the same figure turned in different directions in the same picture, though he would vary their costumes, as in the fresco *Solomon and the Queen of Sheba* in San Francesco, Arezzo. Piero has been shown to be an important influence on French, and it is possible that he built on that model for his paintings of repeated figures.
5. The drawing for *Woman* and a photograph of Margaret French and Paul Cadmus at Fire Island (1941) are reproduced in Grimes, *Jared French's Myths*, pp. xvi–xvii.
6. French's statement was made in 1968; quoted in Berman and Wechsler, *Realism and Realities*, p. 96.
7. The Jung connection was revealed by an anonymous source to Wechsler, who is responsible for the interpretation of French's work based on this clue. See ibid., p. 96.
8. Grimes, *Jared French's Myths*, p. xvi. Grimes goes on to suggest, less convincingly, that the figure(s) might be Venus rising from the sea.
9. An interesting alternative to Wechsler's Jungian interpretation has been proposed by Cole, "Jared French," pp. 227–33, who identifies analogies between French's classifications for the uncompleted series Aspects of Man and inventories of human universals found in contemporary anthropological texts, which were popular in the 1940s, though he found no precise parallels between them and concluded that French probably created his own series of classifications based on his own interests. This theory does not put to rest the questions raised by French's portrayal in *Woman*; his use of the archaic Greek male sculpture to portray the universal Woman seems more logically, though not completely, explained by the connection with Jung's archetypes.

ALBERTO GIACOMETTI

CHIAVENNA BUST I

1964

It's a rather unusual thing for a person to spend more of his time trying to copy a head than in living life.[1]

From the beginning to the end of his career Alberto Giacometti (1901–1966) struggled to grasp the living reality of the human head. The problem, which pursued him through each phase of stylistic evolution, was insurmountable because he wanted his art to capture the ephemeral radiance of existence. The nature of his struggle, which would be hard to divine from his work alone, is known from the artist's own clear articulation (and at times dramatization) of his ambition in various interviews and in his writings. Giacometti's life story has been aptly described as "a saga in which the artistic search and stylistic crises are the adventures and turning points."[2]

Born in 1901 on the Italian border of Switzerland, Giacometti began making portrait sculptures at the age of thirteen. After working with his father, Giovanni Giacometti, a Post-Impressionist painter, he began in 1919 to study painting in Geneva at the École des Beaux-Arts and modeling at the École des Arts Industriels. In Paris between 1922 and 1927, he worked at the Académie de la Grande Chaumière with Émile Antoine Bourdelle, who strongly encouraged his students to make portrait busts.[3] In 1923–24 Giacometti spent an entire winter drawing a skull, but a year later he all but abandoned working from life and, under the influence of Cubism and tribal art, began making abstract, geometrized figures. Even so, in the summer of 1927 he also did some portrait heads—remarkable images of his mother and father that pointed the way to the next phase of his work. In a bronze head of his father he simply engraved the features onto the face, while in a marble head he rendered his father's features as mere surface indentations. Giacometti's first mature sculpture, *Gazing Head* (1928),[4] an abstract plaster with an elusive deep-set eye, drew elements from the simplified portraits of his parents while also hauntingly foreshadowing his heads of the 1950s, in which the gaze became his primary means for capturing the life of the sitter.

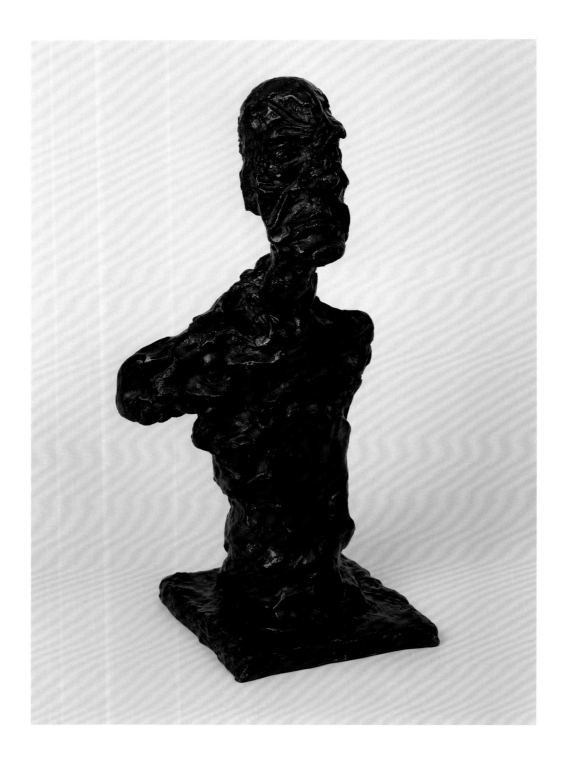

Plate 46
Alberto Giacometti
Swiss, 1901–1966
Chiavenna Bust I, 1964
Bronze, cast 3/6; 16 x 8 x 6 ⅛ inches (40.6 x 20.3 x 15.6 cm)
Philadelphia Museum of Art. Promised gift of C. K. Williams, II

Giacometti's career is characterized by violent breaks from intensive study of live models to work from sources inspired by his imagination—it would almost seem that at times he found the confrontation with reality unbearable and had to retreat to the images in his mind. This was the case when he turned to Cubism and tribal art in 1926 as well as when he began to make Surrealist objects in 1931, yet he never completely ceased making heads.[5] He was also challenged by the problem of how to represent figures seen from afar,[6] which he solved in a mysterious series of tiny busts and figures placed on large pedestals to evoke distance. These showed the way, after 1945, to the minimal, elongated figural sculptures for which Giacometti is best known—the works in which he concentrated on the spatial environment in which figures exist rather than on their physical presence.

During the early to mid-1950s, a magisterial series of sculpted busts of Giacometti's brother Diego continued his fascination with articulating the distance from the model and heralded a return to creating works with greater substance. The portraits of Diego were treated in a highly expressionistic manner characterized by agitated surfaces, haunted, oversized eyes, and, in some of them, startling differences between frontal and profile views.[7] Giacometti's lifelong desire to capture living reality seems finally to have concentrated in these busts, and it intensified in a later series created during the last years of his life, one of which is the present *Chiavenna Bust I*,[8] which also portrays Diego. In the late portraits of Diego and of the photographer Elie Lotar, Giacometti severely reduced the torsos to focus on large, spectral heads that jut forward on improbably long, thin necks. Here the sitter's elevated gaze no longer seems focused but instead stares into an indefinable zone that lies beyond the viewer. Attention is also drawn to the figure's strong, vigorous silhouette as well as to the artist's technique, which indicates passionate kneading and gouging of the sculpture's surface, allowing light to flicker over it and add a mysterious energy. According to Valerie Fletcher, Giacometti worked on his last busts over many weeks and months both from memory and from the sitters, and "considered them works in progress with no absolute state."[9]

Possibly in the end Giacometti had concluded that a head left in "no absolute state" might best capture the ephemeral quality of life he had been seeking for so long.

1. This translation of André Parinaud's 1962 interview with Giacometti appears in Frances Morris, "Laboratory for Likenesses: Giacometti's Studio," in *Alberto Giacometti: The Artist's Studio*, exh. cat. (London: Tate Gallery Publications, for the Tate Gallery Liverpool, 1991), p. 9. The interview is published in Michel Leiris and Jacques Dupin, eds., *Alberto Giacometti: Écrits* (Paris: Hermann, Éditeurs des Sciences et des Arts, 1990), p. 278: "c'est plutôt anormal de passer son temps, su lieu de vivre, à essayer de copier une tête."
2. Reinhold Hohl, "Form and Vision: The Work of Alberto Giacometti," in *Alberto Giacometti: A Retrospective Exhibition*, exh. cat. (New York: The Solomon R. Guggenheim Museum, 1974), p. 15.
3. Reinhold Hohl, *Alberto Giacometti* (New York: Harry N. Abrams, 1971), p. 30.
4. The bronze *The Artist's Father (Flat and Engraved)*, the marble *The Artist's Father*, and *Gazing Head* are reproduced in Christian Klemm et al., *Alberto Giacometti*, exh. cat. (New York: The Museum of Modern Art; Zurich: Kunsthaus Zurich, 2001), nos. 27, 26, and 31, respectively.
5. Such as the severely abstracted *Head/Skull* (1934), created soon after his father's death, which is reproduced in ibid., no. 62.
6. Apparently, in 1937 he discussed with Picasso the problem of how to make small sculptures of figures seen from a distance. See "Chronology," in ibid., p. 284.
7. Some of the busts of Diego from 1951–54 are reproduced in ibid., nos. 138–43.
8. Its title refers to the town of Chiavenna in Switzerland, near Stampa, where Giacometti's family lived.
9. Valerie J. Fletcher, *Alberto Giacometti, 1901–1966*, exh. cat. (Washington, DC: Smithsonian Institution Press, for the Hirshhorn Museum and Sculpture Garden, 1988), p. 234, no. 104.

MORRIS GRAVES

CEREMONIAL BRONZE TAKING THE FORM OF A BIRD II

1947

In the 1948 catalogue of the exhibition in which the first version of *Ceremonial Bronze Taking the Form of a Bird* was shown (fig. 32), Morris Graves (1910–2001) wrote a statement that more than hints at the spiritual meaning he attached to the image:

> The Minnow is that coming-into-tantalizing elusive-focus of a clue within a concentrated moment of awareness (consciousness). Silvery minnow-moment, flash-gleaming in the depths, now seen, now gone. The vessel is here (in part) roused in consternation because the forces were only so recently collected and poised—minnow was triumphantly brought into focus and triumphantly and swiftly caught and brought under control—only to reappear evasively at large again in the interior cosmos.
>
> The Ibis head of this vessel alludes to Egypt and in this way is an attempt to help convey that all great religious systems are faceted reflections of the *identical* self revelation—self knowledge. The vessel is overlaid with symbols, among them latent short comings—a surface of frustrations, of senses and ego.[1]

The second version of the composition is nearly identical to the first, differing only slightly in color, in delineation of the decorative detail on the vessel, and in the bird's expression, here shown staring into the vessel with an expression of surprise that verges on caricature. Vessels and birds were the chief symbols through which Graves communicated moments of consciousness; the elusive minnow momentarily captured in the gaze of the ibis symbolizes the flicker of clarity in that instant of awareness. The comic surprise with which Graves portrayed this magic moment on the face of the ibis reveals the often overlooked humorous side of his deep understanding of nature: "the consistent overtones of wit in the bird and animal people who play central roles in almost all his major pictures. . . . The relevance of the spirit and of humor to the whole creative language of Being."[2]

Plate 47
Morris Graves
American, 1910–2001
Ceremonial Bronze Taking the Form of a Bird II, 1947
Tempera on paper on illustration board, 23 x 27 ½ inches (58.4 x 69.9 cm)
Collection of C. K. Williams, II

Born and raised in the magnificent landscape of the Pacific Northwest, Graves developed his mystical art without formal instruction. As a child prone to frequent illness, his first interests were flowers and garden design; it was not until he was in his late teens that he began to draw and paint regularly. In 1929 Graves took a job aboard a merchant ship going to China and Japan, where he purchased Asian art objects and made drawings of temples and gardens. He visited Asia twice more before completing high school in 1932 at the age of twenty-two; in the following year he received a prize for a painting at the recently founded Seattle Art Museum, which housed the Asian art collection of Dr. Richard E. Fuller, who became one of Graves's early supporters. While living in Seattle, Graves became interested in Buddhism and regularly attended a Buddhist temple, where he met Dorothy Schumacher, a woman whose deep knowledge of Zen and the Noh theater inspired his examination of Asian religion and philosophy. Asian aesthetics became fundamental to Graves's art. In his

oft-quoted words: "In Japan I at once had the feeling that this was the right way to do everything. It was the acceptance of nature—not the resistance to it."[3] Acceptance of nature meant, for example, that Graves did not impose external artistic systems on nature's forms, such as abstraction or Cubist construction; instead, he sought to penetrate their inner spirit. As nature became his means for expressing inner consciousness,[4] the most frequent symbols Graves used to represent that expression were the bird and the chalice.

By the early 1940s Graves was catapulted to fame when the Museum of Modern Art acquired ten of his works following the exhibition *Americans 1942: 18 Artists from 9 States*. His work was exhibited frequently; collectors, such as Duncan Phillips, then director of the Phillips Collection in Washington, DC, bought his work; and in 1945, the Willard Gallery in New York started to represent it. The qualities most admired in Graves's work were his fusion of Asian and European art and its

Fig. 32: **Morris Graves**
American, 1910–2001
Ceremonial Bronze Taking the Form of a Bird, 1947
Gouache on paper, 22 x 27 ½ inches (55.9 x 69.9 cm)
Seattle Art Museum. Gift of Mrs. Fay F. Padelford and Mr. Philip S. Padelford

character of Surrealism. Birds and chalices, serpents and moons populated dusky works often surrounded by a mystical light created by the spectral "white writing" technique Graves had adapted from the older Seattle painter Mark Tobey.

The two versions of *Ceremonial Bronze Taking the Form of a Bird* were part of a large and varied series of paintings Graves made in 1947 while he was in Hawaii awaiting permission to travel to Japan on a Guggenheim fellowship—permission that was eventually denied. The five months in Hawaii proved to be especially prolific, and Graves made about fifty paintings. Graves's admiration of Asian art had never translated into representation of actual objects, but at this time he became attracted by the important collection of Chinese bronze vessels from the Zhou and Huang dynasties at the Honolulu Academy of Art, which inspired the Ritual Bronze series, of which the present work is a part.[5] In many of the Ritual Bronze paintings the vessel's decoration is represented in great detail, as here in *Ceremonial Bronze II* with its depiction of a monster mask on the body of the vessel,[6] showing the artist's close study of the bronzes. In a few, Graves did not include the animated bird growing from the vessel but portrayed the bronze as an isolated work of art. Most frequently, however, the vessel was given life, usually by a bird (of varied species) growing out of its side and comically peering into its contents; in one instance, entitled *Disintegrated and Reanimated*,[7] the bird reclines so the vessel is elongated and set on a slant. Finally, there are vessels that seem to have altogether transformed into birds (or vice versa), sprouting feathers and standing on clawed feet. In most of these works, the "object" appears against a freely brushed background, often surrounded by a glowing white aura that illuminates the expression of inner life that these images portray.

1. *Morris Graves*, exh. cat. (New York: Willard Gallery, 1948), n.p., no. 10. Emphasis in original.

2. *Sky of the Mind: Morris Graves, 1937–1987*, introduction by Maurice Bloch, exh. cat. (New York: Schmidt Bingham Gallery, 1988), p. 9. Bloch also quotes Graves's own words on this subject: "I began by saying that as a painter I am aware of the 'Sky of the Mind.' In concluding I would like to remind us each of the other two languages that all humanity shares—the secret language of silence—and the second language we all share is laughter."

3. Ray Kass, *Morris Graves: Vision of the Inner Eye*, exh. cat. (New York: George Braziller, in association with the Phillips Collection, Washington, DC, 1983), p. 22.

4. Ibid., p. 20, notes how Graves's use of nature as a means of expressing inner consciousness differed from the similar concerns of earlier American artists like Georgia O'Keeffe, Arthur Dove, and John Marin, for whom nature was the springboard for developing a personal language of abstraction.

5. Ibid., pp. 52–53, gives an extended interpretation of the Ritual Bronze series.

6. Ray Kass, "The Art of Morris Graves: Meditation on Nature," in *Sounds of the Inner Eye: John Cage, Mark Tobey, Morris Graves*, ed. Wulf Herzogenrath and Andreas Kreul, exh. cat. (Tacoma: Museum of Glass, International Center for Contemporary Art, in association with University of Washington Press, 2002), p. 43, explains the monster mask as "a compelling symmetrical ornamental motif used to enliven the surfaces of ancient Zhou and Huang dynasty bronzes, infusing them with the spirit of animal life and an imminent sense of 'sacred terror.' Graves' monster masks are double personae of himself, simultaneously symbolizing the internal and external aspects of a single being in images that invite and challenge the viewer."

7. Reproduced in Frederick S. Wight, John I. H. Baur, and Duncan Phillips, *Morris Graves* (Berkeley: University of California Press, 1956), p. 45.

WILLIAM GROPPER

SHOUTING SENATOR

c. 1950

A great draftsman, caricaturist, and social commentator, William Gropper (1897–1977) grew up in the first years of the twentieth century on Manhattan's Lower East Side as the son of immigrant garment workers from Rumania and Ukraine.[1] His artistic talent was recognized early, and before he left school he was offered a scholarship to the progressive Ferrer School, where George Bellows and Robert Henri espoused a curriculum based on individual freedom of expression. This atmosphere clearly agreed with him, for his rebellion against drawing from plaster casts had caused his expulsion from the National Academy of Design in 1916 after just two weeks. He returned to the Ferrer School while working as a clerk in a menswear store, where his caricatures caught the eye of Frank A. Parsons, president of the New York School of Fine and Applied Art, who awarded him a part-time scholarship there. It was not long before Gropper began to work as a cartoonist for the New York Tribune; in 1920 he became the feature artist for the paper's Sunday magazine. His stint there was short-lived, however, for he was drawn into New York's radical circles; his sympathy with the economic problems of the working class led to work as an illustrator for revolutionary magazines and periodicals. In 1921 Gropper began to paint seriously, but it was not until 1936, when he first exhibited his paintings at a Greenwich Village gallery, that he achieved instantaneous success as a painter. Critics were constantly astonished by his ability: Lewis Mumford declared that "one can definitely say that Gropper takes his place henceforth as one of the most accomplished, as well as one of the most significant, artists of our generation";[2] Milton W. Brown commented, "He [Gropper] is continually being seduced by the richness and variety of which the pigment is capable, often to the detriment of his social message." Yet he concluded: "on the whole as Gropper matures he becomes more and more the outstanding personality on the American art scene."[3]

A commission in 1935 from Vanity Fair to make drawings of the U.S. Senate soon led Gropper to make paintings of that subject. Among the first was The Senate (1936),[4] which was acquired by the Museum of Modern Art the following year. The senate rapidly became one of Gropper's best-known themes, and he later commented: "I was assigned by Vanity Fair to cover the Senate.

Plate 48
William Gropper
American, 1897–1977
Shouting Senator, c. 1950
Oil on Masonite, 12 x 14 inches (30.5 x 35.6 cm)
Collection of C. K. Williams, II

I stayed two or three weeks and painted the Senate as I saw it. I think the United States Senate is the best show in the world. If people saw it, they would know what their government is doing. . . . I get bored, so I did one or two Senates, and now I will do a Senate only when a Senator makes a speech that makes me mad."[5] Indeed, he did many more than "one or two Senates," so there must have been lots of speeches that made him mad. For more than thirty years, in prints, drawings, and paintings Gropper repeatedly portrayed U.S. senators shouting, dozing, reading the newspaper, or, less often, paying attention during a colleague's oration. The present small painting, done well over a decade after Gropper's first senate picture, is a highly charged vignette, sharply focused on one bellowing senator surrounded by jagged panels of clashing colors (representing corners of furniture and stacked papers); another senator, napping, is wedged in between them. Gropper's virtuosity with paint is on display here as he applied it in large, boldly handled strokes; color overlaps color; details are swiftly brushed in with wet black lines. The shouting senator's froglike yellow face has features traced in bright green; his bespectacled eyes are blank ovals of white above the cavernous black hole of a mouth. Somehow his bellow seems as hollow as his gaping mouth, as empty as the room in which he stands, and as unheard as it is by his slumbering colleague—all of which is probably the message Gropper wanted to convey.

1. The scholarly literature on Gropper is surprisingly sparse, almost none of it recent, and disagrees in the details of his life. The biographies consulted here are: August L. Freundlich, *William Gropper: Retrospective*, exh. cat. (Coral Gables, FL: Joe and Emily Lowe Art Gallery, University of Miami, 1968); and Wahneta T. Robinson, *William Gropper*, exh. cat. (Long Beach, CA: Long Beach Museum of Art, 1972). The first serious, though focused, study of Gropper that includes a detailed account of his Senate series is Roberta K. Tarbell, "William Gropper: *The Opposition*, 1942," in *Seeing America: Painting and Sculpture from the Permanent Collection of the Memorial Art Gallery of the University of Rochester*, ed. Marjorie B. Searl (Rochester, NY: University of Rochester Press, 2006), pp. 254–57.
2. Lewis Mumford, "The Art Galleries," *New Yorker*, March 27, 1937, p. 41.
3. Milton W. Brown, "Exhibitions: New York," *Parnassus*, vol. 13, no. 4 (April 1941), p. 156.
4. Reproduced in Freundlich, *William Gropper*, p. 111, pl. H.
5. Gropper, n.d., quoted in ibid., p. 29.

GEORGE GROSZ

TWO WOMEN WALKING
1929

THE THEATERGOERS
1933

Nothing escapes the sharp eye of this human botanist. A gesture, a facial expression, a peculiarity of dress or manner of walking—these become the identification tags by which we classify individually those strange flowers known collectively as the human race.[1]

If the dating of *Two Women Walking* to 1929 is correct, as it seems to be, then it and *The Theatergoers (The Couple)* were made, respectively, just before and just after George Grosz (1893–1959) moved from Germany to the United States. *The Theatergoers* bears a date of 1933—the year Grosz settled in New York for good, having spent the previous year there teaching at the Art Students League. He arrived as a famous and successful, although highly controversial, satirist, widely published in illustrated magazines and portfolios, with his drawings and watercolors snapped up by the well-to-do Berlin collectors who were often the butt of his satire. Expecting to find a wild radical in their midst, New York reporters were disappointed by the "Mild Monster" (as *Time Magazine* dubbed Grosz after his arrival in 1932).[2] Incisive and unambiguous as he was in his art, Grosz's persona presented many contradictions. For all his talent, success, and apparently secure family life, he was a conflicted, bitter, and sometimes deluded man.[3] Grosz's deep inner conflict (and hate) seems to have produced an extraordinarily keen psychological insight, which, joined with his superb draftsmanship, resulted in some of the most penetrating satirical drawings in the history of art.

Grosz's subjects were the rich as well as the poor. During the 1920s he made hundreds of watercolors portraying the full range of life in Germany during the Weimar Republic. In *Two Women Walking* he depicts two middle-aged Berlin women walking along the street, simply enjoying each other's company. Similarly decked out in fur-trimmed coats and high-heeled boots, the pair constitutes a recognizable type. Neither attractive nor repulsive, they are observed with straightforward objectivity. What appeals (and what no doubt made such images popular with collectors) is precisely their typicality and the artist's ability to capture that in every detail of their being—not only their costumes but also their behavior, their

Plate 49
George Grosz
German, 1893–1959
Two Women Walking, 1929
Watercolor on paper, 29 ¾ x 23 inches (75.6 x 58.4 cm)
Collection of C. K. Williams, II

Plate 50
George Grosz
German, 1893–1959
The Theatergoers (The Couple), 1933
Watercolor on paper, 25 ¼ x 18 ¼ inches (64.1 x 46.4 cm)
Collection of C. K. Williams, II

everydayness. One could meet these two many times, on any day, on any downtown street. Grosz's watercolor technique is masterfully controlled. He built his forms almost purely with color and very few lines; the wet colors bleed into wet paper and into one another, creating ragged edges and haloes around and within the forms. The figures are surrounded by clouds of mottled gray-blue, an effect that Grosz typically used to create a general ambience in all of his character studies.

Grosz narrowly escaped capture by the Nazis when he returned to New York to stay permanently in January 1933.[4] He personally, in addition to his art, had become a target of Nazi antagonism. He looked forward to a new life with his family in the country he had idealized all his life. From his earliest years, Grosz had loved America, conjuring the romantic image of skyscrapers, cowboys, and pots of gold portrayed in his boyhood books. Paradoxically, his arrival in America coincided with the worst years of the Great Depression, yet Grosz saw only what he had dreamed of. So strong was his mental image that he could overlook not only the wrenching poverty visible all over New York but also the spirit of protest among many of his fellow artists. Grosz aimed to leave his past behind, not only in his art but also in his personality, an impossible and delusional goal that led inevitably to depression and alienation. Before that set in, however, during his first years in New York, Grosz continued to make scores of watercolor characterizations of the people around him, finding many of his subjects around Columbus Circle and in Central Park.[5] Although it is often said that his New York satires are less biting than those done in Berlin, *The Theatergoers* seems equally keen in its portrayal of familiar types. This cheerful, well-to-do couple is on its way to the theater for an evening of entertainment; the smiles on their aging faces suggest that they have recognized friends. There is something oddly innocent about them that, in fact, reflects Grosz's observation about Americans soon after he arrived in New York: they are "'like big children'—who treat everything, even art, with uncomplicated enthusiasm."[6] Yet it was Grosz who was childlike as he clung to his illusion of American prosperity

during the Great Depression. Ironically, his impression was only encouraged by the financial success of his watercolors, which sold as well as they had in Berlin.

1. E. M. Benson, "George Grosz, Social Satirist," *Creative Art*, vol. 12 (May 1933), p. 346.
2. John I. H. Baur, *George Grosz*, exh. cat. (New York: Whitney Museum of American Art, 1954), p. 23.
3. A keen and detailed portrayal of Grosz's personality, leavened with many quotations, is the three-part profile by Richard O. Boyer, "Profiles," *New Yorker*, November 27, 1943, pp. 32–36, 38, 41–43; December 4, 1943, pp. 39–44, 46, 48; December 11, 1943, pp. 37–42, 44.
4. Biographical information on Grosz comes from Herbert Bittner, ed., *George Grosz* (New York: Arts, 1960); Beth Irwin Lewis, *George Grosz: Art and Politics in the Weimar Republic* (Madison: University of Wisconsin Press, 1971); and Hans Hess, *George Grosz* (New York: Macmillan, 1974).
5. Baur, *George Grosz*, p. 24.
6. Quoted in Beeke Sell Tower, *Envisioning America: Prints, Drawings, and Photographs by George Grosz and His Contemporaries, 1915–1933*, exh. cat. (Cambridge, MA: Busch-Reisinger Museum, Harvard University, 1990), p. 108.

PHILIP GUSTON

PORTRAIT OF
THERESA LEWENSOHN

1940

Dated 1940, *Portrait of Theresa Lewensohn* by Philip Guston (1913–1980) was painted shortly before the artist left Manhattan to live in the artists' colony of Woodstock, New York. During most of the previous five years, he had been occupied with making murals commissioned by the Works Progress Administration (WPA), and in leaving the city he hoped to concentrate on easel painting. The present portrait is closely linked to Guston's activity as a mural painter, for it depicts the wife of Ben Lewensohn, owner of a shop known for its superior tempera paints and picture frames, from whom the artist purchased the paint for his murals. Born in Palestine, Lewensohn had trained as an engineer at the Cooper Union in New York and was also a sculptor. Unable to find work during the depression, he opened a shop on Twenty-second Street in Manhattan, where he and his Polish wife, Theresa Arons, sold paint and the frames he designed. According to their daughter, Guston became friends with the couple and asked Theresa to pose for him. He gave them the portrait, which remained in the family until recently; its elaborately carved wood frame was made by Ben Lewensohn himself.[1]

Guston's transition to easel painting extended through the first half of the 1940s, during which time he labored to master working in oil on canvas.[2] He had done only a small number of easel paintings before and had worked little in oil, so it is understandable that as he began to shift away from mural painting, he chose to execute the Lewensohn portrait in tempera, which was the medium he already was using for his murals.[3] The portrait shows clearly that he knew how to handle tempera with confidence and skill, and he lavished great care on it: colors are applied in layers with minute strokes; many textures, such as the hair, are rendered as fine lines that are scratched into the paint surface; other textures are indicated with thin, freely applied brushstrokes, such as the painted wood grain along the composition's right margin.[4] Perhaps most striking is Guston's achievement of perfect balance between the overall design of the composition and the wide assortment of shapes, patterns, and textures contained within it. Obviously, experience with the design and planning of large-scale murals had prepared him well for resolving such problems on a smaller scale.

Plate 51
Philip Guston
American, 1913–1980
Portrait of Theresa Lewensohn, 1940
Tempera on Masonite, 32 ⅛ x 20 inches (81.6 x 50.8 cm)
Collection of C. K. Williams, II

Portraiture plainly had a strong attraction for Guston as he began to concentrate on easel painting, and soon after he painted Theresa Lewensohn he made a number of oil portraits of family and friends that are marked by a feeling of melancholy, detachment, and occasional haunting strangeness.[5] By contrast, *Portrait of Theresa Lewensohn* displays an optimism, clarity, and strength that again link it with his murals, such as the women in his now-destroyed mural for the WPA Building at the New York World's Fair of 1939 or in the 1941 cartoon for the Social Security Board Building.[6] Everything in the design of the present portrait is satisfyingly clear and definite, such as the curves of the wicker chair—just contained within the picture's borders—echoed by the subject's sloping shoulders, or the slight tilt of the triangular cloth that frames her head and hair.

During the early 1940s Guston was not only exploring new formats and materials, he was also increasingly interested in Cubism, owing to his friendship with colleagues on the WPA project, such as Willem de Kooning, Arshile Gorky, and Stuart Davis. Initially, he started to question his devotion to Italian Renaissance art as he "became aware of the total picture space— the total picture plane, that is—as against just using volumes in an empty space."[7] His new quest, inspired by his study of Pablo Picasso and Fernand Léger, was to reconcile representational subject matter with Cubism's abstract structure.[8] For that reason, the great exhibition *Picasso: Forty Years of His Art*, which opened at the end of 1939 at the Museum of Modern Art in New York, was an event of signal importance for Guston.[9] Occurring just at the time when he painted Theresa Lewensohn, the exhibition was full of portraits of seated women showing every aspect of Picasso's varied modes—early portraits, such as the morose 1901 *Woman with Folded Arms*; the monumental *Gertrude Stein* of 1906; and the 1923 *Woman in White* in Picasso's classical style. However, it was not the early portraits that seem to have engaged Guston most forcefully. Rather, his *Portrait of Theresa Lewensohn* suggests that he drew more inspiration from the variegated areas of decorative pattern and the arabesque curves in Picasso's abstract compositions of seated women of 1926–27, or perhaps from the wide-eyed *Portrait of Dora Maar* (then entitled *Portrait of a Lady*, 1937),[10] where the sitter wears puffed sleeves that spring from beneath a decorative bodice.

Yet despite his attraction to many details of Picasso's arabesques, patterns, and flattened planes of color, the powerfully modeled volumes of the figure in Guston's portrait are ultimately inspired by the grand, static figures of Piero della Francesca, whose work Guston revered throughout his career, as well as by the monumental figures in the murals of Diego Rivera and José Clemente Orozco.

1. Stephanie Sacker, daughter of the Lewensohns, kindly provided this information about her parents to David McKee (letter from McKee to Charles Williams, March 6, 2007) and in a telephone conversation with the author on February 22, 2008.
2. See H. W. Janson, "Philip Guston," *Magazine of Art*, vol. 40, no. 2 (February 1947), p. 58.
3. According to H. H. Arnason, *Philip Guston*, exh. cat. (New York: The Solomon R. Guggenheim Museum, 1962), p. 38 n. 3, "before 1941, Guston had painted no more than seven or eight easel pictures." Guston's serious shift to oil took place in about 1941. In an Oral History Interview with Philip Guston, Woodstock, NY, January 29, 1965, by Joseph S. Trovato for the Smithsonian Archives of American Art, transcript, Guston said: "I worked on the design and cartoons [for the Community Building of the Queensbridge Housing Project on Long Island] for about a year. Everything was approved and the walls prepared—casein tempera painted on the wall."
4. I am grateful to Suzanne Penn, Conservator of Paintings at the Philadelphia Museum of Art, for her research and observations on Guston's materials and techniques.
5. This was not Guston's first experience with portraiture, for he is known to have received portrait commissions when he worked in Morelia, Mexico, in 1934. See Dore Ashton, *A Critical Study of Philip Guston* (Berkeley: University of California Press, 1976), p. 32. The later portraits are *Sunday Interior* (1941), *Musa McKim* (1942), *The Sculptor* (1943), *The Young Mother* (1944), and *Self-Portrait* (c. 1944), reproduced in *Philip Guston: Working through the Forties*, exh. cat. (Iowa City: University of Iowa Museum of Art, 1997), pls. 3–6, 8. *Portrait of Shanah* (1941) is reproduced in *Philip Guston*, exh. cat. (Minneapolis: University Gallery, Art Department, University of Minnesota, 1950), n.p., and *Sentimental Moment* (1944) is reproduced in *Art News*, vol. 44 (April 1–14, 1945), p. 18.
6. The cartoon for the Social Security Board Building mural is reproduced in *Philip Guston: Working through the Forties*, p. 6. The World's Fair mural is reproduced in Henry A. Millon and Linda Nochlin, eds., *Art and Architecture in the Service of Politics* (Cambridge, MA: MIT Press, 1980), p. 347, fig. 2.
7. Ashton, *A Critical Study*, pp. 39–41, at 41.
8. Arnason, *Philip Guston*, p. 15.
9. Guston was already a confirmed admirer of Picasso's work, which he had encountered as early as 1930 in California at the home of Walter and Louise Arensberg, and studied later in New York in magazine reproductions as well as at the Gallery of Modern Art at New York University, where he saw *Three Musicians* in the collection of A. E. Gallatin (now in the Philadelphia Museum of Art).
10. Compare, for example, *Seated Woman* (1926–27), where the figure, dressed in stripes, is surrounded by panels of varied patterns and decorative wainscoting; or the arabesque curves of the more simplified *Seated Woman* (1927). The portraits referred to in the text and this note are reproduced in Alfred H. Barr, Jr., ed., *Picasso: Forty Years of His Art*, exh. cat. (New York: The Museum of Modern Art, 1939), nos. 16, 65, 179, 207, 209, 342.

MARSDEN HARTLEY

COMPOSITION

1913

In the end of 1912 Marsden Hartley (1877–1943) wrote from Paris to Alfred Stieglitz about his new abstract paintings: "It is not like anything here—It is not like Picasso—it is not like Kandinsky not like any 'Cubism.'"[1] He went on to discuss his sources of inspiration, which he found not only in Wassily Kandinsky's writings (which he preferred to his paintings) but also in Henri Bergson's philosophy, both of which posited intuition as the true source of artistic expression. Other letters reveal that Hartley was reading even more widely and that he was thinking deeply and analytically about how a variety of theories, mystical as well as pragmatic, applied to the increasingly spiritual basis for his increasingly abstract art.[2] Hartley had recently arrived in Paris on his first trip to Europe, and he was passing rapidly through a variety of stylistic phases, progressing from an initial series of still lifes inspired by Henri Matisse and Paul Cézanne to the abstract work he described in his letter. Serious, intense, and searching, Hartley at this time was wide open to new influences and eclectic in his work. Yet, as Patricia McDonnell put it, "Hartley was often beset with doubts regarding how things would turn out for him, but he rarely doubted his own importance as an artist. . . . he longed to make a name for himself in Europe, something he set about with determined purpose."[3] Hartley's first trip to Europe lasted from April 1912 to November 1913. He spent April through December 1912 in Paris, took a three-week trip to Berlin and Munich in January 1913, and returned to Paris for February through late April 1913. Enthralled by Berlin, he went back in May and stayed there until his departure for New York in November, but he did no painting there until mid-July.[4] It was probably sometime during the late summer or fall in Berlin that Hartley made the unusual abstract painting *Composition*, which is traditionally dated 1913.

Hartley began painting abstract compositions in Paris in the fall of 1912. Dubbed "Intuitive Abstractions," the first ones comprised a series inspired by music, such as *Musical Theme No. 2 (Bach Preludes)*,[5] which uniquely mixed the fragmented angular structure and the use of words and signs derived from Pablo Picasso's Analytical Cubism with forms, shapes, and colors inspired by the work of Kandinsky. The influence of

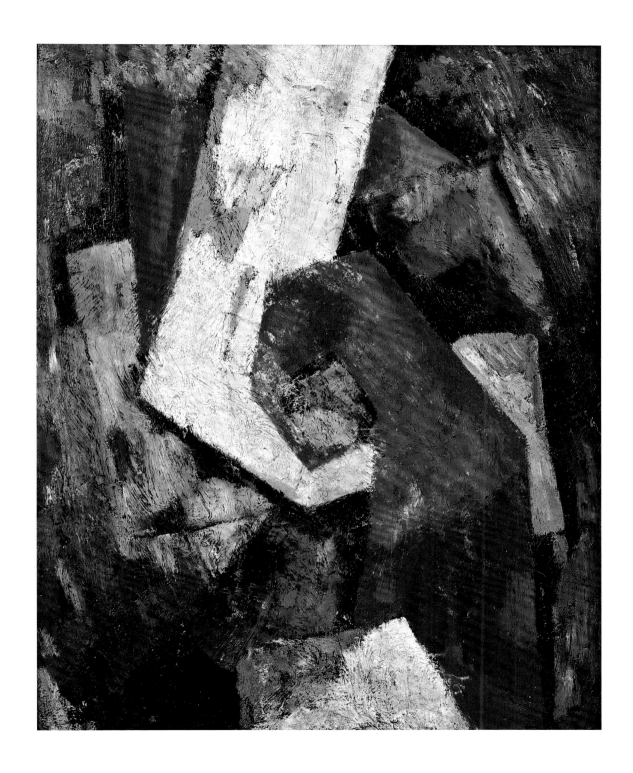

Plate 52
Marsden Hartley
American, 1877–1943
Composition, 1913
Oil on board, 19 ½ x 15 ½ inches (49.5 x 39.4 cm)
Collection of C. K. Williams, II

Kandinsky intensified in works painted during Hartley's last months in Paris in 1913, such as *Painting No. 1*, which is filled with overlapping, rounded, organic shapes as well as circles and stars surrounded by heavy, dark outlines.[6] Hartley's brushwork in these paintings is agitated, with a frequent use of pure white or colors mixed with white. The abstract paintings Hartley made in Paris during 1912 and 1913 had nothing in common with *Composition*, which is heavily painted and composed of flat, tightly compressed, angular shapes; rather than pronounced outlines, in *Composition* the shapes are defined by intense, juxtaposed colors that are thickly brushed. Moreover, *Composition* is made up completely of abstract shapes, unembellished by words, stars, or symbols. The first paintings Hartley made in Berlin in 1913 also have little in common with *Composition*. Works such as *Portrait of Berlin* and *The Warriors*[7] are quite thinly painted and are filled with stars, buddhas, animals, and other mystical signs. *Portrait of Berlin* in particular displays an increased use of white as well as the heavy, dark outlining of forms that can be seen in the 1913 Paris paintings.

Where does *Composition* fit into Hartley's development in 1913? Though a strict chronology of his 1913 abstract paintings has not been firmly established, Barbara Haskell perceptively identified a set of common characteristics that emerge in a few paintings Hartley seems to have made toward the end of his 1913 stay in Berlin, notably *Military* and *Movements*.[8] Although it remains an unusual and perhaps experimental work, *Composition* exhibits several of the same qualities as those pictures. For example, Hartley replaced heavy, dark outlines by juxtaposing large, clearly defined areas of color, giving an appearance that is analogous to a Cubist collage. This collagelike aspect is most pronounced in *Composition*, where the flat shapes have a layered, cutout look, almost as though they had been applied to the surface. Also markedly different are the colors: bright, hot hues, thickly applied with forceful brushstrokes, replace the previous dominance of white. Haskell likens the new handling of color to the dynamism of works by Kandinsky and Franz Marc, and concludes, "By combining the pictorial energy of the Blaue Reiter

Expressionists with the tightly knit, collage format of the Cubists, he achieved a remarkable synthesis of the expressive with the structured."[9] Still, *Military* and *Movements* clearly forecast the next phase of Hartley's work, notably his Indian compositions of 1914. *Composition*, by contrast, was one of Hartley's rare experiments in pure abstraction, almost certainly made when he was exploring the same pictorial concerns as in those two more characteristic pictures.[10]

1. Quoted in Barbara Haskell, *Marsden Hartley*, exh. cat. (New York: Whitney Museum of American Art, in association with New York University Press, 1980), p. 28.
2. Ibid., pp. 28–29.
3. Patricia McDonnell, "'Portrait of Berlin': Marsden Hartley and Urban Modernity in Expressionist Berlin," in Elizabeth Mankin Kornhauser, ed., *Marsden Hartley*, exh. cat. (Hartford, CT: Wadsworth Atheneum Museum of Art, in association with Yale University Press, 2002), p. 42.
4. Haskell, *Marsden Hartley*, p. 32.
5. Reproduced in Bruce Robertson, *Marsden Hartley* (New York: Harry N. Abrams, in association with the National Museum of American Art, Smithsonian Institution, 1995), p. 36, pl. 10.
6. Reproduced in Haskell, *Marsden Hartley*, p. 149, pl. 74.
7. Reproduced in Kornhauser, *Marsden Hartley*, pp. 62–63, pls. 10–11.
8. Haskell, *Marsden Hartley*, p. 33. *Military* is reproduced in Kornhauser, *Marsden Hartley*, p. 64, pl. 12; *Movements* is reproduced in Haskell, p. 150, pl. 75.
9. Haskell, *Marsden Hartley*, p. 33. Gail Levin, *Synchromism and American Color Abstraction, 1910–1925*, exh. cat. (New York: George Braziller, in association with the Whitney Museum of American Art, 1978), p. 43, draws analogies between *Composition* and the paintings of Robert Delaunay and suggests that its flat design looks forward to Hartley's military pictures of 1914–15.
10. Hartley did occasionally make pure abstractions, such as *Abstraction* (1911), reproduced in *Marsden Hartley, 1908–1942: The Ione and Hudson D. Walker Collection*, exh. cat. (San Francisco: Art Museum Association of America, 1983), p. 19, no. 8. Another painting similar in date to *Composition* is *Abstraction: Blue, Yellow, and Green* (c. 1913), reproduced in Levin, *Synchromism*, pl. 146.

EDWARD HOPPER

CORN HILL

c. 1930

When we reached [Hopper's Truro] house, there was Hopper sitting in front of it, looking out over the hills. We found Jo sitting in the back, looking over the bay. "That's what we do all the time," she said sharply. "He sits in his spot and looks at the hills all day, and I look at the sea."[1]

For an artist as definite and directed as Edward Hopper (1882–1967), it is no surprise that watercolor played a specific role in his work and was used during a well-defined period in his career.[2] He began making watercolors in 1923, when he had just abandoned etching; by 1938 he gradually made fewer and fewer of them because he was no longer working spontaneously in the outdoors, instead doing nearly all of his work in the studio.[3] Watercolor had been the medium with which he composed directly on the spot, and so it no longer served a purpose. A man of few words, Hopper knew what he wanted and why. When he came on a new site or used a new medium that excited him, as he did when he started working with watercolors in Gloucester, Massachusetts, he produced a phenomenal amount of work all at once. At other times, when he could not find a place that seemed right—a house or a view, or even a part of the country—he would go for periods of time without working, occasionally traveling to a new area, such as Charleston or Santa Fe, to seek inspiration.[4] Nonetheless, throughout his career, Hopper and his wife, Jo (also an artist), occupied the same modest flat on Manhattan's Washington Square. In the summers they sought the New England coast, from Maine south to Cape Cod; when the specific qualities of the light of a place ceased to hold his attention, they moved elsewhere. By 1928 Gloucester no longer inspired him; he tried Maine, but found the contrasts of light and shadow too sharp; finally, in the summer of 1930, the Hoppers settled in Truro on Cape Cod, where the blond light, pale shadows, and treeless dunes captured and held his interest for the rest of his life.

Hopper's output during his first summer in Truro in 1930 rivaled that of 1923, the first year of making watercolors, when he made more than two dozen views of Gloucester; in his excitement with the new site he produced about twenty new Cape Cod scenes. The character of the work was new as well. In

Plate 53
Edward Hopper
American, 1882–1967
Corn Hill, c. 1930
Watercolor over graphite on watercolor paper; sheet 13 ¹⁵/₁₆ x 20 inches (35.4 x 50.8 cm)
Philadelphia Museum of Art. Gift of C. K. Williams, II, in honor of the 125th Anniversary of the Museum. 2003-63-1

Gloucester he had reveled in the intricacies of light and shadow on shuttered Victorian captains' houses,[5] but now the revelation of the unadorned faces of boxlike Cape Cod barns and dwellings appealed to his increasing inclination toward modernist simplicity.[6] Yellow sand splashed with green grass and violet shadows predominate in the watercolors of his early Cape Cod summers; skies are often a cloudless blue, as in the watercolor *Corn Hill*, one of the many created during that prolific moment. The high dune topped by a row of identical houses was a striking spot as well as a historic landmark, named Corn Hill in 1620 by Captain Miles Standish and his Mayflower crew because it was there that they found ears of corn strewn over recent Indian graves.[7] Hopper made not only a watercolor but also a painting of Corn Hill,[8] each from a different viewpoint and at a different time of day. In both, he stood looking up at the houses and the towering dune whose upper reaches covered parts of their facades. In the painting the houses recede sharply away, while in the watercolor four houses march in a row along the dune's crest. He made the painting in late afternoon as the sun began to set, with golden light falling on the western side of the dune facing Cape Cod Bay; the watercolor, by contrast, was done in full daylight, when the sun bleached the greens and yellows of the dune and the houses loomed darkly against the cloudless sky.

Corn Hill was executed in Hopper's typical method of roughly sketching the composition in pencil before adding color.[9] Working on a stiff, moderately textured watercolor paper, he used pencil to provide only the most general guidelines, primarily indicating the position of the houses, the slope of the dune, and the pathway. Clearly, these were not outlines to be filled in with color, for he brushed over them freely, sometimes leaving them exposed. Color is applied thinly in some areas and allowed to pool in others, overlaid in places with swift, broken touches of green. Hopper seems to have painted the sky last, as he often did with his watercolors, letting his brush skip over uneven areas of the paper surface to expose tiny areas of the white ground. He left a broad strip of the paper along the bottom untouched, suggesting the white-hot sun on the sandy beach where he was working.[10]

1. Raphael Soyer, quoted in Lloyd Goodrich, "Six Who Knew Edward Hopper," *Art Journal*, vol. 41, no. 2 (Summer 1981), p. 132.

2. The principal recent sources for Hopper's watercolors are Gail Levin, *Edward Hopper: A Catalogue Raisonné*, vol. 2, *Watercolors* (New York: Whitney Museum of American Art, in association with W. W. Norton & Company, 1995); Virginia M. Mecklenburg, *Edward Hopper: The Watercolors*, exh. cat. (Washington, DC: National Museum of American Art, Smithsonian Institution, in association with W. W. Norton & Company, 1999); and Gail Levin, *The Complete Watercolors of Edward Hopper* (New York: Whitney Museum of American Art, in association with W. W. Norton & Company, 2001).

3. Hopper's watercolors brought him his first success. Following his summer in Gloucester in 1923, he showed some of them at the Brooklyn Museum, which acquired *The Mansard Roof* (reproduced in Levin, *The Complete Watercolors*, p. 42, no. W-72). In 1924 his exhibition of watercolors at the Frank K. M. Rehn Galleries in New York sold out, and he received unanimous praise from the press. See Mecklenburg, *Edward Hopper*, pp. 27–37. On Hopper's lessening of interest in watercolor about 1938, see pp. 6–7.

4. Several periods when Hopper was unable to work or would not paint unless a site inspired him are recounted in Gail Levin, *Edward Hopper: An Intimate Biography* (New York: Alfred A. Knopf, 1995), pp. 262, 292, 297–98, 316–17.

5. See Carol Troyen, "Hopper in Gloucester," in Troyen et al., *Edward Hopper*, exh. cat. (Boston: MFA Publications, 2007), pp. 57–83.

6. See Ellen E. Roberts, "Painting the Modern Cape: Hopper in Truro," in ibid., pp. 145–55.

7. Mecklenburg, *Edward Hopper*, pp. 103–4, 171 n. 19.

8. The painting is in the McNay Art Museum, San Antonio, and reproduced in *Modern Art at the McNay: A Brief History and Pictorial Survey of the Collection* (San Antonio: McNay, 2001), p. 168.

9. Hopper's watercolor technique is discussed by Mecklenburg, *Edward Hopper*, pp. 5–6; and Troyen, "Hopper in Gloucester," p. 59.

10. Even when compared with some of Hopper's watercolors of pure dunes, *Corn Hill* is one of the most generalized of those he made in Truro about 1930. In most of them he used smaller, more controlled brushstrokes, creating more defined patches of grass and sand. See Levin, *The Complete Watercolors*, nos. W-256, W-258, W-259. Although clearly a finished work, *Corn Hill* more closely resembles the broader application of pale color in three of Hopper's contemporaneous unfinished watercolors: nos. W-254, W-257, W-260.

EARL HORTER

NEWCASTLE, DELAWARE

c. 1932

Rising to the top of the field as an art director in the Philadelphia advertising business and later becoming a beloved teacher in several Philadelphia art schools, Earl Horter (1880–1940) nonetheless aspired to be a fine artist, and he created paintings, watercolors, prints, and drawings throughout his entire career. Horter was also a major collector of modern art, primarily Cubism; at one time he owned more than twenty works by Pablo Picasso, at least eight by Georges Braque, as well as Constantin Brancusi's marble *Mademoiselle Pogany* and a version of Marcel Duchamp's *Nude Descending a Staircase*, all of which he regrettably had to sell for financial reasons during the Great Depression.[1] An avid reader of art books and magazines of all kinds, Horter had an extensive library, was well versed in the history of art, and absorbed the full range of styles and techniques practiced by modern artists, which he often imitated in his work.

In the mode of the cityscapes in which Horter had specialized since the 1910s, *Newcastle, Delaware* is one of a small number of "Pointillist" watercolors he made in the early 1930s. Although the style has often been seen as an imitation of Georges Seurat's Pointillism, closer examination shows that Horter, unlike Seurat, was working in a distinctly unscientific way, using the dotted technique to create a variegated surface texture rather than to fuse colors optically. A number of influences seem to have come together to bring about Horter's brief experimentation with a dotted technique. In the first place, there were the Synthetic Cubist paintings by Pablo Picasso, which Horter not only knew from reproductions but also owned. The most important of these in his collection was *Still Life with Cards, Glasses, and a Bottle of Rum: Vive la [France]*,[2] a painting executed in oil and sand on canvas, in which Picasso covered the surfaces of several still-life objects with multicolored dots. Then there were Georges Braque's paintings of speckled sandy beaches, which Horter imitated in the 1930s.[3] More likely, however, the greatest influence must have come from the techniques Horter himself was using in his prints and watercolors at the time, particularly a method he learned from Charles Demuth, who achieved textural effects in his watercolors by sprinkling salt onto wet paper, which he would

Plate 54
Earl Horter
American, 1880–1940
Newcastle, Delaware, c. 1932
Watercolor on paper; sheet (irregular) 13 15/16 x 21 13/16 inches (35.4 x 55.4 cm)
Philadelphia Museum of Art. Gift of C. K. Williams, II. 1999-27-1

brush off when the paper dried, thereby producing a mottled surface texture. Similarly, in the early 1930s Horter was also working with aquatint, an etching technique in which a granular layer of resin is applied to the etching plate and bitten with acid to create broad tonal effects comparable to wash drawings.[4] Each of these influences from his own and others' work surely combined to encourage Horter about 1932 to create watercolors entirely of dots and even add his signature in the same technique.

1. See Innis Howe Shoemaker with Christa Clarke and William Wierzbowski, *Mad for Modernism: Earl Horter and His Collection*, exh. cat. (Philadelphia: Philadelphia Museum of Art, 1999).
2. See ibid., p. 100, pl. 46. Horter had sold this painting by 1934.
3. Ibid., p. 49.
4. The best example of Horter's use of the salt technique is *The Chrysler Building under Construction* (1931), reproduced in ibid., p. 44, fig. 36. His aquatints, such as *The Kitchen, New Orleans* (c. 1933) and *Light and Shadow* (1932), show the remarkable effects for which Horter became well known in his aquatints (ibid., p. 45, figs. 37–38).

EARL HORTER

ABSTRACTION—STILL LIFE #6

1939

Earl Horter (1880–1940) considered Georges Braque one of his favorite artists. Until the Great Depression forced him to sell them, Horter had owned about eight of Braque's works, most of which were from his Cubist period. However, his admiration of Braque continued without abating until the end of his life. One of his students in the mid-1930s recalled Horter spending hours studying reproductions of Braque's paintings in an issue of *Vanity Fair*.[1] At that time, however, it was not Braque's Cubist work he favored, but his paintings of the 1930s, which had an important impact on Horter's work. In 1939 he based his last important group of still-life watercolors on an intense study of Braque's contemporaneous still-life compositions.

From his boyhood, Horter was well known for his skillful draftsmanship, and his students also marveled at his proficiency with watercolor, which he famously taught by demonstration: "This little man stood in front of us and did magic things so easily with watercolors, and got us so enthusiastic, that we were immediately splashing washes and doing all kinds of wonderful things that he told us in this period of two or three hours."[2] Yet he did not always work effortlessly, as may be seen in this masterful watercolor in which a plate of fruit and a wineglass on a table are surrounded by an elaborately arranged jigsaw puzzle of patterned shapes. While the composition is loosely based on Braque's still lifes of the 1930s, the arrangement is Horter's own, and there is ample evidence that it was achieved only after sheets and sheets of pencil sketches (fig. 33). As one of his admirers described them:

> The preparatory drawings, the sheets of tracing paper covered with stages of gradual clarifications, are lessons in the use of directed effort. They show the reduction of fumbling to a minimum. They also reveal how in the concentrated pursuit of one goal, equal opportunities open out on either side of the path. The final designs are little gems of graphic joinery.[3]

1. Innis Howe Shoemaker with Christa Clarke and William Wierzbowski, *Mad for Modernism: Earl Horter and His Collection*, exh. cat. (Philadelphia: Philadelphia Museum of Art, 1999), p. 48.
2. Quoted in ibid., p. 50.
3. Quoted in ibid., p. 54.

Plate 55
Earl Horter
American, 1880–1940
Abstraction—Still Life #6, 1939
Watercolor on paper, 16 x 17 ½ inches (40.6 x 44.5 cm)
Collection of C. K. Williams, II

Fig. 33: **Earl Horter**
American, 1880–1940
Untitled Sheet of Sketches, c. 1939
Graphite on paper, 13 1/16 x 16 13/16 inches (33.2 x 42.7 cm)
Collection of C. K. Williams, II

HENRY KOERNER

THE ARCADES
1950

Juxtaposition, in my paintings, is the conscious and unconscious assembly of familiar objects (nature and man-made) with human beings, who, in their attitude towards each other and the objects, mean something very deep to me—though they may be separated by time and space. This affinity manifests itself only as a result of personal experiences and persistent memories.[1]

"Juxtaposition" in the art of Henry Koerner (1915–1991) is exactly what is so riveting about his painting *The Arcades* and what also inevitably invites interpretation. An unlikely assortment of ordinary figures in winter garb, united by attitudes of intense concentration and by oddly impassive expressions, are gathered beneath a flimsy stagelike arcade set on a well-trodden sandy beach to observe a hanged Christ-like corpse, a waxworks mannequin with exposed entrails, and a fortune-teller at work in a booth; curious cats wander about, and an amusement park barker in uniform points to turn away a man who kneels in prayer at the platform's edge. The onlookers' grave, ritualistic manner suggests that they are participants in an event of almost sacred importance—a feeling that is heightened by the vast, undifferentiated expanse of sand and sea that stretches behind them.[2] To attempt to fathom the true meaning of this picture would only prove futile, for as the artist clearly explained, his paintings form a collection of deeply rooted personal experiences which, one suspects, even he might not have been able to explain verbally. In any case, as he said of his painting *The Barber Shop*, "most inner secrets you do not give away with words. If you could, you wouldn't have to paint."[3] Koerner's mode of interpretation, when asked, was to identify individual figures in relation to a particular memory. To a scholar in 1981–82, he typically offered a few clues about some of the characters in *The Arcades*: he portrayed himself as the barker, which fulfilled a childhood ambition; the man kneeling at the barker's feet was derived from his recollection of a crazy man who prayed every Sunday at the arcades, "believing that Fatima the fortune-teller and Abdullah the hanging corpse were Mary and Jesus." The site itself recalled the arcades at Coney Island, encountered by Koerner as an adult, but whose true origin lay in his powerful memories of the Prater amusement park near his childhood home in Vienna.[4]

Plate 56
Henry Koerner
American, born Austria, 1915–1991
The Arcades, 1950
Oil on Masonite, 30 x 37 ³/₄ inches (76.2 x 95.9 cm)
Collection of C. K. Williams, II

Koerner's art and life were forever affected by happy remembrances of his boyhood in prewar Vienna, by the loss of his parents and brother in the Holocaust, and by the perplexing dualism he experienced by being a European in America and an American in Europe.[5] Born in 1915 into a family that practiced and encouraged art, he was naturally drawn to the artistic climate of Vienna at the turn of the century with its fascination for the morbid, the fantastic, and the extravagant. Koerner received his training in commercial art at the Graphic Academy of Applied Art in Vienna and worked as an apprentice to a poster artist until Hitler invaded Austria in 1938. Leaving his family in Vienna, Koerner went to Italy and immigrated in 1939 to the United States. As a graphic artist in Manhattan, Koerner made prizewinning posters; at the Office of War Information in 1943 he worked with Ben Shahn, who encouraged him to paint. Soon after becoming an American citizen, he was drafted into the army and was sent to London in 1944. The next year he was transferred to Germany, where he drew Nazi war criminals at the Nuremberg trials. In 1946 Koerner returned to Vienna and learned that his family had perished.

Koerner's paintings of the mid-1940s show the influence of realist artists in both America and Germany, especially Ben Shahn and Philip Evergood, Max Beckmann and Otto Dix, whose work often included carnival imagery. He was particularly attracted to Surrealist depictions of empty spaces, distorted perspectives, and odd juxtapositions, which appeared in some highly expressive paintings of postwar Europe he exhibited with great success in Berlin in 1947. Back in New York the following year, Koerner showed his Berlin paintings again at the Midtown Galleries, accompanied by new ones he had made in New York in a Magic Realist style.[6] His strange images of uncertainty, fear, and violence brought him immediate critical recognition as "a keen intellect which can interpret with a lucid yet profound imagination the violent upheavals of our time."[7]

Throughout his career, Koerner underwent rapid changes of style, and *The Arcades*, which was included in his second exhibition at Midtown Galleries in 1950,[8] showed his development of a grander, more detached, and measured approach to his enigmatic depictions of the everyday world. He was looking hard at the work of Giotto, his favorite artist, whose religious

fresco cycles inspired the stagelike setting in *The Arcades*.[9] Koerner also admired the expressive precision of the figures in Giotto's narratives, which was based on a language of gesture developed in medieval theatrical performances in order to be intelligible at great distances.[10] Indeed, theater itself lies at the heart of this mysterious painting in which the performers as well as spectators execute their roles with the almost surreal clarity that inhabits Giotto's narratives. According to the artist's son: "The arcades were a sort of model for the surrealism my father tried to achieve in his art; it was a sort of popular culture, and thus 'found' surrealism. In a way, he associated Giotto himself with such elemental surrealism."[11]

1. Henry Koerner, "A Sense of Purpose," *College Art Journal*, vol. 10, no. 3 (Spring 1951), p. 265; reprinted from the catalogue of Koerner's solo exhibition at the Midtown Galleries, March 1951.
2. Another aspect of marvelous strangeness, which is not so apparent in reproduction, is the artist's unusual treatment of the sand and ocean as patterns of raised and dented pigment, which contrast with the smooth, even handling of paint in the rest of the composition.
3. Quoted in Joseph Koerner, *Unheimliche Heimat: Henry Koerner, 1915–1991*, exh. cat. (Vienna: Österreichische Galerie Belvedere, 1997), p. 53. *Barber Shop* is reproduced in ibid., p. 101.
4. Gail Stavitsky, *From Vienna to Pittsburgh: The Art of Henry Koerner*, exh. cat. (Pittsburgh: Museum of Art, Carnegie Institute, 1983), p. 53, no. 26. According to Stavitsky, *The Arcades* is featured in an unpublished story by the artist entitled "The Rosebush." I have not been able to obtain the text of the story.
5. This biographical summary is largely dependent on information contained in ibid.; and Koerner, *Unheimliche Heimat*.
6. In 1942 Alfred Barr defined Magic Realism as "a term sometimes applied to the work of painters who by means of an exact realistic technique try to make plausible and convincing their improbable, dreamlike, or fantastic visions." Barr, *Painting and Sculpture in the Museum of Modern Art* (New York: The Museum of Modern Art, 1942), p. 16.
7. S.C., "Spotlight on Koerner," *Art News*, vol. 46 (February 1948), p. 28.
8. The painting is dated 1950 but must have been largely completed during 1949, as a receipt from Midtown Galleries for delivery of the painting is dated January 9, 1950. The title of the painting is given on the receipt as *Under the Arcades*. Midtown Galleries Records, 1904–1997, Artists Correspondence, 1927–1989, undated, Archives of American Art, Smithsonian Institution, Washington, DC, reel 5385, frame 966.
9. While the boxlike form of the arcade resembles buildings in Giotto's frescoes such as *Pentecost* in the Scrovegni Chapel, Padua, Koerner did not follow the Gothic style of Giotto's structures but used the rounded arches on slender pillars seen in early-fifteenth-century Florentine frescoes.
10. See Moshe Barasch, *Giotto and the Language of Gesture* (Cambridge: Cambridge University Press, 1987), pp. 11–12. For Koerner's belief that Giotto based his art on mystery plays, see Stavitsky, *From Vienna to Pittsburgh*, p. 18.
11. Quoted from an e-mail message from Joseph Koerner to the author, August 2, 2008.

JACK LEVINE

WOODSTOCK PASTORALE

1949

When I paint these classical subjects, I see no reason to explain why I do it; but sometimes when I look back at them, I feel like I'm kind of strange doing it at all. I should be doing drawings of Porsches, or Hupmobiles, or astronauts on the moon—something really modern.[1]

Woodstock Pastorale by Jack Levine (born 1915) is one of the artist's earliest paintings based on classical mythology—a new interest he developed in 1946. He said it was his way of integrating nude female figures into his compositions, which he took up with relish.[2] Levine described his reason for painting this odd collection of deities as a desire to "get some of the same qualities that I've seen in Rubens. . . . a subject that might be conducive to paint that way."[3] *Woodstock Pastorale* was also a satire in mythological dress, mocking the joyful camaraderie that prevailed in artists' colonies like Woodstock, New York, where he and his wife spent some time.[4] Levine improvised a classical theme rather than portraying an actual mythological subject, but his study of the old masters made him knowledgeable about the attributes of the ancient gods and goddesses. *Woodstock Pastorale* displays a rollicking lineup of rather ungainly mythological characters: a red-capped goddess balancing a basket of fruit on her head who is the object of Cupid's dart;[5] a pudgy, wreathed Bacchus playing panpipes; Pan himself, seated cross-legged and playing a small French horn; and Venus,[6] looking faintly alarmed, either by the music or her love-struck companion. The figures fill the canvas from top to bottom; their oversize heads and animated faces are emphasized, while Levine's Rubensian colors and open, expressive brush-work enliven an already lively scene. Especially appealing is the uneven row of feet (and hooves) across the bottom of the picture, which lends a slightly chaotic syncopation, as though in response to (dissonant?) sounds of the horn and pipe.[7]

Born in Boston, Jack Levine received his artistic training at the Boston Museum School with Harold Zimmerman, who gave him firm grounding in academic drawing and the techniques of artists of the past; he studied painting with Denman Ross, professor emeritus at Harvard, who taught him about design

186

Plate 57
Jack Levine
American, born 1915
Woodstock Pastorale, 1949
Oil on canvas, 25 x 31 inches (63.5 x 78.7 cm)
Collection of C. K. Williams, II

and color theory. Now in his nineties, Levine is a masterful painter whose work is not sufficiently appreciated today. Throughout his career he has adhered firmly to the grand tradition of fine draftsmanship and old master European painting methods and techniques employed by favorite artists, such as Rembrandt, Rubens, Titian, Velásquez, and El Greco. Levine's subject matter, while wide ranging, is also very much in line with the great old masters. When he emerged as a highly successful young artist in New York in 1937, his satiric paintings of street scenes, cardplayers, and politicians aligned him critically with Social Realist painters such as Ben Shahn and William Gropper. Over subsequent decades, however, he broadened his range of subjects to include religious, mythological, historical, and literary themes, often bringing them up to date and leavening them with his own brand of acute, humorous satire. Levine's grasp of human response to dramatic situations is formidable, as is his keen ability to select trenchant subject matter. Unlike many artists, Levine has the ability to define verbally what he does in his art, and while his style and approach have naturally evolved over his long career, he has not wavered in his mission to achieve "mastery over the image,"[8] which he sees as a prerequisite for every artist's achievement.

1. Jack Levine, with an introduction by Milton W. Brown, *Jack Levine* (New York: Rizzoli, 1989), p. 114.

2. Ibid., p. 43.

3. Ibid., p. 47.

4. Levine, in a conversation with the author, May 4, 2007.

5. Levine associates the red cap worn by this figure with that of the Parisian personification of Liberty.

6. The position of the arms of this figure loosely resembles the modest pose of the Venus Pudica, while her garment revealing one breast is characteristic of the Venus Genetrix. Levine claims that this figure refers to a friend's wife he admired at the time.

7. In 1952 Levine made an etching of *Woodstock Pastorale*, which was printed in 1969. The image appears in reverse and is not an exact replica of the painting. See Kenneth W. Prescott and Emma-Stina Prescott, *The Complete Graphic Work of Jack Levine* (New York: Dover Publications, 1984), pl. 3.

8. Levine, *Jack Levine*, p. 7.

MARTIN LEWIS

RAIL YARDS FROM WEEHAWKEN, NEW JERSEY

1913–15

The rugged cliffs of the Hudson Palisades towering over the rail yards at Weehawken, New Jersey, the steam billowing from the locomotives, and the distant view of the Manhattan skyline along the Hudson River provided an enthralling vista for American artists in the 1910s, romantically combining as it did so many elements of contemporary industrial progress. No less so for Australian-born Martin Lewis (1881–1962), who had arrived in New York sometime about 1900 seeking employment as a commercial artist. His first documented work of 1909 is a pencil drawing of the Palisades,[1] followed over the next decade by several paintings of Weehawken, and in 1915 by his first etchings. *Rail Yards from Weehawken, New Jersey* may be dated stylistically by its similarity to two small paintings Lewis made along the banks of the Hudson about 1913–15; all three were painted in oil, on panels measuring eight by ten inches.[2] Created in the autumn, before red-brown leaves had fallen from the trees along the cliff, Lewis framed his view of the rail yards with the tall, dark profile of jagged rock—early evidence of a compositional device he employed frequently throughout his career.[3] Below, the tracks bend and curve toward the river, punctuated by white puffs of steam from the engines; Manhattan stretches in a pale haze along the distant shore. Lewis's palette is nearly monochromatic, restricted to shades of violet, gray, and red-brown. His curving brushstrokes trace the trailing lines of the tracks that converge in the distance in broken segments of color, recalling the work of such American Impressionists as Childe Hassam and Ernest Lawson.[4]

While not related stylistically, it is nearly impossible to look at Lewis's views of Weehawken without thinking of John Marin, for whom the site held endless fascination during exactly the same years. Marin may have begun painting the rail yards and grain elevators there as early as 1903, but it is certain that the subject had become one of his favorites in 1910,[5] when he portrayed it in at least a dozen watercolors and a few paintings. Marin's Weehawken watercolors seem light, radiant, and expressionistic compared with Lewis's more structured compositions that often concentrate on the dark, dramatic forms of the rocks towering over the rail yards and the distant cityscape. There is little doubt that Lewis was familiar with Marin's work,

Plate 58
Martin Lewis
American, born Australia, 1881–1962
Rail Yards from Weehawken, New Jersey, 1913–15
Oil on panel, 10 x 8 inches (25.4 x 20.3 cm)
Collection of C. K. Williams, II

which was shown almost annually at Alfred Stieglitz's gallery
291. In February 1911 Stieglitz's *Exhibition of Recent Water-
Colors—the Tyrol and Vicinity of New York* included Marin's
watercolor entitled *Weehawken Series* (1910),[6] while Stieglitz's
January 1913 exhibition also featured Marin's New York
watercolors. However, instead of drawing inspiration from
Marin's work, Lewis found Stieglitz's own photographs
of interest, as well as those of other Photo-Secessionists
whose work was shown at 291 and published in Stieglitz's
magazine *Camera Work*. Although less evident in *Rail Yards
from Weehawken, New Jersey*, some of Lewis's other paint-
ings of the same date show how close his work came to
photography in their monochrome tonalities, their selectivity
of vision, and their atmospheric forms diffused by light.[7]
Although Lewis never became a photographer, these predi-
lections led ultimately to his preference for printmaking,
the medium for which he is best known.

1. Paul McCarron, *The Prints of Martin Lewis: A Catalogue Raisonné* (Bronxville,
NY: M. Hausberg, 1995), p. 12.
2. *Hudson River with Orange Sheds* and *Hudson River Sloop and Rail Yards* are
reproduced in *Martin Lewis: Retrospective Exhibition* (New York: Kennedy
Galleries, Inc., 1973), p. 8, figs. 3, 5.
3. Ibid., p. 4.
4. Ibid., p. 6. Most comparable to the present painting is *"Looking Down"
above the Tunnel—Weehawken* (1915), one of Lewis's first etchings, where a
dark tree and figure are perched on the cliff looking down at a train steaming
along the curving track. See McCarron, *The Prints of Martin Lewis*, p. 55, no. 5.
5. See Marin's paintings of Weehawken in this catalogue (pls. 62–64).
6. Sheldon Reich, *John Marin: A Stylistic Analysis and Catalogue Raisonné*, pt.
2, *Catalogue Raisonné* (Tucson: University of Arizona Press, 1970), no. 10.90.
7. Barbara Blackwell, *Emerging from the Shadows: The Art of Martin Lewis,
1881–1962*, exh. cat. (Ithaca, NY: Herbert F. Johnson Museum of Art, Cornell
University, 1983), p. 10. See, for example, *Old Post Office, New York City*
(1913), reproduced on p. 11.

LOUIS LOZOWICK

FACTORY BUILDINGS, NEW JERSEY
c. 1930

I changed to a more realistic [style]. I do not think it was due to a feeling of guilt but it was due to a feeling that this was a little bit more adequate to the times. But I still retained the formal qualities that were found in my earlier work. . . . My work was industrial, factories and so on. I always believed, then and now, that this does not necessarily represent capitalism; it represents something that will ultimately be the property of the worker.[1]

Born in Russia, where he received his early training, Louis Lozowick (1892–1973) moved to New York as a teenager and studied briefly at the National Academy of Design. After graduation from Ohio State University and service in World War I, he spent three crucial years between 1920 and 1923 in Paris and Berlin, where contact with artists and writers introduced him to the theme of industrialization found in the work of Fernand Léger, Dada, De Stijl, and Russian Constructivism. Of these, Constructivism most held his attention, and when he returned to New York, he not only lectured and wrote on that subject, but he also developed his own brand of machine aesthetic, evident in vivid Precisionist paintings of industry in American cities and in severe black-and-white ink drawings of machines that he called "machine ornaments." Along with his work as a lithographer, Lozowick is best known for his Precisionist paintings and drawings from the first half of the 1920s. Less familiar are his more somber, realistic depictions of American industrial sites, which he started to make about 1928, not only in paintings but also in lithographs. The present watercolor, *Factory Buildings, New Jersey* exemplifies the emergence of the change in style Lozowick describes in the statement above.[2]

In 1928 Lozowick made a trip to Russia, where he gave a lecture on contemporary American painting and attended an exhibition of his work at the Museum of Western Art in Moscow (now the Pushkin Museum). He had not been in Russia since 1922, but his art and writings were still held in high regard there, particularly because of the publication of his lectures as *Modern Russian Art* by the Société Anonyme and the Museum of Modern Art, New York, in 1925. During this later trip Lozowick observed that the machine aesthetic of Constructivism appeared to be on the wane, and that Soviet artists were moving away from

Plate 59
Lewis Lozowick
American, born Russia, 1892–1973
Factory Buildings, New Jersey, c. 1930
Watercolor and gouache, with pen and brush and ink, on laid paper; 18 ¹/₁₆ x 25 ¼ inches (45.9 x 64 cm)
Collection of C. K. Williams, II

abstraction toward realism and social content. Soon after his return to New York, his own heretofore clean, vividly colored, semi-abstract renderings of urban American industrial themes began to change in a similar way. This came about not only because of the new realism in Soviet art but also because of the films and theatrical productions he saw, as well as from his involvement with Michael Gold, editor of the radical publication *The New Masses*, who advocated realistic documentation of American life in "proletarian art."[3] At the same time that he altered his style, Lozowick became interested in appealing to mass audiences, and after 1927 lithography became his major medium.

In turning to realism in the late 1920s, Lozowick set aside his treatment of industrial buildings as hard-edged geometric blocks against flat, cloudless skies painted in imaginary colors,[4] but he did not entirely abandon his tendency to simplify forms. In *Factory Buildings, New Jersey,* for example, this may be seen in the clear, geometric shapes of the buildings and their stylized reflections in the river. Lozowick did, however, adopt a more radical handling of color. Instead of the flat, brilliant, unreal colors of his earlier paintings, he used the dull local colors of the industrial landscape, as in *Factory Buildings*, where the faces of the buildings and machinery are grayed by smoke and grime. He painted the sky a mottled blue, partially obscured by a billowing cloud of white smoke that disperses to create a whitish gray haze around the buildings.

The dating of *Factory Buildings* to about 1930 is based on its relationship to Lozowick's 1930 lithograph *River Front, New Jersey* (fig. 34), which depicts another view of the same site, identified as either Hoboken or Weehawken, the Hudson River ports he drew frequently.[5] He approached the site from a closer point of view in the watercolor, focusing on the detail of the buildings and machinery rather than showing them at a distance, as they appear in the lithograph, stretching horizontally between sky and water.

1. Lozowick, interview by Gerald M. Monroe, April 24, 1972, quoted in Virginia Carol Hagelstein Marquardt, ed., *Survivor from a Dead Age: The Memoirs of Louis Lozowick* (Washington, DC: Smithsonian Institution Press, 1997), pp. 267–68.
2. Virginia Carol Hagelstein Marquardt particularly makes a point of the continuity in Lozowick's work, stressing his purposeful synthesis of realism and abstraction after 1928. See Marquardt, "Louis Lozowick: Development from Machine Aesthetic to Social Realism, 1922–1936" (Ph.D. diss., University of Maryland, 1983), chap. 5.
3. Ibid., pp. 112–14.
4. See, for example, his paintings *Pittsburgh* (1922–23) and *Chicago* (1923), reproduced in Karen Tsujimoto, *Images of America: Precisionist Painting and Modern Photography*, exh. cat. (Seattle: University of Washington Press, published for the San Francisco Museum of Modern Art, 1982), pls. 6–7.
5. *Fine American and European Paintings*, exh. cat. (Philadelphia: Schwarz Gallery, 1991), no. 41. The watercolor is clearly independent of the lithograph; Lozowick's customary preparatory studies for his prints were black-and-white crayon drawings.

Fig. 34: **Lewis Lozowick**
American, born Russia, 1892–1973
***River Front, New Jersey**,* 1930
Lithograph; image 5 1/8 x 12 7/16 inches (13 x 31.7 cm), sheet 11 1/2 x 16 inches (29.2 x 40.6 cm)
Philadelphia Museum of Art. Purchased with the Lola Downin Peck Fund from the Carl and Laura Zigrosser Collection. 1980-3-85

MAN RAY

WOOD INTERIOR
1914

At a time when painting, far outdistanced by photography in the pure and simple imitation of actual things, was posing to itself the problem of its reason for existence, . . . it was most necessary for someone to come forward who should be not only an accomplished technician of photography but also an outstanding painter. . . . It was the great good fortune of Man Ray to be that man.[1]

The acclaim of Man Ray (1890–1976) as a photographer far outstrips his reputation as a painter, and yet his paintings show that he was a strong and original talent. Never bound by convention and ever seeking alternatives to the norm, Man Ray's earliest interest was in mechanical drawing. By the time he left high school in 1908, he had decided to become an artist, beginning as an engraver's apprentice and taking on other commercial art jobs before entering life drawing classes in New York at the National Academy of Design and at the Art Students League in 1910 and 1911, respectively. He found, though, that each of them was too restrictive for his independent spirit. The recently established Ferrer Center, with its openness to new and unconventional approaches to artistic practices, where Man Ray enrolled in 1912, was better suited to his temperament. In classes taught by Robert Henri and George Bellows, artists such as Ben Benn, Samuel Halpert, Max Weber, William Zorach, as well as Man Ray, made twenty-minute sketches from the model instead of traditional finished anatomical renderings. Man Ray also became exposed to avant-garde art through association with Weber, one of the first artists in New York who had witnessed European modernism firsthand. He also avidly frequented Alfred Stieglitz's gallery 291, where he observed the freedom of Paul Cézanne's spare watercolors (March 1911), Auguste Rodin's drawings of nudes (1910), as well as drawings and collages by Pablo Picasso (1911). Although he wrote for Stieglitz's magazine *Camera Work* and learned much from conversations with Stieglitz, Man Ray never exhibited his work at 291.[2]

As would be expected with his modernist leanings already in place, in early 1913 Man Ray found the Armory Show a life-changing experience, and he claimed that its impact rendered

Plate 60
Man Ray (Emmanuel Radnitzky)
American, died Paris, 1890–1976
Wood Interior, 1914
Oil on canvas, 18 x 21 inches (45.7 x 53.3 cm)
Collection of C. K. Williams, II

him unable to work for six months afterward.[3] Following this period of inactivity, a series of wide-ranging and stylistically eclectic paintings in 1913 and 1914 show that he was working through a number of influences, yet always maintaining his independence and seeking alternatives to what others had done. Man Ray, unlike other American modernists, such as Weber, Marsden Hartley, and Arthur Dove, had not yet been to Paris, but in fundamental ways he followed a path similar to theirs by trying out a variety of styles while freeing his art from naturalistic form and local color. Man Ray had many strings to his bow, and his work had a distinctive character that combined aspects of his training in commercial art, his interest in decorative design, and influences from the work of European and American contemporaries. Dark outlines often dominated, as did a preference for applying colors in agitated parallel strokes. His subjects remained traditional ones: nudes, portraits, still lifes, and landscapes. While his figure paintings exhibit the most experimentation with abstraction, it was in landscape that he made his most innovative strides in freeing himself from direct observation of nature. Initially, they ranged from busy, loosely brushed watercolors of dappled forest depths, to stacks of varicolored cubic houses emerging from speckled foliage, to hills and fields rendered as broad strips receding toward a distant horizon. In the fall of 1914, however, feeling that "sitting in front of the subject might be a hindrance to really creative work,"[4] he made the decision to stop painting directly from the motif and instead to make imaginary landscapes from memory, so that his compositions and colors became subjective and expressionistic. *Wood Interior* (one of two paintings with that title)[5] falls into the latter category. Beyond an outcropping of rocks springs the red trunk of a pine tree with spreading branches à la Cézanne, their forms defined and illuminated by a moon surrounded by a golden aura.[6] Forms are outlined in heavy black, as they often are in Man Ray's paintings of this period, while colorful stripes and zigzags painted in agitated brushstrokes underline the artist's strong sense of design; his unique combination of dark outlining and jewel-like color here bear some resemblance to stained glass.

Although Man Ray exhibited regularly in group and solo shows at the Daniel Gallery in New York between 1915 and 1919, as well as elsewhere in New York and other American cities, his permanent departure from New York for Europe in 1921 and his subsequent fame as a photographer account for the relative obscurity of his genuine accomplishment as a painter during his New York period. Several key early paintings now in museums came from prescient collectors of Man Ray's early work, such as Ferdinand Howald and A. E. Gallatin and, later, Duncan Phillips and Joseph Hirshhorn, but many of the paintings from this period have been lost, destroyed, or still remain in private hands.

1. André Breton, *Surrealism and Painting*, trans. Simon Watson Taylor (London: Macdonald and Company, 1972), pp. 32–33.
2. The principal source of biographical information cited here is Francis M. Naumann, *Conversion to Modernism: The Early Work of Man Ray* (New Brunswick, NJ: Rutgers University Press, in association with Montclair Art Museum, 2003).
3. Merry Foresta et al., *Perpetual Motif: The Art of Man Ray* (New York: Abbeville Press, in association with the National Museum of American Art, 1988), p. 55.
4. Man Ray, *Self Portrait* (Boston: Little, Brown and Company, 1988), p. 52.
5. Francis M. Naumann, "Man Ray and America: The New York and Ridgefield Years, 1907–1921" (Ph.D. diss., City University of New York, 1988), vol. 2, p. 557, nos. 130–31, lists two oil paintings entitled *Wood Interior*, with no locations indicated. Man Ray's card file, also catalogued by Naumann, lists three works with that title, p. 508, nos. 14–16. A watercolor titled *Wood Interior* (1913) is reproduced in Man Ray, *Self Portrait*, p. 43; it bears certain similarities to the present painting, though it lacks the moon.
6. Naumann, *Conversion to Modernism*, pp. 87–88, suggests that this painting may be based on a lightning storm Man Ray wrote of in his *Self Portrait*: "With each illumination the landscape stood out as in daylight, but with a quality of intense moonlight."

MAN RAY

FEMALE FIGURE
1923

In 1923 Duchamp came back . . . to Paris for a prolonged stay. . . . I was now definitely established as a photographer, but produced a painting now and then to keep myself in form and also in touch with the current art movements. . . . I set about to do a portrait of him in oils, but, influenced by the many photographic portraits I had made of him, the work was in black and sepia, mimicking a photograph. . . . It was neither a painting nor a photograph; the confusion pleased me and I thought this should be the direction my future painting would take.[1]

Man Ray (1890–1976) created *Female Figure* in the same year as the portrait of Duchamp mentioned above. Although it is a more abstract image, *Female Figure* similarly shows the influence of photography on Man Ray's paintings at the time he was producing his first Rayographs. The white and ocher outlines, which barely define the form of an active, angular nude woman against a dark ground, are thickly and roughly applied, almost as though they were squeezed directly from the paint tube (a technique Man Ray described using for a painting he made the following year).[2] The figure's arms and legs are simply indicated by straight lines disposed at right angles and perpendiculars; luminous highlights are merely indicated by daubs of white paint applied with a patterned regularity that appears almost mechanical. The angularity, jerky movements, and the truncated nature of the woman's body recall figures in a number of the artist's earlier paintings, going back as far as *Dance* (1915).[3] However, other elements in the painting resemble those in Man Ray's contemporaneous experiments in photography, such as the rows of small dots in the upper right of the painting, which give the effect of a grater (or, rather, the way a grater would look in one of Man Ray's Rayographs)—a white form in negative appearing against a dark background (fig. 35). Compositionally too, *Female Figure* resembles the frequent diagonal disposition of forms in the Rayographs of 1922–23, as well as the way in which the forms are often cut off at the border of the image. In this painting and others created at this moment, Man Ray attempted to achieve in a painting the effects of light, form, and texture equivalent to those of a photograph.

Plate 61
Man Ray (Emmanuel Radnitzky)
American, died Paris, 1890–1976
Female Figure (Femme figure), 1923
Oil on panel, 13 ¾ x 10 ½ inches (34.9 x 26.7 cm)
Collection of C. K. Williams, II

Female Figure was acquired in the year of its creation by André Breton, the founder of the Surrealist movement and author of the first Surrealist manifesto in 1924. Breton lent the painting to the solo exhibition of Man Ray's work in 1926—the first to be held at the new Galerie Surréaliste in Paris. Commenting on the work he exhibited there, Man Ray wrote: "aside from two or three works created since the birth of the new movement, I showed again my things of the Dada period. They fitted in just as well with the Surrealist idea."[4]

1. Man Ray, *Self Portrait* (Boston: Little, Brown and Company, 1988), p. 185.
2. See *Regatta* (1924) reproduced in ibid., pl. 13. On p. 160 Man Ray described making this picture: "Without brushes, painting directly with the tubes, I sketched in the boats, the sails black against the sky, and the sun in swirls of pure colors behind them."
3. *Dance* is reproduced in Francis M. Naumann, *Conversion to Modernism: The Early Work of Man Ray* (New Brunswick, NJ: Rutgers University Press, in association with Montclair Art Museum, 2003), p. 126, fig. 145.
4. Man Ray, *Self Portrait*, p. 214.

Fig. 35: **Man Ray** (Emmanuel Radnitzky)
American, died Paris, 1890–1976
Les champs délicieux 03, 1921–22
Rayograph, 8 ⅞ x 6 ⅞ inches (22.5 x 17.5 cm)
Fondazione Marconi, Milan

JOHN MARIN

GRAIN ELEVATORS AT WEEHAWKEN
c. 1910

WEEHAWKEN SEQUENCE #3
c. 1916 (1903–4?)

WEEHAWKEN SEQUENCE #41
c. 1916

One responds differently toward different things; one even responds differently toward the same thing. In reality it is the same thing no longer; you are in a different mood, and it is in a different mood.[1]

Best known for his watercolors and etchings, John Marin (1870–1953) also painted in oil throughout his career, usually during concentrated periods of time. Always favoring landscape as a subject, he generally returned to familiar sites, such as Manhattan, Maine (where he spent summers after 1914), as well as northern New Jersey near the Palisades, where he grew up and continued to live in the winters until his death. As a boy, Marin lived in Weehawken, New Jersey, and his earliest watercolors of the 1890s depicted the farms and houses in that region. After a year at the Stevens Institute of Technology, in Hoboken, New Jersey, he spent two years at the Pennsylvania Academy of the Fine Arts, followed by a year at the Art Students League, in New York. Marin spent most of 1905 to 1910 in Paris, where he claimed to have been unaffected by the art of Paul Cézanne and Henri Matisse, despite the fact that he showed his work in two of the salons in which their work was featured. Instead, Marin stated that he was introduced to the work of modern artists by Alfred Stieglitz, his dealer and chief promoter from 1909 until the latter's death in 1946.[2]

According to Sheldon Reich, Marin began to paint the grain elevators and railroad yards in Weehawken about 1910,[3] soon after his return from Europe; it was a subject he repeated many times from different points of view in watercolor, etching, and oil until about 1917. *Grain Elevators at Weehawken* is one of his earliest oil paintings of the subject.[4] Though it is not dated, it is stylistically very similar to watercolors dated 1910,[5] in which the subject is portrayed with relative fidelity to nature; here, even more than in the watercolors, he applied brilliant colors in vigorous, open brushstrokes in the foreground.[6] Marin's handling of the Weehawken scenes varied widely, often becoming nearly totally abstract, as in a series of etchings he made between 1915 and 1917 and in some of the paintings in

the Weehawken Sequence, which seem to have been painted over a number of years, possibly starting as early as 1903 and continuing until 1916.

The Weehawken Sequence, of which two are shown here, was a series of about one hundred paintings measuring approximately nine or ten by twelve, or ten by fourteen, inches. Showing views of the North River and the industrial buildings of Weehawken as well as views across the river to Manhattan, the styles of the paintings are quite diverse, ranging from fairly straightforward realism to near total abstraction; some of them, such as *Weehawken Sequence #3,* are made up of large, interlocking color shapes; others show the dynamic brushwork characteristic of Marin's watercolors. The palette of predominantly blue, peach, ocher, and rose, seen in both of the present paintings, is typical of many in the series. While *#3* is so abstractly handled that the site cannot be identified, *#41* may be compared with the same diagonal view of buildings in Marin's 1910 watercolor *Warehouses and North River,* although the latter is handled in a less abstract manner.[7]

The paintings in John Marin's Weehawken Cliff Sequence, as the series was originally titled,[8] cannot be considered without reference to the controversy surrounding their dating. Until the paintings were first mentioned in 1947 by Marin's biographer MacKinley Helm and discussed by him in greater depth in his monograph in 1948,[9] they were unknown; the first time they were exhibited was at An American Place in 1950.[10] To summarize: during the 1940s Marin told Helm that he painted the series during the winters of 1903 and 1904. At the same time, Marin inscribed some of the paintings on the reverse "Painted between 1903–1904"; the painting here titled *Weehawken Sequence #3* is so inscribed. The controversial point is that if Marin made all of the Weehawken paintings in 1903 and 1904, the abstract compositions might be seen as groundbreaking works, preceding any knowledge of Cubism and created well in advance of experimentations with abstraction by other American artists—a fact Marin would have been well aware of in the 1940s when he assigned dates to the series.

The dates ascribed by Helm and Marin survived until 1970, when Reich redated the series on the basis of stylistic correspondences to Marin's work of 1912–16; Reich came out strongly in favor of dating the paintings about 1916.[11] Until recently, scholars have wavered between the dates advanced by Helm and Reich. Beginning with Ruth Fine in 1990,[12] a more expansive approach has been advanced, with a well-reasoned proposal that Marin probably worked on the series between 1910 and 1916. A more complicated but interesting suggestion of Barbara Rose places some of the paintings in 1903–4 (specifically, those that Marin inscribed with that date), others right after Marin's return from Europe in 1910, and the remainder between 1910 and 1915.[13] In this author's opinion, the wider range of dates proposed by Fine and Rose makes sense. Moreover, it is useful to revisit the idea that some of the paintings in the series were done as early as 1903 and 1904 simply because of the detailed nature of Marin's remembrance of making them, as recorded by Helm:

> Using as medium a mixture of turpentine, linseed oil, and varnish, Marin worked out of doors, applying the pigments with the greatest rapidity, sometimes with palette knife, in midwinter temperatures which froze the paint to the canvas. Crowded with color and form, the little pictures explored the North River. . . . Marin thinks of this work as largely intuitive, not so well schooled as the drawings. He received personal visions which he set down in color as directly as possible—and with a swiftness inspired by intemperate weather. . . . "I was looking at the world and wanted to put it down in paint, *all* of it."[14]

If one extracts Helm's romantic imaginings of Marin's "wistful face frosted under a rimed circlet of bangs, his numbed fingers clutching his small, frozen paintings"[15] from his account of Marin's recollections of the practical circumstances involved in making the paintings—the cold and the technical difficulties—as well as what Marin said he was trying to achieve in making them, the account has a ring of authenticity. Admittedly, Marin's recollections do not help to clarify the dating, but they do show his clear memory of making the paintings at the time

Plate 62
John Marin
American, 1870–1953
Grain Elevators at Weehawken, c. 1910
Oil on canvas, 20 x 24 inches (50.8 x 61 cm)
Collection of C. K. Williams, II

Plate 63
John Marin
American, 1870–1953
Weehawken Sequence #3, c. 1916 (1903–4?)
Oil on canvas board, 9 ½ x 12 ¼ inches (24.1 x 31.1 cm)
Collection of C. K. Williams, II

Plate 64
John Marin
American, 1870–1953
Weehawken Sequence #41, c. 1916
Oil on canvas board, 9 ½ x 12 ¼ inches (24.1 x 31.1 cm)
Collection of C. K. Williams, II

of the dates he inscribed on some of them. There is no doubt that Marin always nurtured the image of his art as having been formed in a vacuum, untainted by outside influence—a myth that the early dating of the Weehawken paintings would help sustain. Still, thinking of them as Rose did, in relation to the long tradition of the oil sketch rather than as the first flowering of abstract painting,[16] opens the possibility that Marin's early dating might be correct for some of the Weehawken paintings.

1. Marin, in *The Forum Exhibition of Modern American Painters*, exh. cat. (New York: Anderson Galleries, 1916), n.p.

2. For the most complete recent treatment of Marin's career, see Ruth E. Fine, *John Marin*, exh. cat. (Washington, DC: National Gallery of Art, in association with Abbeville Press, 1990).

3. Sheldon Reich, *John Marin: A Stylistic Analysis and Catalogue Raisonné*, pt. 1, *A Stylistic Analysis* (Tucson: University of Arizona Press, 1970), p. 40. It is possible that Marin began to paint in Weehawken as early as 1903, as is discussed in the text.

4. The Weehawken Grain Elevator in the painting was a 160-foot-tall, tin-roofed grain elevator operated by the New York Central Railroad. It was called the West Shore Elevator and Pier 7. See images of the structure at www.weehawkenhistory.org.

5. See Reich, *John Marin*, pt. 2, *Catalogue Raisonné*, p. 355, no. 10.84; p. 356, nos. 10.89–.90. *Weehawken Railroad Yards and Grain Elevators* is reproduced in color in Fine, *John Marin*, p. 116, pl. 104.

6. Reich, *John Marin, Catalogue Raisonné*, p. 419, no. 16.18, inexplicably dates this painting to 1916, and he reproduces it twice with the catalogue numbers 16.18 and 16.48. While 16.18 corresponds to the present picture, 16.48 is probably the painting with the same title, date, and dimensions reproduced in Larry Curry, *John Marin, 1870–1953*, exh. cat. (Los Angeles: Los Angeles County Museum of Art, 1970), p. 40, pl. 48.

7. The 1910 watercolor is reproduced in Reich, *John Marin, Catalogue Raisonné*, p. 355, no. 10.84.

8. See Fine, *John Marin*, p. 117.

9. MacKinley Helm, *John Marin* (Boston: Pellegrini & Cudahy, in association with the Institute of Contemporary Art, 1948), pp. 9–10.

10. *John Marin: Oils—1903–1950*, unillustrated checklist (New York: An American Place, 1950).

11. Reich, *John Marin, A Stylistic Analysis*, pp. 85–98. Reich (pp. 88–90) describes the way in which Helm and Marin catalogued the paintings, relying on the artist's recollection, the recognition of the subject, and Helm's chronology.

12. Fine, *John Marin*, pp. 117–19.

13. *John Marin: The 291 Years*, essay by Barbara Rose (New York: Richard York Gallery, 1998), p. 10.

14. Helm, *John Marin*, p. 9. Emphasis in original.

15. Ibid., p. 10.

16. In *John Marin: The 291 Years*, p. 10, Rose wrote: "One explanation for the abstractness and lack of detail of these early oil sketches is that, like Gustave Moreau's studies, they were technical experiments that coincidentally appear abstract. It is more likely, however, that they are tied to the academic tradition of producing an oil sketch in advance of a complex, large-scale work, laying out mass and tone generally in broad areas of color and shadow."

REGINALD MARSH

GAYETY BURLESK

1932

Reginald Marsh (1898–1954), a graduate of Yale from a well-to-do family, arrived in New York in the 1920s with the intention of becoming an illustrator. He was employed to make drawings for the *New Yorker* magazine and began studies at the Art Students League in 1922 with George Luks, George Bridgman, and Kenneth Hayes Miller. In 1924 an exhibition of his paintings and watercolors was held at the Whitney Studio Club, and, following a trip to Europe in 1925, he returned to study again with Miller, who had a profound influence on his work. Marsh, along with Miller and Isabel Bishop, all of whom had studios on Fourteenth Street in the 1920s, concentrated on portraying the ordinary people of New York in their immediate surroundings. Miller, who encouraged Marsh to study the images and techniques of old master painters, also provided sharp insight into the heart and soul of the younger artist's work, observing, "You are a painter of the body. . . . Sex is your theme."[1]

As a painter of the human body, Marsh focused on individual figures, small groups, or surging masses engaged in strictly contemporary activities that took him from one end of New York to the other: Coney Island beaches, dance halls and burlesques, bums in the Bowery, daily life around Fourteenth Street. Sex was indeed his favorite theme, most often evident in paintings, drawings, and etchings of the public displays of scantily clothed women in burlesque theaters performing before leering male audiences, subject matter that accounts for nearly one-third of his oeuvre.[2] Marsh's comment on the burlesque is noteworthy, revealing an ambivalent attitude toward the subject, which separates his judgment of the social phenomenon of the burlesque from his aesthetic enjoyment of it:

> The burlesque show is a very sad commentary on the state of the poor man. It is the only entertainment, the only presentation of sex that he can afford. . . . As for painting it, the whole thing is extremely pictorial. You get a woman in the spotlight, the gilt architecture of the place, plenty of humanity. Everything is nice and intimate, not spread out and remote as in a regular theatre. Here you can get the complete setting, it's all compact.[3]

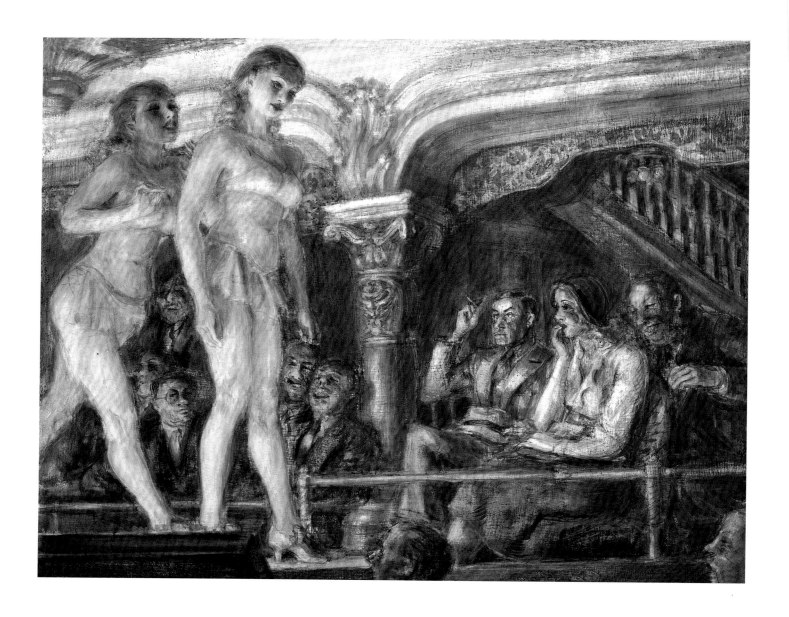

Plate 65
Reginald Marsh
American, born Paris, 1898–1954
Gayety Burlesk (Gayety Burlesque), 1932
Tempera on paper, mounted on panel; 24 x 30 inches (61 x 76.2 cm)
Collection of C. K. Williams, II

But his response was apparently even more complicated. In *Gayety Burlesk (Gayety Burlesque)* it is neither the poor man's only entertainment that one encounters, nor the artist's purely aesthetic response to the spectacle. Instead, we see a well-dressed audience reacting with a combination of bawdy laughter, unabashed gawking, world-weary nonchalance, and (in the case of the single female spectator) nail-biting nervousness. This is an audience of well-to-do people slumming—out of their usual social milieu for a night of lewd entertainment. Their generally amused reactions imply that more of the performance is going on than one sees, for only a small portion of it is visible: two towering female dancers stride awkwardly and rather tentatively forward, their barely clothed bodies and masklike faces lit from below and their eyes exaggerated by thin black outlines.

A recent study of Marsh's burlesques by Michele L. Miller adds considerably to the interpretation of this painting, based in part on her identification of two sketches Marsh made at the Gayety Burlesque Theater in Brooklyn in March 1932. The sketches demonstrate that in the development of the unfinished etched version of the subject and of the final painting[4] Marsh transformed the attitude of the woman in the audience from a confident spectator to a cringing and vulnerable creature: "As an image of the burlesque theater, *Gayety Burlesque* is unusual not only because it contains a woman in the audience, but because it goes further than any other image in suggesting that the burlesque theater was a space into which women were not welcome, even implying that it was ominous and potentially threatening to them."[5]

Gayety Burlesk also conforms quite well to Kathleen Spies's reading of Marsh's burlesques, which is partly documented by the artist's correspondence with his major patron, William Benton. Spies points out that (as in *Gayety Burlesk*), Marsh routinely excluded male comedians from his portrayals of burlesque performances so that the laughs of the spectators were directed solely at the clumsy female dancers: "Marsh highlighted the link between sex and humor that was essential to the grotesque character of the burlesque. This pairing

allowed him to capture the ambivalent reaction to the exposed lower-class female body, a response that alternated between desire, humor, and disgust."[6] A further revelation of the complexity of Marsh's response to his favorite subject was provided by his artist friend Adolf Dehn, who observed how Marsh always distanced himself from the seamy burlesque performances by obsessively sketching, concentrating more on drawing the details of the architecture than the performers.[7]

Marsh largely abandoned oil painting in 1929, when he was introduced to egg yolk tempera, which was perfectly suited to his desire not to obliterate the underdrawing beneath his painted surface.[8] With this medium he could draw his composition on paper or a gessoed panel, then apply many layers of transparent colored glazes without obscuring the drawing. Marsh's intention to concentrate on the varied expressions of the audience in *Gayety Burlesk* becomes apparent in his precise linear definition of each of their faces and bodies, thereby heightening their emotions and gestures. These important details emerge from under a subdued palette of colored glazes, which Marsh laid on with his characteristically nervous, agitated strokes.

1. Marilyn Cohen, *Reginald Marsh's New York: Paintings, Drawings, Prints and Photographs* (New York: Whitney Museum of American Art, in association with Dover Publications, 1983), p. 24.
2. Kathleen Spies, "'Girls and Gags': Sexual Display and Humor in Reginald Marsh's Burlesque Images," *American Art*, vol. 18, no. 2 (Summer 2004), p. 34.
3. Marsh on burlesque, quoted in *Reginald Marsh, 1898–1954: Paintings and Works on Paper*, exh. cat. (New York: Hirschl & Adler Galleries, 1985), no. 11.
4. According to a note in Marsh's desk calendar, Marsh began this painting on April 14, 1932; four days earlier he had started another version of the composition in an etching that he never completed. See Norman Sasowsky, *The Prints of Reginald Marsh* (New York: Clarkson N. Potter, 1976), p. 182.
5. Michele L. Miller, "'The Charms of Exposed Flesh': Reginald Marsh and the Burlesque Theater" (Ph.D. diss., University of Pennsylvania, 1997), pp. 81–83, at 81.
6. Spies, "'Girls and Gags,'" p. 55.
7. Ibid., p. 54.
8. *Reginald Marsh: A Retrospective Exhibition*, introduction by Thomas H. Garver, exh. cat. (Newport Beach, CA: Newport Harbor Art Museum, 1972), n.p.

JAN MATULKA

THE WHITE OAK

c. 1923

One of the favorite subjects of Jan Matulka (1890–1972) in the mid-1920s was the image of a huge, bare tree with gnarled branches, sometimes silhouetted against a blank background or more often dominating a landscape with cows and farm buildings. Matulka's tree series is frequently said to have been inspired by his 1921 visit to the farm in Czechoslovakia where he had grown up.[1] This may have had something to do with his fondness for a bucolic subject, but an even more direct source of inspiration were Fernand Léger's *paysages animés* (animated landscapes) that he saw in Paris in the early 1920s, which, more than coincidentally, depict monumental bare trees looming over men and cows set against geometric architectural forms (fig. 36).[2] Nonetheless, in paintings such as *The White Oak*, Matulka made the subject his own, imbuing it with a lively animation quite different from the solidity and monumentality of Léger's static, interwoven forms.

Matulka spent most of his time between 1920 and 1924 in Paris, but that was not his first exposure to modern art, which he saw in New York during the 1910s. Born in 1890 in Czechoslovakia, he moved with his family to New York in 1907 and entered the conservative National Academy of Design the following year. While there is no documentation of his having visited the Armory Show in 1913 or the Forum Exhibition of Modern American Painters in 1916, not to mention other New York gallery exhibitions, his work began to show the influence of Cubism in about 1917 in paintings of monumental nude figures with their bodies rendered in faceted planes. Following the award of a travel grant from the National Academy in 1918, Matulka went to New Mexico and Arizona, a trip that inspired paintings and watercolors of Indian dancers, similarly showing an energetic rendition of Cubism. By the time he reached Paris in 1920, Matulka was already launched as a modern artist; his well-known attraction to Léger's work and his imitations of the *paysages animés*, bolstered by the farm imagery of his native Czechoslovakia, propelled him to one of his strongest series of paintings.

Plate 66
Jan Matulka
American, born Czechoslovakia, 1890–1972
The White Oak, c. 1923
Watercolor on paper, 18 x 12 inches (45.7 x 30.5 cm)
Collection of C. K. Williams, II

The spirited style of *The White Oak* derives primarily from Matulka's animated application of patches of color to the branches, which give a syncopated rhythm to the twisting forms. His dissonant colors—royal blue and burnt umber, olive green and maroon, along with black—pool and blend into the paper; untouched areas of the white paper are used to lend volume to the protruding branches. Matulka also injects some humor with the slightly caricatured portrayal of the munching cow. It is not possible to date *The White Oak* firmly, nor may one establish a chronology for his many paintings of gnarled trees, for there is no significant change in his treatment of the subject. In fact, this is a common problem with all of Matulka's works, for he hardly ever dated them. Fortunately, one of his tree paintings is dated 1927, which suggests a date of the mid-1920s for the series. *The White Oak* appears to have been a composition that Matulka

found extremely satisfying, for he repeated it in another version that differs only slightly from the present one in its vantage point and in the slightly more mottled patterns of color on the tree branches.[3]

1. Patterson Sims, "Jan Matulka: A Life in Art," in *Jan Matulka, 1890–1972*, exh. cat. (Washington, DC: Smithsonian Institution Press, for the National Collection of Fine Arts and the Whitney Museum of American Art, 1980), p. 16.
2. Merry A. Foresta, "Matulka and the Modern Movement," in ibid., pp. 55, 58, 61. Foresta makes the connection between Matulka's tree compositions and Léger's *paysages animés*; she also cites as possible sources Charles Demuth's watercolors of spreading tree branches and the landscapes of André Lhote.
3. The other version of *The White Oak* is in the Hirshhorn Museum and Sculpture Garden, Washington, DC. It is reproduced in Abraham A. Davidson, *Early American Modernist Painting, 1910–1935* (New York: Harper & Row, 1981), p. 255, fig. 146.

Fig. 36: **Fernand Léger**
French, 1881–1955
Animated Landscape, 1921
Oil on canvas, 19 ⅞ x 25 ⅜ inches (50.5 x 64.5 cm)
Location unknown

JAN MATULKA

VIEW FROM SHIP

c. 1932

As a painter, he was the real thing. There is nothing false or unfelt in his work, nothing faked, nothing ill-understood. He knew what he was doing, and he did it well.[1]

Unlike many artists of his period, Jan Matulka (1890–1972) left no words to clarify what he was trying to accomplish in his art, but he must have been able to explain it in person. We know that he was a highly successful teacher at the Art Students League between 1929 and 1931, where he counted Francis Criss, Dorothy Dehner, Burgoyne Diller, Irene Rice Pereira, and David Smith among his students. A tribute written in 1980 by Dehner notes Matulka's bold concepts, unique palette, and unshakable convictions, and, most significantly, how he was in tune with current trends in art, literature, architecture, and music in New York as well as in Europe. All this he shared generously with his students, sending them to galleries to see an interesting show or letting them know that two Braques were on view at the French consulate.[2] Matulka's deep absorption of the styles of modern art, Cubism in particular, was apparent in his own work, and while he did not date most of his paintings, his shifting interests may be traced through the series that he made while under the influence of one or another artist or style. Matulka's work reveals that he was a clear thinker—serious, dedicated, and determined; he seems to have looked and thought harder than most, penetrating the essence of work by such artists as Pablo Picasso, Fernand Léger, the Precisionists, and Stuart Davis, and making it his own. Sometimes, he inserted his own objects into compositions clearly dependent on Picasso's still lifes; at others, as in his tree series (see pl. 66), he borrowed a subject from Léger and imbued it with an entirely different spirit. Derivative, yes, but always showing an authentic and unusually strong sense of design and pattern, executed with a palette of colors uniquely his own.

In *View from Ship* Matulka displays his absorption of the style and subject matter of his friend Stuart Davis, with whom he spent time during summers in Gloucester, Massachusetts, during the late 1920s and early 1930s. Davis had invented a distinctive method of constructing his compositions with a

Plate 67
Jan Matulka
American, born Czechoslovakia, 1890–1972
View from Ship, c. 1932
Oil on canvas, 36 x 30 inches (91.4 x 76.2 cm)
Collection of C. K. Williams, II

jigsaw puzzle of colored shapes, filled with carefully chosen and placed areas of pattern. Matulka's *View from Ship* is more complex and varied than any of Davis's compositions ever were, in color, pattern, and spatial complexity. What is astonishing here is the clarity that results despite so many oppositions and juxtapositions: the dramatic thrust into depth of the body of the ship and the boom versus the flat surface pattern created by parts of the rigging; and the multitudinous reversals and changes of direction of colors and patterns (white on blue, blue on white; patches of vertical, horizontal, and diagonal stripes). The odd color combinations also depart radically from Davis's usual adherence to the primaries plus black and white: all manner of shades of orange, green, tan, and gray enliven but do not overwhelm the dominant blue and white. All of this is held under control by Matulka's extraordinary sense of design: his instinctive knowledge of where to limit the amount of detail or color, of how to balance the large, bold forms with the detailed patterns and shapes, as well as his sense of when to add a note of humor and pure decorative fantasy, as in the cameo appearance made by the ship's captain looking drolly out from his quarters below.

1. Hilton Kramer, "The Pictorial Styles of Jan Matulka," *New York Times*, October 31, 1970.
2. Dorothy Dehner, "Memories of Jan Matulka," in *Jan Matulka, 1890–1972*, exh. cat. (Washington, DC: Smithsonian Institution Press, for the National Academy of Fine Arts and the Whitney Museum of American Art, 1980), pp. 77–78.

KENNETH HAYES MILLER

WAITING FOR THE BUS
1931

By connecting his up-to-date woman with idealized goddesses, whose pose and proportions suggested enduring models of nurture, beauty, and fertility, Miller transformed the shopper into a goddess of commerce, a Venus of Fourteenth Street.[1]

Kenneth Hayes Miller (1876–1952) was an influential teacher at William Merritt Chase's New York School of Art between 1899 and 1911 and then at the Art Students League from 1911 until the end of his life. In about 1920, just before he moved to a studio on Manhattan's Fourteenth Street, Miller began to paint shoppers in New York—a subject that would occupy him for the rest of his career. Always deeply influenced by the Italian Renaissance masters (his idols were Titian and Michelangelo), he had concentrated in his early work on poetic nudes and landscapes. The change to contemporary subjects began slowly in the 1910s, when Miller started to observe the people around him in the Twenty-third Street terminal of the Hudson River Ferry: "not sketching, just trying to see what people *looked like*, probably realizing to the full for the first time that they actually were *there*!"[2] Next, he became interested in costume, writing to his cousin Rhoda Dunn in January 1920, "For many years I have wanted to do figures in contemporary clothes."[3] Soon afterward, he reported to Dunn that on February 16, 1920, eight canvases, entitled the Fashion Series, would go on exhibition at the Macbeth Gallery.[4] This first series of shoppers portrayed stylish, well-to-do women shopping in elegant stores on Fifth Avenue, which Miller painted with fluffy, open brushwork that would tighten as his style changed over the next decade.

After he moved his studio to Fourteenth Street in 1923, with its bargain stores and less affluent population, Miller's shoppers increasingly became the eager bargain-hunters who frequented cut-rate stores like Klein's. But despite the ill effects of the Great Depression on New Yorkers as the 1930s progressed, Miller's attitude toward the shoppers was never politically or socially motivated. As Ellen Wiley Todd observed, "Miller's only response to concerns expressed by artists and social critics preoccupied with the common man was to broaden the socio-economic base of his matrons. His shopper became

Plate 68
Kenneth Hayes Miller
American, 1876–1952
Waiting for the Bus, 1931
Oil on Masonite, 30 x 20 ⅛ inches (76.2 x 51.1 cm)
Collection of C. K. Williams, II

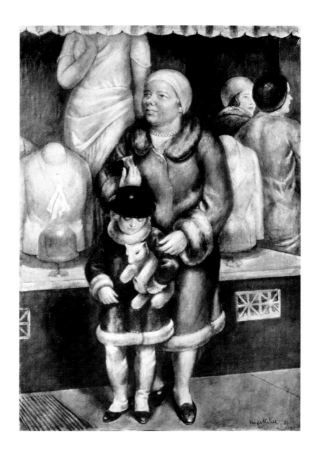

two versions reveal the attention Miller paid to the smallest and most telling details to convey (and here transform) the meaning of his subjects; while they vary in minor ways, the mood of each painting is entirely different. In the first version (fig. 37), the pug-nosed mother looks upward with a smile as though she spots the approaching bus, while her daughter gazes fondly at her teddy bear. In the present picture, the mother (more serious and attractive than her counterpart) looks anxious, pensive, and a bit tired; the little girl's hat has tipped over her eyes and she grasps but pays no attention to her bear; their attitudes suggest that after a busy day of shopping the pair has been waiting for the bus for a long time. Other new details in this version interpret the reason for their apparent exhaustion: a sign in the window proclaims "Last Day," and the standing mannequin is no longer clothed (her garment has apparently been sold). Miller frequently incorporated oddly chosen references to well-known art historical sources in his paintings, which never fail to add charm and fascination to his images. Here, in the second version of *Waiting for the Bus*, Miller gave the nude mannequin a gray, stonelike surface and a pose suggestively approaching that of an antique Venus Pudica.[7]

1. Ellen Wiley Todd, *The "New Woman" Revised: Painting and Gender Politics on Fourteenth Street* (Berkeley: University of California Press, 1993), p. 138.
2. Lincoln Rothschild, *To Keep Art Alive: The Effort of Kenneth Hayes Miller, American Painter (1876–1952)* (Philadelphia: Art Alliance Press; Cranbury, NJ: Associated University Presses, 1974), p. 32. Emphasis in original.
3. Ibid., p. 33.
4. Ibid.
5. Todd, *The "New Woman" Revised*, p. 161.
6. The first version (location unknown) is dated "31"; the second version is dated "31+." They are approximately the same size. Miller occasionally made more than one version of his compositions; he also sometimes repainted his pictures at a later date. For paintings done in more than one version, see Rothschild, *To Keep Art Alive*, figs. 46, 97. Rothschild, p. 97, also states that "+" after a date indicates later repainting.
7. This was not the only time that Miller inserted a variant of the pose of the Venus Pudica into a painting. See Todd, *The "New Woman" Revised*, pp. 137–38.

humbler, plumper, and more awkward in appearance."[5] In Miller's paintings these stout, contemporary matrons in their bulky, fur-trimmed coats and cloche hats assumed the dignity and variety of expression characteristic of the women in Giotto's Scrovegni Chapel in Padua. In fact, Miller's sources of inspiration for the poses and attitudes of his matronly shoppers were old master painters, including Giotto, for he did not work from live models.

Waiting for the Bus, which is the second version of a subject that Miller painted twice in 1931,[6] is typical of Miller's paintings of Fourteenth Street shoppers in the 1930s. Together, the

Fig. 37: **Kenneth Hayes Miller**
American, 1876–1952
Waiting for the Bus, first version, 1931
Medium unknown, 30 x 20 inches (76.2 x 50.8 cm)
Location unknown

ELIE NADELMAN

WOUNDED STAG

c. 1915

I employ no other line than the curve, which possesses freshness and force. I compose these curves so as to bring them in accord or in opposition to one another. In that way I obtain the life of form, i.e., harmony. In that way I intend that the life of the work should come from within itself.[1]

In its general outline, the early career path of Elie Nadelman (1882–1946) seems not to differ a great deal from that of many of his American contemporaries: he received his first training in his native city (in his case, at the Warsaw Gymnasium and High School of Liberal Arts) and continued his study in foreign art capitals, first briefly in Munich in 1904, followed by Paris, where he lived until 1914. While in Paris, Nadelman studied life drawing at the Académie Colarossi, made drawings at the Louvre, and exhibited at the Salon d'Automne; he also met and befriended the siblings Leo and Gertrude Stein, who acquired his work. However, the immediate success of his exhibition of thirteen plasters and a group of drawings at the Galerie Druet in Paris in 1909 changed everything, catapulting the twenty-seven-year-old Nadelman to fame enjoyed by few other young artists at that time: the exhibition "revealed an artist whose work had seemingly arrived upon the scene miraculously full-blown."[2] Nadelman, in fact, had not been following the same path as the others in Paris. Eschewing teachers and working largely on his own, he had made a thorough analysis of an astonishing number of historical and contemporary styles,[3] which resulted in sculptures and drawings of figures whose rounded volumes were achieved through the intersection of curving lines. Coupled with the precision of his silhouettes and curvilinear volumes was Nadelman's scrupulous attention to material and surface, all of which made each of his pieces seem unified, complete, and final.[4]

Nadelman's triumphs multiplied. He published a statement in Alfred Stieglitz's *Camera Work* in 1910 defining his concept of abstraction in terms of "significant form";[5] his exhibition of marbles in 1911 at Paterson's Gallery in London was bought out by the cosmetics manufacturer Helena Rubinstein, who became his patron. Success also brought him somewhat out of seclusion, and he joined other Polish artists in Paris to found

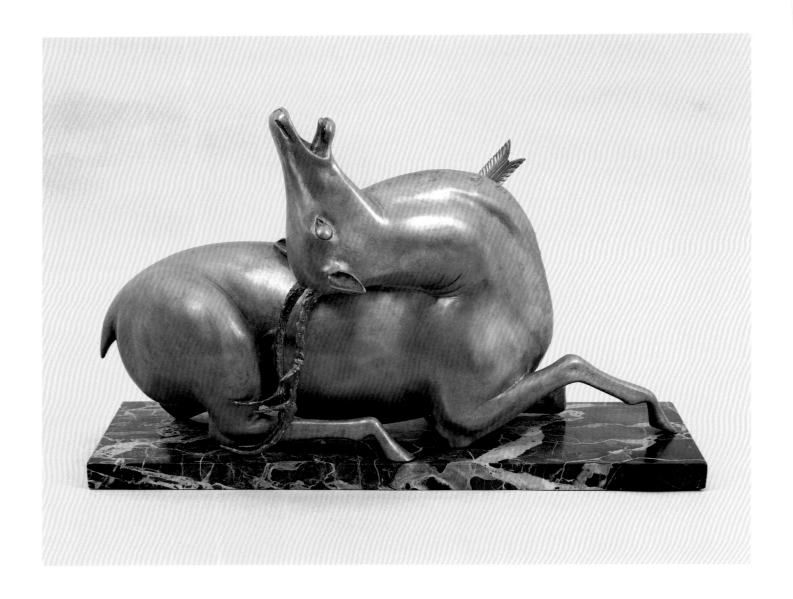

Plate 69
Elie Nadelman
American, born Poland, 1882–1946
Wounded Stag, c. 1915
Bronze and natural golden patina, 13 ³/₈ x 20 ³/₄ x 7 ¼ inches (34 x 52.7 x 18.4 cm) with original onyx base
Collection of C. K. Williams, II

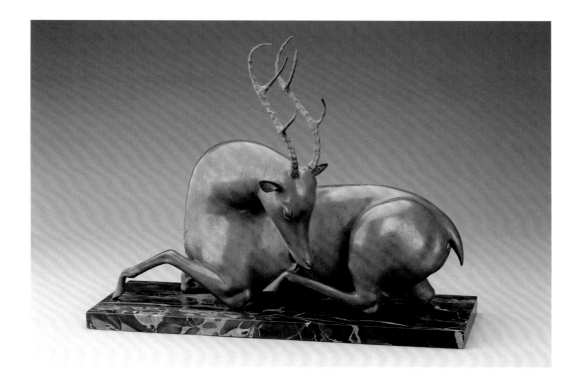

the Society of Polish Artists. About 1912 Nadelman began to work mostly in bronze, creating elegant, elongated figures inspired by Italian Mannerist sculptures. He varied their patinas, sometimes gilding or painting their surfaces. Another subject he began at this time was horses. He investigated the animal in a series of drawings and bronze reliefs with rounded bodies formed by simplified opposing curves, which were barely supported on slim, prancing legs.[6] These were the forerunners of the bronze animal sculptures Nadelman began soon after he moved to New York in 1914.

At the outbreak of war and unable to join the Russian army, Nadelman left for New York with passage obtained for him by Rubinstein on the *Lusitania*. His first exhibition in 1915 at Stieglitz's gallery 291 included the bronze relief *Horse and Figure* as well as a large plaster, *Horse*, that Rubinstein had

commissioned for her New York apartment.[7] The subjects of many of the sculptures Nadelman produced in New York differed from those he had made in Paris in that they were drawn from everyday life, and American popular culture became an important influence; he began at this time to produce the satiric sculptures of American society figures for which he is best known.

Nadelman's second exhibition, organized by the dealer and critic Martin Birnbaum at Scott and Fowles in 1917, generated even greater success. It included a new genre of small animal sculptures, particularly deer and stags, which instantaneously became beloved of collectors.[8] The critic Henry McBride's review of the exhibition at Scott and Fowles engagingly captured the winning qualities of the small bronze animals:

Fig. 38: **Elie Nadelman**
American, born Poland, 1882–1946
Resting Stag, c. 1916–17
Bronze, 18 x 21 x 10 ½ inches (45.7 x 53.3 x 26.7 cm) with original onyx base
Museum of Fine Arts, Boston. Museum purchase with funds donated by Frank B. Bemis Fund, Barbara L. and Theodore B. Alfond, an anonymous donor, Edwin E. Jack Fund, Arthur Mason Knapp Fund, Ernest Kahn Fund, Arthur Tracy Cabot Fund, Frederick Brown Fund, Morris and Louise Rosenthal Fund, Samuel Putnam Avery Fund, and Joyce Arnold Rusoff Fund. 2002.1

The conventions Nadelman imposes are rather steep, but although we are not used to seeing stags and colts with such slender shanks, still we see it to be a convention. . . . At the second glance we become so enamored of the spirit of these beasts that we accept everything. The "Jeune Cerf" is particularly engaging. There's a mixture of a Greek vase and the Central Park zoo in it. But who cares? It's really like Debussy music.[9]

Wounded Stag is the most dramatic of the series, and Nadelman made at least six casts of it in a variety of patinas, some with light gilding. He cast the arrow piercing the stag's breast in a separate piece, because "some collectors considered the presence of the arrow disturbingly cruel."[10] In fact, the drama of the wounded creature's taut and swollen body, its head thrown back in agony, and its open mouth crying out in pain gains even greater poignancy when seen together with the gentle, intimate *Resting Stag* (fig. 38), which Nadelman created as its companion. The present cast, with its unusual golden patina, seems to have been highly prized by the artist, who presented it along with *Resting Stag*[11] to his stepdaughter on her marriage in 1919.

1. Elie Nadelman, "Notes for a Catalogue," *Camera Work*, no. 32 (October 1910), p. 41.
2. James R. Mellow, "Is This the 'Proper Time' for Elie Nadelman?" *Art News*, vol. 81 (Summer 1982), p. 104.
3. John I. H. Baur, *The Sculpture and Drawings of Elie Nadelman*, exh. cat. (New York: Whitney Museum of American Art, 1975), p. 7, called Nadelman a deliberate connoisseur of style, enumerating many of his sources: "Before he left Paris in 1914 at the age of 32, he was apparently affected by Rodin, perhaps by the 15th-century carver Viet [*sic*] Stoss, by the drawings of Aubrey Beardsley, by Greek sculpture of both the Hellenistic period and 5th century B.C., by the Art Nouveau of Obrist, Adolph Von Hildebrand's neoclassicism, Michelangelo's *Bound Slaves*, the mannerism of Giovanni da Bologna, the sculpture of Clodion and Houdon, the drawings of Constantin Guys and the paintings of Seurat."
4. Lincoln Kirstein, *The Sculpture of Elie Nadelman*, exh. cat. (New York: The Museum of Modern Art, 1948), p. 7, wrote: "Little is evident from 1903 to 1946 of improvisation or a tentative approach. Even his drawings or small plaster figures were seldom sketchy."
5. Nadelman, "Notes for a Catalogue," p. 41.
6. Barbara Haskell, *Elie Nadelman: Sculptor of Modern Life*, exh. cat. (New York: Whitney Museum of American Art, 2003), pp. 60–61, figs. 62–64.
7. Ibid., pp. 74, 77, fig. 80.
8. Ibid., p. 85: "By March 1917, less than a month after the show opened, the entire edition of *Le jeune cerf (Fawn)* had been sold."
9. Henry McBride, *The Flow of Art: Essays and Criticisms of Henry McBride*, selected, with an introduction by Daniel Catton Rich (New York: Atheneum, 1975), pp. 108–9. The review appeared in the *Sun*, February 4, 1917.
10. Lincoln Kirstein, *Elie Nadelman* (New York: Eakins Press, 1973), p. 305, no. 186.
11. *Resting Stag* is in the Museum of Fine Arts, Boston. Both sculptures are on their original onyx bases.

LOUISE NEVELSON

RAIN FOREST COLUMN XXIV
1964

Louise Nevelson (1899–1988) frequently made the point that she had always known she would be an artist. She was born in the Ukraine in 1899, moved to the United States at age six, and grew up in Rockland, Maine, where her father was in the lumber business—a fact that certainly had an impact on her later interest in wood as the principal material for sculpture. Further elaborating on her preordained destiny, she claimed to have known from birth that she would live in New York, where she moved in 1920 with her new husband.[1] Yet not until 1929 did she enter the Art Students League, and two years later she abandoned her husband and child to move to Munich and study with Hans Hofmann. Little of Nevelson's artistic training seems to have impressed her, and she forged her own path, working as an assistant to Diego Rivera, teaching as part of the Works Progress Administration, and participating in group exhibitions.[2] Finally, in 1941, Nevelson presented her work to the prestigious Nierendorf Gallery in New York, where she received her first solo exhibition. Her first sculptural environment, *The Circus*, created by putting together some of her individual sculptures that she discovered could function even more successfully when installed as a group, was shown in 1943 at the Norlyst Gallery in New York. Nevelson naturally thought of her sculptures collectively, and she continued to make large environments of reliefs, boxes, columns, and entire walls to which she affixed multifaceted arrangements of carved wood fragments and pieces of found wood. Her unique, additive concept of sculpture was indebted both to Pablo Picasso's Cubist paintings and collages and to pre-Columbian art and architecture. She unified the elements in her complex abstract constructions by painting them black to diminish the identity of the applied pieces and to place the focus on the light and shadow playing across their surfaces.

Columnar forms became important elements in Nevelson's work in one of her first consciously created environments, *Royal Voyage*, shown at Grand Central Moderns Gallery in New York in 1956, which was the first one to be painted entirely black. Initially, the columns had anthropomorphic overtones, evoking mythical figures, but their associations broadened to include trees in her 1957 installation, *The Forest*.[3] But it was in her next

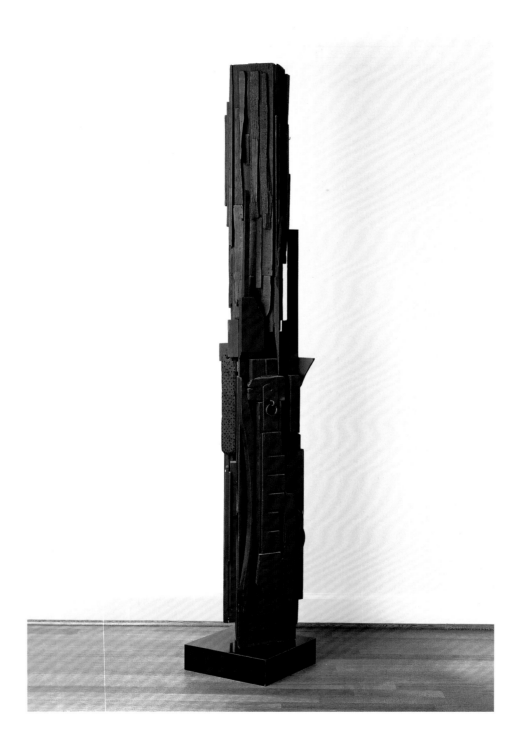

Plate 70
Louise Nevelson
American, born Ukraine, 1899–1988
Rain Forest Column XXIV, 1964
Wood (painted black) and iron, 91 ½ x 16 x 16 inches (232.4 x 40.6 x 40.6 cm)
Collection of C. K. Williams, II

two environments, *Moon Garden Plus One* (1958) at Grand Central Moderns and *Sky Columns Presence* (1959) at Martha Jackson Gallery, that columns assumed a dominant role.[4] In *Moon Garden*, each column was a tall, shallow box enclosing unique assemblages of pieces of wood; in *Sky Columns*, smaller pieces of wood were applied to stacked square or triangular pillars, resulting in a series of tall forms with varied, irregular profiles. Simultaneously, Nevelson began to create columns that existed independently of the environments, with varied forms and titles such as *Night Column* (1959) or *Wing Column* (1959).[5] In 1962 she began an important series entitled Rain Forest Column, which she seems to have worked on in two separate campaigns—the first between 1962 and 1964 and the second in 1967.

Rain Forest Column XXIV is part of the initial series of 1962–64. The columns in this group are distinguished by the superimposition of long, thin pieces of wood arranged in upright formation over approximately the top half of the columns, emphasizing their slender verticality. The silhouette of *Rain Forest Column XXIV*, as well as others in the series,[6] is mostly closed, with few irregularities or protrusions interrupting its upward thrust. In this example, a thin slat of wood placed slightly apart from the central core creates a long, vertical shaft of light along its side, only minimally disturbing the column's silhouette. The wooden pieces applied to the lower half of the column are more varied and complicated, although they lie flat against each other, maintaining the overall verticality: curved pieces adhere to overlapping shinglelike elements; an iron ring is fastened along one side, not far from a board with a surface pitted with tiny holes. However, it is worth repeating that to analyze the component parts of a sculpture by Nevelson is to deny her stated aesthetic purpose, for she painted the entire sculpture black to unify and conceal the identity of the myriad pieces of applied wooden fragments. Instead, what matters here is the remarkable variety of shadows that play in and around the column's multiple surfaces, allowing light to soften, unite, and occasionally transform the parts as well as the whole, just as the artist intended.[7]

1. Louise Nevelson, "Nevelson on Nevelson," *Art News*, vol. 71, no. 7 (November 1972), p. 67.
2. The best recent accounts of Nevelson's biography are in Brooke Kamin Rapaport, ed., *The Sculpture of Louise Nevelson: Constructing a Legend*, exh. cat. (New York: The Jewish Museum, published by Yale University Press, 2007). See esp. Michael Stanislawski, "Louise Nevelson's Self-Fashioning: 'The Author of Her Own Life,'" pp. 27–37, in ibid.
3. Rapaport, *The Sculpture of Louise Nevelson*, figs. 15–17, shows installation views of *Royal Voyage* and *The Forest*.
4. Arnold B. Glimcher, *Louise Nevelson* (New York: Praeger, 1972), pls. 42–43 (*Moon Garden Plus One*); pls. 47–48 (*Sky Columns Presence*).
5. *Wing Column* is reproduced in John Gordon, *Louise Nevelson*, exh. cat. (New York: Whitney Museum of American Art, 1967), pp. 31, 59, no. 59.
6. I have been unable to see all of the columns in this series, but the characteristics are typical of all of those I have seen.
7. Nevelson's second Rain Forest Column series of 1967 differs significantly from the earlier one. The later columns are distinguished by active, highly varied profiles, which are often created by stacked box forms twisting around vertical axes. Nevelson was known for disassembling, reassembling, and revising earlier pieces, and it seems that in 1967 she rebuilt or used parts from some of the first Rain Forest Column series, for some of the later columns are dated 1964–67. See Martin Friedman, *Nevelson Wood Sculptures*, exh. cat. (Minneapolis: Walker Art Center, 1973), p. 26, nos. 17–18.

EMIL NOLDE

RED POPPIES

c. 1920

I would like my work to grow out of the material just as in Nature the plants sprout from the soil appropriate to them.[1]

In 1902, at the age of thirty-five, Emil Nolde (1867–1956), born Emil Hansen, adopted the name of the town on the German-Danish border where he had been born and, after years of working as a wood-carver in furniture factories, began a career as a professional artist. He had begun painting in oil in 1895, but he had used watercolor previously in his meticulous drawings of furniture and in some straightforward landscapes and city views made during the early 1890s. Two years before he started formal art training, about 1895, Nolde exploited the expressive potential of watercolor's fluidity in a vibrant and romantic painting of a vivid red sun rising through clouds above dark fir trees,[2] giving prescient evidence of his later emergence as one of the great creative masters of the medium. After studying at private art schools in Munich and Dachau in 1897, in 1900 he went to Paris, where he enrolled in the Académie Julian and studied paintings in the Louvre, concluding that "Paris has given but little to me."[3] Nolde's vividly colored paintings, which were shown in Dresden in 1906, were noticed by Karl Schmidt-Rottluff, who invited him to show with the Brücke painters.[4] It was also in 1906 that Nolde made his first oil paintings of flowers. He claimed no interest in the flowers' names,[5] but he had clear favorites, such as the red, ragged-edged blooms of the poppy. Even as a boy, he had made his first paintings with elderberry and beetroot juice because he loved the color red.[6]

It was not until about 1918–20 that Nolde started to paint flowers in watercolor,[7] which he continued in many varied compositions until the last years of his life. Exact dating of the flower paintings has confounded scholars, and, in fact, Nolde encouraged the confusion, stating: "To the annoyance of art historians I shall destroy all lists that give information about the dates of my pictures."[8] Traditionally dated about 1920, *Red Poppies* is a vivid example of Nolde's many flower watercolors on Japanese paper. He is known to have had a stock of absorbent Japanese papers of various weights, which allowed him to experiment with different effects of color

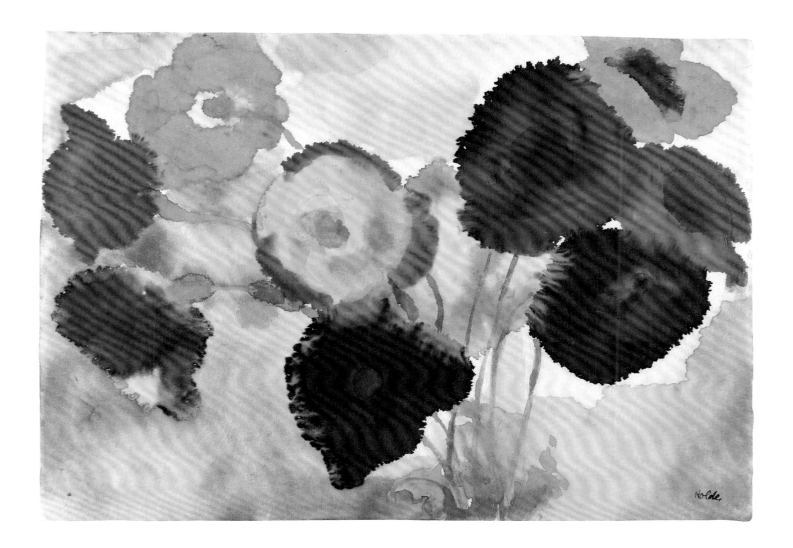

Plate 71
Emil Nolde
German, 1867–1956
***Red Poppies (Roter Mohn)**, c. 1920
Watercolor on Japanese tissue; sheet 13 ½ x 18 ⅞ inches (34.3 x 47.9 cm)
Philadelphia Museum of Art. Gift of C. K. Williams, II. 2006-49-1

washes.[9] Generally, he applied colors rapidly to moistened paper, wet in wet, so that they literally stained the paper like a textile. Sometimes, after the colors dried, he painted over an area again to strengthen a detail, or he painted on the reverse side of the paper, allowing the color to bleed through to the front.[10] During the creation of watercolors like *Red Poppies*, the artist must have enjoyed watching the flowers grow and expand within the moistened paper as he touched it with color. Here, some blossoms boldly move to the edges of the paper and appear to expand beyond them; fluid washes of gray hover like clouds around the pink and red blooms. Remarkably, light appears to emanate from within the flowers rather than striking them from the outside. Nolde often, as here, signed his watercolors on both the front and the back; indeed, the staining of the colors through the paper creates a mirror image of the front on the reverse—a second composition to which he applied his signature.

1. Nolde, quoted and translated in Clifford S. Ackley, *Nolde: Watercolors in America* (Boston: Museum of Fine Arts, 1995), n.p.

2. For the evolution of Nolde's use of watercolor, see ibid., n.p. The watercolor *Sonnenaufgang (Sunrise)* (c. 1895) is reproduced in Martin Urban, *Emil Nolde: Landscapes; Watercolors and Drawings* (New York: Praeger, 1970), p. 10.

3. Quoted in Martin Urban, *Catalogue Raisonné of the Oil-Paintings*, vol. 1, *1895–1914* (London: Sotheby's Publications; New York: Harper & Row, 1987), p. 15.

4. The Brücke artists were Ernst Ludwig Kirchner, Max Pechstein, Erich Heckel, Otto Mueller, Schmidt-Rottluff, and Nolde.

5. Martin Urban, "Aquarelle und 'Ungemalte Bilder,'" in *Emil Nolde*, ed. Rudy Chiappini, exh. cat. (Lugano: Museum für Moderne Kunst der Stadt Lugano, 1994), p. 156.

6. Urban, *Catalogue Raisonné*, p. 13: "I liked the reddish-purple colour so much."

7. Urban, "Aquarelle und 'Ungemalte Bilder,'" p. 156.

8. Quoted in Achim Moeller, *Private Views* (New York: Achim Moeller Fine Art, 1990), no. 33.

9. Manfred Reuther, "When My Tied Hands Were Freed," in *Emil Nolde: Unpainted Pictures; Watercolours, 1938–1945, from the Collection of the Nolde-Stiftung Seebüll*, ed. Tilman Osterwold and Thomas Knubben (Ostfildern-Ruit: Hatje Cantz Verlag, 2000), p. 10.

10. Martin Urban, *Emil Nolde: Landscapes; Watercolours and Drawings* (London: Pall Mall Press, 1970), p. 32.

GEORGIA O'KEEFFE

NUDE SERIES V

1918

Working in Canyon, Texas, during the fall of 1916, Georgia O'Keeffe (1887–1986) turned from charcoal drawing to watercolor and for the next two years produced more than one hundred works in the new medium. Generally small in scale, the watercolors depict radiant landscapes, dramatic skies and weather effects, and occasionally human figures in bright, pure color brushed directly onto the paper, unguided by any pencil underdrawing. Often O'Keeffe worked in series, as is true of her unique group of watercolor nudes, generally acknowledged to show the influence of Auguste Rodin's freely executed nudes in pencil and watercolor, which had been shown and published during the 1910s by Alfred Stieglitz.[1] The arrangement of the twelve nudes in the catalogue raisonné of O'Keeffe's work suggests visually that she made them in a single campaign,[2] for the figures seem to strike sequential poses; the ordering of images also shows a progressive elimination of blue in favor of sparer red and brown figures silhouetted (some almost as shadows) against the white paper ground. *Nude Series V* is the most shadowy of the group, for the figure is reduced to a nearly flat silhouette, with facial features and anatomy all but completely obliterated by mottled tones of brown and red, with abstract shapes formed by peach highlights where the sun strikes the side of the legs and torso.[3]

The woman portrayed in O'Keeffe's nude series is thought by some to be Leah Harris, a home economics food demonstrator with whom the artist formed an intimate friendship while she was working in southwestern Texas in 1917–18.[4] In the spring of 1918 they were living at Harris's family farm in Waring, Texas, where O'Keeffe was recovering from the flu. Reports of her ill health alarmed Stieglitz, who dispatched the young photographer Paul Strand to visit her, with the hope of his bringing her back to New York. During his stay Strand, too, became fascinated by Harris, and he made many photographs of her, as he wrote to Stieglitz on May 31, 1918: "I am in a state—photographing Leah—nude—body wet shining in the sunlight," and he continued, "Georgia painting Leah now."[5] Strand's photographs of Harris unfortunately have

Plate 72
Georgia O'Keeffe
American, 1887–1986
Nude Series V, 1918
Watercolor on paper, 11 ⅞ x 8 ¾ inches (30.2 x 22.2 cm)
Collection of C. K. Williams, II

not surfaced; it would be fascinating to compare them with O'Keeffe's watercolors, particularly with the four sun-drenched brown-red nudes that correspond so well to Strand's description of his subject.

1. Sarah Whitaker Peters, *Becoming O'Keeffe: The Early Years* (New York: Abbeville Press, 1991), p. 110, argues that O'Keeffe was inspired by reproductions of Rodin drawings in a copy of *Camera Work*, nos. 34–35 (April–July 1911) that was sent to her by her friend Anita Pollitzer. O'Keeffe had also seen the exhibition of Rodin drawings at Stieglitz's gallery 291 in 1908, when she was a student in New York. Peters does not say when Pollitzer sent the magazine to O'Keeffe, though she implies that it was when the artist made her watercolor series of nudes in Texas.
2. Barbara Buhler Lynes, *Georgia O'Keeffe: Catalogue Raisonné*, vol. 1 (New Haven: Yale University Press, in association with the National Gallery of Art and the Georgia O'Keeffe Foundation, 1999), nos. 176–87. Regarding the arrangement of the catalogue, Lynes explains, p. 12: "For works done in the period 1916–18 . . . considerations of chronology within a year take precedence over subject matter, in order to keep together works executed in a particular geographical location."
3. The nude series has traditionally been dated to 1917, which is supported in ibid., nos. 176–87. Labels inscribed in O'Keeffe's hand on two of the watercolors, including *Nude Series V*, also indicate a date of 1917. However, Lynes, ibid., p. 19, notes that O'Keeffe often wrote the wrong date on the backs of her pictures.
4. Roxana Robinson, *Georgia O'Keeffe: A Life* (New York: Harper & Row, 1989), pp. 199, 580 n. 50, seems to have been the first to suggest that the watercolors depict Harris and that they probably date from early 1918. Several other authors have also proposed that some or all of O'Keeffe's nude series are self-portraits. See, for example, Barbara Rose, "O'Keeffe's Originality," in *The Georgia O'Keeffe Museum*, ed. Peter H. Hassrick (New York: Harry N. Abrams, in association with the Georgia O'Keeffe Museum, 1997), p. 102. In addition to the twelve watercolors in the nude series, a drawing and a watercolor depicting Harris in the nude are reproduced in Lynes, *Georgia O'Keeffe*, nos. 241–42.
5. The complicated story of the relationship of O'Keeffe, Harris, and Strand in the spring of 1918 is recounted in Benita Eisler, *O'Keeffe and Stieglitz: An American Romance* (New York: Penguin Books, 1991), pp. 167–79. Strand's letter to Stieglitz is quoted on p. 177. Eisler suggests that O'Keeffe's nudes were made in two campaigns, beginning in late 1917, but all evidence points to the fact that because of her ill health, O'Keeffe was not working between November 1917 and February 1918.

ALTON PICKENS

GAME OF PRETEND
1944

It is generally agreed that the art of Alton Pickens (1917–1991) defies classification. Elements of Surrealism have been recognized, and social commentary, as well as "modernism," have been rejected. Pickens's own words (intentionally) do little to translate images that are allegedly based on reality yet seem unreal. His often-dissonant subjects, such as *Game of Pretend*, present situations of human anxiety, cruelty, and struggle; in his need to express emotional feeling through his art, Pickens's outlook oddly parallels that of his Abstract Expressionist contemporaries, which he admittedly found sympathetic.[1] Over the years, Pickens offered oblique observations about his work, somewhat mocking, to those who might ask him to interpret it.[2] The most convincing characterization of Pickens's complex art concludes: "the irreality of American reality might be considered Pickens' great theme: his well-known allegories strip away the vanities, pretensions, and dissimulations of our national existence. . . . Pickens' art is conditioned by a consuming appetite for truth, and is impelled by a fine, uncompromised anger."[3]

Lucien Alton Pickens was born in Seattle and reportedly spent a peripatetic childhood, which included a trip to Germany, where he acquired a taste for German culture that persisted throughout his life. At Reed College, his interest in art was nurtured by a professor of literature who encouraged him to draw and make prints and suggested that he attend the Portland Art Museum School. Pickens left there after a year and in 1939 headed for New York, where he spent nearly a decade. After a brief and unsuccessful term at the New School for Social Research, Pickens gave up formal education and supported himself with odd jobs. He continued to study art on his own, especially in the Metropolitan Museum of Art and the Museum of Modern Art, where his favorite artists were Francisco de Goya, Honoré Daumier, Pierre Bonnard, Max Beckmann, and German old master painters. In 1941 he taught in the Works Progress Administration program and provided illustrations for such radical publications as *Now* and *The New Masses*. During this time, Pickens was living on the Lower East Side of Manhattan and became friends with the Jewish immigrants in the neighborhood who had recently escaped from Nazism.[4]

Plate 73
Alton Pickens
American, 1917–1991
Game of Pretend, 1944
Oil on burlap, 18 x 23 ½ inches (45.7 x 59.7 cm)
Collection of C. K. Williams, II

Missing from Pickens's biography are the personal relationships he must have had in order to bring his work to the attention of the major New York museums that showed it in the early 1940s: in 1942 his paintings were included in *Artists for Victory* at the Metropolitan and in 1943 in *Romantic Painting* at the Museum of Modern Art, from which the museum purchased his painting *The Blue Doll*.[5] In 1946 his work was in the Modern's *Fourteen Americans*, which included eight paintings, three drawings, and two woodcuts, among them *Game of Pretend*. According to the catalogue for the exhibition, Pickens's work was represented by the Buchholz Gallery, which lent nine works; *The Blue Doll* from the Modern's own collection was joined by two paintings lent by private collectors. He was obviously well connected in the New York art world in 1946, though he did not have a solo exhibition until a decade later.

Like *The Blue Doll*, which was painted in 1942, *Game of Pretend* reflects Pickens's observation of the children playing in the Lower East Side neighborhood where he lived. However, while those in the earlier painting are portrayed as aged grotesques, the four girls in *Game of Pretend* display more realistic human responses, despite being far from prepossessing. Pickens exaggerates their wretched physical appearance, even while portraying their emotions realistically. Their hardened, vapid faces, their skinny arms and legs protruding from ill-fitting garments, and the setting—a dark, shallow, trash-laden curbside space, lit only by shafts of light between buildings—mark them as poor children entertaining themselves with an empty carton. Still, the girls are actually acting like any bunch of kids at play—one yanks away a box with a cutout face, unmasking her grimacing companion who has been hiding beneath it, another interrupts her game to watch the struggle, while the smallest, finger in mouth, pathetically clutches at herself.

When *Game of Pretend* was shown at the Museum of Modern Art in 1946, Pickens wrote in the catalogue: "When once an occupation or movement of people catches my eye, I attempt to capture some minute aspect of it, enlarge and draw from it all of the many things that it implies."[6] Surely, the key action in

Game of Pretend that holds wider implication is the unmasking, for masks, unmaskings, and faceless figures appear repeatedly in Pickens's work throughout his career. His abhorrence of hypocrisy and pretension as well as his overwhelming desire for authenticity of feeling must have drawn him to such images, whether consciously or not. For that reason, the subject of *Game of Pretend* suggests deeper meaning than poor children's play, and indeed, Pickens cryptically invited his viewers to supply the meaning: "I try to compose material upon which the observer may build. In the larger sense he provides the significance when there is any."

1. Greta Berman and Jeffrey Wechsler, *Realism and Realities: The Other Side of American Painting, 1940–1960*, exh. cat. (New Brunswick: Rutgers University Art Gallery, Rutgers, State University of New Jersey, 1981), p. 103.
2. A long statement from Pickens, in which he speculated ironically about different ways he might describe his work, concluded as follows: "I am a Sunday painter, and that is my own affair. I live by teaching; if you like we could discuss that." In *The New Decade: 35 American Painters and Sculptors* (New York: Whitney Museum of American Art, 1955), p. 67. Pickens taught at Indiana University from 1947 to 1956 and at Vassar College from 1956 until his retirement in 1982.
3. Peter Morrin, *Alton Pickens: Paintings, Prints, Sculpture*, exh. cat. (Poughkeepsie, NY: Vassar College Art Gallery, 1977), n.p.
4. Ibid.
5. Reproduced in Dorothy C. Miller, ed., *Fourteen Americans*, exh. cat. (New York: The Museum of Modern Art, 1946), p. 51.
6. For this quotation and the next, see ibid., p. 49.

MAURICE B. PRENDERGAST

BATHERS, NEW ENGLAND

c. 1916–19

Maurice Prendergast . . . plays with his public his usual baffling little game of pretending to repeat himself and never doing it. That psychically sensitive public continually is hypnotized into thinking that because the little figures continue satisfactorily to exist without features and to picnic joyously upon a sunny shore there is nothing new to be got out of the Prendergast designs. Let them invent a little game for themselves and practice tracing the composition in pure line. Hardly a painter can be found to give more variety of linear pattern.[1]

In the work of Maurice B. Prendergast (1859–1924), the ongoing theme is a crowd of people at leisure in public places. His early work usually featured flocks of small figures, rendered as masses of brilliant mosaiclike touches of color, thronging through parks, streets, and beaches. As time went on, his subjects remained basically the same, but the figures became larger, their poses more emphatic and differentiated. Indeed, as the figures grew in size and decreased in number, it became easy to believe that Prendergast replicated the same compositions over and over again. Yet one searches in vain through the vast catalogue of his work for repeated compositions. One finds endless variations on the familiar themes, but not strict repetition. For him, the subject matter was essentially a vehicle for his constant pursuit of a fresh orchestration of color, line, pattern, and compositional design.

Between approximately 1910 and 1920, Prendergast began to draw with pastel over the surface of some of his watercolors.[2] Such is the case with *Bathers, New England*, one of his typical late compositions of bathers arranged along a shallow beach strewn with rocks. With their expressionless faces turned toward the viewer,[3] self-conscious female bathers, interspersed by playing children, strike mannered attitudes as though they were posing for a photograph. Together they form a densely interwoven pattern of forms that occupy about three-quarters of the height of the sheet, behind which rise a stretch of water and a distant shore with houses. The carefully composed medley of bright reds, yellows, greens, and blues applied in broad, wet strokes and dabs of watercolor are as varied and selectively placed as the poses of the figures. Much of the

Plate 74
Maurice B. Prendergast
American, 1859–1924
Bathers, New England, c. 1916–19
Watercolor and pastel with graphite on heavy wove paper; sheet 15 ¾ x 22 ⁷/₁₆ inches (40 x 57 cm)
Philadelphia Museum of Art. Gift of C. K. Williams, II, in honor of the 125th Anniversary of the Museum. 2003-63-2

composition's patterned effect derives from the dark outlines around the figures, which the artist reinforced with black pastel; other colors were deepened and solidified by the artist's free application of waxy pastel over the transparent watercolor.

Recent scholars have recognized that Prendergast's emphasis on formal elements over subject matter, his use of brilliant color, the flattening and patterning of forms, and his free handling of mediums (which at times approached abstraction) are characteristics that link his art closely with European Post-Impressionism and modernism. Yet somehow, in the fifty or so years after his death, Prendergast was portrayed in the literature as a reclusive character who functioned "outside the mainstream of American artistic life."[4] Indeed, a great deal about his art and reputation seems to have been lost, confused, or misinterpreted. It was not until 1980 that Patterson Sims recognized how misunderstood Prendergast's contribution had become, when he wrote: "Because of his association with The Eight, Prendergast's commitment to modernism and his real achievement as a modernist have been minimalized and misunderstood."[5] A decade later, in the catalogue raisonné of Prendergast's work, Nancy Mowll Mathews plumbed the depths of this issue, revealing in detail Prendergast's lifelong attraction to modernism and his incorporation of many of its principles into his work, and showing that he had been recognized during his lifetime as a modernist.[6]

Born in St. John's, Newfoundland, in 1857, Prendergast moved with his family to Boston in 1868. Beginning in the early 1890s and until 1914 he traveled several times to Europe. Largely self-taught, he received his most sustained artistic training in Paris in 1891–94 at the Académie Julian and the Académie Colarossi. As early as 1900, when he received a solo exhibition at the esteemed Macbeth Gallery in New York, Prendergast already was using the bold brushwork and luminous color that foreshadowed the watercolors of John Marin.[7] More important, however, would be the influence of Paul Cézanne, Henri Matisse, and the Fauves on the work that emerged after his 1907 Paris sojourn, causing him to heighten the intensity of his color, the freedom of his brushwork, and increasingly to flatten and simplify forms. In the 1910s Prendergast became an active participant in the New York art world, exhibiting his work there nearly every year, joining organizations of artists, and visiting exhibitions such as those of Matisse, Auguste Rodin, and others at Alfred Stieglitz's gallery 291, which had an evident influence on his work.[8] Prendergast's membership on the committee that selected work by American artists for the Armory Show, to which he contributed seven of his own works, gives further testimony to the fact that during his lifetime he was recognized by his contemporaries as a leading American modernist artist.[9]

1. "The World of Art: Modern Art of One Kind and Another," *New York Times*, January 27, 1924, p. 10.
2. The dating of Prendergast's watercolor-pastels varies somewhat. *Bathers, New England* is dated 1910–15 by Cecily Langdale, "The Late Watercolors/Pastels of Maurice Prendergast," *Magazine Antiques*, vol. 132, no. 5 (November 1987), p. 1085, pl. II; in *The Unknown Pastels: Maurice Brazil Prendergast* (New York: Universe Books and Coe Kerr Gallery, 1987) it is dated 1916; accepted here is the date of c. 1916–19 proposed in Carol Clark, Nancy Mowll Mathews, and Gwendolyn Owens, *Maurice Brazil Prendergast, Charles Prendergast: A Catalogue Raisonné* (Williamstown, MA: Williams College Museum of Art; Munich: Prestel-Verlag, 1990), no. 1304.
3. Traces of features are indicated in graphite on some of the women's faces, but they are nearly invisible.
4. Milton W. Brown, "Maurice B. Prendergast," in Clark, Mathews, and Owens, *Maurice Brazil Prendergast, Charles Prendergast*, p. 18.
5. Patterson Sims, *Maurice B. Prendergast: A Concentration of Works from the Permanent Collection*, exh. cat. (New York: Whitney Museum of American Art, 1980), p. 4. The other members of The Eight were George Luks, Arthur B. Davies, Ernest Lawson, John Sloan, Robert Henri, Everett Shinn, and William Glackens.
6. Nancy Mowll Mathews, "Maurice Prendergast and the Influence of European Modernism," in Clark, Mathews, and Owens, *Maurice Brazil Prendergast, Charles Prendergast*, pp. 35–58. In the same publication, Dominic Madormo, "The 'Butterfly' Artist: Maurice Prendergast and His Critics," pp. 59–70, shows that Prendergast's critical fortune also fell victim to misinterpretation in the years following his death.
7. Brown, "Maurice B. Prendergast," p. 20.
8. Nancy Mowll Mathews, "Thoroughly Modern Maurice," in *Maurice Prendergast: Paintings of America*, exh. cat. (New York: Adelson Galleries, 2003), p. 171.
9. Brown, "Maurice B. Prendergast," p. 15.

ODILON REDON

SEA MONSTER

c. 1895

The pastel *Sea Monster* is unusual within the oeuvre of Odilon Redon (1840–1916) for its combination of artistic medium and pictorial subject. The Symbolist artist's interest in the underwater world as a place of mystery and wonder was encouraged by literary and scientific research from the late nineteenth century. Though not a true illustration, this pastel is conceptually related to ideas Redon explored in his three lithographic series based on Gustave Flaubert's *The Temptation of Saint Anthony* (1874). Redon first encountered this book in 1882 and became mesmerized by the spiritual quest and enigmatic imagery Flaubert described.[1] Redon produced his first two lithographic groups based on the book in 1888 and 1889.[2] He returned to the subject in 1896 with his third and most extensive album of twenty-four lithographs. What characterizes the third album from the previous two is Redon's fascination with depicting Flaubert's enigmatic description of the underwater world, full of mysterious sea creatures and hybrid animals. Though not specifically part of the third *Temptation of Saint Anthony* album, *Sea Monster* relates generally to underwater scenes like *And That Eyes without Heads Were Floating Like Mollusks* (no. 13) and *The Beasts of the Sea, Round Like Leather Bottles* (no. 22).[3]

The title *Sea Monster* does not seem to explain precisely the imagery of this scene. In the center of the work, a child's head floats among a swirling series of curvilinear shapes that denote, in Redon's artistic vocabulary, germination and the origins of life.[4] Here, these forms make up the body of the titular sea monster. Unusually, however, the face of the figure has no monstrous qualities; instead, the tender, young features recall other images the artist produced, including the charcoal *Dream Polyp* of 1891.[5] It is even possible that Redon was thinking of his son Arï, who was a young child when this pastel was created.[6] While not a portrait of Arï, the upturned nose and lips curving down compare closely to the younger Redon's facial features as captured in other works by his father.[7] The remaining unidentifiable objects within the composition reflect indistinct aquatic life floating in the current, as if Redon captured a horizontal cross section of the depths of the ocean.

Plate 75
Odilon Redon
French, 1840–1916
Sea Monster (Monstre sous-marin), c. 1895
Pastel on paper, 21 ⅞ x 18 ½ inches (55.6 x 47 cm)
Collection of C. K. Williams, II

Redon's interest in the ocean world was shared by his contemporaries. Scientific study in the mid-nineteenth century had led to a greater understanding of both the variety of marine life and the innumerable microorganisms being discovered as existing within single droplets of water. Redon personally knew Jules Michelet and studied the author's *La mer (The Sea)* (1861), which discussed underwater animal and plant life from the perspective of natural history rather than biblical creation. Michelet's philosophy inspired Flaubert's description of the aquatic world in *The Temptation of Saint Anthony*, and it is the combination of the two authors' discussions of the ocean and its inhabitants that inspired Redon for the decade he worked on his interpretations of Flaubert's work. Yet *Sea Monster* also demonstrates the impact that scientific analysis of marine life had on popular culture in the later nineteenth century. The theme of underwater mysteries had taken the French public by storm in Jules Verne's *Twenty Thousand Leagues under the Sea* (1870).[8] Moreover, as Ursula Harter describes, Redon was fascinated with the numerous aquariums being built for public viewing, and he visited them frequently, particularly the one located in the town of Arcachon.[9] Redon's self-described "aquarium pictures" of the later 1890s, among which *Sea Monster* could arguably be placed, were based directly on his observations of aquariums.

Redon's manipulation of medium in this work makes *Sea Monster* a significant though little studied image. For the first twenty years of his career, Redon worked primarily in charcoal or black-ink prints. Starting in the mid-1890s, however, the artist began to work regularly and then only with color, both pastel and oil paint.[10] *Sea Monster* may be one of Redon's transitional works in which he replaced charcoal with colorful pastels. Two swaths of black charcoal fill the background of the image, creating a three-dimensionality in the scene by representing a nebulous space in the depths of the sea behind the monster and within the crevices of the oblong shell in the central foreground. The remainder of the underwater space is filled with a variety of colors ranging from pale greens to brilliant purples to intense reds and oranges, all infused with touches of blue. Together, this range of colors, coupled with the innocence of the childlike face of the sea monster, creates a sense of tranquility and underwater calm. It was perhaps this

combination of color, subject, and the artist's characteristic enigmatic element that attracted the work's original owner. Andries Bonger was Redon's first major patron and introduced the latter to a wide circle of artistic and literary figures as well as other buyers for his work.[11] Bonger's attention to Redon led to the development of an important collection of the Frenchman's work in the Netherlands starting in the early twentieth century.

Jennifer T. Criss

1. Redon's friend the writer Émile Hennequin first directed the artist's attention to Flaubert's work. Hennequin considered *The Temptation of Saint Anthony* Flaubert's masterpiece. See Fred Leeman, "Odilon Redon: The Image and the Text," in Douglas W. Druick et al., *Odilon Redon: Prince of Dreams, 1840–1916*, exh. cat. (Chicago: The Art Institute of Chicago, in association with Harry N. Abrams, 1994), pp. 189–90.
2. The first series of *The Temptation of Saint Anthony* included ten lithographs. The second album was titled *To Gustave Flaubert* and comprised six lithographs.
3. Both of these titles come directly from lines in Flaubert's text. However, they are not direct visual illustrations of the passages. As Ursula Harter has explained, "Like Flaubert, Redon rejected any form of visual paraphrase of literature or literary paraphrase of art." Harter, "The Secret of Embryonic Life—from the Water Drop to the Micro-ocean," in *As in a Dream: Odilon Redon*, ed. Margret Stuffmann and Max Hollein, exh. cat. (Frankfurt: Schirn Kunsthalle; Ostfildern: Hatje Cantz, 2007), p. 87. Both works are reproduced in ibid., pp. 86, 239, no. 142.
4. These curvilinear shapes exist in many of Redon's *noirs* as well as a few pastels. The vast majority of them appear in scenes depicting animals in various stages of molecular evolution. Also, some of Redon's chimera images as well as the In the Dream (1879) and Origins (1883) lithographic series show similar forms.
5. *Dream Polyp* (1891, charcoal and Conté crayon, The Museum of Modern Art, New York) is reproduced in Alec Wildenstein, *Odilon Redon: Catalogue raisonné de l'oeuvre peint et dessiné*, vol. 2, *Mythes et légendes* (Paris: Wildenstein Institute, La Bibliothèque des Arts, 1994), no. 1217.
6. Arï Redon was born in 1889, and his face, with its characteristic features, appeared in several portraits that Redon created. While some of the Arï images show the growth and maturity of the artist's son, others seem to incorporate the child's features into works that are not explicitly portraits, like *Sea Monster*.
7. Compare the head in *Sea Monster*, for example, with the pastel *The Child* of 1894 (Musée des Beaux-Arts, Dijon). For a reproduction, see Wildenstein, *Odilon Redon*, vol. 1, *Portraits et figures* (Paris: Wildenstein Institute, La Bibliothèque des Arts, 1992), no. 32.
8. Gloria Groom, "The Emergence of a Decorative Aesthetic," in Druick et al., *Odilon Redon*, p. 314.
9. Harter, "The Secret of Embryonic Life," p. 91. See also her article "Die Geburt aus dem Meer: Odilon Redon und Jules Michelet," in *Re-Visionen: Zur Aktualität von Kunstgeschichte*, ed. Barbara Hüttel, Richard Hüttel, and Jeanette Kohl (Berlin: Akademie Verlag, 2002), pp. 177–94.
10. On Redon's shift to pastels, see Roseline Bacou, introduction to *Odilon Redon Pastels*, trans. Beatrice Rehl (New York: George Braziller, 1987), pp. 7–20.
11. Bonger began to purchase Redon's work in 1895, and the artist dedicated his essay "Confessions of an Artist" (1909/1912) to Bonger.

ODILON REDON

THE BOAT

c. 1900

Beautiful, gentle ships; so dear to the sailor, what do you carry in the depth of your skiff? From the bosom of the Ocean, to the immortal source, fishing, treasure, the catch was so great. And the breath of the air, and the rhythm of the waves cradle the spirit like a gentle harmony.

Oh sea, oh great friend![1]

For Odilon Redon (1840–1916), an artist known primarily for his mysterious and enigmatic reinterpretations of the natural and spiritual worlds, *The Boat (La Barque)* represents an attention to a theme both peaceful and personal whose simplicity of form depends on the artist's full embrace of working in color. Thoughts of the sea and boats were omnipresent in Redon's own mythology: a passage in his autobiography details their importance in his life. Recounting his parents' return to France from a stay in New Orleans in 1840, the artist wrote, "Travel by sea was at that time a long and dangerous adventure. . . . bad weather or winds made the boat which carried my parents run the risk of being lost at sea, and I would have loved . . . to have had the chance or destiny, to have been born in the middle of those waves which, since then, I have often contemplated with pain and sadness."[2] Moreover, his childhood home in the Médoc region of France in Bordeaux's outskirts at the Château Peyrelebade was itself halfway between the Atlantic and the Gironde. The local landscape provided a sanctuary for the Symbolist painter until 1898, when the estate was sold. In the ensuing years, memories of his happiness at Peyrelebade continued to inspire the evolution of Redon's art.

Throughout his career, Redon returned frequently to the theme of the ocean and its mystical wonders, including the period of about 1897–1905 during which *The Boat* was probably created.[3] After the dark and tumultuous period of the charcoal and lithographic *noirs*, his full and complete embrace of color emerges in this oil painting. The thick impasto of the paint itself pairs with the luminescence of bright yellows, oranges, reds, magenta, and aqua, with each color dancing independently on the surface of the panel on which this work was created. Redon's

Plate 76
Odilon Redon
French, 1840–1916
***The Boat (La Barque)**, c. 1900
Oil on panel, 11 ³/₄ x 6 ³/₈ inches (29.8 x 16.2 cm)
Collection of C. K. Williams, II

small boat drifts along without passengers. Its sail billows lightly from the breath of an invisible wind, while touches of white paint coupled with soft pastel colors denote a cloud-filled sky. This mixing of the natural world, depicted in vibrant colors, with a commonplace subject became characteristic of Redon's later works.

Redon's repetition of the theme of boats drifting on the ocean can be interpreted as emblematic of man's personal quest for spiritual and psychic understanding.[4] This particular boat has no human hand to steer its course. Many of the other paintings and pastels of this series, however, take their meaning from the solitary figure or paired couple who are the passengers. These boat scenes are loose interpretations of Christian themes: Christ or the Virgin Mary protecting the metaphorical Church-as-boat, the pair of Mary and Martha, or Mary Magdalene trusting her faith in Christ for safe passage across the spiritual ocean.[5] Redon's interest in depicting a Christian journey may also have been related to a series of Christ on the Sea of Galilee by the Romantic painter Eugène Delacroix, an artist the younger Redon greatly admired for his devotion to color, passion, and the human element.[6] Redon, however, did not intend to refer to any specific biblical passage in his boat paintings. Instead, they evoked spiritual longings that were personal for the artist and that remained distinct from Christian doctrine. As he wrote in 1898 in his journal, "It has been said that what gives the most happiness to man is the sight of things which do not belong to him, like the sea."[7] Because he inserted no figures in this particular painting, Redon allows the viewer to contemplate the natural world and the spiritual search in an attempt to gain the inner comfort he associated with the marine seascape.

The pure, simple beauty of *The Boat* perhaps attracted its first owner, Redon's friend and patron the marquis de Gonet. Probably introduced through their mutual friend Gustave Fayet, an important collector of late-nineteenth-century French art, around 1900,[8] the marquis purchased many of Redon's most colorful works depicting boats, flowers, and vases. The friendship between Redon and the marquis was evidenced by

the painter serving as a witness at his patron's wedding in 1903; the face of the marquis de Gonet even appeared in the guise of Saint Anthony in the panel *Day* that Redon painted at the abbey of Fontfroide, owned by Fayet, in 1910–11.[9] The marquis de Gonet acquired this panel directly from Redon, and it remained hidden from public view in his family's collection until 1997.

Jennifer T. Criss

1. Redon, journal entry for June 12, 1885, in Odilon Redon, *To Myself: Notes on Life, Art and Artists*, trans. Mira Jacob and Jeanne L. Wasserman (New York: George Braziller, 1986), p. 73.
2. Odilon Redon, "Confessions of an Artist," in ibid., p. 8.
3. Redon's work is notoriously difficult to date, and many of his works can only be so placed by notes the artist kept throughout his life. The majority of his other boat paintings and pastels date from this general period, though he continued to explore the theme into the 1910s. For a comprehensive catalogue of these images, see Alec Wildenstein, *Odilon Redon: Catalogue raisonné de l'oeuvre peint et dessiné*, vol. 3, *Fleurs et paysages* (Paris: Wildenstein Institute, La Bibliothèque des Arts, 1996), pt. 5, "Marines," pp. 323–55.
4. Fred Leeman, "Redon's Spiritualism and the Rise of Mysticism," in Douglas W. Druick et al., *Odilon Redon: Prince of Dreams, 1840–1916*, exh. cat. (Chicago: The Art Institute of Chicago, in association with Harry N. Abrams, 1994), p. 233.
5. Ibid.
6. Redon's writings on Delacroix are reproduced in Redon, *To Myself*, pp. 140–52.
7. Redon, journal entry from August 1898, in ibid., p. 82.
8. "The Collection of the Marquis de Gonet (1872–1925)," in Christie's, New York, "The Collection of the Marquis de Gonet: Ten Important Paintings by Odilon Redon," November 11, 1997, p. 23.
9. Ibid.

HUGO ROBUS

THE ACCORDIONIST

c. 1917

I reached the realization that complete satisfaction with the result of one's efforts just cannot be reached; the ideal advances too.[1]

It is difficult to tell whether Hugo Robus (1885–1964) was plagued by excessively high standards for his art or by a lack of self-confidence, or perhaps a bit of both. Not only did he destroy many of the paintings he had done during his early career, but also, after turning to sculpture in 1920, he ceased exhibiting for twelve years until he felt ready to put his work on public view. In any case, the statement above shows that Robus came to terms with his demons and finally began to exhibit his sculpture in 1933 and 1934; he achieved considerable critical success, which continued for the rest of his life.[2]

Despite the uneven trajectory of his career, Robus's story is similar to that of many of his American contemporaries. He received his initial training at the Cleveland School of Art, followed by two years at the National Academy of Design in New York, and capped by an important period of study between 1912 and 1914 in Europe, primarily Paris, where he developed a taste for modern art. One unusual aspect of Robus's early training, however, was his work with the Cleveland jewelry designer and master craftsman Horace E. Potter, which was his source of income during his student years and beyond. Much to his mentor's disappointment, Robus decided to become a painter and worked for Potter only as a means of support for his painting. In Paris, Robus studied briefly at the École de la Grande Chaumière, taking a class in sculpture with Émile Antoine Bourdelle. Initially, his paintings were inspired by Impressionism, although he kept abreast of exhibitions of Cubism, Futurism, and Synchromism, which he analyzed and pondered in long letters to his artist-fiancée, Irene Chubb. Through close personal contact with Stanton Macdonald-Wright, to whom he taught boxing, and Morgan Russell, a neighbor who "found my compositions very interesting,"[3] the color abstractions of the Synchromists brought about Robus's shift in 1913 to brighter color and a more painterly style. However, he never subscribed to Synchromist theories of musical color rhythms and emotional states, nor did he ever experiment with abstraction. An encounter with Futurism in a 1912 exhibition

Plate 77
Hugo Robus
American, 1885–1964
The Accordionist, c. 1917
Oil on canvas, 36 x 32 inches (91.4 x 81.3 cm)
Collection of C. K. Williams, II

at the Galerie Bernheim-Jeune had no immediate impact on his work, but it did later influence some paintings he produced in New York between 1917 and 1920.

Robus returned to the United States in mid-1914, spent time in Cleveland, where he had a solo exhibition, and moved to New York in February 1915; in June he married Chubb and they retained an apartment on Fourteenth Street, later acquiring a second residence in the artists' colony of New City, New York. Between 1915 and 1918 Robus taught at the progressive Modern School of Art, and the couple became familiar figures in the New York art world. Still, Robus always followed his own path in relation to his art and career, exploring a variety of modern styles in his painting and including his work in only two New York exhibitions in 1917 and 1918. *The Accordionist* and another painting could be seen in 1917 at the Society of Independent Artists;[4] thus, it was one of the three paintings the artist deemed worthy of public display at that time. In terms of style and color, it is among the boldest compositions Robus had done up to that moment. It is not so much a portrait of the musician as of the accordion's bellows, which form a fretted diagonal arc across the upper part of the canvas that is countered by the performer's crossed legs beneath. The back-and-forth movement of the bellows is suggested by its extension into lines of force that cross and partially obliterate the musician's face, finally melting into yellow sunlight.

Robus's few surviving paintings of 1916–20 range widely in style, particularly his paintings of figures.[5] *The Accordionist* looks ahead to the characteristics of Robus's last paintings of 1920, such as *Train in Motion*,[6] in which he took up a Futurist style and subject. In the latter picture, motion is portrayed through the Futurists' method of repeating overlapping portions of a single form surging through space and ultimately dissolving in brilliant light. Certainly, those same characteristics are introduced in *The Accordionist*, although only partially. It has been suggested that Robus's interest in Futurism was inspired by the exhibition of Gino Severini's work at Alfred Stieglitz's gallery 291, which took place March 6–17, 1917.[7] As *The*

Accordionist was exhibited only a month after that show, it would seem either that he was already experimenting independently with elements of Futurism (with which he had been familiar since 1912) or that he painted it in the weeks before the Society of Independent Artists exhibition, which opened on April 10. In any case, *The Accordionist* is an initial, exuberant experiment with the Futurist portrayal of motion and light, and Robus was sufficiently satisfied with it to submit it for exhibition.

1. Hugo Robus, "The Sculptor as Self Critic," *Magazine of Art*, vol. 36 (March 1943), p. 96.
2. Biographical details of Robus's career are primarily based on Roberta K. Tarbell, *Hugo Robus (1885–1964)* (Washington, DC: Smithsonian Institution Press, for the National Collection of Fine Arts, 1980).
3. Robus, quoted in ibid., p. 37.
4. *Catalogue of the First Annual Exhibition of the Society of Independent Artists*, exh. cat. (New York: Society of Independent Artists, 1917), nos. 67–68. In the exhibition catalogue, the title is given as *Accordion Player*. The other painting, now lost, was entitled *Birth of Eve*. The 1918 exhibition, in which Robus showed *Train and Bridge*, also lost, was at the Penguin Club.
5. *The Wrestlers* (1916) shows two intertwined bulbous figures in a fairly representational style; *Bathers* (1917) is a quasi-Cubist rendering of female nudes enmeshed in a background of broken planes. Only an undated painting, *The Sleeper*, somewhat resembles the composition of *The Accordionist* in that it includes an oversize figure whose complicated pose is crowded into the confines of the canvas, yet in style the two paintings are entirely different. Other paintings of 1916–17 include Cubist arrangements of rooftops, such as *Backyards, New York* (1916). *The Wrestlers*, *The Sleeper*, and *Backyards, New York* are reproduced in *Hugo Robus: Sculpture and Paintings*, exh. cat. (New York: Forum Gallery, 2007), n.p.; *Bathers* is reproduced in Lincoln Rothschild, *Robus*, exh. cat. (New York: American Federation of Arts, 1960), n.p.
6. Reproduced in Tarbell, *Hugo Robus*, p. 50.
7. Ibid., p. 49.

HUGO ROBUS

SUPPLICATION

c. 1925, cast 1954

*Hugo Robus is a sculptor whose message is very personal. . . .
[His] whole work is turned inward and deals with the weird, the
strange, the nostalgic mysteries of our inner emotions and
dreams. He conveys a feeling of strangeness and fantasy. His
surfaces are painstakingly polished—each piece is a new
experience and shock for the artist as well as for the public.
Whether one likes it or not, it is always fascinating.*[1]

Somehow the various modern painting styles through
which Hugo Robus (1885–1964) had searched since 1915 did
not satisfy his desire to create palpable three-dimensional
form, nor did they permit him adequately to express his
deeply felt emotion and unusual brand of wit. In 1920 he
abandoned painting and turned decisively to making sculpture.
He found that his interest in organizing forms in rhythmic
patterns (as was apparent in his last paintings, such as *Train
in Motion*)[2] was better achieved by working in three dimen-
sions, and he began to model in clay. For his first sculpture
he chose a subject he had already portrayed in a painting of
a sculptor's hand modeling,[3] and for the next twelve years
he concentrated intently on learning the techniques of
modeling and casting. Robus did not show his sculptures
until 1933; nor did he teach, as he felt that he did not know
enough about technique to be able to guide others. He
worked slowly and methodically, making innumerable
preparatory drawings before beginning to work in clay.
Always his goal was to create sculptures with silhouettes
that were complete and comprehensible from every point
of view. He cast his clay models in plaster and considered
them finished works, although bronze was his ultimate
ambition for them; for financial reasons, however, it was
not until the 1940s that most of the plasters were cast.
Supplication, whose plaster was created about 1925,[4] was
first cast in bronze in 1941 at the Bedi-Rassy Foundry in
Brooklyn, which worked with most of Robus's first sculptures.
Typically, Robus's sculptures had three bronze casts: the
present example was the second one, made at the Roman
Bronze Works, New York, in 1954; the third was made
at the Fonderia Battaglia, Milan, in 1962.[5]

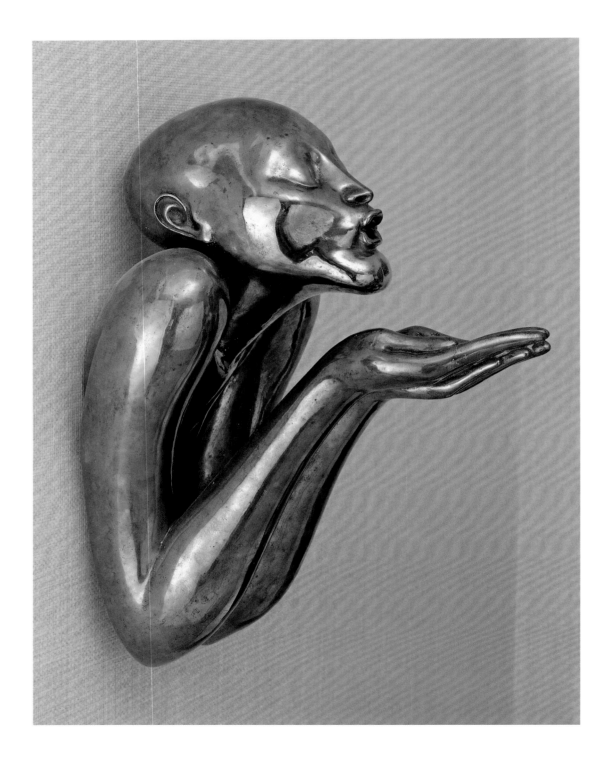

Plate 78
Hugo Robus
American, 1885–1964
Supplication, c. 1925, cast 1954
Bronze, cast 2/3; 18 ½ x 9 ½ x 14 inches (47 x 24.1 x 35.6 cm)
Collection of C. K. Williams, II

Supplication contains all of the qualities that describe Robus's sculpture as a whole. His subject matter was quite often a human emotion, frequently portrayed by focusing on details rather than entire figures, as is true of the present work. Although the artist's impeccable craftsmanship is always remarkable, particularly the smooth, flowing surfaces of the simplified forms and the perfection of details, the most striking feature of *Supplication*, and other works like it, is the precision with which Robus captures a specific emotional state through gesture and facial expression. Reduced to its essential expressive parts, the spare figure with its forward thrust personifies ardent pleading, whether viewed frontally or in profile. As Louise Cross wrote soon after Robus began to exhibit his sculptural work in 1934: "Robus starts with a subject, and his conscious intention is to develop a form which will fully represent that subject and only that subject, and to give it life."[6]

1. William Zorach, "American Sculpture," *Studio*, vol. 127, no. 615 (June 1944), pp. 186–87.
2. Reproduced in Roberta K. Tarbell, *Hugo Robus (1885–1964)*, exh. cat. (Washington, DC: Smithsonian Institution Press, for the National Collection of Fine Arts, 1980), p. 50.
3. Louise Cross, "The Sculpture of Hugo Robus," *Parnassus*, vol. 6, no. 4 (April 1934), p. 13. See also Tarbell, *Hugo Robus*, p. 59.
4. When Robus showed the plaster of *Supplication* with two other plasters in 1935 at the Brooklyn Museum, a reviewer observed: "I felt a desire to see them in polished brass or copper such as Brancusi uses. They would not, then, I am sure, convey the impression of having been modeled with a brush." Elisabeth Luther Cary, "A Diversity of Sculpture: Some Individual Notes," *New York Times*, May 12, 1935, p. 7.
5. Tarbell, *Hugo Robus*, pp. 167–68. Tarbell dates *Supplication* to 1925–30.
6. Cross, "The Sculpture of Hugo Robus," p. 14.

MORGAN RUSSELL

SYNCHROMIST NUDE
1913

Above all, Morgan Russell (1886–1953) loved sculptural form and color; he had an analytic mind, and he filled notebooks, sketchbooks, and scraps of paper with notes on art, artists, and color theory as he worked his way through whatever preoccupied him at the time. In the second decade of the twentieth century his notes overflowed with his thoughts about how to give color the principal role in defining sculptural form in painting, a method he eventually named Synchromism. Russell coined the term "Synchromism" ("with color") in early 1913 to attach a meaningful label to his use of the colors of the spectrum (rather than local color) to define mass and volume in the painting he submitted to the Salon des Indépendants in Paris.[1] He had arrived at Synchromism through a wide variety of sources: his training as a sculptor; his combined admiration of Paul Cézanne's structural use of color and Michelangelo's powerful sculptural forms; his study with Henri Matisse; as well as independent investigations of color theory and formal study of it with Ernest Percyval Tudor-Hart. Russell had begun formulating the principles of Synchromism in his notebooks as early as 1911, and he had already produced Synchromist paintings in late 1912 before he invented the name. Soon after the 1913 Salon, Russell was joined by fellow painter and Tudor-Hart student Stanton Macdonald-Wright, and they announced Synchromism as an artistic movement. While Russell and Macdonald-Wright ultimately made abstract paintings, their first Synchromist works were representational; however, even Russell's abstract paintings would always retain a basis in the human figure.

Synchromist Nude is an important example of Synchromism in its formative stage, created when Russell was painting still-life and figural compositions in a basically representational style, using patches of spectral colors applied in rhythmic dashes to construct palpable volumes. A comment Russell wrote in his notebook in 1912 best describes what he was striving to achieve in these pictures: "forget the objects forming the subject: make little spectrums of color and sharp encounters between them . . . and let the form result."[2] In Synchromist Nude, Russell arranged a seated model leaning to the side against the back of a chair; with arms crossed and knees bent up to her chest,

252

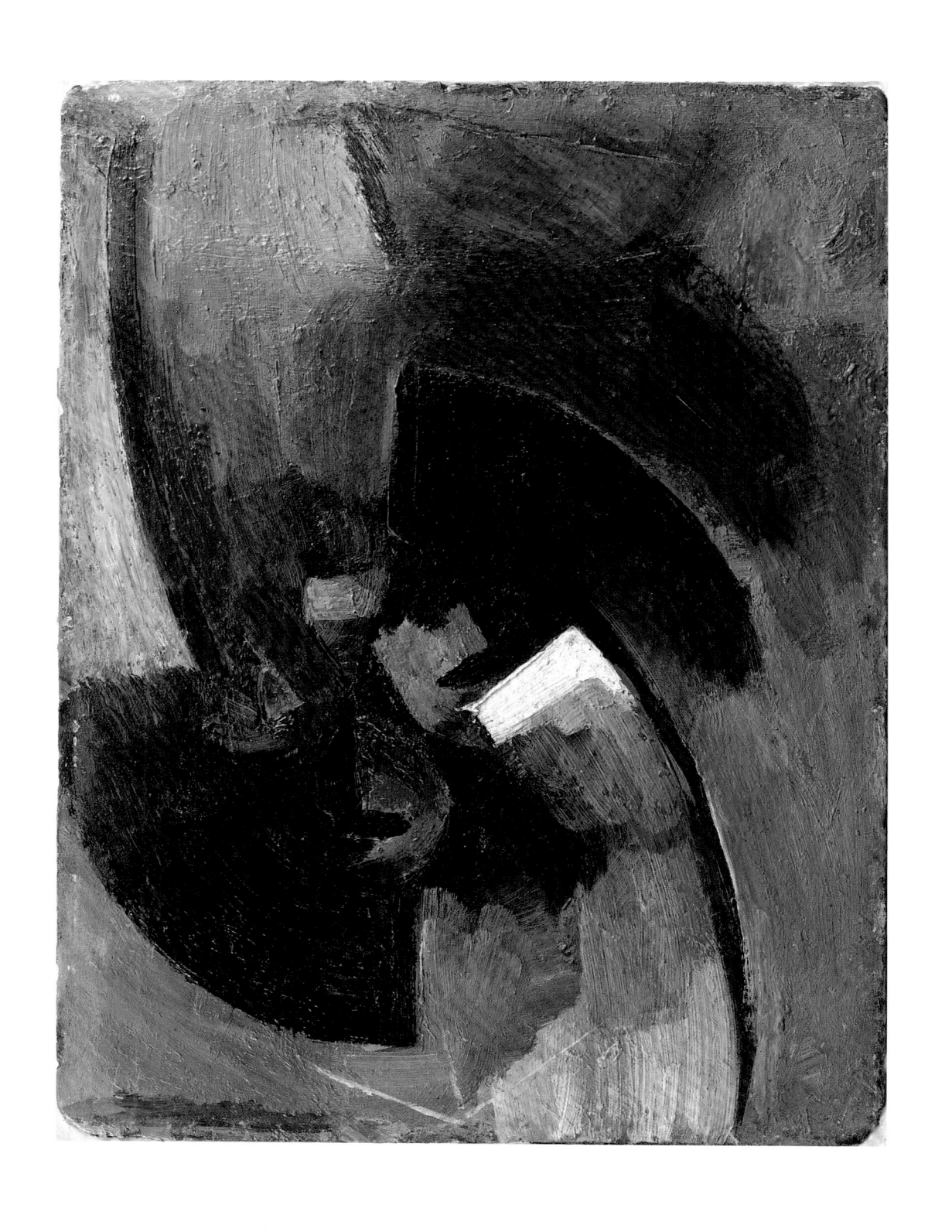

Plate 80
Morgan Russell
American, 1886–1953
Synchromy No. 8, Part II, 1916
Oil on panel, 12 ¾ x 9 ½ inches (32.4 x 24.1 cm)
Collection of C. K. Williams, II

MORGAN RUSSELL

SYNCHROMY NO. 8, PART II
1916

Synchromy No. 8, Part II must have been one of the last paintings Morgan Russell (1886–1953) produced during his short-lived Synchromist period. As he later claimed that he had stopped producing Synchromies by the time he went to New York in March 1916 to see his work in the Forum Exhibition of Modern American Painters,[1] it would seem that the small painting must have been made in the first months of 1916. Indeed, some of the fourteen works Russell exhibited in New York, such as *Archaic Compositions #1* and *#2* (1915),[2] showed that his style had already undergone a change: he was using fewer bright spectral colors, and black and white played a more dominant role. About 1915 Russell had also begun to think of his individual compositions as separate parts brought into harmony with one another; he described them as "symphonies in three or four parts of superimposed and adjacent orders."[3] This line of thinking led him about 1920 to create ensembles of his earlier, small Synchromies, such as *Four-Part Synchromy No. 7* (fig. 39), the only composition that has survived with its parts assembled.[4]

From what may be pieced together from the literature, Russell seems to have made at least three of these ensembles of small canvases, the latest of which is *Synchromy No. 8* (1916). Three parts of *Synchromy No. 8* have been published, but the physical appearance of only two of them is known, and there is no indication of how they were configured.[5] The present painting, *Synchromy No. 8, Part II*, is an animated abstract composition of countercurves. Unlike the apparently earlier *Four-Part Synchromy No. 7*, where colors are placed in defined areas, in the present composition Russell used looser brushwork and blended colors into one another. Large, black forms create a pinwheel effect around two multicolored, curving vertical shapes; colors are no longer limited to those of the spectrum, and they are replaced by bright patches of intermediate shades like sienna and rose. Many colors, such as green, yellow, and blue, are mixed with white, while a single pure white rectangle stands out as an accent near the center. Russell apparently thought of the parts of the ensembles as self-sufficient and only marginally connected to the other parts,[6] so it is not surprising that (as is true of the four parts of

she is posed in a manner that allowed the artist to maximize, with his rainbow of colors, the three-dimensionality of each body part. Contrasting warm colors (predominantly orange, yellow, and bright green) define the areas where light touches the surface of the sitter's body; its volumes gain in depth and substance from surrounding darker areas of blue and violet, such as beneath the arms, which recede into shadow. Hair and facial features are delineated by patches of flat black.

Russell and Macdonald-Wright formally introduced Synchromism in an explanatory statement written for an exhibition at Der Neue Kunstsalon, Munich, in June 1913. Dismissing the innovations of Impressionism, Renoir and Cézanne, Cubism, and Futurism, they added provocatively: "Is it not extremely curious that painters never realized that a single color, without being brought into relation with other colors, has the capacity of producing the impression of the weight, massiveness and spatial depth of objects!" They concluded that they had solved "the great problem of form and color."[3] Gail Levin pointed out that most of the works in the Munich exhibition have not been located; as *Synchromist Nude* is a work of considerable scale and finish, it seems highly possible that it was one of the paintings shown at the exhibition, which consisted only of representational works.[4]

The provenance of *Synchromist Nude* is worthy of mention as well, for it comes from what must have been an important collection of Synchromist paintings, formed at the time of their creation by Jean Dracopoli, a friend of Russell and Macdonald-Wright, whose portrait the latter painted in 1912.[5] At least three paintings besides *Synchromist Nude*, all of which are now unlocated, belonged to Dracopoli: Russell's *Small Synchromy in Green* (1913), which was in the Munich exhibition; Macdonald-Wright's *Synchromy in Green* (1912), which was lent by Wright to the exhibition at Bernheim-Jeune in October 1913 (and which the artist claimed was the first Synchromist painting to be bought by a collector);[6] and Russell's *Synchromate in Purple*, which was already owned by Dracopoli when it was exhibited in the 1914 Salon des Indépendants.[7] Little is known of the collector, whose family had roots in Montenegro, France,

England, and Italy. In 1964 Macdonald-Wright said, "he was nobody in particular. He was just an extraordinarily nice fellow." Nonetheless, Dracopoli had "vast properties in France," lived for a time in America, and eventually settled in England.[8]

1. William C. Agee points out that Paul Sérusier had used the term to title three paintings in the Salon des Indépendants of 1910 and 1911, but that there is no evidence that Russell knew Sérusier. See Agee, "Morgan Russell," in Marilyn S. Kushner, *Morgan Russell*, exh. cat. (New York: Hudson Hills Press, in association with the Montclair Art Museum, 1990), p. 18.

2. Quoted in William C. Agee, *Synchromism and Color Principles in American Painting, 1910–1930*, exh. cat. (New York: M. Knoedler & Co., 1965), p. 19.

3. Quoted in Gail Levin, *Synchromism and American Color Abstraction, 1910–1925*, exh. cat. (New York: George Braziller, in association with the Whitney Museum of American Art, 1978), p. 128.

4. Ibid., pp. 20–21. Willard Macdonald-Wright, brother of Stanton Macdonald-Wright, stated that the first "wholly abstract canvas" was shown in the exhibition at Bernheim-Jeune in Paris in October 1913. The Munich exhibition's checklist included a *Seated Woman*, but there are other "Synchromies" listed that might also refer to this painting.

5. See *The Neuberger Collection: An American Collection: Paintings, Drawings, and Sculpture* (Providence: Museum of Art, Rhode Island School of Design, 1968), pp. 325, 329, fig. 358, no. 358. The portrait was included in the Synchromist exhibition in Munich in June 1913.

6. *Les Synchromistes Morgan Russell et S. Macdonald-Wright*, exh. cat. (Paris: Bernheim-Jeune et Cie, 1913), no. 26; and Levin, *Synchromism*, p. 24.

7. Levin, *Synchromism*, p. 27.

8. Betty Lochrie Hoag and Stanton Macdonald-Wright, "Oral History Interview with Stanton Macdonald-Wright at His Pacific Palisades Home," April 13, 1964, Archives of American Art, Smithsonian Institution, Washington, DC.

Plate 79
Morgan Russell
American, 1886–1953
Synchromist Nude, 1913
Oil on canvas, 25 ⅛ x 19 ¾ inches (63.8 x 50.2 cm)
Collection of C. K. Williams, II

Synchromy No. 7), *Parts II* and *III* of *Synchromy No. 8* appear to exhibit similar brushwork and coloration,[7] but their compositions differ significantly. *Part III* is composed of rather static, biomorphic shapes, while *Part II* consists of an active sequence of curves.

1. Gail Levin, *Synchromism and American Color Abstraction, 1910–1925*, exh. cat. (New York: George Braziller, in association with the Whitney Museum of American Art, 1978), p. 31.

2. Reproduced in Marilyn S. Kushner, *Morgan Russell*, exh. cat. (New York: Hudson Hills Press, in association with the Montclair Art Museum, 1990), p. 12, pls. 89–90. *Archaic Composition #1* was purchased from the Forum Exhibition by Alfred Stieglitz; Russell gave *Archaic Composition #2* to Stieglitz.

3. Quoted from Russell's notes on a preparatory sketch in William C. Agee, *Synchromism and Color Principles in American Painting, 1910–1930*, exh. cat. (New York: M. Knoedler & Co., 1965), p. 27.

4. Kushner, *Morgan Russell*, p. 114, following Agee, believes that *Four-Part Synchromy No. 7* was begun in 1915 and "done on four separate panels that were assembled at a later date." Reproduced in Levin, *Synchromism*, pl. 16. Levin dates the composition 1914–15.

5. *Parts I* and *II* of *Synchromy No. 8* were listed, but not reproduced, in *Morgan Russell, 1884–1953: An Exhibition in Memoriam*, exh. cat. (New York: Rose Fried Gallery, 1953), nos. 8–9. *Part III* was reproduced in *Over Here! Modernism, the First Exile, 1914–1919*, exh. cat. (Providence, RI: David Winton Bell Gallery, Brown University, 1989), p. 179, no. 56. It is noted there that chips on the corners of the panel suggest that it may have been nailed or affixed alongside other works. A part of a third ensemble, *Synchromy No. 6, Part II* (1914–15), is listed, but not reproduced, in *Pioneers of American Abstract Art*, exh. cat. (New York: American Federation of Arts, 1955), p. 11.

6. David C. Ogawa, in *Over Here!* p. 179.

7. The only known reproduction of *Synchromy No. 8, Part III* is a poor photograph in black and white (see note 5 above). However, the accompanying text gives a detailed description of the color and the handling of brushwork. No known reproduction exists of *Synchromy No. 8, Part I*.

Fig. 39: **Morgan Russell**
American, 1886–1953
Four-Part Synchromy No. 7, 1915
Oil on canvas, 15 3/4 x 11 1/2 inches (40 x 29.2 cm)
Whitney Museum of American Art, New York. Gift of the artist in memory of Gertrude Vanderbilt Whitney

JOHN SINGER SARGENT

A WATERFALL

c. 1910

One of the most sought-after portrait artists of his day, John Singer Sargent (1856–1925) grew weary of painting faces. About 1900 he began an annual rhythm of work that would gradually shift his energy—and draw his patrons—into other directions. Typically, he stayed in London from November to June, teaching or working on portraits and murals, and then devoted the summer and early fall to travel and landscape painting. More than just an alternation of work and holiday, it was a regimen of studio projects refreshed by a different, but equally disciplined, kind of study outdoors.

In his flight from portraiture, Sargent renewed a passion that had burned brightly in the mid-1880s, when he worked alongside Claude Monet in France and with American colleagues in rural England. Mastering the techniques of Impressionism, he applied his skill in capturing effects of color and light to his portraits, but his return to landscape painting after 1900 brought his talents as a plein air painter to new levels of virtuosity.

Summer travel also happily retraced the routes that Sargent had known as a child, ranging around Europe with his expatriate American parents. As an adult, he would gather up his sisters and friends into a company that posed for his pictures or worked alongside him, supplying convivial support to his athletic pursuit of light and shadow. The mountains linking Switzerland, Italy, and France drew his troupe repeatedly, offering cool and exhilarating summer pastures. First sketching the Alps as a teenager in 1870, he rediscovered the mountains in 1900 and enjoyed annual visits from 1904 to 1909 to the green hillsides and riverbanks of the Val Veny and the Val d'Aosta. Seeking a different topography, Sargent and his company pushed on in the summer of 1909 to the higher, treeless terrain of the Simplon Pass, where he launched a series of more panoramic views. Enthralled by bright skies and rough landscapes of glaring rock, Sargent returned again in the summer of 1910, when he produced a sheaf of watercolors and a collection of major oils, probably including the undated canvas A Waterfall.[1]

Plate 81
John Singer Sargent
American, born Florence, died London, 1856–1925
A Waterfall, c. 1910
Oil on canvas, 44 ½ x 28 ½ inches (113 x 72.4 cm)
Philadelphia Museum of Art. Partial and promised gift of C. K. Williams, II. 2004-5-1

Sargent may have explored this subject first in a watercolor, a medium he found well suited to outdoor sketching and ideal for capturing the white light reflected off stones and water. Like many of his Alpine pictures, *Mountain Torrent* (fig. 40) is oddly cropped, seeking abstract shapes in the rock walls of the canyon; typically, the sky is pressed to the top of the composition, and the glance is down, into the foaming water.[2] Beginning with a light pencil sketch, he organized the composition in simple blocks and applied washes with great speed, confidently suggesting a misty distance and the broken, lit surfaces of wet rock. However, he seems to have abandoned his page before bringing it to resolution,[3] perhaps because he realized that he had an exciting idea for a larger composition that needed the stronger weight and value contrast of oil painting.

His canvas, four times the size of the watercolor, began from darkness rather than from light, throwing the waterfall and the glint of lavender sky into dazzling relief. The sunnier tints of the watercolor became shadows glimmering with skeins of red, ocher, violet, and green. In moving to a larger scale and lower, cooler tone, Sargent also compressed and stretched his composition, accentuating the vertical fall of the landscape and the repeated wedges of mist and water. Building up the whites with flecks of aqua and purple, he brought the waterfall closer while aggressively forcing an awareness of the paint surface. Animated brushwork, much like that in the watercolor, suggests form and texture, foliage and moving water, and yet denies recession, asserting the presence of the artist and the powerfully decorative and abstract appeal of the paint surface.

The impact of the painting—at once atmospheric from a distance and thrillingly tactile from up close—followed the strategy of his friend Monet's late works. Like Monet, Sargent worked both outdoors and indoors, where larger canvases were more easily managed. Looking from the Impressionist vitality of the watercolor, surely painted on the spot, to the forcefulness of the oil, it might be conjectured that the oil derived its naturalism from the watercolor and plein air observation, and its power from reconsideration in the studio. In his skillfulness, Sargent made his process almost impossible to

sort out: the American painter Manierre Dawson, who watched Sargent work outdoors in Italy in September 1910, commented on his ability to veil the careful construction of his paintings with "a look of spontaneous dash" added at the last, supplying a convincing look of outdoor authenticity and ease.[4]

Sargent's sense of the painting's importance as a more studied and monumental work can be read in its strategic debut. Since 1903 he had been sending his landscapes to the more progressive and informal exhibition venues in London; finally, in 1910, he submitted his first landscape to the Royal Academy of Art's annual exhibition, where he had previously shown

Fig. 40: **John Singer Sargent**
American, born Florence, died London, 1856–1925
Mountain Torrent, c. 1910
Watercolor, graphite, and wax crayon on wove paper; 21 1/8 x 14 7/8 inches (53.7 x 37.8 cm)
The Metropolitan Museum of Art, New York. Gift of Mrs. Francis Ormond, 1950. 50.13.80k

only portraits and figures. The triumph of the spectacular *Glacier Streams: The Simplon* (Museum of Fine Arts, Springfield, Massachusetts) must have encouraged him to send *A Waterfall* the following spring in 1911, along with a portrait, an architectural subject, and one of the Boston mural panels, *Armageddon*. His selection demonstrated the success of his intent to broaden his reputation. Critics applauded the Alpine painting as "a sincere and brilliant experiment" and described Sargent as "a landscape artist of the first rank."[5]

American admirers agreed. Purchased almost immediately by an American collector, *A Waterfall* became the first major landscape by Sargent to be widely exhibited in the United States. Following the extraordinary purchase of eighty-three watercolors by the Brooklyn Museum in 1909, the appearance of *A Waterfall* at the annual exhibitions of the National Academy of Design in New York late in 1913 and then at the Pennsylvania Academy of the Fine Arts in Philadelphia in 1914 accompanied a general scramble by American museums and collectors for Sargent's landscapes and watercolors.[6] The critic in the *New York Times* acknowledged *A Waterfall* as masterful and a model to other artists; the writer in Philadelphia's *Public Ledger* noted two examples of "the sublimity of genius" in the Academy's show: Thomas Eakins's *Agnew Clinic* and Sargent's majestic landscape.[7]

Sargent rarely offered any interpretative commentary on his landscapes, and *A Waterfall* may be best understood simply in visual terms, as an impression of a sparkling view, artistically organized by a virtuoso in paint. In the context of his other work in 1910, it can be seen as a holiday from the complex figure compositions for his Boston murals, *The Triumph of Religion*. At the Royal Academy, *A Waterfall* appeared with the tormented *Armageddon*, depicting the fall of "Gog and Magog" in the great battle before Judgment Day. Both paintings may have been completed in London over the winter of 1910–11, and certainly the mural panel had been under way since at least 1909. Side by side, the two subjects demonstrate the range of Sargent's ambitions at this time and the refreshment gained from contrasting efforts. However, his later, jesting references

to his "Alpine nightmare" landscapes from the Simplon may indicate that visions of Armageddon continued to roil in Sargent's mind as he painted stony landscapes at the top of the world.[8]

Kathleen A. Foster

1. Confirming earlier scholars, Elaine Kilmurray dated the painting to the summer of 1910; see Sotheby's, New York, "American Paintings, Drawings and Sculpture from the IBM International Foundation," May 25, 1995, lot 21. Her colleague Richard Ormond concurred, noting in conversation (December 2, 2007) that the site was in Passo del Sempione between Switzerland and Italy, showing melt-off from the Kaltewasser Glacier. See Ormond, "In the Alps," in Warren Adelson et al., *Sargent Abroad: Figures and Landscapes* (New York: Abbeville Press, 1997), p. 109; and Richard Ormond and Elaine Kilmurray, *John Singer Sargent: Complete Paintings*, volume on late landscapes (New Haven: Yale University Press, forthcoming).
2. Erica E. Hirshler traces the history of Sargent's involvement in landscape painting and his habits in these subjects, such as a high horizon, downward gaze, confusion of scale and distance, and a tightly cropped, design-oriented composition, in "Huge Skies Do Not Tempt Me: John Singer Sargent and Landscape Painting," in Hilliard T. Goldfarb, Hirshler, and T. J. Jackson, *Sargent: The Late Landscapes*, exh. cat. (Boston: Isabella Stewart Gardner Museum, 1999), pp. 53–75.
3. See Stephanie L. Herdrich and H. Barbara Weinberg, *American Drawings and Watercolors in the Metropolitan Museum of Art: John Singer Sargent* (New York: The Metropolitan Museum of Art, 2000), p. 324, no. 302. This watercolor remained in Sargent's family until given to the Metropolitan Museum by his sister. On Sargent's mastery of watercolor in these travel subjects, and his compositional habits, see ibid., pp. 271–73; for a chronology of travels and traveling companions, and an invaluable exhibition history, see ibid., pp. 363–93.
4. Dawson's journal, September 26, 1910, Archives of American Art, Smithsonian Institution, Washington, DC; quoted in ibid., p. 271. Photos of Sargent at work outdoors show him working on smaller canvases or watercolor blocks, although he traveled well equipped and assisted, and stayed in hotels close to his sketching grounds. Other artists reported his working on four-foot canvases outdoors; see Richard Ormond, in *Sargent and Italy*, ed. Bruce Robertson (Los Angeles: Los Angeles County Museum of Art, 2003), p. 125.
5. "The Royal Academy: Third Notice, Landscape," *Times (London)*, May 8, 1911, p. 10; and *Studio*, cited in William Howe Downes, *John S. Sargent, His Life and Work* (Boston: Little, Brown and Company, 1925), p. 238. A less cordial reviewer described the painting as "vividly literal but undistinguished"; see "Fine Arts and the Royal Academy (First Notice)," *Atheneum*, no. 4357 (April 29, 1911), p. 483.
6. The Museum of Fine Arts, Boston, acquired a group of watercolors in 1912, as did the Metropolitan Museum in 1915, and the Worcester Art Museum in 1917, while the artist's dealer, Knoedler's, sold many oils in the period 1912–15. Elizabeth Oustinoff, "The Critical Response," in Adelson et al., *Sargent Abroad*, pp. 228–29.
7. "Prize Pictures in Academy's Exhibit," *New York Times*, December 20, 1913, p. 12; and "Academy Opens 109th Exhibition," *Public Ledger*, February 8, 1914, p. 11.
8. See Hilliard T. Goldfarb, "Sargent in Pursuit of Landscapes, in His Own Words: 'I am off again to try the simple life (ach pfui),'" in Goldfarb, Hirshler, and Jackson, *Sargent*, p. 103.

MORTON SCHAMBERG

LANDSCAPE (WITH BRIDGE)

1914

It is not the business of the artist to imitate or represent nature. Art is creative, or, rather, interpretive. The artist does not reproduce that which is in itself pleasurable, he receives a pleasurable sensation from nature and within himself translates that sensation into terms of plastic expression, thereby creating a work of art which presents this pleasure in plastic form.[1]

Those who have taken the trouble to know the work of Morton Schamberg (1881–1918) have expressed unanimous admiration of his originality and the extent of his contributions to the history of modern art during a brief career that was cut off at age thirty-seven by the flu epidemic of 1918.[2] Not until 1982 was a study of Schamberg's artistic evolution undertaken by William C. Agee, who was the first to present his work as a logical continuum rather than as a disjointed series of phases.[3] Agee recognized Schamberg's enduring and unusual gift for color, which developed as he proceeded from chromatic abstraction to severe, yet coloristically sophisticated depictions of machines and mechanical abstractions now thought to be the earliest works of Precisionism.[4] Yet there are other explanations for the difficulty in fully assessing Schamberg's career, for much of his work remained in his family or in private collections after his death; moreover, few color reproductions of his paintings were published before the late 1970s and early 1980s, making his important contribution as a colorist difficult if not impossible to appreciate.

Schamberg's evolution as a painter proceeded rapidly and surely from 1906, when he left the Pennsylvania Academy of the Fine Arts, where he was a pupil of William Merritt Chase. Successive trips to Europe between 1904 and 1909 (an early one in the company of Chase) encouraged an enduring love of the old masters whose work he would always claim had a greater effect on him than the moderns.[5] Nonetheless, his introduction in Paris in early 1909 to the art of Paul Cézanne, Vincent van Gogh, Henri Matisse, Pablo Picasso, and Georges Braque left a profound and lasting impact on his development. Traces of these influences appeared about 1910–12, when Schamberg began to replace his impressionistically treated street scenes and landscapes with more structured

Plate 82
Morton Schamberg
American, 1881–1918
Landscape (with Bridge), 1914
Oil on canvas, 26 x 32 inches (66 x 81.3 cm)
Philadelphia Museum of Art. Promised gift of C. K. Williams, II

compositions displaying brushwork and color reminiscent of Cézanne. After the Armory Show in 1913, Schamberg for the most part abandoned naturalistic colors, and he began to shatter forms into cubistic broken planes, though he did not yet venture into total abstraction. A series of figure paintings, called Geometric Patterns, was followed by landscapes constructed of prismatic planes of blue, rose, yellow, and green arranged in distinctive combinations and juxtapositions.

Landscape (with Bridge) is a large and mature example of the Cubist landscapes Schamberg made in 1913–14, perhaps depicting a site near the Doylestown, Pennsylvania, house that Schamberg shared with Charles Sheeler in the 1910s. The arches of the bridge provide the only hints of the subject, which is otherwise an abstract arrangement of color planes. Schamberg adopts a diagonal point of view, producing a more complex planar structure than he had in previous, more realistic landscapes, and using more colors and more gradations of tones within each plane; colors occasionally blend with one another, so that some of the planes merge. Schamberg's use of chromatic Cubism is generally acknowledged to have its source in the work of the Puteaux Cubists, such as Albert Gleizes, Jacques Villon, and Jean Metzinger, whose work he would have seen at the Armory Show. However, his sense for selecting, combining, and placing colors has an instinctive and authoritative flavor unrivaled by any of his contemporaries. As much if not more so, the colors in Schamberg's chromatic Cubist paintings of 1913–14 recall the clear hues of Italian quattrocento painting, for which he is known to have had special affection.[6]

1. Schamberg, article in the Philadelphia *Inquirer*, January 19, 1913, quoted in Ben Wolf, *Morton Livingston Schamberg* (Philadelphia: University of Pennsylvania Press, 1963), p. 27.
2. See, for example, Lawrence Campbell, "Morton Livingston Schamberg," review of exhibition at Zabriskie Gallery, *Art News*, vol. 62 (January 1964), p. 14; and Anne d'Harnoncourt, "Morton Livingston Schamberg," in *Philadelphia: Three Centuries of American Art*, exh. cat. (Philadelphia: Philadelphia Museum of Art, 1976), pp. 498–99, 505–6, 515–16.
3. William C. Agee, *Morton Livingston Schamberg (1881–1918)*, exh. cat. (New York: Salander-O'Reilly Galleries, 1982), p. 3. The earlier monograph by Ben Wolf (see n. 1 above) is not an art historical study.
4. Barbara Rose, *American Art since 1900: A Critical History* (New York: Frederick A. Praeger, 1967), p. 102: "Schamberg was the first to develop these machine forms into the basis for a lucid geometric art."
5. Schamberg, quoted in Wolf, *Morton Livingston Schamberg*, p. 27: "I have never studied under any of the above mentioned moderns. . . . I have seen many of their pictures, I like them, and have been much stimulated and influenced by them, but much more so by the old art."
6. Agee, *Morton Livingston Schamberg*, pp. 4–5.

BEN SHAHN

STUDY FOR "JERSEY HOMESTEADS MURAL"

c. 1936

I like doing murals because more people see them than they do easel pictures. . . . My first big job was the Jersey Homesteads school, and in one way it's still the most successful. People really look at it. They know it by heart. To them it's like the building, a part of the community.[1]

Jersey Homesteads was the first planned community developed by President Franklin D. Roosevelt's Resettlement Administration (RA). Located near Hightstown, New Jersey (and later renamed Roosevelt), the community was created to house and provide work for a group of Jewish garment workers from New York laid off from their jobs during the Great Depression. Ben Shahn (1898–1969), a member of the RA's Special Skills division, which was committed to placing works of art in the Resettlement communities,[2] received the commission to execute a mural for the school and community center of Jersey Homesteads; it was the first of four murals Shahn would do for the New Deal art program. Like most of the residents of Jersey Homesteads, Shahn had immigrated to New York from Eastern Europe. Born in Lithuania, he moved with his family to Brooklyn in 1906; early training as an apprentice lithographer provided Shahn with the means to support further study at New York University, the City University of New York, and the National Academy of Design and allowed him to travel to Europe. Right from the start, Shahn was a natural storyteller with an ardent commitment to social justice—attributes that profoundly affected his work as an artist. Abandoning the early influence of French Impressionism, he developed a distinctive style characterized by flat, bright colors with forms articulated by an overlay of finely drawn outlines—an inheritance from his work as a lithographic engraver.[3] Shahn also became a distinguished photographer, and his first commission from the RA in 1935 was to document conditions and people throughout the American South and Midwest. His photographs would continually provide a rich resource for the subjects of his paintings, including the Jersey Homesteads mural, which he began to plan in 1936.

Shahn was well prepared to take on the mural commission. In 1932 he had worked as an assistant to Diego Rivera for the Rockefeller Center mural and was active in the protests following

Plate 83
Ben Shahn
American, born Lithuania, 1898–1969
Study for "Jersey Homesteads Mural" (right side), c. 1936
Tempera on paper, mounted to Masonite; 20 x 29 inches (50.8 x 73.7 cm)
Collection of C. K. Williams, II

its destruction because of its subversive content. Although
Shahn was primarily a picture researcher for the project, he
learned the technique of true fresco from Rivera, which he used
for the Jersey Homesteads mural. His method of mathematically
subdividing the mural into successively smaller areas "so that
even the very smallest detailed part of the mural will bear an
organic relation to the whole" was also learned from the
Mexican master,[4] although his use of architecture to provide
major subdivisions of compositions is indebted to Italian
Renaissance frescoes.[5] Shahn divided the subject of the Jersey
Homesteads mural into three major sections, presenting the
history of the Jersey Homesteads residents beginning with their
arrival in New York, through their employment in the sweatshops,
and concluding with the planning of the community by labor
leaders, shown taking place beneath a poster of Roosevelt
labeled "A Gallant Leader."

Shahn did an enormous amount of research for the mural and
he must have made countless studies for it, although only a
handful has survived.[6] Two tempera paintings, one of which is
the present study for the right side of the mural, are detailed
compositional studies in full color; each of them differs from
the final mural not only in small details but also in significant
changes Shahn made in the subject matter. Several scholars
have carefully traced the Jersey Homesteads commission,
focusing on the alterations Shahn made as he designed the
mural and giving different interpretations of the reasons for
those changes.[7] All are in agreement, however, that the final
mural reflected Shahn's "own experiences within the commu-
nity, his similar personal and political background, and his
awareness of contemporary political issues."[8] For example,
while the present study for the right side of the mural includes
the general subdivisions of the final composition, some of the

Fig. 41: **Ben Shahn**
American, born Lithuania, 1898–1969
Jersey Homesteads Mural (detail, right side), 1937–38
Fresco, 12 x 45 feet (3.6 x 13.5 m)
Jersey Homesteads Community Center (now the Roosevelt Public School),
Roosevelt, New Jersey

scenes within them are removed and replaced in the mural.
Most telling here is the substitution of a generic arched stone
structure in the top center of the study by a view of an identifi-
able failed Long Island housing project, labeled "Dezencorps'
Delightful Dwellings," which directly contrasted its poor
management with the government-run community at Jersey
Homesteads. Shahn added many other explicit details to the
mural, such as the Roosevelt poster, the plan of the Jersey
Homesteads, and the portraits of the men around the table,
specifically pointing to the successes of organized labor and
the Roosevelt administration that had led to the establishment
of the community (fig. 41).[9]

As a government-sponsored project, the Jersey Homesteads
mural was subject to a complicated process, involving initial
approval of Shahn's sketches, followed by weekly supervisor's
visits, and required records of daily progress. But Shahn's
work was also under surveillance by the FBI, as a result of
reports that the entire project was Soviet-inspired, which were
fueled by Shahn's work as an assistant of Rivera. As work
on the mural progressed, the FBI relaxed its watch on him,
but not before an agent created a satirical photomontage
by pasting cut-outs of heads of well-known political figures
and other recognizable contemporary individuals onto photo-
graphs of a preparatory drawing for the mural (fig. 42).[10]
Notably, the study used for the photomontage includes the
many specific details that Shahn added to the finished mural,
suggesting that it may represent the final version of the
composition submitted by the artist to the RA.

1. Shahn, quoted in John D. Morse, "Ben Shahn: An Interview," *Magazine of
Art*, vol. 37, no. 4 (April 1944), p. 140.
2. Frances K. Pohl, "Constructing History: A Mural by Ben Shahn," *Arts
Magazine*, vol. 62 (September 1987), p. 36.
3. Susan Chevlowe, "A Bull in a China Shop: An Introduction to Ben Shahn," in
Chevlowe et al., *Common Man, Mythic Vision: The Paintings of Ben Shahn*, exh. cat.
(New York: Jewish Museum; Princeton: Princeton University Press, 1998), p. 9.
4. Bernarda Bryson Shahn, *Ben Shahn* (New York: Harry N. Abrams, 1972), p. 288.
5. Susan Noyes Platt, "The Jersey Homesteads Mural: Ben Shahn, Bernarda
Bryson, and History Painting in the 1930s," in *Redefining American History
Painting*, ed. Patricia M. Burnham and Lucretia Hoover Giese (Cambridge:
Cambridge University Press, 1995), p. 303.

6. *The Mural Art of Ben Shahn: Original Cartoons, Drawings, Prints and Dated
Paintings*, exh. cat. (Syracuse, NY: Joe and Emily Lowe Art Gallery, Syracuse
University, 1977), no. 4, lists the present tempera study for the right side of the
mural and a tempera study for the left side, plus four other studies. The
tempera study for the left side and a tempera study entitled *Hightstown*, which
differs considerably from the studies of the left and right sides as well as the
mural, are reproduced in *The Exhibition of Ben Shahn* (Tokyo: National Museum
of Modern Art, 1970), pp. 40–41, nos 8, 10. A number of diagrams and photo-
graphs of preparatory studies for the mural are in the possession of the artist's
son. According to Pohl, "Constructing History," p. 36, Shahn conducted
photographic research at the New York Public Library, newspaper archives,
and the Associated Press; study of family photograph albums as well as
Shahn's own RA photographs also provided inspiration for imagery, as did the
personal histories of the Jersey Homesteads residents, whom he grew to
know during the course of his work.
7. The three principal sources are Pohl, "Constructing History," pp. 36–40;
Platt, "The Jersey Homesteads Mural," pp. 295–309; and Diana L. Linden,
"Ben Shahn's New Deal Murals: Jewish Identity in the American Scene," in
Chevlowe et al., *Common Man, Mythic Vision*, pp. 37–65.
8. Pohl, "Constructing History," p. 40.
9. Ibid., pp. 39–40.
10. The attribution of the photomontage to an FBI agent appears in *The Mural
Art of Ben Shahn*, n.p., figs. 1–2. The story probably originated with the artist's
widow, who was involved with the organization of the exhibition in 1977. The
artist's son has speculated that Shahn himself could have created the
photomontage.

Fig. 42: Lampoon photomontage of the *Jersey Homesteads Mural* (detail, right
side), c. 1937–38

BEN SHAHN

MELANCHOLIA

1953

There were four or five persistent themes, notable among which were tragedy and futility, that dominated the diversity of his art. He had experienced personal tragedy first in a fire in which his father had been painfully disfigured, and again in the drowning of his younger brother and in his own failure to save him. These events never specifically figured in his work, but their agonies permeated much of his imagery. Indeed, in very little of Ben's painting was any such actual episode detailed. The tragedy lay elsewhere and he knew that.[1]

After World War II Ben Shahn (1898–1969) turned from Social Realist subjects to symbolic images portraying collective human emotion, an approach he named "personal realism." Rather than representing specific horrors of war, he focused on universal feelings of anxiety, grief, hopelessness, and fear—the emotional moods generated by disaster. He also rediscovered his Jewish religious origins, sometimes covering images with the words of poems and prayers in Hebrew lettering.[2] In the paintings, prints, and posters Shahn made between the mid-1940s and the early 1960s, hands became important expressive symbols, used to emphasize emotion or to underscore some special meaning. A poignant and often repeated image was that of a man with his face buried in his hands,[3] which first appeared in the painting *Composition for Clarinets and Tin Horn* in 1951 and in six preparatory drawings for that figure.[4] A year later, Shahn isolated that detail in a large ink and watercolor drawing, *Warsaw*, which won a prize in a competition for artistic representations of the courageous resistance of Warsaw ghetto Jews against the Nazis in 1943.[5] He reduced the subject to an enormous pair of clenched hands, the wrists covered by the words of the Hebrew "Ten Martyrs' Prayer."

Expanding and varying the *Warsaw* image in 1953, in *Melancholia* Shahn focused on a man with massive arms and shoulders clutching his head with a vicelike hand that entirely obscures his face, his strength entirely subdued by his wretchedness. Streaks of pigment surround and envelop the figure, suggesting marks left by clawing hands. During the 1960s Shahn repeated *Warsaw* in two serigraphs,[6] and he returned to the image of

Plate 84
Ben Shahn
American, born Lithuania, 1898–1969
Melancholia, 1953
Gouache on paper, 19 ½ x 26 ½ inches (49.5 x 67.3 cm)
Collection of C. K. Williams, II

Melancholia in 1968 in a portfolio of lithographs illustrating a portion of Rainer Maria Rilke's *The Notebooks of Malte Laurids Brigge*.[7] Here Shahn endowed the image with new meaning in an austere black-and-gray lithograph entitled *Beside the Dead*, which accompanied the text ". . . must have sat / beside the dead in the room / with the open window and the / fitful noises."[8]

1. Bernarda Bryson Shahn, *Ben Shahn* (New York: Harry N. Abrams, 1972), p. 76.

2. Stephen Polcari, "Ben Shahn and Postwar American Art: Shared Visions," in Susan Chevlowe et al., *Common Man, Mythic Vision: The Paintings of Ben Shahn*, exh. cat. (New York: Jewish Museum; Princeton: Princeton University Press, 1998), pp. 70–81.

3. Even in his Depression-era photographs Shahn was moved by an image of grief expressed by a man burying his face in his hands, as in his 1936 photograph *Bowery, New York*, reproduced in Deborah Martin Kao, Laura Katzman, and Jenna Webster, *Ben Shahn's New York: The Photography of Modern Times*, exh. cat. (Cambridge, MA: Fogg Art Museum, Harvard University Art Museums, 2000), p. 147, no. 128. He may also have been drawn, consciously or unconsciously, to José Clemente Orozco's well-known lithograph *Grief* (1929).

4. The painting and the drawings are in the Detroit Institute of Arts. The painting is reproduced in Shahn, *Ben Shahn*, p. 79. See also William E. Woolfenden, "A Composition by Ben Shahn," *Bulletin of the Detroit Institute of Arts*, vol. 32, no. 1 (1952–53), pp. 20–21.

5. Kenneth W. Prescott, *The Complete Graphic Works of Ben Shahn* (New York: Quadrangle / New York Times Book Co., 1973), p. 51, fig. 49.

6. Ibid., pp. 56, 66, figs. 54, 64.

7. An undated variant of the image in an ink drawing entitled *Melancholia* resembles figures in Shahn's prints of the 1960s. It is reproduced in Sotheby Parke Bernet, Inc., New York, "American 19th and 20th Century Paintings, Drawings, Watercolors and Sculpture," April 21, 1977, lot 223.

8. Prescott, *The Complete Graphic Works of Ben Shahn*, p. 116, fig. 135.

CHARLES SHEELER

WATER
1944

NEIGHBORS
1951

NEIGHBORS NO. 2
1951

Perpetually fascinated by unconventional sources such as tools, Shaker furniture, rural architecture, advertisements, modern machines, and industrial structures, all of which permeated his artistic imagery, Charles Sheeler (1883–1965) worked simultaneously in several mediums that interacted in his art in different ways at different moments in his career. He was trained in applied design at the Philadelphia Museum School of Industrial Art before entering the Pennsylvania Academy of the Fine Arts in 1903, where he learned to paint in the rapid, bravura style of his teacher, William Merritt Chase. Travel to France in 1908–9 with his Academy classmate Morton Schamberg brought him in contact with the modern painting styles of Paul Cézanne, Pablo Picasso, and Henri Matisse, leading eventually to a break with his earlier style. About 1910 he and Schamberg took up photography, which wrought an important transformation of his vision as well as his working methods. While commercial photography commissions supplemented his income, Sheeler also exhibited his photographs independently as well as along with his paintings.

Initially, his photographs were influenced by painted imagery,[1] but photography gradually took the lead in becoming the source for many of his paintings. Sheeler provided few specifics about the way his paintings and photographs interacted in his working process, although it is known that in 1929 photographs took the place of preparatory drawings for his paintings.[2] The most important example of this practice was the series of photographs made on commission for the Ford Motor Company's River Rouge plant in 1927, which was followed by painted versions of the subjects three years later. Using the photographic techniques of cropping, sharply angled views, and focus on details, Sheeler gradually began to make paintings that resembled photographs in their sharp-edged precision, obliterating as much as possible any trace of brushwork or impasto.

Still, the role of the photograph in the preparatory process was evidently not sufficient for Sheeler to achieve the kind of perfection he sought in his paintings, and in the late 1920s he began occasionally to make small tempera studies on paper, sometimes similar in scale to a photograph, in which,

Plate 85
Charles Sheeler
American, 1883–1965
Water, 1944
Tempera on paper, 7 ½ x 9 ¼ inches (19.1 x 23.5 cm)
Collection of C. K. Williams, II

Plate 86
Charles Sheeler
American, 1883–1965
Neighbors, 1951
Oil on canvas, 18 x 15 inches (45.7 x 38.1 cm)
Collection of C. K. Williams, II

Plate 87
Charles Sheeler
American, 1883–1965
Neighbors No. 2, 1951
Tempera on paper, 5 ³/₄ x 5 inches (14.6 x 12.7 cm)
Collection of C. K. Williams, II

presumably, he was able to fix his ideas of color before progressing to a finished work in oil on canvas. Two examples of these small studies are in the present collection, one of which is paired with its corresponding painting.

Sheeler's small tempera *Water* was preparatory for a larger oil painting (fig. 43) completed the following year. The grand scale of the massive system of pipes and blocklike towers, devoid of any human presence, continues the approach he had taken to the industrial structures in a series of paintings made in 1940 for *Fortune Magazine* on the subject of Power. While *Water* differs from the Power series by depicting an entire mechanical structure rather than concentrating on gigantic details of machinery, Sheeler maintains the sense of an aggressive, almost threatening mechanized world in which human beings are apparently no longer in control.[3] In both versions of *Water* (the location of the site still has not been identified), the bland, colorless structures achieve a certain dynamism owing to their sheer monumentality and their repetitive, seemingly endless, diagonal recession

into the distance. Here, as frequently occurs in Sheeler's photographs, the structure appears to extend far beyond the limits of the canvas.

From what is known of Sheeler's working procedure for his industrial scenes of the 1930s and 1940s, it seems probable that *Water* was made on commission and that its composition originated from a now-lost photograph he took of the site. The tempera differs from the oil painting chiefly in its color: the cloudless blue sky in the study is replaced in the final painting by dense, low clouds hanging below a swath of threatening dark gray; yet despite the different weather conditions, Sheeler repeats almost exactly the patterns of light and shadow falling over the structures. While the tempera seems bold and almost surreal in its clarity, the final painting is gloomy and brooding. *Water* has been called a transitional work,[4] as indeed it is, for it was painted at a time when Sheeler was beginning to experiment with a new abstract manner characterized by strongly patterned forms and bright, contrasting colors;[5] yet in 1945 he was still making works like *Water* in the straightforward, realistic style that he had developed in the late 1930s. This vacillation between realism and semiabstraction seems to have been brought about by the critical reception of his 1939 exhibition at the Museum of Modern Art in New York and the paintings in the Power series, which were faulted for their illustrative, photographic character.[6]

By 1951, when Sheeler created the oil painting *Neighbors* and the smaller tempera *Neighbors No. 2*, he had evolved a new method of compositional design that involved superimposing two or more photographic negatives to print a composite photograph, which he transferred to paper or canvas. Although he had been using composite photographs in making paintings for years, in the compositions of the late 1940s his purpose had changed, for, as Carol Troyen explains, "his use of photographic composites was less an end in itself than an inventive means of generating a composition in another medium."[7] Like the tempera study for *Water* and its corresponding oil painting, the two versions of *Neighbors* differ in coloration; disparities also occur in minor details, such as the patterns of

Fig. 43: **Charles Sheeler**
American, 1883–1965
Water, 1945
Oil on canvas, 24 x 29 ⅛ inches (61 x 74 cm)
The Metropolitan Museum of Art, New York. Arthur Hoppock Hearn Fund, 1949. 49.128

1. Susan Fillin Yeh, "Charles Sheeler and the Machine Age" (Ph.D. diss., City University of New York, 1981), p. 108: "He began as a painter whose photographs were influenced by painting. He ended up as a painter and photographer whose paintings had been influenced by photographs."
2. Ibid., p. 110, says that this change began with the painting *Upper Deck* (1929; Harvard Art Museum/Fogg Museum, Cambridge, Massachusetts).
3. This interpretation of Sheeler's industrial pictures has been most comprehensively advanced by Karen Lucic, *Charles Sheeler and the Cult of the Machine* (London: Reaktion Books, 1991), pp. 108–15.
4. Ibid., p. 113.
5. See *Incantations* (1946), reproduced in Carol Troyen and Erica E. Hirshler, *Charles Sheeler: Paintings and Drawings*, exh. cat. (Boston: Museum of Fine Arts, 1987), p. 186, no. 67.
6. For reactions to the exhibition at the Museum of Modern Art, see ibid., p. 32. For the reception of the *Fortune Magazine* series and Sheeler's reaction to it, see Lucic, *Charles Sheeler and the Cult of the Machine*, pp. 112–13.
7. Troyen, in Troyen and Hirshler, *Charles Sheeler*, p. 36.
8. Christie's, New York, "Important American Paintings, Drawings, and Sculpture of the 18th, 19th, and 20th Centuries," December 1, 1989, lot 278, acknowledges Troyen's identification of *Neighbors* with Sheeler's photographs of Rockefeller Center and St. Patrick's Cathedral. However, it is stated that "*Neighbors* has no photographic counterpart." As is suggested here, *Neighbors* appears to be composed from a composite photograph based upon two (or more?) negatives.
9. In fact, it is possible that the detail of St. Patrick's might derive from the reversal of the negative for *Shadows on St. Patrick's, New York*; this image contains an identical white vertical shape ending in a jagged point, which is silhouetted against the long area of black at the far right margin of the two paintings. In the photograph, this shape is created by sunlight shining between the church and the rectory. The photograph is reproduced in Theodore E. Stebbins, Jr., and Norman Keyes, Jr., *Charles Sheeler: The Photographs*, exh. cat. (Boston: Museum of Fine Arts, 1987), no. 86.

shadow in the center of the somewhat more freely handled tempera. The source for *Neighbors* may be found in a series of photographs Sheeler took in Manhattan in 1950 of Rockefeller Center and nearby St. Patrick's Cathedral,[8] and indeed some details of the office buildings in the center and to the right in *Neighbors* derive specifically from the photograph *Figures on Fifth Avenue, New York* (fig. 44), while the Gothic windows of St. Patrick's come from some other unidentified photograph in the series.[9] As in several of these composite pictures, Sheeler's palette in *Neighbors* is an odd mixture of grays, taupes, and violets, evoking the hazy juxtapositions that occur in a dream or a distant memory.

Fig. 44: **Charles Sheeler**
American, 1883–1965
Figures on Fifth Avenue, New York, 1950
Gelatin silver print, 9 ¼ x 6 ¼ inches (23.5 x 15.9 cm)
The Lane Collection

JOSEPH STELLA

STUDY FOR "BATTLE OF LIGHTS"

c. 1913–14

Joseph Stella (1877–1946) was one of the most versatile and original talents of the American modernists. Having been born in southern Italy near Naples, he moved at age nineteen to New York, where he studied at the Art Students League and the New York School of Art.[1] Stella's genius as a draftsman was recognized during the first decade of the twentieth century, and he received several commissions for magazine illustrations. Best known are those he made for the *Pittsburgh Survey*, which included romantic, smoke-laden scenes of industrial Pittsburgh and penetrating realistic portraits of coal miners. It was in those drawings that Stella first became transfixed by the imagery of modern America.

Fascinated as well as repelled by New York, however, Stella longed for his homeland, and in 1909 he returned to Italy to study the old masters and, inspired by Venetian painting, to learn the arduous technique of glazing. Two years later, Stella took the advice of the artist and critic Walter Pach and went to Paris, where he quickly met Henri Matisse, Pablo Picasso, and the Italian Futurists; the shock of their work was overwhelming, and he claimed to have been unable to work for six months because of it. Stella wrote in vivid terms of this time, for he saw it as the moment when his independent spirit awakened: "I began to work with real frenzy. What excited me most was the vista in front of me of a new panorama, the panorama of the most hyperbolic chromatic wealth. . . . To feel absolutely free to express this adventure was a bliss and rendered painting a joyful source, spurring the artist to defy and suffer any hardship in order to obtain his goal."[2] Still, it was not until after Stella returned to New York in late 1912 that his artistic independence truly asserted itself. In September 1913, seven months after the International Exhibition of Modern Art (the Armory Show),[3] which affected him deeply, he experienced a breakthrough on a visit to Coney Island at night, which launched the new style and subject matter that appeared in his first masterpiece, *Battle of Lights, Coney Island, Mardi Gras* (fig. 45).

Battle of Lights expressed the technological dynamism of the amusement park as a kaleidoscope of brilliantly colored shards surging around a central axis. It was shown at the Montross

Plate 88
Joseph Stella
American, born Italy, 1877–1946
Study for "Battle of Lights," c. 1913–14
Oil on canvas, 12 x 9 ½ inches (30.5 x 24.1 cm)
Collection of C. K. Williams, II

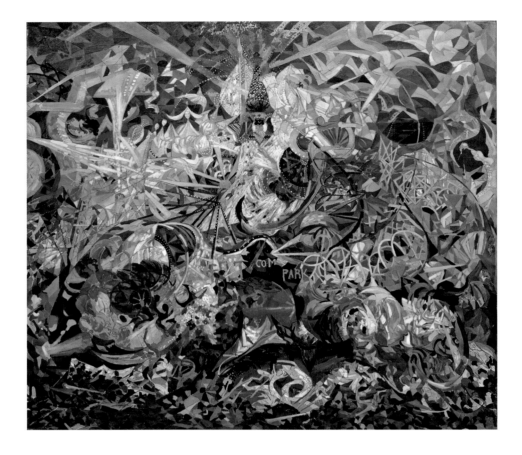

Gallery in 1914, where it caused a sensation and immediately established Stella as a leading American modernist. However, the painting was the result of huge effort and a great many preparatory studies, as Stella's friend and former teacher Carlo de Fornaro recounted:

> Several weeks were dedicated to myriads of observations . . . in a manner of an artistic detective in a hunt for the solution of a pictorial mystery. He had to visualize the picture on a flat and square canvas . . . Several nights were dedicated to meditation upon the accumulation of impressions, and then followed the execution in oils of his clear drama . . .

While discussing this artistic parturition, Stella remarked that after weeks of studies and cogitations the full-blown idea had flashed into his mind like an inspiration.[4]

Indeed, Stella's development of a uniquely American brand of Futurism between 1913 and 1918 yielded a wealth of vibrant studies in oil, pastel, and watercolor. Some of them are clearly preparatory for finished paintings, but others are abstract, emotionally charged depictions of the dynamic effects of movement, color, light, or a combination of all of them. The bright, dotted compositions of the Italian Futurist Gino Severini, whom Stella knew personally, formed the principal influence

Fig. 45: **Joseph Stella**
American, born Italy, 1877–1946
Battle of Lights, Coney Island, Mardi Gras, 1913–14
Oil on canvas, 77 x 84 ³/₄ inches (195.6 x 215.3 cm)
Yale University Art Gallery, New Haven. Gift of the Collection Societé Anonyme

on his work of this period, but he was also well aware of the work of other Futurist contemporaries through personal acquaintances as well as through exhibitions he saw in New York and abroad. A total of seven oil studies and a large rectangular version of the painting have been linked to the *Battle of Lights, Coney Island, Mardi Gras*, plus the present small oil, which has traditionally been related to that group.[5]

Among the studies in oil on canvas associated with *Battle of Lights*, this glowing painting stands alone, for it is the only oil sketch that does not depict an identifiable view of the Coney Island amusement park. Here, Stella concentrated on a purely abstract composition of colored shapes in a type of study he usually executed in pastel or watercolor on paper.[6] A central diamond is set against a background of dark colored triangles, which encloses brighter variegated shapes arranged at different angles. As in *Battle of Lights*, the colors surrounding and defining the diamond are deep and jewel-like, but within it are strokes of pastel shades, thickly applied and overlaid here and there with sprinklings of small dots; these culminate at the base of the diamond in a dense concentration of colors that form a brilliant rosette nucleus. In some ways, these characteristics— especially the glowing rosette of colors—resemble a motif that occurs in another of Stella's paintings of this period: *Madonna of Coney Island* (1914).[7] Yet it would be difficult to argue this connection conclusively, for, as Irma Jaffe acutely observed in her analysis of Stella's work during 1913–18: "There is no way to establish the sequence of the paintings in this group, and therefore no evidence of a consistent evolution of Stella's style during these years."[8]

1. The most recent biographical information on Stella, on which this summary depends, is in Barbara Haskell, *Joseph Stella*, exh. cat. (New York: Whitney Museum of American Art, 1994).
2. Quoted in Irma B. Jaffe, *Joseph Stella* (Cambridge, MA: Harvard University Press, 1970), p. 34.
3. Stella himself had two paintings in the Armory Show.
4. Quoted in Jaffe, *Joseph Stella*, p. 40.
5. The rectangular version, *Battle of Lights, Coney Island*, is in the Sheldon Memorial Art Gallery, University of Nebraska–Lincoln. The seven oil studies are the following: *Luna Park* (1913; Whitney Museum of American Art, New York); *Battle of Lights* (1913; The Museum of Modern Art, New York); *Battle of*

Lights, Mardi Gras (lost). The above are reproduced in Haskell, *Joseph Stella*, pls. 58, 51–53, respectively. The lost work has recently been thought to be a photograph of the unfinished painting with Stella's ink additions. Two studies are in the Hirshhorn Museum and Sculpture Garden, Washington, DC: *Study for "Battle of Lights, Coney Island, Mardi Gras"* (1913; 66.4791) and *Study for "Battle of Lights, Coney Island, Mardi Gras"* (1913; 66.4792), reproduced in Judith Zilczer, *Joseph Stella: The Hirshhorn Museum and Sculpture Garden* (Washington, DC: Smithsonian Institution Press, for the Hirshhorn Museum and Sculpture Garden, 1983), nos. 3–4. A *Study for "Battle of Lights, Coney Island"* (mid-1913) sold at Christie's, New York, March 12, 1992, lot 244 (repro.). *Study for "Battle of Lights, Mardi Gras,"* unpublished, is in a Philadelphia private collection. A double-sided watercolor, *Study for "Battle of Lights, Coney Island"* (1913–14; Amon Carter Museum, Fort Worth) is also associated with the painting, but it is so abstract that it could be related to any number of Stella's paintings of 1913–18.
6. See, for example, *Futurist Composition* (1914, pastel over graphite) reproduced in Haskell, *Joseph Stella*, p. 60; or *Abstraction: Mardi Gras* (1914–16, watercolor, gouache, pencil, and metallic paint), reproduced in Zilczer, *Joseph Stella*, no. 5.
7. Reproduced in Haskell, *Joseph Stella*, pl. 62. I am indebted to Suzanne Penn, Conservator of Paintings at the Philadelphia Museum of Art, for her observations on this subject.
8. Jaffe, *Joseph Stella*, p. 45.

JOSEPH STELLA

PORTRAIT OF JOE GOULD

c. 1920

In the first years of the 1920s Joseph Stella (1877–1946) made a group of spare silverpoint or graphite portrait drawings—mostly profiles—of friends in the New York art world. They include two portraits each of the artists Marcel Duchamp and Louis Eilshemius, one of the composer Edgard Varèse, and one of the novelist-poet Kathleen Millay, plus an unidentified portrait of a bearded man.[1] In addition, Stella made three portrait drawings of the "author" Joe Gould,[2] who had arrived in New York in 1916 and was working by the early 1920s as a book reviewer for literary newspapers and magazines and as an occasional model at the Art Students League. More important, however, Gould had recently begun his lifelong occupation as author of a monumental *Oral History of the World*, purported in 1942 to have reached nine million words. By that same year, when the first of two profiles of him by Joseph Mitchell was published in the *New Yorker* magazine, Gould, who was a descendant of an old New England family and a graduate of Harvard College, had become an unemployable Greenwich Village bohemian and perpetual solicitor of contributions to the "Joe Gould Fund," which provided him with lodgings in flophouses, as well as food, cigarettes, and alcohol.[3]

Gould was already a luridly fascinating figure in New York in 1923, meriting an article in the magazine *Broom*, in which his appearance was described as "striking." This is how Gould must have looked when Stella drew him in the early 1920s:

> Should he be coming around a corner the first harbinger of his approach is a prodigiously long cigarette holder which heaves into view like the bow-sprit of a large schooner. . . . Immediately following the bow-sprit, there appears a small sharp nose, or prow, on which a pair of bent wire spectacles rests askew. This in turn is followed by a sparse and goatish beard, a scraggly mustache, two singularly bright eyes and finally an entire head crowned by an absurdly small pill-box hat.[4]

Stella's portrait drawings have been likened to the genre of finely executed profile portraits by Italian Renaissance artists. His rediscovery of the Renaissance silverpoint technique as

Plate 89
Joseph Stella
American, born Italy, 1877–1946
Portrait of Joe Gould, c. 1920
Silverpoint and crayon on paper, 13 ¹³⁄₁₆ x 10 ⅜ inches (35.1 x 26.4 cm)
Collection of C. K. Williams, II

well as the clarity of execution of the profiles certainly hark
back to those sources, though Barbara Haskell has rightly
pointed out that these drawings also find analogies in "the
impersonal, linear style favored by Duchamp and other members
of the Arensberg circle."[5] Yet the purity of Stella's profiles is
nearly always disturbed by strange, small irregularities in the
shape of the head or hair of the sitter. The present drawing is
an especially compelling example of such eccentricities, for
Stella has inserted into its composition a wonderful series of
visual echoes created by such shapes and patterns as the
upward curve of a lock of hair over the sitter's forehead that is
repeated in an odd knob protruding from the back of his
head; or the curling under of his beard, echoed in a second
outcropping of hair near the base of the neck. But these
pleasing curves and countercurves are utterly counteracted by
Gould's arrow-straight gaze, which must have been a distinc-
tive trait of this obsessive character. Stella's other profile of
Gould does not display such a plethora of oddities, though it
shows his frequent inclination to distort the shape of the head
so that it almost comes to a point. In several of his other portrait
drawings Stella repeated this peculiarity, which lends a slightly
bizarre aspect to these otherwise purified images.[6]

1. The two profile portraits of Duchamp, the profile portrait of Eilshemius, the
portrait of Varèse, and the portrait of Millay are reproduced in Barbara Haskell,
Joseph Stella, exh. cat. (New York: Whitney Museum of American Art, 1994,
pls. 145–51). The frontal portrait of Eilshemius is reproduced in Joann Moser,
Visual Poetry: The Drawings of Joseph Stella, exh. cat. (Washington, DC:
Smithsonian Institution Press, for the National Museum of American Art,
1990), fig. 21. The unidentified *Portrait of a Bearded Man* is reproduced in
Drawings of Joseph Stella from the Collection of Rabin & Krueger (Newark, NJ:
Rabin & Krueger Gallery, 1962), pl. 125.
2. The frontal portrait of Joe Gould is unlocated. It was reproduced with the
article by E[dward] N[agle] and S[later] B[rown], "Joseph Gould: The Man,"
Broom: An International Magazine of the Arts, vol. 5, no. 3 (October 1923), p. 144.
The other profile portrait, besides the present one, is reproduced in Moser,
Visual Poetry, fig. 20.
3. Joseph Mitchell, *Joe Gould's Secret* (New York: Vintage Books, 1996) is a
reprinting, with introduction, of the two *New Yorker* profiles.
4. See Nagle and Brown, "Joseph Gould," p. 146.
5. See Haskell, *Joseph Stella*, p. 123.
6. The shapes of hair and head were clearly the elements that Stella loved
to alter in order to add visual interest and even humor to his images. In the
silverpoint *Profile of Marcel Duchamp* he gave a slightly pointed shape to
the back of the head and added a peculiar knob to the base of the neck. He
stylized into pointed shelves the silhouettes of the hair in the profiles of
Eilshemius and Millay, and he made the locks of hair on the head of Varèse
look like flickering flames.

JOSEPH STELLA

PALM TREE AND BIRD
1927–28

TROPICAL FLORAL
c. 1928

TROPICAL FLOWERS
c. 1929

He loved fruit and flowers—the thousands of silverpoint and pastel studies he made attest to that. Often, when walking along 14th Street we would pass fruit stands and he very carefully selected his fruit for size and peculiarity of color shapes, exclaiming constantly on their beauty and shape. Nothing made him happier than to bring him flowers. He always and instinctively selected the largest and lushest of each. He was in love with the grand, the big, the most vivid of color of any object or scene.[1]

Joseph Stella (1877–1946) seems to have started to make his magnificent paintings, drawings, and watercolors of plants, trees, birds, fruit, and flowers about 1919, the date that appears on several silverpoint and crayon drawings executed with exquisite precision in pale colors. In addition to taking liberties with many of their forms, he drew unexpected combinations of plants, sometimes with birds, or single stalks that alternately stand straight or form arabesques across the sheet. Often he preferred compositions with a strong central vertical axis, placing the subjects like pale specimens floating on the page without a groundline and adding faint sketches of individual blooms. Stella's haphazard manner of applying dates to his work—sometimes adding them after the fact—confounds any attempt to place them in order.[2] The problem of precise dating persists from his early fanciful paintings of nature, such as the delicate, magical *Tree of My Life* (1919–20)[3] and includes the paintings of Madonnas and mythological figures surrounded by plant life that he made in the mid-1920s, as well as the magnificent tropical birds and flowers that appeared about 1927–29, three of which are under discussion here.

Large in scale and brilliant in coloring, *Palm Tree and Bird* is among the most impressive of Stella's paintings from the second half of the 1920s; its composition presents a marvelous example of his inspired sense of design. Repetitions of undulating curves and razor-sharp points enliven an all-encompassing upward swell of energy that begins in the upturned head of a crowing bird and culminates above in the splendid fan of fronds that part as though to form a pair of wings.[4] Barbara Haskell suggests that the bright, light-filled color and exuberant spirit of this work associate it with paintings that Stella made

282

Plate 90
Joseph Stella
American, born Italy, 1877–1946
Palm Tree and Bird, 1927–28
Oil on canvas, 54 x 40 ¼ inches (137.2 x 102.2 cm)
Philadelphia Museum of Art. Promised gift of C. K. Williams, II

Plate 91
Joseph Stella
American, born Italy, 1877–1946
Tropical Floral, c. 1928
Oil on canvas, 23 x 16 ⅜ inches (58.4 x 41.6 cm)
Collection of C. K. Williams, II

Plate 92
Joseph Stella
American, born Italy, 1877–1946
Tropical Flowers, c. 1929
Watercolor and casein on paper, 25 x 18 inches (63.5 x 45.7 cm)
Collection of C. K. Williams, II

in Capri in 1927 and 1928—images that "paid homage to the lyricism and spiritual dimension of nature."[5] No doubt she drew this conclusion because *Palm Tree and Bird* exhibits certain similarities to paintings whose location in southern Italy is specifically identifiable.[6] Yet while the clear light and joyous colors of the present painting coincide with Stella's Italian pictures, its imagery bears no specific connection to that location and more likely originated in drawings made elsewhere. Stella is known to have made many studies in the Museum of Natural History, the New York Zoological Gardens, and the Bronx Botanical Garden, where he could have drawn the magnificent gannet, from whose back the fan of pandanus leaves rises and spreads.[7] The fine delineation of the vertical stem's uneven texture is unusually detailed and finds its closest analogies in some of his crayon drawings of palm trees.[8]

Stella soon abandoned the bright daylight colors inspired by his time in southern Italy and returned to a palette more like the one he had favored earlier in such works as *Battle of Lights, Coney Island, Mardi Gras* (fig. 45). In *Tropical Floral*[9] he used glowing dark blues, reds, and greens, with a high-gloss surface that recall some paintings on glass he had made in the late 1910s. Exotic flowers—most often lotuses and water lilies emerging mysteriously from pools of darkness—create lustrous, mystical images. While some of the compositions are quite formal, hieratic arrangements of flowers and birds,[10] *Tropical Floral* is more freely composed: the bright blue blossom on a glowing green-golden stalk stands straight against deeper blue water, surrounded by floating leaves in jewel-like colors, their reflections hovering darkly in the water below.

The sweeping diagonal composition of the watercolor *Tropical Flowers* is unusual in Stella's oeuvre; he preferred to organize his compositions, whether large or small, around a central axis. The abstract treatment of the green background, which echoes the upward direction of the stems and blossoms, is also atypical. Even more unusual is the fact that one blossom at the far left swells beyond the edge of the paper, for Stella's flower and plant compositions generally present a sense of completeness, even when a leaf or flower is cut off at the border.

The flower itself defies identification and is almost certainly Stella's own invention; it is most closely associated with the oleander (*Nerium*) family, although its petals are not as separate as those of the oleander. Whereas the tightly layered petals resemble the way phlox blossoms grow, the leaves are definitely not those of the phlox.

1. August Mosca, "Memories of Joseph Stella," 1961, August Mosca Papers, Archives of American Art, Smithsonian Institution, Washington, DC, reel N70-7, frame 109.
2. A metalpoint drawing, *Maple Leaves*, reproduced in Joann Moser, *Visual Poetry: The Drawings of Joseph Stella*, exh. cat. (Washington, DC: Smithsonian Institution Press, for the National Museum of American Art, 1990), fig. 108, bears the unlikely date of 1910; it has been suggested that Stella later added dates to some of these drawings.
3. Reproduced in Barbara Haskell, *Joseph Stella*, exh. cat. (New York: Whitney Museum of American Art, 1994), pl. 133.
4. Irma B. Jaffe makes this analogy as part of an interesting interpretation of this image in *Joseph Stella: The Tropics*, exh. cat. (New York: Richard York Gallery, 1988), p. 26.
5. Haskell, *Joseph Stella*, p. 152.
6. See *Neapolitan Song*, which includes Vesuvius in the background, which Haskell juxtaposes with the present painting and dates to the same time. Ibid., pl. 187.
7. I am indebted to William S. Moye for identification of the species of flora and fauna in these pictures. Moye cautions that Stella took many liberties with the plants and animals in his pictures (in this case the forms of the gannet and the pandanus leaves), which makes positive identification nearly always very difficult. The pandanus leaves also appear in one of Stella's undated silverpoint drawings, reproduced in *Joseph Stella: The Tropics*, p. 33, fig. 22.
8. See *Drawings of Joseph Stella from the Collection of Rabin & Krueger* (Newark, NJ: Rabin & Krueger Gallery, 1962), nos. 89–90.
9. Moye identifies this flower as "most likely *Nymphaea caerula*, the Egyptian 'lotus' or blue waterlily."
10. See, for example, *Lotus* (c. 1929), *Red Flower* (1929), and *Black Swan (The Swan of Death)* (1928–29), reproduced in Haskell, *Joseph Stella*, pls. 197, 195, and 196, respectively.

JOSEPH STELLA

GOLDEN FALL

1940

For the daring, adventurous painter Barbados is a magic island. Unheralded, the enchantment of its beauty dazzles as the golden vehemence of the unexpected rising of a NEW SUN. . . .

And periodically—as a climax to this everlasting celebration of THE JOY OF LIVING—gorgeous rainbows unfold all the glory of celestial hues, unsealed from Paradise, to clasp in divine unity the terse blue and the vivid emerald resplendent from sky and sea.[1]

Joseph Stella (1877–1946) was notoriously elusive when it came to the details of his private life: "Basic details about his birth date, the dating of his paintings, and whether or not he was married and, if so, for how long and to whom, were subjects about which he gave, at best, conflicting information."[2] So one is inclined to take with a grain of salt information he seems to have given to a reporter in 1941 about *Golden Fall*, and yet it is appealing to think of this spellbinding painting as a recollection (not necessarily a portrait) of the wife Stella had left in Barbados in 1938, who had died the following year:[3] "The 'Golden Fall' of tresses flow in waves of deep auburn upon the pink-robed back of one whose faint profile will always recall to Stella his late wife in whose memory he painted this monumentally magnificent color creation."[4] The glowing aura over that "faint profile" in fact recalls Stella's own ecstatic description of the dazzling quality of light in Barbados, quoted above; certainly, the golden radiance produced by this canvas has a hallucinatory effect never achieved to this degree in his other paintings, which lends credibility to the idea that this work had a special significance for him.

Equally captivating is the odd decorative flatness of the floral pattern on the back of the subject's dress, which is treated independently of her anatomy or her movement.[5] As though separate from the curve of her back and shoulders, the pattern contradicts the movement of the ropelike locks that part and blow over her left shoulder, suggesting that she is in motion. Indeed, the way in which the trailing vine on the fabric seems to have a life of its own finds compelling validation in Irma Jaffe's intriguing interpretation of the painting's subject. Jaffe was unaware

Plate 93
Joseph Stella
American, born Italy, 1877–1946
Golden Fall, 1940
Oil on canvas, 26 x 20 inches (66 x 50.8 cm)
Collection of C. K. Williams, II

that Stella claimed to make the painting in memory of his wife, a factor that does not refute her interpretation, but gives it an oddly new flavor:

> With her face turned away from the viewer, interest is focused on the woman's thick ropes of hair, which are like tropical tree roots [which Stella often drew], or the cables of Stella's *Brooklyn Bridge*. Like the bridge cables, the ropes of hair are realized through a system of light and shade that rounds them, and they open up away from the center to the margins of the picture plane. The pointed shape formed by the spreading apart of the hair penetrates the mass of hair with suggestive sensuality. The figure seems to be in flight. . . . Knowing Stella's mind to be well furnished with ancient myths, and being aware of his way of fusing aesthetic and sexual imagery, it appears likely that this figure represents the nymph Daphne, fleeing from Apollo's lust and saved by her father, the river-god Peneus, who turned her into a tree right before Apollo's (and the viewer's) eyes.[6]

1. Joseph Stella Papers, Archives of American Art, Smithsonian Institution, Washington, DC, reel 346, frames 1240–41. Emphasis in original.
2. Barbara Haskell, *Joseph Stella*, exh. cat. (New York: Whitney Museum of American Art, 1994), p. 127.
3. Little is known of Stella's wife, and there are no records of their marriage. Reportedly Stella married Mary Geraldine Walter French before 1910 and they were separated for many years. In the mid-1930s they reconciled; in 1937, when she was suffering from diabetes and wanted to return to her family in Barbados, Stella accompanied her there and stayed until 1938. She died in Barbados on November 29, 1939. See ibid., pp. 170, 175.
4. A. Z. Kruse, "At the Art Galleries," unidentified clipping, January 1941, August Mosca Papers, Archives of American Art, Smithsonian Institution, Washington, DC, reel 1576, frame 1006.
5. This flattened treatment of fabric behind a woman's shoulder somewhat recalls the shawl draped over a flat chair back in Stella's *Torso* (c. 1929; Hirshhorn Museum and Sculpture Garden, Washington, DC).
6. Irma B. Jaffe, *Joseph Stella's Symbolism* (San Francisco: Pomegranate Artbooks, 1994), p. xvii.

JOHN STORRS

STUDY IN FORM

1923

Let the artists create for your public buildings and homes forms that will express that strength and will to power, that poise and simplicity that one begins to see in some of your factories, rolling-mills, elevators and bridges.[1]

A native of Chicago who spent much of his life in France, John Storrs (1885–1956) was one of the first Americans to create nonobjective sculpture. The son of an architect and real estate developer, he received his first training in wood working at the Chicago Manual Training School; in 1907–9 he studied sculpture in Germany, creating traditional representational work. When he returned from Europe, Storrs took classes at the School of the Art Institute of Chicago, the School of the Museum of Fine Arts, Boston, and the Pennsylvania Academy of the Fine Arts in Philadelphia, culminating in a period of study with Auguste Rodin in 1912–13. Rodin impressed on his pupil the important role of light in sculpture and his firm conviction that the sculptor should "work by the volume and not by the surface, from inside to outside."[2] Storrs, however, maintained his independence; he passed through an eclectic, nonlinear development as he absorbed Rodin's teachings and pursued an inclination toward simplified form and geometric stylization. A trip to the American West to install Rodin's sculptures at the Panama-Pacific International Exposition in 1915[3] fostered that preference, as Storrs came in contact with American Indian art, began to collect it, and to incorporate its decorative motifs into his own work.[4]

The essential characteristics of Storr's style began to come together about 1917–19 when he combined simplified planar forms that often incorporated a dynamic, forward-thrusting movement (evident also in his woodcuts and drawings at that time). His work—figural as well as nonobjective sculptures, inspired by Futurism, Cubism, and Vorticism—combined colorful, unusual, and diverse materials (painted terracotta, inlaid enamel and glass, as well as stone, plaster, wood, and marble). Storrs increasingly blended sculpture with architecture in columnar figurative groups, inlaid relief panels, and designs for monuments. About 1920 a group of architectonic sculptures[5] revealed his interest in the machine—a

Plate 94
John Storrs
American, 1885–1956
Study in Form (Forms in Space), 1923
Oak (by eye), stained brown and partially ebonized, 20 x 12 ¼ x 2 ⅛ inches (50.8 x 31.1 x 5.4 cm)
Collection of C. K. Williams, II

fascination he shared with such contemporary European Dada and Surrealist artists as Man Ray, Francis Picabia, and Marcel Duchamp.

Storrs's series of architectural sculptures, variously titled *Study in Form*, *Architectural Form*, and *Forms in Space*, which date from 1923–24, is universally recognized as the most original work of his career. In these modestly scaled columnar towers and skyscrapers made of stone or a combination of metals, the union of sculpture and architecture came to splendid fruition. It is important to note that Storrs's series was not simply an expression of his admiration of the soaring towers of New York and Chicago—a passion he shared with his artist contemporaries. His architectural sculptures also originated in the love of buildings he learned from his architect father and from his early exposure to the Arts and Crafts movement in Hamburg, which fostered an appreciation of the interdependence of the arts.[6] Frank Lloyd Wright's work was influential too, for Storrs's sculptures and their decoration incorporated the vocabulary forms that originated in Wright's shop, most notably in the use of sharp cutout shapes contrasted with the smooth surfaces of the towers' shafts.[7]

Study in Form (Forms in Space), the model in wood for a bronze of the same scale and title, is an unusual member of this important series.[8] Unlike the columnar forms of most of the other sculptures in the group, this piece is more earthbound than soaring. It has been called "a fragment of architectural ornamentation that has been pried off a building,"[9] but the bronze as well as its model seem almost too sturdy and self-sufficient to be an ornament: solidly grounded on a base of serried triangles, the vertical elements press down into and seem wedged firmly between them. The triangles forming the base of the wood model gain weight through their darker color.[10] Contrasting patterns of wood grain disrupt the upward thrust of the vertical elements, and the cutout zigzag applied along the periphery of the triangular base also reinforces a downward direction. The exquisite craftsmanship of the model—particularly the careful differentiation of wood grains and the use of pattern and

color not only to decorate but also to express the strength and solidity of the forms—is testimony to the sculptor's early training in woodworking.

A drawing dated December 20, 1923, for *Study in Form (Forms in Space)* (fig. 46) differs from the sculpture in the noticeable shortening of the vertical elements. Executed in pen and black ink without any modeling, it is more of a diagram than an attempt to represent three-dimensional form. Although it has been suggested that the wood model

Fig. 46: **John Storrs**
American, 1885–1956
Drawing for "Study in Form (Forms in Space)," 1923
Ink and graphite on wove paper, 10 ¼ x 8 ¼ inches (26 x 21 cm)
Munson-Williams-Proctor Arts Institute, Museum of Art, Utica, New York. 90.26

perhaps preceded the drawing,[11] a detail of the model's structure suggests that Storrs may have decided to elongate the vertical elements while he was building it, for he added a small piece of wood to extend the height of one of them and matched the other two to its greater height—proportions he maintained in the bronze.

1. John Storrs, "Museums or Artists," *Little Review* (Winter 1922), p. 63.

2. Storrs, quoted in Noel Frackman, *John Storrs*, exh. cat. (New York: Whitney Museum of American Art, 1986), p. 13.

3. Joan M. Marter, Roberta K. Tarbell, and Jeffrey Wechsler, *Vanguard American Sculpture, 1913–1939*, exh. cat. (New Brunswick: Rutgers University Art Gallery, Rutgers, State University of New Jersey, 1979), p. 23.

4. Frackman, *John Storrs*, p. 20.

5. Ibid., p. 48.

6. Ann Rosenthal, "John Storrs, Eclectic Modernist," in Jennifer Gordon, Laurie McGavin, Sally Mills, and Rosenthal, *John Storrs and John Flannagan: Sculpture and Works on Paper*, exh. cat. (Williamstown, MA: Sterling and Francine Clark Art Institute, 1980), p. 12.

7. Frackman, *John Storrs*, p. 60, cites the Larkin Company Administration Building in Buffalo.

8. The bronze, dated January 9, 1924, is in the Hirshhorn Museum and Sculpture Garden, Smithsonian Institution, Washington, DC; it is reproduced in Marter, Tarbell, and Wechsler, *Vanguard American Sculpture*, p. 96, fig. 149. Frackman, *John Storrs*, p. 63, says that the sculptures were "based on wood models and drawings . . . [and] fabricated under Storrs' supervision."

9. Jeffrey Wechsler, "Machine Aesthetics and Art Deco," in *Vanguard American Sculpture*, p. 96, made this statement in reference to the bronze rather than the wood model.

10. The bronze sculpture also has different colored patinas: the vertical elements are the lightest in tone and the triangles are slightly darker than the horizontal base. I received this information from Valerie Fletcher, curator, Hirshhorn Museum and Sculpture Garden. While Storrs typically used a variety of metals in his series of sculptures, Roberta K. Tarbell (in conversation with the author, July 2008) established that he also combined different patinas in bronze sculptures.

11. Mary E. Murray and Paul D. Schweizer, *Life Lines: American Master Drawings, 1788–1962, from the Munson-Williams-Proctor Institute*, exh. cat. (Utica, NY: Munson-Williams-Proctor Institute, 1994), p. 99, use the date of the drawing to support the idea that it preceded the wood model, but the model is not precisely dated; the bronze is dated January 9, 1924.

PAVEL TCHELITCHEW

PIERROT

1930

Pavel Tchelitchew (1898–1957) was born into an aristocratic family in prerevolutionary Russia.[1] Despite his father's vehement opposition, he pursued in secret his interests in painting and ballet with financial support from an aunt. Passionately interested in theater, he spent his time designing costumes for imaginary performances; at nineteen, he was invited to collaborate in designing scenery for a production of the Bolshoi Opera, which he declined. His escape from Russia to Kiev during the revolution brought him into contact with Alexandra Exter and Constructivism as well as the Suprematists Kasimir Malevich and Vladimir Tatlin, whose theatrical projects were of particular interest to him. Yet his proclivity for figural works and portraiture led him to favor the Blue and Rose Periods of Pablo Picasso, an influence he sustained into the 1920s and early 1930s. Tchelitchew traveled from Kiev to Constantinople, Sophia, and finally Berlin, where he designed a new production of Nikolay Andreyevich Rimsky-Korsakov's *Le coq d'or* for the Berlin State Opera, which suffered severe criticism for costumes and scenery that overpowered both soloists and chorus. In 1923, at the suggestion of the ballet impresario Sergey Diaghilev, Tchelitchew and his lover, a young American pianist, Allen Tanner, departed for Paris. Without any financial support, Tchelitchew took jobs designing costumes for the Folies Bergère. He also began painting portraits, which eventually became an important source of income, owing to his masterful draftsmanship and extraordinary talent for creating arresting, often poetic images of his sitters. One of his favorite weekly pastimes in Paris was to frequent sideshows and circuses, which inspired an important series of paintings of circus subjects that he undertook in about 1929–30. *Pierrot* is one of the most striking images from that group—clearly a portrait of an unidentified sitter cast in the role of the sad clown, a stock character in mime and commedia dell'arte.

Many of Tchelitchew's circus pictures depict single figures, often shown full-length, as in *Green Clown* (1930). Sometimes the characters perform poignant dramas, such as in *Fallen Rider* (1930). Occasionally, they are engaged in routine activities, as in the mysterious painting *The Mirror (Circus Dressing Room)* (1932).[2] Tchelitchew seems not only to have drawn actual

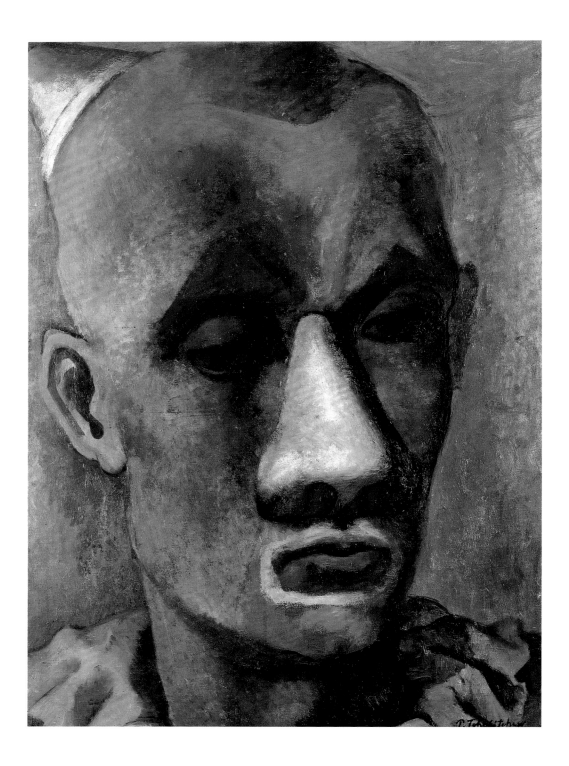

Plate 95
Pavel Tchelitchew
American, born Russia, 1898–1957
Pierrot, 1930
Oil on canvas, 28 ¾ x 21 ¼ inches (73 x 54 cm)
Collection of C. K. Williams, II

In the first serious study of Tchelitchew's work for the Museum of Modern Art's solo exhibition in 1942, James Thrall Soby made an acute analysis of the specific nature of the influence of Picasso's Rose Period clowns on Tchelitchew's circus paintings:

> In . . . 1929–30 the influence of Picasso's Rose period reached a close point of application. This influence was not merely one of subject matter. . . . Rather it consisted primarily in the stylization of the figures and the technique of floating them against a monochromatic variant of their own color, sometimes defining their contours with heavy outlines but often letting the volumes wash loosely against the closely related color of the background.[4]

In *Pierrot*, Tchelitchew employs precisely this technique of limiting his palette to a range of closely related colors for both figure and background, allowing the figure alternately to merge with and emerge from the background—an effect that mysteriously heightens the pathos of the image, as Picasso must also have recognized.

1. The ensuing summary of Tchelitchew's biography is largely drawn from Lincoln Kirstein, *Tchelitchev* (Santa Fe: Twelvetrees Press, 1994), pp. 15–31.
2. *Green Clown* and *Fallen Rider* are reproduced in ibid., pls. 30, 32. *The Mirror* is reproduced in Michael Duncan, *Pavel Tchelitchew: The Landscape of the Body*, exh. cat. (Katonah, NY: Katonah Museum of Art, 1998), p. 24.
3. Tchelitchew's biographer described Vincent: "This fair, muscular young man has that rather indolent, animal-like male nature, self-aware yet unself-conscious, entirely sweet and given up to things as they are, to which Tchelitchew is especially attracted. Such persons have for the artist that *vraie sagesse du monde* consisting wholly in the dignity of the body." Parker Tyler, *The Divine Comedy of Pavel Tchelitchew: A Biography* (London: Weidenfeld and Nicolson, 1967), p. 344. *The Rose Necklace* is reproduced in ibid., n.p.
4. James Thrall Soby, *Tchelitchew: Paintings—Drawings*, exh. cat. (New York: The Museum of Modern Art, 1942), p. 20.

performers; he also posed his studio models in circus roles, as exemplified by the two paintings of Charles Vincent, his favorite model, who appears in *Portrait of an Acrobat* (fig. 47) and *The Rose Necklace* (1931) as a serious, sensitive circus character, lost in thought.[3] The subject of the present painting, *Pierrot*, by contrast, is outwardly expressive, marked by a long, ovoid head and anguished expression that oddly recalls Donatello's sculpture *Lo Zuccone*. Much of this expression is achieved by the exaggeration of features: the white protruding nose; the red triangles above the eyebrows; the painted line encircling the lips, and the shell-like pink ear. Pierrot's eyes are cast in deep shadow and seem almost sightless.

Fig. 47: **Pavel Tchelitchew**
American, born Russia, 1898–1957
Portrait of an Acrobat, c. 1931
Oil on canvas, 28 1/2 x 19 1/2 inches (72.4 x 49.5 cm)
Location unknown

GEORGE TOOKER

VOICE I
1963

George Tooker (born 1920) is best known for his meticulous egg tempera technique, his uncanny ability to evoke and portray different kinds and degrees of anxiety, and his creation of unique figure types that sometimes bear remarkable resemblances to himself. After his education at Andover and Harvard and a short period of military service, in 1943 Tooker began to study at the Art Students League in New York with Reginald Marsh, Kenneth Hayes Miller, and Harry Sternberg. Marsh was his mentor, but Miller's preference for basing his figures on Renaissance sources rather than live models and his practice of using variations on a single figure type were methods that stuck with Tooker as he developed his style. Like Miller, Tooker used compact figures in contemporary dress, which were often devoid of emotion. His introduction to egg tempera came from Paul Cadmus, a fellow student at the Art Students League, who encouraged him to read D. V. Thompson's *The Practice of Tempera Painting*. Cadmus also introduced Tooker to his friend Jared French, and soon they became the "close-knit triumvirate of Renaissance worshipers whom many writers would accurately associate in terms of technique and theme."[1] Tooker seized on the slow, painstaking egg tempera technique with its bright, layered, gleaming surface, because it matched his methodical working practice; he has continued to use it for the rest of his career.

Tooker has said of *Voice I*: "The figures on either side of the wall are identical. The painting is about non-communication."[2] This puts a bland face on a highly disturbing image, but it is accurate because his intention here is not to present an anecdotal happening but instead the universal dilemma of noncommunication. Such an outlook is typical of Tooker, who throughout his career has sought to address society at large rather than the individual. In *Voice I*, his message is clear because the man who cannot communicate and the man unable to hear are not two individuals but the same person. Only the situations are contrasted: the former is entrapped in darkness, while the latter is bathed by an eerie light; both appear terrified, one by his inability to communicate and the other by what he fears about the information he cannot hear.

Plate 96
George Tooker
American, born 1920
Voice I, 1963
Egg tempera on gessoed panel, 20 x 18 inches (50.8 x 45.7 cm)
Collection of C. K. Williams, II

While Tooker's earliest pictures, such as *Dance* (1946) and
Children and Spastics (1946),[3] contain some figures displaying
strong emotion, those in the majority of his paintings are
marked by their lack of expression or, at most, an aura of
anxiety. In fact, the expressive character of Tooker's paintings
is oddly derived from his way of presenting figures drained
of emotion, moving as though in a dream world, unaware of
each other's presence even when trapped in crowded sur-
roundings. On the infrequent occasions when Tooker chooses
to convey emotion through facial expression, it is fear that is
most often expressed; it occurs in paintings that range over
many years, such as *Subway* (1950), *Cornice* (1959), *Voice I*
(1963), and *The Lesson* (1974). In Tooker's world, emotion is
limited because that would convey individuality; in *Voice I*
anxiety is multiplied in a single person shown twice.

In a number of Tooker's works, such as his so-called public
paintings of the 1950s (*Subway*, *Government Bureau*, and
The Waiting Room), he used walls as a means to express
hopeless and frightening isolation. In the 1960s the theme
of the impenetrable wall emerged in paintings that confront
frustration and entrapment. *Voice I* is the first and most overtly
expressive, followed by the bleached, unnerving *White Wall*
(1964–65); *Two Heads* (1966), an emotionless version of
Voice I; and *Door* (1969–70), where a man presses his weight
against a door to shut out some unseen external force.
Tooker continued these themes in the 1970s, with a slightly
exaggerated version of *Voice I*, entitled *Voice II* (1970);
Standing Figures (1973), where the figure in *Voice I* is repeated
in one of several figures, each pressed against a separate
wall; *Woman at the Wall* (1974); and a lithograph of *Voice I*
(1977) in which the image appears in reverse.

1. Greta Berman and Jeffrey Wechsler, *Realism and Realities: The Other Side
of American Painting, 1940–1960*, exh. cat. (New Brunswick: Rutgers University
Art Gallery, Rutgers, State University of New Jersey, 1981), p. 24.
2. Quoted in Thomas H. Garver, *George Tooker*, rev. ed. (Rohnert Park, CA:
Pomegranate Communications, 2002), p. 82.
3. All of the works cited in this text are reproduced in ibid.

MAX WEBER

FOUR FIGURES
1912

THE FOREST
1912

Through his steadfast and articulate advocacy, his small private collection of work by Henri Matisse, Pablo Picasso, and Henri (the Douanier) Rousseau, as well as his own work as a painter, Max Weber (1881–1961) played a key role in introducing modern art to America.[1] His crucial three years in Europe between 1905 and 1908 provided him with the fullest possible experience of avant-garde art in Paris.[2] Weber initially took classes at the Académie Julian, but he matured quickly and became part of the group of artists who frequented the collection of the siblings Gertrude and Leo Stein at 27, rue de Fleurus; he attended and exhibited his work in the Salons, visited Picasso's studio, and became friendly with the Douanier Rousseau, who became a mentor. Weber was first drawn to Paul Cézanne's work at the Salon d'Automne in 1905, and in 1908 he took classes with Matisse, yet it was not until he returned to New York in 1909 that his work showed Picasso's influence. Clearly he admired Picasso's work, as he acquired a small painting by him in 1908. In 1909 Weber made paintings of nudes in landscape settings that showed an understanding of Cézanne's use of color to construct volumes in space combined with Matisse's bright colors and the rhythmic, undulating poses of his 1905–7 nudes.

A radical change took place, however, in 1910, when Weber reacted forcefully to the reproductions of Georges Braque's and Picasso's Cubist work in an article by Gelett Burgess, published in *Architectural Record* that spring.[3] Suddenly monumental Cubist nudes bulged out of the limits of their compositions and struck carefully orchestrated poses inspired by a drawing of three nudes by Braque that was reproduced in the article. These powerful nudes were among the paintings that greeted visitors to Weber's solo exhibition at Alfred Stieglitz's 291 in January 1911—an event that sadly ended the brief but productive friendship of Stieglitz and Weber.[4]

Four Figures (Sisters) and Weber's other figure paintings of 1911–13 do not develop logically from his Cubist paintings of 1910, and he never strove to integrate his figures completely with surrounding space, as did Picasso and Braque. A detail of one painting of about 1911–13 suggests that Weber

Plate 97
Max Weber
American, born Russia, 1881–1961
Four Figures (Sisters), 1912
Oil on canvas, 36 x 21 inches (91.4 x 53.3 cm)
Collection of C. K. Williams, II

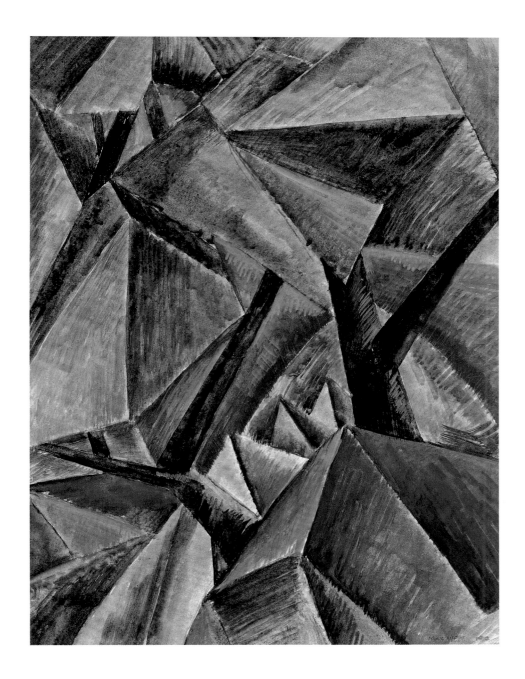

Plate 98
Max Weber
American, born Russia, 1881–1961
The Forest, 1912
Gouache on paper, 14 ½ x 10 ¾ inches (36.8 x 27.3 cm)
Collection of C. K. Williams, II

experimented with that possibility,[5] but others, such as *Four Figures*, show that he ultimately did not pursue that direction. Instead, although there are obvious differences between them, Weber makes many references in *Four Figures* to Picasso's 1907 *Les Demoiselles d'Avignon* (fig. 48)[6] in his presentation of four women with fixed stares striking similarly angled poses in front of a faceted curtain. As in the *Demoiselles*, two of Weber's women have bent arms upraised behind their heads, while another holds an outstretched hand against the curtain; a plant growing upward in front of the figures echoes the fruit that marks the foreground of Picasso's composition. Weber's colorfully clothed figures move with jerky, angular gestures as though performing a rhythmic dance, and their stark white faces create a lively syncopation—features that distinguish them from Picasso's lighter, less varied colors and more emphatic, emblematic poses. Weber's bow to Picasso's *Demoiselles* five years after its creation emanates chiefly from his adoption of key details from that painting; his use of vigorous parallel hatchings for shading, by contrast, derives from a technique of brushwork Picasso and Braque employed later, about 1908–9.

In what was clearly an experimental period for Weber about 1911–13, he also made a few explorations of abstraction. The small gouache *The Forest* is one such work, showing the impact of the exhibition of Picasso drawings and watercolors held in the spring of 1911 at 291. As Michael Fitzgerald has recently observed, Weber as well as Arthur Dove and Marsden Hartley seem especially to have responded to the landscapes Picasso had painted in the summer of 1908,[7] leading each of them to create powerful, overall compositional constructions of tree branches and dense masses of foliage. In its restrained palette and in the application of washes in long parallel strokes, Weber's *Forest* reflects several of Picasso's gouaches from that period.[8] The structure of the clustered pyramidal forms that make up the composition denotes a rare instance in which the artist abandoned representation in favor of nearly total abstraction, which is denied only by a few tree branches nestled among the geometric forms.

1. The best recent discussion of Weber's influential role is that of Michael Fitzgerald, *Picasso and American Art*, exh. cat. (New York: Whitney Museum of American Art, in association with Yale University Press, 2006), pp. 15–25.
2. On Weber's experiences in Paris, see Jill Kyle, "Paul Cézanne, 1911: Nature Reconstructed," in Sarah Greenough, *Modern Art and America: Alfred Stieglitz and His New York Galleries*, exh. cat. (Washington, DC: National Gallery of Art, 2000), pp. 107–8.
3. Gelett Burgess, "The Wild Men of Paris," *Architectural Record*, vol. 27, no. 5 (May 1910), pp. 401–14. For a discussion of Weber's style before and after the Burgess article, see John R. Lane, "The Sources of Max Weber's Cubism," *Art Journal*, vol. 35, no. 3 (Spring 1976), pp. 231–36.
4. The conflicting accounts of the break between Weber and Stieglitz are discussed in Percy North, "Turmoil at 291," *Archives of American Art Journal*, vol. 24, no. 1 (1984), pp. 12–20. Weber's friendship with Stieglitz was of critical importance in encouraging him to exhibit the work of Cézanne and Picasso at 291. Weber's small painting by Picasso that he brought back from Paris in 1909 was the first Picasso Stieglitz had ever seen. See Kyle, "Paul Cézanne, 1911," p. 108; and Charles Brock, "Pablo Picasso, 1911: An Intellectual Cocktail," in Greenough, *Modern Art and America*, p. 117.
5. See Weber's *Composition—Three Figures* (c. 1911–13), reproduced in Lane, "The Sources of Max Weber's Cubism," p. 235, fig. 6.
6. *Les Demoiselles d'Avignon* was one of the paintings reproduced in Burgess's 1910 article (see n. 3 above).
7. Fitzgerald, *Picasso and American Art*, p. 317 n. 56: "Although contemporary accounts do not specify that the show included these works, the reviews are far from exhaustive, and the cluster of drawings by Marsden Hartley, Arthur Dove, and Weber is so consistent and unprecedented that a source in Picasso's work is extremely likely."
8. See, for example, Pierre Daix and Joan Rosselet, *Picasso: The Cubist Years, 1907–1916* (Boston: New York Graphic Society, 1979), nos. 180, 188.

Fig. 48: **Pablo Picasso**
Spanish, 1881–1973
Les Demoiselles d'Avignon, 1907
Oil on canvas, 96 x 92 inches (243.8 x 233.7 cm)
The Museum of Modern Art, New York. Acquired through the Lillie P. Bliss Bequest

GRANT WOOD

PLOWING

1936

Though he spent his entire career living and working in his native Iowa, chose to wear the bibbed overalls of a farmer, and became the principal spokesman for American Regionalism, which encouraged artists to focus on local subject matter, Grant Wood (1891–1942) himself was far from the countrified farmer depicted in *American Gothic*,[1] his iconic painting of an Iowa farm couple, which became his best-known work from the first time it was exhibited in 1930. True as he was to his native origins, Wood was never provincial; during the 1910s he received training in Minneapolis and Chicago in art, design, and metalwork—fields in which he exhibited equal talent and success, though he achieved his greatest fame as a painter. In his youth, Wood was also well aware of the importance young artists attached to study abroad. While working in Cedar Rapids, Iowa, as a public school art teacher in his late twenties, he saved his money to go to Paris in 1920. Then, in 1923–24, he took a leave of absence, returning to Paris to study at the Académie Julian and travel in Europe. At this time his paintings consisted primarily of plein air landscapes executed with open, impressionistic brushwork.[2]

The most important event for the future direction of Wood's painting was a trip in 1928 to Munich, where enthusiasm for the precise execution and minute detail of fifteenth-century Flemish and German painting led him to develop his signature painting style, which he would employ to depict scenes drawn from his local surroundings. However, while early northern painting may have been the immediate inspiration for Wood's new direction, his work in design and the decorative arts provided a meaningful background for his new style as well. As a result of having worked simultaneously as a painter and interior designer, art and craft were always merged for Wood: the clean efficiency and simplified ornamental design are best exemplified by his Cedar Rapids studio interior he created in 1924, where details like the arrangements of pottery on shelves or the round rug carefully centered on the checkerboard floor tiles foreshadowed the precise, patterned style that emerged in his paintings in 1930.[3]

304

Plate 99
Grant Wood
American, 1891–1942
Plowing, 1936
Colored crayons over charcoal with touches of opaque white paint on paper, 23 ½ x 29 ½ inches (59.7 x 74.9 cm)
Philadelphia Museum of Art. Promised gift of C. K. Williams, II

Stone City, Iowa (1930), exhibited at the Art Institute of Chicago along with American Gothic, launched an important series of landscapes executed in Wood's new style of painting; it is to this group of works that the large, finished drawing Plowing belongs. A contemporary photograph of Stone City shows that Wood drew his landscapes directly from actual sites,[4] though his simplification and stylization of forms in the landscapes made them seem like imaginary, idealized places. The first paintings in the group, which date from 1930–32, are the most detailed and stylized, displaying bulbous lollipop trees, rows of regimented haystacks reduced to small knobs, tiny fans of corn sprouting in orderly lines from tilled earth, and roads with knife-sharp edges carved from the fields.[5] Plowing is closely related to Wood's magnificent green painting Spring Turning and its preparatory drawing,[6] all of which were executed in 1936. Grander and more monumental in concept than the earlier landscapes, these three compositions are simplified and abstracted in their depiction of large, brown, quiltlike squares of plowed earth spread over undulating green fields that stretch as far as the eye can see. Plowing is related to no known painting,[7] yet its scale and technique are similar to the kind of finished preparatory drawings that Wood typically made just before a painting. Though it includes considerably more detail than Spring Turning, Plowing might even be a variant view of the same farm, though it could equally show an entirely different site.

More than one scholar has pointed out that Wood chose not to depict the technologically advanced farming of the 1930s in his landscapes, but instead presented a nostalgic vision of the preindustrial methods of his late-nineteenth-century childhood, when the earth was turned by the farmer walking behind a horse-drawn plow. He was criticized for portraying such idealized scenes of pastoral calm during the Depression-era conditions in his native Iowa during the 1930s, which saw a collapsing farm economy and various natural disasters.[8] Yet, as James Dennis has acutely observed, in landscapes such as Plowing Wood wove together an intricate blend of the past and the present, the old and the new, not only in content but also in style. For indeed, the grand scale and structure of the fields being cultivated in Plowing could not be accomplished by a single farmer with a horse-drawn plow but are a feat of modern machinery.[9] Nor does the simplified patterning that came to dominate Wood's mid-1930s landscapes have anything to do with the picturesque. The abstracted shapes of the landscape in Plowing are bold and streamlined—compared by Dennis with "a contemporary machine aesthetic derived from industrial design."[10] On the other hand, as correct as this interpretation may be, coinciding as it does with Wood's sophisticated ability to mingle art and design,[11] in Plowing one still cannot overlook the breathtaking romance of his vision of a world being perfectly formed by a distant, solitary plowman.

1. Illustrated in Wanda M. Corn, Grant Wood: The Regionalist Vision, exh. cat. (New Haven: Yale University Press, for the Minneapolis Institute of Arts, 1983), p. 128, pl. 32.
2. Biographical information presented in this text is chiefly drawn from James M. Dennis, Grant Wood: A Study in American Art and Culture (New York: Viking Press, 1975); Corn, Grant Wood; Brady M. Roberts et al., Grant Wood: An American Master Revealed, exh. cat. (San Francisco: Pomegranate Artbooks; Davenport, IA: Davenport Museum of Art, 1995); and Jane C. Milosch, ed., Grant Wood's Studio: Birthplace of "American Gothic," exh. cat. (Cedar Rapids, IA: Cedar Rapids Museum of Art; Munich: Prestel, 2005).
3. On Wood's studio, see esp. Jane C. Milosch, "Grant Wood's Studio: A Decorative Adventure," in Milosch, Grant Wood's Studio, pp. 79–109.
4. Stone City, Iowa and a 1930–35 photograph of Stone City are discussed and reproduced in Corn, Grant Wood, pp. 72–74, fig. 109, pl. 6.
5. See, for example, Young Corn (1931) and Fall Plowing (1931), reproduced in Corn, Grant Wood, pp. 92–93, pls. 15–16.
6. Spring Turning and the preparatory drawing for it are reproduced in Dennis, Grant Wood, pp. 167, 187, fig. 156, pl. 34.
7. An inscription on the back of this drawing indicates that it was commissioned from Wood by a Mr. Stuart B. White, which suggests that it was not preparatory for a painting.
8. Dennis, Grant Wood, pp. 206, 208; Corn, Grant Wood, p. 90.
9. Dennis, Grant Wood, p. 220.
10. Ibid., p. 227.
11. It is not surprising that Wood later used the neatly bordered squares of his "quilted" landscapes in a design for a textile that was never realized, reproduced in Milosch, Grant Wood's Studio, p. 109, fig. 98.

MARGUERITE THOMPSON ZORACH

MOUNTAINS

1910–11

Climb the mountains and get their good tidings. Nature's peace will flow into you as sunshine flows into trees. The winds will blow their own freshness into you, and the storms their energy, while cares will drop off like autumn leaves.[1]

From her earliest childhood vacations spent in the Sierra Nevada in California, Marguerite Thompson Zorach (1887–1968) drew inspiration from mountainous terrains; the naturalist John Muir's joyous declaration, quoted above, was pinned to the wall of her Paris studio when she was a student there in 1911.[2] Daughter of a prosperous lawyer in Fresno, California, Marguerite could trace her family's roots to New England and Quaker Pennsylvania. Her education included lessons in French, German, and the piano, and her artistic talent was encouraged. In 1908 she was admitted to Stanford University, but almost immediately after she arrived there she accepted an invitation to join her aunt, an artist who had settled in Paris. Photographs taken in Paris show that Marguerite Thompson (she married William Zorach in 1912) already had a well-developed style of her own. In 1911, seated in the Luxembourg Gardens, she is wearing a distinctive dress of vertical patterned stripes and a bonnet adorned with a cluster of flowers.[3] Marguerite designed and made her own clothes, and she favored strong patterns and designs put together in beautiful and unusual combinations. Had her introduction to the art of Henri Matisse and the Fauves in 1908 Paris never occurred, it seems certain that even without them she would have developed a unique style that made use of many of the same elements that distinguished their work. Fortunately, however, at the Paris salons and at the home of Gertrude Stein (a friend of her aunt's), she found an approach that immediately resonated with her natural inclinations, and she quickly adopted the Fauves' bright, pure colors as well as their simplification and strong outlining of forms.

During summer travels in the south of France in 1910 and 1911, Marguerite relished the brilliant light and color similar to that of California, which she had missed during the gray Paris winters. During that time, she painted at least ten small wood panels, measuring roughly twelve by sixteen inches, several of which portray the mountainous landscape around

Plate 100
Marguerite Thompson Zorach
American, 1887–1968
Mountains, 1910–11
Oil on board, 12 ¼ x 15 ½ inches (31.1 x 39.4 cm)
Collection of C. K. Williams, II

Les Baux.[4] *Mountains* appears to be one of that group of landscapes—a dense, compact composition of mauve and salmon pink rocks interwoven with patches of deep blue-green and olive shrubbery, their shapes traced by bright blue outlines; rugged peaks, strongly outlined, stand out against a bright sky. The paint is thickly applied, covering the entire surface of the panel, and it is possible to see the path of the artist's brush as it moved over the interwoven lines and forms.[5] Although small in scale, *Mountains* possesses a monumentality seen only occasionally in the 1910–11 paintings of the landscape in southern France. Here, the mountains fill the panel from bottom to top—a pile-up of large shapes reaching to its top border; space is compressed so that there is little sense of a path from foreground to background. The feeling of the mountains' grand scale in this picture has led to the suggestion that *Mountains* might have been painted in the summer of 1912, after the artist's return to California when she painted a series of canvases of the Sierra. However, in those larger compositions on canvas, measuring approximately twenty-six by twenty inches, she employed a more vibrant technique, using separate, agitated brushstrokes and leaving areas of canvas exposed. In those works, too, she employed starker contrasts of white, royal blue, red-orange, and emerald green, abandoning the more muted Mediterranean palette seen in *Mountains* and the other small paintings of southern France.[6]

panel, thickly building up areas of blended pigment. However, in *Village Square* [1911] the surface treatment is quite different; . . . the panel is covered with dabs of almost pure pigment laid down next to one another in an effect reminiscent of Pointillism." If this distinction is accepted, the present painting corresponds to the technique of the earlier, 1910, landscapes.

6. The dating of c. 1912 for *Mountains* was suggested by Meredith Ward. For color reproductions of the paintings of the Sierra, see *Marguerite Zorach: A Life in Art*, pls. 4–5.

1. John Muir, "Impression Leaflet #19," quoted in Roberta K. Tarbell, *William and Marguerite Zorach: The Maine Years*, exh. cat. (Rockland, ME: William A. Farnsworth Library and Art Museum, 1979), p. 11.

2. Roberta K. Tarbell, *Marguerite Zorach: The Early Years, 1908–1920*, exh. cat. (Washington, DC: Smithsonian Institution Press, for the National Collection of Fine Arts, 1973), p. 60 n. 41, speculates that Marguerite knew Muir personally.

3. See ibid., fig. 2.

4. Ibid., pp. 20–25, gives the most detailed analysis of the development of Marguerite's paintings in the south of France in 1910 and 1911. Several of the small panels are reproduced by Tarbell in figs. 6–12. For a color reproduction, see also *Marguerite Zorach: A Life in Art*, exh. cat. (New York: Gerald Peters Gallery, 2007), pl. 2.

5. Elizabeth Thompson Colleary, "Marguerite Thompson Zorach: Some Newly Discovered Works, 1910–1913," *Woman's Art Journal*, vol. 23, no. 1 (Spring–Summer 2002), p. 25, makes a distinction between the landscapes painted in the summer of 1910 and those painted in 1911: "In the earlier Provence paintings, the artist appears to have mixed the colors on the surface of the

MARGUERITE THOMPSON ZORACH

THE AWAKENING

c. 1916

We rented a fish loft [in Provincetown] on the shore. . . . Tessim was a year old. . . . Marguerite shocked Provincetown by wheeling Tessim up and down Main Street and letting him play on the beach naked. She said it was much easier to wash a baby than to wash his clothes, and besides he was handsome to look at and draw.[1]

The year 1915 was an especially important one for Marguerite (1887–1968) and William Zorach: on March 28 their first child—a son—Tessim was born, followed by a summer in New Hampshire at a decrepit farmhouse lent to them by the artist, critic, and teacher Hamilton Easter Field; during the following winter they were given a joint exhibition at the Daniel Gallery in New York. Although their work survived Daniel's show, all but one of the paintings done in New Hampshire flaked and crumbled owing to the artists' experimentation with a paint formula that had been recommended to them by Field.[2]

Marguerite Zorach's *The Awakening*, depicting a naked child seated beneath the protective arm of a reclining father figure, was clearly inspired by her new motherhood. Given the fate of her paintings from 1915, it seems likely that it was made sometime after the Daniel exhibition, perhaps during the summer of 1916, described above, which the Zorachs spent in Provincetown, Massachusetts, with one-year-old Tessim. A review of the exhibition at Daniel's suggests that *The Awakening* shares the general characteristics of the lost pictures: "There are landscapes and landscapes, with figures, some family groups in surroundings, which recall in composition the primitive painters."[3] Not only were the Zorachs—who were then working with closely related subjects and styles—experimenting with the Cubists' geometric fragmentation of form, but they were also strongly affected by "primitive" art, particularly African, Oceanic, and American folk art sculptures.[4] Both influences account for the geometric compartmentalization of the monumental reclining male in *The Awakening*, whose outstretched arm and torso shelter the robust child in the composition's center, disarmingly striking the pose of an ancient Zeus hurling a thunderbolt. The composition is an intricately interwoven design of monumental volumes and minute details, which curiously resembles the seamless

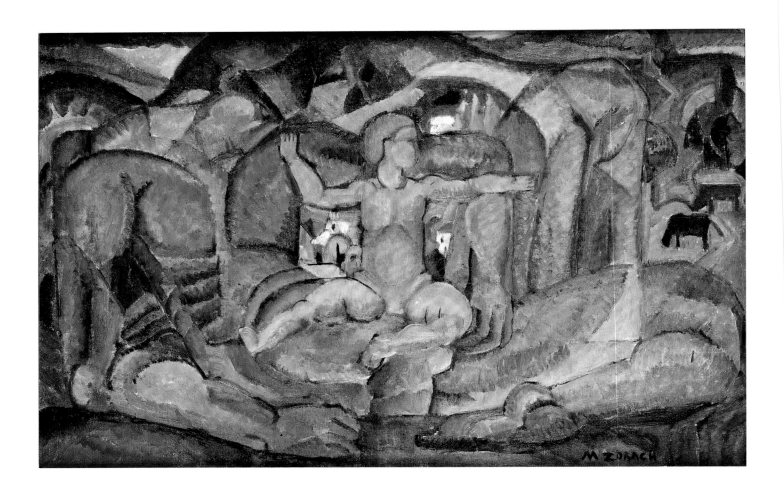

Plate 101
Marguerite Thompson Zorach
American, 1887–1968
The Awakening, c. 1916
Oil on canvas, 18 x 28 inches (45.7 x 71.1 cm)
Collection of C. K. Williams, II

structure of some of Marguerite's embroidered tapestries. Tiny buildings, hills, trees, cows, and fields appear behind, in, and around the figures so that the reclining male and the landscape can scarcely be separated from one another. Marguerite replaced her customary bright Fauve palette with earth tones, punctuated only by small details in bright color. Paint is applied in small parallel strokes; as in the past, most major forms are outlined in black.

About 1917 William Zorach repeated *The Awakening* in a linocut entitled *Father and Son* (printed in reverse),[5] and he also embellished the scene with panels of text for a Christmas card (fig. 49). Many years later, about 1939, he created another variant of what must have been a favorite image in his marble sculpture *The Faith of the Nation*.[6]

1. William Zorach, *Art Is My Life: The Autobiography of William Zorach* (Cleveland: World, 1967), p. 44.
2. Ibid., p. 41; and Roberta K. Tarbell, *Marguerite Zorach: The Early Years, 1908–1920*, exh. cat. (Washington, DC: Smithsonian Institution Press, for the National Collection of Fine Arts, 1973), p. 44.
3. A. v. C., "The Zorachs at Daniels," *American Art News*, vol. 14, no. 9 (December 4, 1915), p. 5.

4. *Marguerite and William Zorach: Harmonies and Contrasts*, exh. cat. (Portland, ME: Portland Museum of Art, 2001), pp. 38–39.
5. See Efram L. Burk, "Testament to American Modernism: The Prints of William and Marguerite Zorach" (Ph.D. diss., The Pennsylvania State University, 1998), p. 210, no. ZPL.36.
6. Reproduced in *Marguerite Zorach: A Life in Art*, exh. cat. (New York: Gerald Peters Gallery, 2007), p. 12, fig. 3.

Fig. 49: **William Zorach**
American, born Lithuania, 1889–1966
After Marguerite Thompson Zorach (American, 1887–1968)
Father and Son, c. 1917
Linocut; image (irregular) 6 x 12 1/8 inches (15.2 x 30.8 cm); sheet (irregular)
7 5/16 x 12 5/8 inches (18.5 x 32.1 cm)
Philadelphia Museum of Art. Gift of an anonymous donor. 1958-67-82

WILLIAM ZORACH

YOSEMITE FALLS

1920

I spent five months in the Yosemite Valley sketching, drawing, painting, and doing watercolors. . . .

Never had I dreamed of such awe-inspiring magnitude, such beauty and grandeur of forms. The tremendous waterfalls dropping from the blue sky thousands of feet into the valley, the domes and mountains of granite, the silent lakes, the rushing streams, the giant sequoias with their delicate fern-like needles and tremendous slabs of bark. . . . This was the Garden of Eden, God's paradise. I sketched and painted in ecstasy.[1]

Throughout his career, William Zorach (1889–1966) frequently wrote about his own work and that of others.[2] One of his earliest articles, "a discussion of the new meanings of line and form and color that are developing in the world today,"[3] written in 1921, addresses his desire to articulate the vision of the modern painter and its relation to nature. The article has special significance because Zorach wrote it the year between the completion of his largest and most successful painting, *Yosemite Falls*, and his decision to end his career as a painter to concentrate on sculpture. Entitled "The New Tendencies in Art," it is dense and searching, and it seems to summarize his discoveries as a painter during a decadelong struggle to break free of his academic training. Yet it is remarkably at odds with the series of works he had recently "sketched and painted in ecstasy."

Zorach was born in Lithuania and immigrated with his family to the Cleveland area at the age of four.[4] He left school after the eighth grade and, with support from one of his teachers, obtained a job at W. J. Morgan Lithograph Company; later, he began studying at night at the Cleveland School of Art. By 1908 Zorach was able to save enough money to move to New York, where he took classes in painting and drawing at the National Academy of Design and briefly at the Art Students League. Visiting commercial galleries brought an awareness of Impressionism, but he continued to work in the academic tradition even when he decided in 1910 to go to Paris to continue his studies. Inability to understand the instructors in the French art academies led him to the progressive Académie

Plate 102
William Zorach
American, born Lithuania, 1889–1966
Yosemite Falls, 1920
Oil on canvas, 72 x 30 inches (182.9 x 76.2 cm)
Collection of C. K. Williams, II

de la Palette, where he was taught by the Scottish artist John Duncan Fergusson and Charles-Émile Blanche, who encouraged the young artist to begin working in an Impressionist-inspired style. An even more progressive influence was a fellow student at La Palette, his future wife, Marguerite Thompson, who introduced him to Gertrude Stein and her collection and accompanied him to the 1911 Salon des Indépendants where her work was exhibited. By later that year, when he and Marguerite exhibited in the Salon d'Automne, his work showed an interest in Fauvism.

Although he quickly adopted the pure color of the Fauves in Paris, Zorach had trouble accepting modern artists' distortion of form, hampering his ability to absorb Cubism. Not until 1916, four years after he and Marguerite had moved to New York and married, did his work begin to show serious interest in Cubism, principally encouraged through his friendship with Max Weber.[5] Zorach destroyed most of his first Cubist paintings, but he continued to work in a pictorial form of Cubism similar to that of his American contemporaries and the less radical European Cubists such as Albert Gleizes and Jacques Villon.[6] Many of Zorach's paintings of the late 1910s seem to be intellectualized *applications* of Cubist structure to his compositions. Indeed, his 1921 article about modern art suggested some suspicion of emotional engagement: "Some emotional or intellectual reaction in the artist is necessary to arouse the creative impulse. But in the creation of a work of art the artist is interested only in the problems of expression. He is creating something that must live within the square of his canvas, find complete being there through a building up of plastic form and color, the interlacing of planes and textures, of depths and surfaces."[7]

How different this is from Zorach's remembrance of his ecstatic response to the Yosemite Valley, not to mention the many works he made at that moment! In numerous little-known drawings and watercolors he left theory and analysis behind to create fluid, abstract, joyous evocations of plunging cascades, bouncing bubbles, narrow streams, and burgeoning torrents.[8] The most definitive statement on the subject, often named as Zorach's greatest painting, is the narrow, six-foot canvas *Yosemite Falls*. Here he captures the fall's precipitous journey that begins beneath a tiny triangle of blue sky, spreads wide into a billowing, cloudlike surge, then retracts and reemerges with greater downward force. With radiating bursts and fans of color painted with small, agitated strokes, Zorach evoked the dramatic power of the landscape through which the falls descend. Although it was not the last painting he made before turning to sculpture, *Yosemite Falls* is the work in which he broke free of Cubism, a style that had always seemed to burden him.

1. William Zorach, *Art Is My Life: The Autobiography of William Zorach* (New York: World, 1967), p. 60.
2. Zorach was born Zorach Samovich, which was changed to William Finkelstein after he moved to America. In 1912 he changed his name again to William Zorach. Between 1916 and 1967 he issued at least twenty-seven publications, culminating in his posthumously published autobiography.
3. William Zorach, "The New Tendencies in Art," *Arts*, vol. 2 (October 1921), p. 10.
4. The most complete biographical information for Zorach is still Roberta K. Tarbell, "Catalogue Raisonné of William Zorach's Carved Sculpture" (Ph.D. diss., University of Delaware, 1976), vol. 1.
5. See *Marguerite and William Zorach: Harmonies and Contrasts*, exh. cat. (Portland, ME: Portland Museum of Art, 2001), p. 39: Zorach said that Weber broadened "the range of my vision; he made me more conscious of a more three-dimensional vision."
6. Tarbell, "Catalogue Raisonné," vol. 1, p. 43.
7. Zorach, "The New Tendencies in Art," p. 10.
8. Zorach joined the photographer Ansel Adams on mountain-climbing trips in the Yosemite Valley. See Zorach, *Art Is My Life*, p. 62.

CHECKLIST

ALEXANDER ARCHIPENKO
American, born Ukraine, active Paris, 1887–1964

Plate 1: *Figure in Movement (Figure)*,
1913
Collage, graphite, and pastel on paper,
18 3/4 x 12 1/4 inches (47.6 x 31.1 cm)
Signed and dated, on verso: *A. Archipenko 1913*
Collection of C. K. Williams, II

Provenance:
Galerie Der Sturm, Berlin; Galerie Goltz, Munich;
Galerie Jean Chauvelin, Paris, by 1971; Sotheby & Co.,
London, "Twentieth Century Russian and East
European Paintings, Drawings, and Sculpture,
1900–1930," July 4, 1974, lot 16 (repro.); Perls
Gallery, New York, 1974; Donald Karshan, FL,
1974–91; Ronnie Meyerson, Inc., New York, 1991;
Dr. Robert and Connie Nowinski, Seattle, 1991–97;
Hirschl & Adler Galleries, Inc., New York; purchase
from Hirschl & Adler Galleries, Inc., March 19, 1997.

Exhibitions:
Galerie Gmurzynska-Baargeram, Cologne.
Osteuropäische Avant-Garde. October 8, 1970–
January 21, 1971. Exh. cat.; n.p., no. 8, pl. 8.

Städtisches Museum, Mönchengladbach, Germany.
*Rationale Spekulationen, Konstructivistische Tendenzen
in der europäischen Kunst zwischen 1915 und 1930,
ausgewählt aus deutschen Privatsammlungen.*
October 1–November 26, 1972. Exh. cat.; n.p.,
no. 8, pl. 8.

Norton Center for the Arts, Centre College, Danville,
KY. *Archipenko: Sculpture, Drawings, and Prints,
1908–1963; As Collected, Viewed, and Documented
by Donald Karshan.* March 23–May 6, 1985. Exh. cat.
by Donald Karshan; pp. 34, 44, 54, no. 16 (repro).

National Gallery of Art, Washington, DC. *Alexander
Archipenko: A Centennial Tribute.* November 16, 1986–
February 16, 1987. Exh. cat.; p. 153, no. 9. Traveled
to Tel Aviv Museum, March 12–June 13, 1987.

Nassau County Museum of Art, Roslyn Harbor, NY.
*Twentieth Century Master Watercolors, Drawings,
and Sculpture from the Nowinski Collection.* May 10–
August 9, 1992. Exh. cat. by Ronnie Meyerson; pp.
10–11 (repro.). Traveled to The Art Museum, Princeton
University, NJ, February 28–April 11, 1993.

Henry Art Gallery, University of Washington, Seattle.
*Modern Masters and the Figure: Picasso to de
Kooning.* September 17–November 28, 1993. Exh.
cat.; n.p., no number (no repro.).

References:
Karshan, Donald. *Archipenko: The Sculpture and
Graphic Art, Including a Print Catalogue Raisonné.*
Tübingen: Ernst Wasmuth Verlag, 1974; pp. 42–43
(repro.).

Strauss, Michel, ed. *Impressionism and Modern
Art: The Season at Sotheby Parke Bernet, 1973–74.*
London and New York: Sotheby Parke Bernet
Publications, 1974; p. 91 (repro.).

Michaelsen, Katherine Jánszky. *Archipenko: A Study
of the Early Works, 1908–1920.* New York: Garland,
1977; p. 214, no. D10 (repro.).

Plate 2: *Head: Construction with Crossing Planes (Sketch for "Woman in Front of a Mirror" [Étude pour femme à la toilette]),* late 1950s
Bronze, height 15 1/16 inches (38.2 cm)
Signed and dated on base: *Archipenko 1913*
Cast 3/6
Collection of C. K. Williams, II

Provenance:
Perls Gallery, New York, by 1970; Donald Karshan,
FL, 1972; corporate collection, New York, 2000;
purchase from Martha Parrish & James Reinish,
Inc., New York, October 15, 2002.

Exhibitions:
The Museum of Modern Art, New York. *Archipenko:
The Parisian Years.* July 20–October 18, 1970. Exh.
cat.; n.p., no. 9 (no repro.).

Los Angeles County Museum of Art. *The Cubist
Epoch.* December 15, 1970–February 21, 1971;
p. 243, no. 1, pl. 293. Traveled to The Metropolitan
Museum of Art, New York, April 7–June 4, 1971.

Norton Center for the Arts, Centre College,
Danville, KY. *Archipenko: Sculpture, Drawings, and
Prints, 1908–1963; As Collected, Viewed, and
Documented by Donald Karshan.* March 23–May 6,
1985. Exh. cat. by Donald Karshan; pp. 44, 52,
59–61, nos. 18a–18c (repro.).

References:
Archipenko, Alexander, and Fifty Art Historians.
Archipenko: Fifty Creative Years, 1908–1958. New York:
Tekhne, 1960; no. 182 (repro.). Version unknown.

Karshan, Donald. *Csáky.* Paris: Dêpot 15, 1970;
p. 16 (repro.).

Elsen, Albert. *Origins of Modern Sculpture: Pioneers
and Premises.* New York: George Braziller, 1974;
pp. 51–52, 170, no. 70 (repro.). Version unknown.

Karshan, Donald. *Archipenko: The Sculpture and
Graphic Art, Including a Print Catalogue Raisonné.*
Tübingen: Ernst Wasmuth Verlag, 1974; pp. 18–19,
29, 39 (repro.).

Michaelsen, Katherine Jánszky. *Archipenko: A Study
of the Early Works, 1908–1920.* New York: Garland,
1977; p. 218, fig. 16 (repro.). Version unknown.

GEORGE AULT
American, 1891–1948

Plate 3: *Loft Buildings, No. 1,* 1922
Oil on canvas, 20 x 14 inches (50.8 x 35.6 cm)
Signed and dated, lower right: *G.C. Ault '22*
Collection of C. K. Williams, II

Provenance:

Estate of the artist; Harry and Nancy Koenigsberg, New York, c. 1960–82; Gail Chesler and Richard Lippe, New York, 1983–96, through Zabriskie Gallery, New York; Martha Parrish & James Reinish, Inc., New York, 1996–98; purchase from Martha Parrish & James Reinish, Inc., October 19, 1998.

Exhibitions:

Anderson Galleries, Inc., New York. *Salons of America: 1922 Autumn Salon.* October 16– November 4, 1922. Exh. cat.; n.p., no. 6 (no repro.).

Bourgeois Galleries, Inc., New York. *Annual Exhibition of American Painters and Sculptors.* 1923. Exh. cat.; n.p., no. 4 (no repro.).

Woodstock Art Gallery, NY. *George Ault: Memorial Exhibition.* September 9–23, 1949. Exh. cat.; n.p., no. 3 (no repro.).

Whitney Museum of American Art at Equitable Center, New York. *George Ault.* April 8–June 8, 1988. Exh. cat. by Susan Lubowsky; pp. 12, 52, no. 6 (repro.). Traveled to Memphis Brooks Museum of Art, November 13, 1988–January 1, 1989; Joslyn Art Museum, Omaha, February 4–April 2, 1989; New Jersey State Museum, Trenton, April 29– June 11, 1989.

Richard York Gallery, New York. *Modernism at the Salons of America, 1922–1936.* October 19– December 8, 1995. Exh. cat.; p. 15, no. 1 (no repro.).

Nassau County Museum of Art, Roslyn Harbor, NY. *American Vanguards.* January 21–April 28, 1996. Exh. cat. by Constance Schwartz and Franklin Hill Perrell; pp. 30, 87 (repro.).

Reference:

Ault, Louise. "George Ault: A Biography." Typescript, n.d.; pp. 12–13. George Ault artist file, Library and Archive, Smithsonian American Art Museum, Washington, DC.

Plate 4: *The Machine (The Engine)*, 1922

Oil on canvas, 26 ¼ x 16 inches (66.7 x 40.6 cm)
Collection of C. K. Williams, II

Provenance:

Estate of the artist; Mr. and Mrs. I. David Orr, Cedarhurst, NY, by April 22, 1963; Zabriskie Gallery, New York; Martha Parrish & James Reinish, Inc., New York; Bernard Goldberg Fine Arts, LLC, New York; purchase from Bernard Goldberg Fine Arts, LLC, June 14, 2005.

Exhibitions:

Gallery of Modern Art, New York. *The Twenties Revisited.* June 29–September 6, 1965. Exh. cat.; n.p., no number (no repro.).

Whitney Museum of American Art at Equitable Center, New York. *George Ault.* April 8–June 8, 1988. Exh. cat. by Susan Lubowsky; pp. 16, 52, no. 11 (repro.). Traveling exhibition but only shown in New York.

Reference:

Ault, Louise. "George Ault: A Biography." Typescript, n.d.; p. 12. George Ault artist file, Library and Archive, Smithsonian American Art Museum, Washington, DC.

Plate 5: *Tree Stump*, 1934

Oil on canvas, 28 x 20 inches (71.1 x 50.8 cm)
Signed and dated, lower left: *G.C. Ault '34*
Collection of C. K. Williams, II

Provenance:

Private collection; Gerald Peters Gallery, New York, 2002; purchase from Gerald Peters Gallery, October 18, 2002.

Exhibitions:

Whitney Museum of American Art, New York. *Second Biennial Exhibition of Contemporary American Painting.* November 27, 1934–January 10, 1935. Exh. cat.; n.p., no. 19 (no repro.).

Woodstock Art Gallery, NY. *George Ault: Memorial Exhibition.* September 9–23, 1949. Exh. cat.; n.p., no. 23 (no repro.).

Milch Galleries, New York. *George Ault: Memorial Exhibition.* January 30–February 18, 1950. Exh. cat.; n.p., no. 6 (no repro.).

References:

Ault, Louise. "George Ault: A Biography." Typescript, n.d.; p. 26. George Ault artist file, Library and Archive, Smithsonian American Art Museum, Washington, DC.

Ault, Louise. *Artist in Woodstock, George Ault: The Independent Years.* Philadelphia: Dorrance & Company, 1978; pp. 72, 136 (no repro.).

Plate 6: *Night at Russell's Corners*, 1946

Oil on canvas, 16 x 30 inches (40.6 x 76.2 cm)
Signed and dated, lower right: *G.C. Ault '46*
Collection of C. K. Williams, II

Provenance:

Private collection, Brooklyn Heights, NY, by 1949; Vanderwoude Tanenbaum Gallery, New York, by 1982; private collection, New York, by 1988; Martha Parrish & James Reinish, Inc., New York; purchase from Martha Parrish & James Reinish, Inc., February 21, 2001.

Exhibitions:

Probably Vanderwoude Tanenbaum Gallery, New York. *George Ault, 1920s–1940s: Works on Paper with Related Paintings.* November 16–December 11, 1982. No cat.

Whitney Museum of American Art at Equitable Center, New York. *George Ault.* April 8–June 8, 1988. Exh. cat. by Susan Lubowsky; pp. 35, 54, no. 33 (repro.). Traveled to Memphis Brooks Museum of Art, November 13, 1988–January 1, 1989; Joslyn Art Museum, Omaha, February 4–April 2, 1989; New Jersey State Museum, Trenton, April 29– June 11, 1989.

Reference:

Looking Back: Martha Parrish & James Reinish; 15 Years. New York: Martha Parrish & James Reinish, 2008; pp. 50, 92, no. 30 (repro.).

MILTON AVERY
American, 1893–1965

Plate 7: *Red Nude*, 1955

Oil on canvas, 22 x 50 inches (55.9 x 127 cm)
Signed and dated, lower left: *Milton Avery 1955*
Collection of C. K. Williams, II

Provenance:

Grace Borgenicht Gallery, New York; Mr. and Mrs. Malcolm K. Fleschner, New York and FL, by 1965; Gerald Peters Gallery, New York, by 2001; purchase from Gerald Peters Gallery, May 2001.

Exhibitions:

Grace Borgenicht Gallery, New York. *Milton Avery: Recent Paintings.* April 16–May 5, 1956. Exh. cat.; n.p., no. 8 (no repro.).

Park Gallery, Detroit. *Milton Avery.* April 24–May 7, 1960. Exh. cat.; n.p., no number (no repro.).

The Phillips Collection, Washington, DC. *Milton Avery Paintings, 1941–1963.* May 17–June 26, 1965. Circulated by The Museum of Modern Art, New York. Exh. cat. by Alicia Legg; n.p., no. 13 (no repro.). Traveled to Mercer University, Macon, GA, September 10–November 11, 1965; Indiana University, Bloomington, November 26–December 19, 1965; Mary Washington College, University of Virginia, Fredericksburg, January 7–28, 1966; Michigan State University, East Lansing, February 24–March 27, 1966; Coe College, Cedar Rapids, IA, April 1–22, 1966; Witte Memorial Museum, San Antonio, May 8–29, 1966; Colorado Springs Fine Arts Center, June 13–July 4, 1966; Madison Art Center, WI, September 4–25, 1966; Munson-Williams-Proctor Institute, Utica, NY, November 13–December 11, 1966.

Gerald Peters Gallery, New York. *The Modern Figure.* April 19–June 1, 2001. Exh. cat.; n.p., no number (repro.).

ROMARE BEARDEN
American, 1914–1988

Plate 8: *Trombone Player*, c. 1986

Paper collage and gouache on board, 8 x 11 inches (20.3 x 27.9 cm)
Signed, dated, and inscribed, middle left: *For / Russ: / Romare / 87*
Collection of C. K. Williams, II

Provenance:

Russell Goings, New York; Seth Taffae Fine Art, New York; ACA Galleries, New York; purchase from ACA Galleries, April 1, 2003.

GEORGE WESLEY BELLOWS
American, 1882–1925

Plate 9: *The Beach, Newport (In the Sand)*, 1919
Oil on panel, 26 x 32 inches (66 x 81.3 cm)
Inscribed by the artist's widow, Emma S. Bellows, lower left: *Geo. Bellows / E.S.B.*
Collection of C. K. Williams, II

Provenance:
Estate of the artist, 1925–64; Mr. and Mrs. Raymond J. Horowitz, New York, 1964–73; H. V. Allison & Co., Inc., New York; Sotheby Parke Bernet, Inc., New York, "Important Twentieth Century American Paintings, Watercolors, and Sculpture," December 13, 1973, lot 66 (repro.); Mrs. Miriam Sterling, New York, 1973–91; Hirschl & Adler Galleries, Inc., New York; purchase from Hirschl & Adler Galleries, Inc., January 5, 1993.

Exhibitions:
Frank K. M. Rehn Galleries, New York. *Exhibition by George Bellows: Paintings, Drawings, Lithographs.* January 2–21, 1928. Exh. cat.; no. 3.

The Metropolitan Museum of Art, New York. *Summer Loan Exhibition.* 1966. Exh. cat.; p. 1, no. 2 (no repro.).

Marlborough-Gerson Gallery, New York. *The New York Painter: A Century of Teaching; Morse to Hofmann. Benefit Exhibition for the New York University Art Collection.* September 27–October 14, 1967. Exh. cat.; pp. 56, 82 (repro.).

Tampa Museum of Art. *At the Water's Edge: 19th and 20th Century American Beach Scenes.* December 9, 1989–March 4, 1990. Exh. cat.; pp. 10, 92, 121, no number (repro.). Traveled to Center for the Arts, Vero Beach, FL, May 4–June 17, 1990; Virginia Beach Center for the Arts, July 8–September 2, 1990; The Arkansas Art Center, Little Rock, November 8, 1990–January 6, 1991.

References:
"George Bellows Seen in Varied Productions." *New York Evening Post*, January 1928 (repro.). Clipping, Rehn Galleries Papers, reel 5869, frame 1419, Archives of American Art, Smithsonian Institution, Washington, DC.

Bellows, Emma S. *The Paintings of George Bellows.* New York: Alfred A. Knopf, 1929; n.p., no. 83 (repro.).

Conway, Robert. *The Powerful Hand of George Bellows: Drawings from the Boston Public Library.* Washington, DC: Trust for Museum Exhibitions, in cooperation with the Boston Public Library, 2007; pp. 35, 90, 92 (no repro.).

THOMAS HART BENTON
American, 1889–1975

Plate 10: *Sugar Cane*, c. 1938–43
Pen and ink over graphite on paper, 14 x 20 inches (35.6 x 50.8 cm)
Signed and titled, lower right: *Sugar Cane / Benton*
Collection of C. K. Williams, II

Provenance:
Private collection, New York, through 1996; purchase from Gerald Peters Gallery, New York, January 8, 1996.

Exhibition:
Springfield Art Museum, MO (per label on back of frame, no. 73B).

Reference:
Benton Drawings: A Collection of Drawings by Thomas Hart Benton. Columbia: University of Missouri Press, 1968; p. 73, no. 73 (repro.).

Plate 11: *Sugar Mill (Syrup Mill)*, 1946
Watercolor on paper, 20 x 29 inches (50.8 x 73.7 cm)
Signed and dated, lower right: *Benton 46*
Collection of C. K. Williams, II

Provenance:
Associated American Artists Galleries, Chicago, 1946; James Street, NC; by gift to private collection and descent until 1991; Hirschl & Adler Galleries, Inc., New York, 1991–92; purchase from Hirschl & Adler Galleries, Inc., October 15, 1992.

Exhibition:
Associated American Artists Galleries, Chicago. *Benton.* March 1946. Exh. cat.; n.p., no. 24 (no repro.).

Plate 12: *The Apple of Discord*, 1949
Tempera glazed with oil on gessoed mahogany panel, 33 ½ x 43 ¼ inches (85.1 x 109.9 cm)
Signed and dated, lower left: *Benton '49*
Signed, titled, and dated, on verso
Philadelphia Museum of Art. Promised gift of C. K. Williams, II

Provenance:
Thomas Hart Benton Testamentary Trust, Kansas City, MO, after 1975; purchase from Thomas Hart Benton Testamentary Trust through Forum Gallery, New York, June 1, 1999.

Exhibitions:
Joslyn Art Museum, Omaha. *Benton Retrospective: Paintings, Prints, and Drawings by Thomas Hart Benton.* November 14–December 30, 1951. Exh. cat.; n.p., no number (no repro.).

University of Kansas Museum of Art, Lawrence. *Thomas Hart Benton.* April 12–May 18, 1958. Exh. cat.; n.p., no. 54 (repro.).

Madison Art Center, WI. *Thomas Hart Benton.* March 22–April 12, 1970. Exh. cat.; n.p., no number (repro.).

Helen Foreman Spencer Museum of Art, University of Kansas, Lawrence. *Benton's Bentons: Selections from the Thomas Hart Benton and Rita P. Benton Trust.* July 13–September 13, 1980. Exh. cat.; p. 59, no. 21 (no repro.). Traveling exhibition under the sponsorship of the Mid America Arts Alliance, February 15, 1981–September 26, 1982, to venues including Oklahoma Art Center, Oklahoma City, December 1981; Smart Gallery, University of Chicago, June 3–July 4, 1982; and Albrecht Gallery, St. Joseph, MO, dates unknown.

Pennsylvania Academy of the Fine Arts, Philadelphia. *In Private Hands: 200 Years of American Painting.* October 1, 2005–January 8, 2006. Exh. cat. by Lynn Marsden-Atlass, Nicolai Cikovsky, Jr., and Robert Rosenblum; pp. 43, 157, 247, pl. 56.

References:
Baigell, Matthew. *Thomas Hart Benton.* New York: Harry N. Abrams, 1973; p. 220, fig. 178.

Marling, Karal Ann. *Tom Benton and His Drawings: A Biographical Essay and a Collection of His Sketches, Studies, and Mural Cartoons.* Columbia: University of Missouri Press, 1985; p. 178 (no repro.).

Dennis, James M. *Renegade Regionalists: The Modern Independence of Grant Wood, Thomas Hart Benton, and John Steuart Curry.* Madison: University of Wisconsin Press, 1998; p. 140, fig. 71.

GEORGE BIDDLE
American, 1885–1973

Plate 13: *Self-Portrait*, 1933
Oil on canvas, 14 x 10 inches (35.6 x 25.4 cm)
Signed and dated, upper right: *Biddle / 1933*
Collection of C. K. Williams, II

Provenance:
Gift of the artist to The Museum of Fine Arts, Houston, 1934–73; Samuel Hart Galleries, Houston, 1973; private collector; Schwarz Gallery, Philadelphia, by 2002; purchase from Schwarz Gallery, 2003.

Exhibitions:
The Museum of Fine Arts, Houston. *Endowment Collection Exhibition.* November 27–December 2, 1934. No cat.

Schwarz Gallery, Philadelphia. *Winter Exhibition: One Hundred and One American Paintings.* December 2002. Exh. cat.; n.p., no. 92 (repro.).

ISABEL BISHOP
American, 1902–1988

Plate 14: *The Club*, 1935
Oil and tempera on pressed board, 17 x 20 inches
(43.2 x 50.8 cm)
Signed, lower right: *Isabel Bishop*
Collection of C. K. Williams, II

Provenance:
Possibly The Metropolitan Museum of Art, New York,
1936; Midtown Galleries, New York; Hon. and Mrs.
Bertram Wegman, New York, 1957–76; Edwin
Wegman, New York, after 1976; Midtown Payson
Galleries, New York, 1993; purchase from Midtown
Payson Galleries, April 28, 1993.

Exhibitions:
Midtown Galleries, New York. *Isabel Bishop*.
February 11–29, 1936. Exh. cat.; n.p., no. 5 (no
repro.).

New Jersey State Museum, Trenton. *Paintings by
Isabel Bishop, Sculpture by Dorothea Greenbaum*.
May 2–July 5, 1970. Exh. cat.; no. 2 (no repro.).

Laband Art Gallery, Loyola Marymount University,
Los Angeles. *Isabel Bishop, the Affectionate Eye:
Paintings, Drawings, Etchings and Aquatints,
1925–1982*. February 9–March 16, 1985. Exh. cat.
by Bruce St. John; pp. 30–31, no. 14 (repro.).
Reproduced inverted.

Sordoni Art Gallery, Wilkes University, Wilkes-Barre,
PA. *Between Heaven and Hell: Union Square in
the 1930s*. January 21–March 3, 1996. Exh. cat. by
Stanley I. Grand; pp. 8, 10, 19, 62, no. 4 (repro.).

References:
Art Students League of New York. *Isabel Bishop:
Instructor, Life Painting, Composition*. New York: Art
Students League of New York, 1940; n.p. (repro.).

Lunde, Karl. *Isabel Bishop*. New York: Harry N.
Abrams, 1975; n.p., no. 76 (repro.).

Yglesias, Helen. *Isabel Bishop*. New York: Rizzoli,
1989; p. 77 (repro.).

Todd, Ellen Wiley. *The "New Woman" Revised:
Painting and Gender Politics on Fourteenth Street*.
Berkeley: University of California Press, 1993; pp.
132–33, 274–75, fig. 3.39.

Plate 15: *Out to Lunch*, 1953
Oil and tempera on gessoed panel,
24 ¼ x 16 ¼ inches (61.6 x 41.3 cm)
Signed, lower right: *Isabel Bishop*
Collection of C. K. Williams, II

Provenance:
Midtown Galleries, New York; Dr. Elizabeth Levitin,
Glencoe, IL, 1956; Midtown Gallery, New York,
1976; R. S. Stecher, New York, 1976–81; V. Miller,
Salem, MA; Midtown Galleries, 1981; Dr. Jacob V.
Vargish, NJ, 1981–2006; DC Moore Gallery, New York;
purchase from DC Moore Gallery, July 17, 2006.

Exhibitions:
Whitney Museum of American Art, New York.
*1953 Annual Exhibition of Contemporary American
Painting*. October 15–December 6, 1953. Exh. cat.;
n.p., no. 8 (no repro.).

Midtown Galleries, New York. *Twenty-second
Anniversary Exhibition*. January 19–February 6, 1954.
No cat.

National Academy, New York. *129th Annual
Exhibition of the National Academy of Design*. April
1–25, 1954. Exh. cat.; p. 13, no. 115 (no repro.).

Toledo Museum. *Forty-first Annual Exhibition of
Contemporary American Paintings*. June 6–August
29, 1954. Exh. cat.; n.p., no. 4 (no repro.).

Corcoran Gallery of Art, Washington, DC.
*Twenty-fourth Biennial Exhibition of Contemporary
American Oil Paintings*. March 13–May 8, 1955.
Exh. cat.; n.p., no. 7 (no repro.). Traveled to Museum
of Fine Arts, Boston, June 1–July 31, 1955.

Midtown Galleries, New York. *Photographs,
Paintings, and Drawings by Isabel Bishop*. October
25–November 19, 1955. Exh. cat.; n.p., no. 4
(no repro.).

Pennsylvania Academy of the Fine Arts, Philadelphia.
151st Annual Exhibition of Painting and Sculpture.
January 22–February 26, 1956. Exh. cat.; n.p., no. 79
(no repro.).

Midtown Galleries, New York. *Isabel Bishop
Retrospective*. February 2–March 31, 1989. Pamphlet;
checklist no. 25.

References:
S.P. "20 Artists Show Work at Gallery." *New York
Times*, January 29, 1954, p. 24 (no repro.).

"Isabel Bishop." *Archives of American Art Journal*,
vol. 4, no. 2 (April 1964), p. 10 (repro.).

Yglesias, Helen. *Isabel Bishop*. New York: Rizzoli,
1989; p. 110 (repro.).

OSCAR BLUEMNER
American, born Prussia, 1867–1938

Plate 16: *Harlem River from Morris Mansion*; verso: *Study Sketch*, 1914
Charcoal and ink on paper, 4 ½ x 8 inches
(11.4 x 20.3 cm)
Titled, dated, and inscribed, lower left: *S 10-14 /
5:30 p / Harlem River from Schuyler / Morris Mansion*
Inscribed in graphite by unknown hand, upper right:
Suburban / RR / Bridge N / of End / of Elect. / RR
Inscribed in graphite by unknown hand, lower
center: *Schuyler*
Illegible color notes inscribed in ink, right side
Inscribed on verso in ink with illegible color notes
Collection of C. K. Williams, II

Provenance:
Gerald Peters Gallery, New York; purchase from
Gerald Peters Gallery, January 8, 1996.

Plate 17: *Motif Milltown*, 1915
Graphite on paper, 3 ⅝ x 5 ⅜ inches (9.2 x 13.7 cm)
Titled and dated on verso
Collection of C. K. Williams, II

Provenance:
Estate of the artist; Irma Rudin; S. R. Koman; DC
Moore Gallery, New York, February 1999; gift of
DC Moore Gallery, February 2006.

Exhibitions:
Arkansas Arts Center, Little Rock. *2001 Collector's
Show*. November 30, 2001–January 6, 2002.
No cat.; no. 138.

DC Moore Gallery, New York. *Inspiration and
Innovation: American Drawings and Watercolors,
1900–1960*. March 5–30, 2002. No cat.; no number.

Plate 18: *Red Port in Winter, Morris Canal*, 1922
Watercolor and graphite on paper, 5 ¼ x 6 ⅞ inches
(13.3 x 17.5 cm)
Collection of C. K. Williams, II

Provenance:
Estate of the artist; artist's daughter Vera Bluemner,
until c. 1967; private collection, New York, until
1996; Richard York Gallery, New York; purchase
from Richard York Gallery, 1996.

Exhibition:
Whitney Museum of American Art, New York.
Oscar Bluemner: A Passion for Color. October 7,
2005–February 12, 2006. Exh. cat. by Barbara
Haskell; p. 209, fig. 158.

Plate 19: *Red Port in Winter*, 1922
Oil on panel, 14 ¾ x 19 ¾ inches (37.5 x 50.2 cm)
Signed, lower right: *OBlümner* [OB in ligature]
Collection of C. K. Williams, II

Provenance:
Edward B. Bruce, New York, 1922; Florence Cane,
Westport, CT, by 1927; her widower, Melville Cane,
New York, until 1979; Terry Dintenfass, Inc., New
York, 1979; private collection, 1980; Richard York
Gallery, New York; purchase from Richard York
Gallery, March 6, 1996.

Exhibitions:
Possibly Anderson Galleries, Inc., New York.
Salons of America: 1922 Autumn Salon. October
16–November 4, 1922. Exh. cat.; n.p., no. 23.

Richard York Gallery, New York. *Modernism at the
Salons of America, 1922–1936*. October 19–
December 8, 1995. Exh. cat.; pp. 2, 15, fig. 4, no. 4.

Whitney Museum of American Art, New York.
Oscar Bluemner: A Passion for Color. October 7,
2005–February 12, 2006. Exh. cat. by Barbara
Haskell; p. 81, fig. 69.

Plate 20: *Moonshine Fantasy*, 1928–29
Watercolor on paper, 7 ½ x 5 inches (19.1 x 12.7 cm)
Collection of C. K. Williams, II

Provenance:
Richard York Gallery, New York; purchase from Richard York Gallery, October 31, 1993.

Plate 21: *Composition for Color Themes*, 1932
Watercolor on paper, 7 ¾ x 10 ½ inches (19.7 x 26.7 cm)
Signed and dated, lower left: *O.F.B. –32* [in monogram]
Collection of C. K. Williams, II

Provenance:
Estate of the artist, until c. 1960s; private collection, New York; Richard York Gallery, New York; purchase from Richard York Gallery, January 5, 1993.

References:
Dobrzynski, Judith H. "The Art Landscape: A Study in Realism." *Business Week*, no. 3299 (December 28, 1992–January 4, 1993), pp. 112–13 (repro.).

Richard York Gallery. *An American Gallery, Vol. 7.* New York: Richard York Gallery, 1992; n.p., no. 28 (repro.).

HUGH HENRY BRECKENRIDGE
American, 1870–1937

Plate 22: *Abstraction with Bouquet*, c. 1930
Oil on canvas, 28 ¼ x 32 ¼ inches (71.8 x 81.9 cm)
Signed, lower right: *Hugh H. Breckenridge*
Collection of C. K. Williams, II

Provenance:
Estate of the artist; Valley House Gallery, Dallas; private collection; Sid Deutsch Gallery, New York; Owings-Dewey Fine Arts, Santa Fe; Richard York Gallery, New York; purchase from Richard York Gallery, January 2, 1997.

CHARLES BURCHFIELD
American, 1893–1967

Plate 23: *Waterfall (Untitled, January 1916)*, 1916
Watercolor and graphite on paper, 13 ⅞ x 10 inches (35.2 x 25.4 cm)
Signed and dated, lower left: *Chas. Burchfield / 1916*
Collection of C. K. Williams, II

Provenance:
Private collection; Cottone Auctions and Appraisals, Mount Morris, NY, October 27, 2006, lot 130; private collection, New York; DC Moore Gallery, New York; purchase from DC Moore Gallery, January 2009.

Exhibition:
Hunter Museum of American Art, Chattanooga, TN. *Charles Burchfield: The Seasons.* March 2–June 1, 2008. Exh. cat. by Ellen Simak; pp. 23, 26, fig. 19.

Plate 24: *August Noon (Butterflies and Black Barn)*, 1916
Watercolor and graphite on paper, 20 x 14 inches (50.8 x 35.6 cm)
Signed, lower right: *CHASBURCHFIELD*
Inscribed on verso: *August 25, 1916 / Yellow butterflies and flies darting among the garden plants which glitter with white sunlight—the insects move so swiftly that they appear to the slow human eye as continuous zigzags (butterflies) or waving streaks (flies).*
Collection of C. K. Williams, II

Provenance:
Frank K. M. Rehn Galleries, New York, to 1929; Mrs. Courtlandt D. Barnes, New York, 1929–c. 1942; James W. Barney, New York [possibly by gift from Mrs. Courtlandt D. Barnes, his sister], to 1944; Parke-Bernet Galleries, Inc., New York, "Modern French Art," October 26, 1944, lot 15 (no repro.), did not sell; Parke-Bernet Galleries, Inc., New York, "English and American Furniture and Decorations," April 11, 1946, lot 171 (no repro.); Edwin D. Hewitt, New York; Parke-Bernet Galleries, Inc., New York, "Modern Paintings, Drawings and Prints," November 12, 1953, lot 27 (no repro.); private collection; Sotheby Parke Bernet, Inc., New York, "American Impressionist and 20th Century Paintings, Drawings, Watercolors and Sculpture," December 4, 1980, lot 174 (repro.); Kennedy Galleries, Inc., New York, by 1981; purchase from Kennedy Galleries, Inc., date unrecorded (1988 or after).

Exhibitions:
Department of Fine Arts, Carnegie Institute, Pittsburgh. *An Exhibition of Water Colors and Oils by Charles Burchfield.* March 8–April 3, 1938.

Kennedy Galleries, Inc., New York. *A Kennedy Galleries Selection of American Art for Public and Private Collections.* April 14–May 29, 1981. Exh. cat.; n.p., no. 48 (repro.).

Kennedy Galleries, Inc., New York. *Charles E. Burchfield: Watercolors from 1915 to 1920.* May 10–June 10, 1983. Exh. cat.; n.p., no. 22 (repro.).

Kennedy Galleries, Inc., New York. *Watercolors by Charles Burchfield and John Marin.* March 27–April 20, 1985. Exh. cat.; n.p., no. 22 (repro.).

Hirschl & Adler Galleries, Inc., New York. *Modern Times: Aspects of American Art, 1907–1956.* November 1–December 6, 1986. Exh. cat.; p. 20, no. 11 (repro.).

Columbus Museum of Art, OH. *The Early Works of Charles E. Burchfield, 1915–1921.* December 13, 1987–February 7, 1988. Exh. cat.; pp. 31, 66, no. 24 (repro.). Traveled to Laguna Museum of Art, Laguna Beach, CA, March 5–April 24, 1988; Burchfield Art Center, Buffalo, NY, May 14–July 3, 1988.

References:
"Charles Burchfield's Painting Index." Charles E. Burchfield Archives, Burchfield-Penney Art Center, Buffalo State College, Buffalo, NY; vol. 1, no. 85 (no repro.).

Straus, John W. "Charles E. Burchfield: An Interview with the Artist, an Account and Analysis of His Production, a Catalogue of His Paintings with Two Hundred Fourteen Reproductions." Honors thesis, Harvard College, 1942; no. 186 (no repro.), with reversed dimensions.

Trovato, Joseph S. *Charles Burchfield: Catalogue of Paintings in Public and Private Collections.* Utica, NY: Munson-Williams-Proctor Institute, 1970; p. 50, no. 179 (no repro.), with reversed dimensions.

Fort, Ilene Susan. "American Art." *Arts Magazine*, vol. 56, no. 1 (September 1981), p. 27 (repro.).

Makowski, Colleen Lahan. *Charles Burchfield: An Annotated Bibliography.* Lanham, MD: Scarecrow Press, 1996; pp. 50, 103 (no repro.).

Plate 25: *Stormy November Day*, 1946; augmented 1959
Charcoal, watercolor, and gouache on paper board, 29 ¾ x 37 inches (75.6 x 94 cm)
Signed and dated, lower left: *CEB* [in monogram] *1946–59*
Titled and dated, on verso: *Stormy November Day / Nov. 7, 1946*
Collection of C. K. Williams, II

Provenance:
Frank K. M. Rehn Galleries, New York; Christie's, New York, "Important American Paintings, Drawings, and Sculpture," November 30, 1999, lot 136 (repro.); purchase from Christie's auction, November 30, 1999.

Exhibition:
Philadelphia Museum of Art. *Andrew Wyeth and the American Landscape Tradition.* May 27–July 16, 2006. No cat.

PAUL CADMUS
American, 1904–1999

Plate 26: *Preliminary Study for "Aspects of Suburban Life: Polo Spill,"* 1935
Mixed technique (oil and tempera) on paper, 5 ⅛ x 7 ⅜ inches (13 x 18.7 cm)
Signed, lower left: *Cadmus*
Collection of C. K. Williams, II

Provenance:
Given by the artist to Jon Anderson; Midtown Payson Galleries, New York; purchase from Midtown Payson Galleries, March 7, 1992.

Exhibition:
Midtown Payson Galleries, New York. *Paul Cadmus: Paintings, Drawings and Prints.* March 12–April 18, 1992. No cat.

Reference:
Kirstein, Lincoln. *Paul Cadmus*. Rev. ed. New York: Chameleon Books, 1996; p. 133, no number (repro.).

ARTHUR B. CARLES
American, 1882–1952

Plate 27: *Reclining Nude*, 1927–35
Oil on canvas, 18 x 22 inches (45.7 x 55.9 cm)
Signed, lower left: *ARTHUR CARLES*
Collection of C. K. Williams, II

Provenance:
Mr. and Mrs. Evan Randolph, Philadelphia; Bernard Danenberg Gallery, New York; Janet Fleisher Gallery, Philadelphia; Judy and Alan Goffman; Janet Fleisher Gallery; Mr. and Mrs. Philip Jamison, West Chester, PA, 1979–94; Richard York Gallery, New York; purchase from Richard York Gallery, April 1, 1998.

Exhibitions:
USArtists. *Women and Children in American Art.* November 3–6, 1994. Sponsored by the Women's Committee of the Pennsylvania Academy of the Fine Arts, Philadelphia. No cat.

Richard York Gallery, New York. *Arthur Beecher Carles, 1882–1952*. October 2–November 14, 1997. Exh. cat.; pp. 10, 19, no. 15 (repro.).

Reference:
Wolanin, Barbara A. "Arthur B. Carles, 1882–1952: Philadelphia Modernist." Ph.D. diss., University of Wisconsin, 1981; p. 478, no. VA-27.

GIORGIO DE CHIRICO
Italian, born Greece, 1888–1978

Plate 28: *Portrait of Carlo Cirelli*, 1915
Oil on canvas, 29 ½ x 24 ½ inches (74.9 x 62.2 cm)
Signed, dated, and dedicated, lower center: *A Carlo Cirelli gentile / mio e multisensibile amico. / G. de Chirico / Ferrara Ottobre MCMXV*
Philadelphia Museum of Art. Partial and promised gift of C. K. Williams, II. 2008-111-1

Provenance:
Carlo Cirelli, Ferrara, Italy; Adriano Pallini, Milan, by 1945–55; Galleria del Millione, Milan; Ivan Dombrowsky, Milan; Piero Dorazio, Rome and St. Gall, Switzerland, 1956–c. 1988; deposited at Marlborough-Gerson Gallery, Inc., New York, 1968; Moeller Fine Art Ltd., New York, 1988–99; Sotheby's, New York, "Impressionist and Modern Art, Part I," November 16, 1998, lot 66 (repro.), did not sell; purchase from Moeller Fine Art Ltd., January 19, 1999.

Exhibitions:
The Museum of Modern Art, New York. *Giorgio de Chirico.* September 7–October 30, 1955. Exh. cat. by James Thrall Soby; pp. 108, 216 (repro.).

Frankfurter Kunstverein; Kuratorium Kulturelles Frankfurt; Steinernes Haus Römerberg. *Italien 1905–1925: Futurismus und Pittura metafisica.* November 16, 1963–January 5, 1964. Exh. cat.; no. 41.

Haus der Kunst, Munich. *Giorgio de Chirico.* November 17, 1982–January 30, 1983. Exh. cat. by William Rubin, Wieland Schmied, and Jean Clair; p. 168, no. 33 (repro.). Traveled to Centre Georges Pompidou, Musée national d'art moderne, Paris, February 24–April 25, 1983.

Moeller Fine Art Ltd., New York. *Private Views: 19th and 20th Century European and American Masters.* Spring 1989, fifth anniversary show. Exh. cat.; cover and inside flap, n.p., no. 8 (repro.).

References:
Carrieri, Raffaele. *Giorgio de Chirico.* Milan: Garzanti, 1942; pl. 2 (repro.).

Chirico, Giorgio de. *Memorie della mia vita.* Rome: Astrolabio, 1945; pp. 125–26, 132 (no repro.).

Ragghianti, Carlo L. "Il primo De Chirico." *La critica d'arte*, 3rd ser., vol. 8, no. 4, fasc. 30 (November 1, 1949), p. 326, fig. 252.

Bruni Sakraischik, Claudio, with the collaboration of Giorgio de Chirico and Isabella Far and with the special consultation of Giuliano Briganti. *Catalogo generale: Giorgio de Chirico; Opere dal 1908 al 1930.* Milan: Electa Editrice, 1971; vol. 1, n.p., no. 26 (repro.).

Chirico, Giorgio de. *The Memoirs of Giorgio de Chirico.* Translated by Margaret Crosland. London: Peter Owen, 1971; pp. 81–82, 85–86, 251 n. 5.

Briganti, Giuliano, and Ester Coen, eds. *La pittura metafisica.* Exh. cat. Vicenza: Neri Pozza Editore, 1979; pp. 53, 117, fig. 24.

Far de Chirico, Isabella, and Domenico Porzio. *Conoscere De Chirico: La vita e l'opera dell'inventore della pittura metafisica.* Milan: A. Mondadori, 1979; pp. 22–23, 287, fig. 9, pl. 48.

Fagiolo dell'Arco, Maurizio. *L'opera completa di De Chirico, 1908–1924.* Milan: Rizzoli Editore, 1984; pp. 96–97, no. 90 (repro.).

Fagiolo dell'Arco, Maurizio. *La vita di Giorgio De Chirico.* Turin: Umberto Allemandi Editore, 1988; pp. 59, 62, 64 (no repro.).

Gale, Matthew. "The Uncertainty of the Painter: De Chirico in 1913." *Burlington Magazine*, vol. 130, no. 1021 (April 1988), p. 276 n. 27 (no repro.).

Russell, John. "Review/Art." *New York Times*, March 24, 1989 (no repro.).

Baldacci, Paolo. *De Chirico: The Metaphysical Period, 1888–1919.* Translated by Jeffrey Jennings. Boston: Bulfinch Press / Little, Brown and Company, 1997; pp. 305, 342, 348, no. 96 (repro.).

Moeller, Achim. *In Good Hands: Twenty-five Years of Art in the Life of a Dealer.* New York: Achim Moeller Fine Art, 1997; pp. 30–31, 75.

Scardino, Lucio, and Antonio P. Torresi, eds. *Antichi e moderni: Quadri e collezionisti ferraresi del XX secolo.* Ferrara: Liberty House, 1999; p. 48 (no repro.).

RALSTON CRAWFORD
American, 1906–1978

Plate 29: *Boat and Grain Elevators*, 1942
Oil on canvas, 30 x 36 inches (76.2 x 91.4 cm)
Signed, lower right: *Crawford*
Signed on verso, upper stretcher: *Ralston Crawford*
Collection of C. K. Williams, II

Provenance:
Grace Borgenicht Gallery, New York; Meredith Long & Company, Houston; Hirschl & Adler Galleries, Inc., New York; purchase from Hirschl & Adler Galleries, Inc., date unrecorded.

Exhibitions:
Flint Institute of Arts, MI. *The Works of Ralston Crawford.* 1942.

Downtown Gallery, New York. *Ralston Crawford: In Peace and in War.* January 4–29, 1944. Exh. cat.; n.p., no. 7 (no repro.).

Honolulu Academy of Arts. *Ralston Crawford: Paintings, Photographs, Photograms.* 1947. No cat.; no. 21.

Milwaukee Art Center. *Ralston Crawford.* February 6–March 9, 1958. Exh. cat.; p. 22, no. 8 (no repro.).

The Contemporary Arts Center, Cincinnati. *Ralston Crawford Retrospective Exhibition, 1931–1971.* February 19–March 25, 1971. Exh. cat.; p. 36, no number (no repro.).

Hirschl & Adler Galleries, Inc., New York. *Ralston Crawford and the Sea.* March 9–April 20, 1991. Exh. cat.; pp. 27, 69, 79, no. 26 (repro.).

Hirschl & Adler Galleries, Inc., New York. *Streamlined: The Precisionist Impulse in American Art.* November 22, 1995–January 6, 1996. Exh. cat. by Meredith E. Ward; pp. 4, 6, 33, no. 15 (repro.).

Hirschl & Adler Galleries, Inc., New York. *Ralston Crawford's America.* September 28–November 9, 1996. Exh. cat. by Meredith E. Ward; no. 20.

References:
Freeman, Richard B. *Ralston Crawford.* Tuscaloosa: University of Alabama Press, 1953; p. 45, no. 42.8 (no repro.).

Agee, William C. *Ralston Crawford.* Pasadena, CA: Twelve Trees Press, 1983; p. 9, pl. 21.

JEAN JOSEPH CROTTI
French, 1878–1958

Plate 30: *Cubist Landscape (Paysage cubiste)*, 1923
Oil on canvas, 24 x 18 inches (61 x 45.7 cm)
Signed, lower left: *J. Crotti.*
Collection of C. K. Williams, II

Provenance:
Jean Crotti, Paris; Suzanne Duchamp, Paris; Elizabeth Buckles, Columbus, OH; her descendants;

purchase from Francis M. Naumann Fine Art, New York, October 22, 2008.

Exhibitions:
Musée Galliéra, Paris. *Rétrospective Jean Crotti*. December 11, 1959–January 11, 1960. Exh. cat., with an introduction by Raymond Cogniat; no. 34 (no repro.).

Columbus Gallery of Fine Arts, OH. *Jean Crotti in Retrospect*. January 7–February 28, 1965. Exh. cat., with an introduction by Edmund K. Kuehn; no. 57 (repro.).

Reference:
Bertoli, Jean Carlo. *Jean Crotti: L'oeuvre peint, 1900–1958; Catalogue raisonné*. Milan: 5 Continents Editions, 2007; p. 147, no. 23-11 (repro.).

STUART DAVIS
American, 1892–1964

Plate 31: *Composition 1863 (Factory by the Sea)*, 1932
Gouache and traces of graphite on paper, 22 1/4 x 30 1/4 inches (56.5 x 76.8 cm)
Signed, lower right: *Stuart Davis*
Collection of C. K. Williams, II

Provenance:
The artist; Downtown Gallery, New York; The Miller Company and Mr. and Mrs. Burton Tremaine, Meriden, CT, 1945–91; Christie's, New York, "Important American Paintings, Drawings and Sculpture of the 18th, 19th and 20th Centuries," December 6, 1991, lot 229; Joshua Strychalski American Paintings, New York, 1991; Harvey and Françoise Rambach, NJ, 1991–99; Martha Parrish & James Reinish, Inc., New York, 1999; purchase from Martha Parrish & James Reinish, Inc., May 11, 1999.

Exhibitions:
Downtown Gallery, New York. *Stuart Davis: Recent Paintings; Oil and Watercolor*. April 25–May 12, 1934. Pamphlet, no. 13.

Indiana University Art Museum, Bloomington. *Paintings by Marsden Hartley and Stuart Davis*. December 1–15, 1941.

Wadsworth Atheneum, Hartford. *Painting toward Architecture: The Miller Company Collection of Abstract Art*. December 11, 1947–January 4, 1948. Exh. cat.; pp. 68–69, 116 (repro.). Traveled to 24 American cities between 1948 and 1952, including Walker Art Center, Minneapolis, to February 22, 1948; Akron, OH, March 1948; Baltimore, April 1948; Milwaukee, May 1948; and to the West Coast through October 1948.

National Collection of Fine Arts, Washington, DC. *Stuart Davis Memorial Exhibition, 1894–1964*. May 28–July 5, 1965. Exh. cat.; pp. 61, 68, no. 44 (repro.). Traveled to The Art Institute of Chicago, July 30–August 29, 1965; Whitney Museum of American Art, New York, September 14–October 17, 1965.

Andrew Crispo Gallery, New York. *Pioneers of American Abstraction*. October 17–November 17, 1973. Exh. cat.; n.p., no. 26A (no repro.).

The Solomon R. Guggenheim Museum, New York. *Twentieth-Century American Drawing: Three Avant-Garde Generations*. January 23–March 23, 1976. Exh. cat.; p. 54, no. 63 (no repro.). Traveled to Staatliche Kunsthalle Baden-Baden, May 27–July 11, 1976; Kunsthalle Bremen, July 18–August 29, 1976.

Wadsworth Atheneum, Hartford. *The Tremaine Collection: 20th Century Masters; The Spirit of Modernism*. February 26–April 29, 1984. Exh. cat. by Robert Rosenblum et al.; pp. 18, 157 (repro.).

Wadsworth Atheneum, Hartford. *Delaunay to de Kooning: Modern Masters from the Tremaine Collection and the Wadsworth Atheneum*. May 4–September 15, 1991. No cat.; no. 21.

The Butler Institute of American Art, Youngstown, OH. *Masterpieces of American Modernism: The Rambach Collection*. January 11–April 26, 1998. Exh. cat. by Louis A. Zona and Sam Hunter; n.p., no number (repro.).

References:
Hitchcock, Henry-Russell. *Painting toward Architecture: The Miller Company Collection of Abstract Art*. New York: Duell, Sloan and Pearce, 1948; pp. 68, 116 (repro.).

Benedikt, Michael. "New York Letter." *Art International*, vol. 9, no. 8 (November 20, 1965), pp. 40, 44 (repro.).

Daxland, John. "Some Class Drawing." *Daily News*, March 2, 1976, p. 42 (repro.).

Gerald Peters Gallery. *American Modernism: The Françoise and Harvey Rambach Collection*. New York: Gerald Peters Gallery, 1999; p. 271 (no repro.).

Housley, Kathleen L. *Emily Hall Tremaine: Collector on the Cusp*. Meriden, CT: Emily Hall Tremaine Foundation, 2001; p. 163 (no repro.).

Boyajian, Ani, and Mark Rutkoski, eds. *Stuart Davis: A Catalogue Raisonné*. 3 vols. New Haven: Yale University Art Gallery, in association with Yale University Press, 2007; vol. 2, p. 596, no. 1174 (repro.).

Looking Back: Martha Parrish & James Reinish; 15 Years. New York: Martha Parrish & James Reinish, 2008; pp. 49, 93, no. 29 (repro.).

CHARLES DEMUTH
American, 1883–1935

Plate 32: *Straw Flowers*, c. 1916
Graphite and watercolor on paper, 8 1/8 x 10 5/8 inches (20.6 x 27 cm)
Signed, lower left: *C. Demuth*
Collection of C. K. Williams, II

Provenance:
Jordan-Volpe Gallery, New York; purchase from Jordan-Volpe Gallery, October 13, 1995.

Exhibition:
Jordan-Volpe Gallery, New York. *Ashcan to Abstraction: American Selections, 1900–1950*. September 30–November 11, 1995. Exh. cat.; n.p., no. 6 (no repro.).

Plate 33: *Nana before the Mirror*, 1916
Graphite and watercolor on paper, 8 x 10 inches (20.3 x 25.4 cm)
Signed, dated, and titled, lower left: *For(?) Nana—1916 / C.D.*
Collection of C. K. Williams, II

Provenance:
By bequest to Robert E. Locher, Lancaster, PA, 1935–January 8, 1946; gift to Richard Weyand, Lancaster, PA, 1946–56; C. W. Kraushaar Art Galleries, 1956–61; Mr. and Mrs. R. Barclay Scull, New York, 1961–82; Salander-O'Reilly Galleries, New York, 1982–86; Lafayette Parke Gallery, New York, 1987; Hirschl & Adler Galleries, Inc., New York; Christie's, New York, "Important American Paintings, Drawings and Sculpture of the 18th, 19th and 20th Centuries," November 30, 1990, lot 182 (repro.); Kennedy Galleries, Inc., New York, 1990; purchase from Kennedy Galleries, Inc., December 19, 1990.

Exhibitions:
Daniel Gallery, New York. *Nana* series shown to select patrons concurrent with exhibition *Water Colors by Charles Demuth; Paintings by Edward Fisk*. November–December 4, 1917. No cat.

Daniel Gallery, New York. No title. December 1920. No cat.

Grafton Galleries, London, and Whitney Studio, New York. Exhibition of *Nana* series shown as supplement to Venice Biennale. 1921. No cat.

The Art Institute of Chicago. *The Fourteenth International Exhibition of Watercolors, Pastels, Drawings and Monotypes*. March 21–June 2, 1935. Exh. cat.; n.p., no. 295 (no repro.).

Whitney Museum of American Art, New York. *Charles Demuth Memorial Exhibition*. December 15, 1937–January 16, 1938. Exh. cat.; n.p., no. 5 (no repro.).

Philadelphia Art Alliance. *Water Colors by Charles Demuth*. February 14–March 5, 1939. No cat.

The Phillips Memorial Gallery, Washington, DC. *Charles Demuth: Exhibition of Water Colors and Oil Paintings*. May 3–25, 1942. Exh. cat.; n.p., no. 42 (no repro.).

The Museum of Modern Art, New York. *Charles Demuth*. March 7–June 11, 1950. Exh. cat. by Andrew Carnduff Ritchie; pp. 41, 90, no. 46 (repro.). Traveled to The Detroit Institute of Arts, October 1–29, 1950; University of Miami Art Gallery, Coral Gables, FL, November 20–December

12, 1950; Winnipeg Art Gallery, Manitoba, Canada, December 28, 1950–January 18, 1951; Lawrence Art Museum, Williams College, Williamstown, MA, February 3–24, 1951; University of Delaware Memorial Library, Newark, March 10–31, 1951; Allen Memorial College Art Museum, Oberlin College, Oberlin, OH, April 14–May 5, 1951.

Philadelphia Museum of Art. Gallery installation. 1961–May 9, 1962.

Salander-O'Reilly Galleries, Inc., New York. *Important Watercolors by Charles Demuth*. September 15–October 30, 1982. No cat.

International Exhibitions Foundation, Washington, DC. *Twentieth Century American Drawings: The Figure in Context*. Exh. cat.; p. 48, no. 27 (repro.). Traveling exhibition, locations unrecorded, March 1, 1984–May 30, 1985.

Barbara Mathes Gallery, New York. *Mabel Dodge: The Salon Years, 1912–1917*. September 28–November 2, 1985. Exh. cat.; n.p., no. 7 (no repro.).

Whitney Museum of American Art, New York. *Charles Demuth*. October 15, 1987–January 17, 1988. Exh. cat. by Barbara Haskell; pp. 96, 99–100, pl. 36. Traveled to Los Angeles County Museum of Art, February 25–April 24, 1988; Columbus Museum of Art, OH, May 8–July 10, 1988; San Francisco Museum of Modern Art, August 7–October 2, 1988.

References:
Farnham, Emily. "Charles Demuth: His Life, Psychology and Works." Ph.D. diss., Ohio State University, 1959; vol. 2, p. 681, no. 701 (no repro.).

Allara, Pamela Edwards. "The Water-color Illustrations of Charles Demuth." Ph.D. diss., Johns Hopkins University, 1970; pp. 97–101, 271, pl. 23, no. 10.

Eiseman, Alvord L. "A Study of the Development of an Artist: Charles Demuth," Ph.D. diss., New York University, 1976; vol. 1, p. 188, no. 101 (no repro.).

Guieu, Jean-Max. "Les illustrateurs des romans d'Émile Zola aux États-Unis." *Les cahiers naturalistes*, vol. 38, no. 66 (1992), pp. 216–17, fig. 19.

Weinberg, Jonathan. *Speaking for Vice: Homosexuality in the Art of Charles Demuth, Marsden Hartley, and the First American Avant-Garde*. New Haven: Yale University Press, 1993; pp. 69–70 (no repro.).

Plate 34: *Gloucester—Sails and Masts*, 1919
Graphite and tempera on board, 20 x 15 ½ inches (50.8 x 39.4 cm)
Signed and dated, lower left: *C. Demuth / 1919*
Collection of C. K. Williams, II

Provenance:
Dr. Ananda Kentish Coomaraswamy, 1921–47; Dr. Rama F. Coomaraswamy (his son), 1947–83; Mr. and Mrs. Morris P. Silver, NY, 1983–84; Kennedy Galleries, Inc., New York, 1985; private collection; Richard York Gallery, New York; purchase from Richard York Gallery, May 3, 1993.

Exhibition:
Kennedy Galleries, Inc., New York. *Summits: Outstanding American Paintings, 1763–1985*. November 6–December 7, 1985. Exh. cat.; n.p., no. 10 (repro.).

Plate 35: *Jazz (Jass)*, 1921
Oil on canvas, 20 x 16 inches (50.8 x 40.6 cm)
Signed, dated, and titled on verso: *Jass / Charles Demuth– / 1921*
Collection of C. K. Williams, II

Provenance:
Mrs. Augusta Demuth, Lancaster, PA, 1935–43; bequest to Robert E. Locher, 1943–50/51; Herbert S. Levy, Lancaster, PA, 1950/51–80; Mrs. Mary Levy (his widow), 1980–84; Hirschl & Adler Galleries, Inc., New York, by 2000; purchase from Hirschl & Adler Galleries, Inc., November 2000.

Exhibitions:
William Penn Memorial Museum, Harrisburg, PA. *Charles Demuth of Lancaster*. September 24–November 6, 1966. Exh. cat. by the Pennsylvania Historical and Museum Commission; n.p., no. 143 (no repro.).

The Art Galleries, University of California, Santa Barbara. *Charles Demuth: The Mechanical Encrusted on the Living*. October 5–November 14, 1971. Exh. cat. by David Gedhard and Phyllis Plous; pp. 50, 83, no. 74 (repro.). Traveled to University Art Museum, University of California, Berkeley, November 22, 1971–January 3, 1972; The Phillips Collection, Washington, DC, January 19–February 29, 1972; Munson-Williams-Proctor Institute, Utica, NY, March 19–April 16, 1972.

Pennsylvania Academy of the Fine Arts, Philadelphia. *In Private Hands: 200 Years of American Painting*. October 1, 2005–January 8, 2006. Exh. cat. by Lynn Marsden-Atlass, Nicolai Cikovsky, Jr., and Robert Rosenblum; front cover, pp. 126–27, 247, pl. 41.

Reference:
Eiseman, Alvord L. "A Charles Demuth Retrospective Exhibition." *Art Journal*, vol. 31, no. 3 (Spring 1972), pp. 283–84, fig. 3.

Plate 36: *Tuberoses*, 1922
Graphite and watercolor on paper, 13 x 10 ½ inches (33 x 26.7 cm)
Signed and dated on flower stem, lower center: *C. Demuth 1922*
Collection of C. K. Williams, II

Provenance:
Mr. and Mrs. William Carlos Williams, Rutherford, NJ, c. 1923–at least 1963; private collection; Barbara Mathes Gallery, New York; SBC Collection, San Antonio, c. 1993–2004; Martha Parrish & James Reinish, Inc., New York, 2004; purchase from Martha Parrish & James Reinish, Inc., June 2004.

Exhibitions:
The Museum of Modern Art, New York. *Charles Demuth*. March 7–June 11, 1950. Exh. cat. by

Andrew Carnduff Ritchie; pp. 79, 92, no. 119 (repro.). Traveled to The Detroit Institute of Arts, October 1–29, 1950; University of Miami Art Gallery, Coral Gables, FL, November 20–December 12, 1950; Winnipeg Art Gallery, Manitoba, Canada, December 28, 1950–January 18, 1951; Lawrence Art Museum, Williams College, Williamstown, MA, February 3–24, 1951; University of Delaware Memorial Library, Newark, March 10–31, 1951; Allen Memorial College Art Museum, Oberlin College, Oberlin, OH, April 14–May 5, 1951.

Whitney Museum of American Art, New York. *William Carlos Williams and the American Scene, 1920–1940*. December 12, 1978–February 4, 1979. Exh. cat. by Dickran Tashjian; pp. 66, 163, fig. 32.

San Antonio Museum of Art. *Southwestern Bell Corporation: Selections of American Art*. September 2–November 7, 1993. No cat.

The Museum of Fine Arts, Houston. *Southwestern Bell Presents American Images: The SBC Collection of Twentieth-Century American Art*. November 9, 1997–January 25, 1998. No cat. Traveled to the Austin Museum of Art, February 14–May 10, 1998; Museum of South Texas, Corpus Christi, June 13–September 5, 1998; El Paso Museum of Art, September 25–December 31, 1998.

References:
Farnham, Emily. "Charles Demuth: His Life, Psychology and Works." Ph.D. diss., Ohio State University, 1959; vol. 1, pp. 328–29, vol. 2, p. 582, no. 432 (no repro.).

Dijkstra, Bram. *The Hieroglyphics of a New Speech: Cubism, Stieglitz, and the Early Poetry of William Carlos Williams*. Princeton: Princeton University Press, 1969; pp. 172–73, pl. 20.

Eiseman, Alvord L. "A Study of the Development of an Artist: Charles Demuth," Ph.D. diss., New York University, 1975; vol. 2, p. 475 (no repro.).

Breslin, James E. "William Carlos Williams and Charles Demuth: Cross-Fertilization in the Arts." *Journal of Modern Literature*, vol. 6, no. 2 (April 1977), pp. 250–58 (repro.).

Marling, William. *William Carlos Williams and the Painters, 1909–1923*. Athens: Ohio University Press, 1982; pp. 191–92 (no repro.).

American Images: The SBC Collection of Twentieth Century American Art. New York: Harry N. Abrams, 1996; pp. 82, 286, pl. 25.

Plate 37: *Three Sailors on the Beach*, 1930
Graphite and watercolor on paper, 13 ½ x 16 ½ inches (34.3 x 41.9 cm)
Signed, on arm of left figure: *C.D.*
Dated, lower right: *1930*
Collection of C. K. Williams, II

Provenance:
By bequest to Robert E. Locher, Lancaster, PA, 1935; gift to Richard Weyand, Lancaster, PA; Mr.

and Mrs. Edwin S. Weyand, Boise, ID; Sotheby Parke Bernet, New York, "American Impressionists and 20th Century Paintings, Drawings, and Sculpture," December 10, 1981, lot 159 (repro.); James Maroney Inc., New York; private collection; Sotheby's, New York, "American Paintings, Drawings and Sculpture," December 1, 1988, lot 256 (repro.); Jonathan Greenberg, Inc., New York; Martha Parrish & James Reinish, Inc., New York; purchase from Martha Parrish & James Reinish, Inc., October 4, 1996.

Exhibition:
Salander-O'Reilly Galleries, Inc., New York. *Charles Demuth: Watercolors and Drawings (from the Estate, with Additions)*. April 30–May 30, 1981. Exh. cat.; n.p., no. 21 (repro.).

References:
Farnham, Emily. "Charles Demuth: His Life, Psychology and Works." Ph.D. diss., Ohio State University, 1959; vol. 2, p. 683, no. 709 (no repro.).

Haskell, Barbara. *Charles Demuth*. Exh. cat. New York: Whitney Museum of American Art, 1987; pp. 206–9, fig. 106.

Weinberg, Jonathan. "Demuth and Difference." *Art in America*, vol. 76, no. 4 (April 1988), pp. 192, 194 (repro.).

Weinberg, Jonathan. *Speaking for Vice: Homosexuality in the Art of Charles Demuth, Marsden Hartley, and the First American Avant-Garde*. New Haven: Yale University Press, 1993; pp. 1–3, 19, 102, 105–8, fig. 1, pl. 2.

Meyer, Richard. "Speaking for Vice." *Art Journal*, vol. 53, no. 3 (Autumn 1994), p. 102 (no repro.).

PRESTON DICKINSON
American, 1891–1930

Plate 38: *Still Life, No. 3*, c. 1924
Pastel and graphite on paper adhered to board
Sheet 14 3/8 x 17 5/8 inches (36.5 x 44.8 cm)
Support 19 1/2 x 21 15/16 inches (49.5 x 55.7 cm)
Signed, lower left: *Dickinson*
Philadelphia Museum of Art. Gift of C. K. Williams, II. 1999-114-1

Provenance:
Daniel Gallery, New York; Ferdinand Howald, New York and Columbus, OH, 1925–31; Columbus Museum of Art, gift of Ferdinand Howald, 1931–80; Kennedy Galleries, Inc., New York, 1980; purchase from Kennedy Galleries, Inc., October 1, 1994; gift to the Philadelphia Museum of Art, 1999.

Exhibitions:
Daniel Gallery, New York. *Recent Pastels by Preston Dickinson*. February 10–March 5, 1927. Exh. cat.; n.p., no. 2 (no repro.).

Columbus Gallery of Fine Arts, OH. *Inaugural Exhibition*. January–February 1931. No cat.; unpublished checklist no. 76.

Arts Club of Chicago. *Watercolors and Pastels by Four Modern American Painters*. December 6–21, 1939. Exh. cat.; n.p., no. 14 (no repro.).

University Gallery, University of Minnesota, Minneapolis. *Our Leading Watercolorists*. November 29–December 20, 1942. No cat.

American Federation of Arts, New York. *Early Twentieth Century American Watercolors*. No cat. Traveled to Dayton Art Institute, OH, September 5–25, 1948; Rochester, NY, October 8–31, 1948; Western College, Oxford, OH, November 9–30, 1948; unrecorded location, December 14, 1948–January 5, 1949; Williamstown, MA, January 19–February 15, 1949; Manchester, NH, March 1–22, 1949; Cambridge, MA, April 5–23, 1949; The Minneapolis Institute of Arts, May 10–31, 1949.

Cleveland Institute of Art. 30 Howald paintings exhibited. May 1951. No cat.

Corcoran Gallery of Art, Washington, DC. *The New Tradition: Modern Americans before 1940*. April 27–June 2, 1963. Exh. cat.; p. 58, no. 30.

Wildenstein & Co., Inc., New York. *The Ferdinand Howald Collection*. May 19–July 3, 1970. No cat.; unpublished checklist no. 56.

References:
American Magazine of Art, vol. 29, no. 8 (August 1936), p. 492 (repro.).

Pollak, Frances M., ed. "Preston Dickinson—Painter." *The Index of Twentieth Century Artists*, vol. 3, no. 4, supplement (January 1936). Reprint, New York: Arno Press, 1970; p. 525.

Tucker, Marcia. *American Paintings in the Ferdinand Howald Collection*. Columbus, OH: Columbus Gallery of Fine Arts, 1969; p. 39, no. 56 (no repro.).

Rubenfeld, Richard Lee. "Preston Dickinson: An American Modernist, with a Catalogue of Selected Works." Ph.D. diss., Ohio State University, 1985; pp. 434–35, no. 110, fig. 111.

ARTHUR DOVE
American, 1880–1946

Plate 39: *Gear*, c. 1922
Oil on canvas, 22 x 18 inches (55.9 x 45.7 cm)
Philadelphia Museum of Art. Promised gift of C. K. Williams, II

Provenance:
The Intimate Gallery, New York, 1926; estate of Arthur Dove through The Downtown Gallery, New York, March 1954; William H. Lane Foundation, Leominster, MA, May 8, 1954; exchange with The Downtown Gallery, March 5, 1955; estate of Helen Torr Dove, September 8, 1967, inventoried by The Downtown Gallery; Terry Dintenfass, Inc., New York, through 1980; William T. Janss, Sun Valley, ID, 1980–97; Sotheby's, New York, "American Paintings, Drawings and Sculpture," June 6, 1997, lot 134 (repro.), did not sell; Richard York Gallery,

New York, 1997; Forum Gallery, New York, April 1998; purchase from Forum Gallery, April 13, 1998.

Exhibitions:
The Intimate Gallery at the Anderson Galleries, New York. *Arthur G. Dove*. January 11–February 7, 1926. No cat.

Contemporary Arts Museum, Houston. *Arthur G. Dove, Charles Sheeler*. January 7–23, 1951. Exh. cat.; no. 19 (no repro.).

Andrew Dickson White Art Museum, Cornell University, Ithaca, NY. *Arthur G. Dove, 1880–1946: A Retrospective*. November 1954. Exh. cat.; no. 12 (no repro.).

University of Maryland Art Gallery, College Park. *Arthur Dove: The Years of Collage*. March 13–April 19, 1967. Exh. cat. by Dorothy Rylander Johnson; pp. 12–13, paintings, no. 2 (repro.).

Heckscher Museum, Huntington, NY. *Arthur Dove of Long Island Sound*. August 20–September 17, 1967. Exh. cat.; p. 4, no. 3 (repro.).

Terry Dintenfass, Inc., New York. *Arthur G. Dove, Exhibition of Paintings, 1917–1946*. February 1–26, 1972. Exh. cat.; no. 2 (no repro.).

Delaware Art Museum, Wilmington. *Avant-Garde Painting and Sculpture in America, 1910–1925*. April–May 1975. Exh. cat.; p. 69 (repro.).

Hayward Gallery, London. *Dada and Surrealism Reviewed*. January 11–March 27, 1978. Exh. cat. by Dawn Ades; p. 44, no. 2.4 (repro.).

The Boise Gallery of Art, ID. *American Modernists*. August 28–October 3, 1982. No cat.; no. 9.

Richard York Gallery, New York. *Arthur Dove: Major Works*. October 5–November 17, 1990. Exh. cat.; n.p., no. 2 (repro.).

Joan T. Washburn Gallery, New York. *The Room*. October 28–December 4, 1992. Exh. cat.; checklist no. 14 (no repro.).

Richard York Gallery, New York. *Modernism at the Salons of America, 1922–1936*. October 19–December 8, 1995. Exh. cat.; p. 12, no. 14 (repro.).

John Berggruen Gallery, San Francisco. *American Modernism: Paintings and Drawings from the Collection of William and Glenn Janss*. September 12–October 12, 1996. Exh. cat.; p. 35, no. 19 (no repro.).

Whitney Museum of American Art, New York. *Making Mischief: Dada Invades New York*. November 21, 1996–February 23, 1997. Exh. cat. by Francis M. Naumann with Beth Venn; pp. 162, 291 (repro.).

The Phillips Collection, Washington, DC. *Arthur Dove: A Retrospective*. September 20, 1997–January 4, 1998. Exh. cat. by Debra Bricker Balken, in collaboration with William C. Agee and Elizabeth Hutton Turner; p. 30, fig. 16. Traveled to Whitney Museum of American Art, New York, January 15–April 12, 1998.

References:

Wight, Frederick S. *Arthur G. Dove*. Berkeley: University of California Press, 1958; p. 53 (no repro.).

Morgan, Ann Lee. "Toward the Definition of Early Modernism in America: A Study of Arthur Dove." Ph.D. diss., University of Iowa, 1973; pp. ix, 241, 465, no. 22.2 (repro.).

Tashjian, Dickran. *Skyscraper Primitives: Dada and the American Avant-Garde, 1910–1925*. Middletown, CT: Wesleyan University, 1975; p. 200 (repro.).

Thompson, Jan. "Picabia and His Influence on American Art, 1913–17." *Art Journal*, vol. 39, no. 1 (Autumn 1979), p. 20, fig. 18 (repro.).

Morgan, Ann Lee. *Arthur Dove: Life and Work, with a Catalogue Raisonné*. Newark: University of Delaware Press; London: Associated University Presses, 1984; p. 126, no. 22.2 (repro.).

Cohn, Sherrye. *Arthur Dove: Nature as Symbol*. Ann Arbor, MI: UMI Research Press, 1985; p. 102 (no repro.).

Cassidy, Donna M. "Arthur Dove's Music Paintings of the Jazz Age." *American Art Journal*, vol. 20, no. 1 (1988), p. 13 (no repro.).

Vetrocq, Marcia E. "The New York Pre-School." *Art in America*, vol. 85 (June 1997), p. 86 (no repro.).

Plate 40: *Frozen Pool at Sunset*, 1933
Oil on canvas, 16 x 20 inches (40.6 x 50.8 cm)
Signed, lower right: *dove*
Collection of C. K. Williams, II

Provenance:

Probably An American Place, New York, 1933; The Downtown Gallery, New York, after 1946; Andrew Crispo Gallery, Inc., New York, 1984; Harry Spiro, New York, 1996–97; Richard York Gallery, New York, 1997; private collection, New York, 1997–2004; Martha Parrish & James Reinish, Inc., New York; purchase from Martha Parrish & James Reinish, Inc., January 22, 2004.

Exhibition:

Probably An American Place, New York. *Arthur G. Dove, Helen Torr, New Paintings and Watercolors*. March 29–April 15, 1933. Cat. unlocated; Dove checklist no. 16.

References:

Morgan, Ann Lee. "Toward the Definition of Early Modernism in America: A Study of Arthur Dove." Ph.D. diss., University of Iowa, 1973; p. 281, no. 33.1 (no repro.).

Morgan, Ann Lee. *Arthur Dove: Life and Work, with a Catalogue Raisonné*. Newark: University of Delaware Press; London: Associated University Presses, 1984; p. 208, no. 33.1 (repro.).

Plate 41: *The Barn Next Door*, 1934
Oil on canvas, 20 x 28 ½ inches (50.8 x 72.4 cm)
Signed, lower center: *dove*
Collection of C. K. Williams, II

Provenance:

An American Place, New York; Duncan Phillips, Washington, DC, 1934–50; by gift to John Gernand, Washington, DC, 1950–82; Sotheby's, New York, "American Impressionist and 20th Century Paintings, Drawings, and Sculpture, with a Selection of 19th Century Paintings," December 2, 1982, lot 99 and cover (repro.), did not sell; private collection; Christie's, New York, "Important American Paintings, Drawings, and Sculpture from the 18th, 19th, and 20th Centuries," December 4, 1992, lot 131 (repro.); private collection, New York; Menconi & Schoelkopf Fine Art, LLC, New York, by 2000; purchase from Menconi & Schoelkopf Fine Art, LLC, New York, January 2006.

Exhibitions:

Probably An American Place, New York. *Arthur G. Dove: New Things and Old*. April 17–May 15, 1934, extended to June 1. No cat.

Phillips Memorial Art Gallery, Washington, DC. *Retrospective Exhibition of Paintings by Arthur G. Dove*. April 18–September 22, 1947. No cat.

The Phillips Collection, Washington, DC. *Arthur Dove and Duncan Phillips: Artist and Patron*. June 13–August 16, 1981. Exh. cat. by Sasha M. Newman; p. 147, no. 30, pl. 53 (mislabeled as *Slaughter House*). Traveled to High Museum of Art, Atlanta, September 11–October 30, 1981; William Rockhill Nelson Gallery and Atkins Museum of Fine Arts, Kansas City, MO, November 13, 1981–January 3, 1982; The Museum of Fine Arts, Houston, January 21–March 21, 1982; Columbus Museum of Art, OH, April 18–June 9, 1982; Seattle Art Museum, July 1–September 6, 1982; New Milwaukee Art Center, September 29–November 14, 1982.

Salander-O'Reilly Galleries, New York. *American Paintings and Sculpture*. April 29–May 31, 2003. No cat.

References:

Morgan, Ann Lee. "Toward the Definition of Early Modernism in America: A Study of Arthur Dove." Ph.D. diss., University of Iowa, 1973; pp. xii, 71, 282, 522, no. 34.2 (repro.).

Morgan, Ann Lee. *Arthur Dove: Life and Work, with a Catalogue Raisonné*. Newark: University of Delaware Press; London: Associated University Presses, 1984; pp. 212–13, no. 34.2 (repro.).

LYONEL FEININGER
American, 1871–1956

Plate 42: *Night Hawks (Nachtfalken*, also *Nachtvogel)*, 1921
Oil on canvas, 23 ⅝ x 19 ⅝ inches (60 x 49.8 cm)
Frame designed by the artist
Signed, upper right: *Feininger*
Collection of C. K. Williams, II

Provenance:

Deposited by the artist with Hermann Klumpp, 1937; given by the artist to Werner Rothmaler; by descent to Elisabeth Rothmaler, 1962; by descent to her son; Moeller Fine Art Ltd., New York, 1997; purchase from Moeller Fine Art Ltd., March 28, 1997.

Exhibitions:

Staatsgalerie moderner Kunst, Munich. *Delaunay und Deutschland*. October 4, 1985–January 6, 1986. Exh. cat. by Peter-Klaus Schuster; pp. 270, 426, no. 248, pl. 32.

Neue Nationalgalerie Staatliche Museen zu Berlin. *Lyonel Feininger: Von Gelmeroda nach Manhattan; Retrospektive der Gemälde*. July 3–October 11, 1998. Exh. cat. by Roland März; pp. 126, 270, 364, no. 61 (repro.). Traveling exhibition; shown in Berlin only.

References:

Hess, Hans. *Lyonel Feininger*. New York: Harry N. Abrams, 1961; p. 268, no. 222 (repro.).

Werner, Petra. *Der Fall Feininger*. Leipzig: Koehler und Amelang, 2006; pp. 177–81, 245.

Plate 43: *Old Stone Bridge (Alte Steinbrücke)*, 1943
Oil on canvas, 20 ½ x 27 ¾ inches (52.1 x 70.5 cm)
Signed, lower left: *Feininger*
Signed, dated, and titled, on verso on stretcher
Collection of C. K. Williams, II

Provenance:

Lilienfeld Gallery, New York; Lucien B. Day, by 1961; Leslie Sacks Fine Art, West Los Angeles, early 1980s–2000; consigned to Moeller Fine Art Ltd., New York, 2000–2001; purchase from Moeller Fine Art Ltd., February 1, 2001.

Exhibition:

Leslie Sacks Fine Art, Los Angeles. *Lyonel Feininger, Oils and Works on Paper, 1919–1948*. May 9–June 3, 1998. Pamphlet (repro.).

References:

Hess, Hans. *Lyonel Feininger*. New York: Harry N. Abrams, 1961; p. 290, no. 440 (repro.).

Luckhardt, Ulrich, and Martin Faass, with the assistance of Felix Krämer. *Lyonel Feininger: Die Zeichnungen und Aquarelle*. Exh. cat. Cologne: Dumont, 1998; p. 217, no. 89.

Plate 44: *Mid Manhattan*, 1952
Ink, charcoal, pastel, and watercolor on paper; 18 ¾ x 12 ½ inches (47.6 x 31.8 cm)
Signed and dated, lower left: *Feininger 29. viii. '52*
Collection of C. K. Williams, II

Provenance:

Curt Valentin Gallery, New York; Mrs. Alan Rosenthal, New York; estate of Mrs. Alan Rosenthal; Moeller Fine Art Ltd., New York; purchase through Hirschl & Adler Galleries, Inc., New York, December 28, 1991.

Exhibitions:

Moeller Fine Art Ltd., New York. *Feininger and Tobey, Years of Friendship, 1944–1956*. October

10–November 16, 1991. Exh. cat., ed. Stephen E. Hauser; p. 14, no. 8 (repro.).

Hamburger Kunsthalle, Germany. *Lyonel Feininger: Die Zeichnungen und Aquarelle*. January 23–April 5, 1998. Exh. cat. by Ulrich Luckhardt and Martin Faass, with the assistance of Felix Krämer; pp. 188, 224, no. 150 (repro.). Traveled to Kunsthalle, Tübingen, April 18–June 8, 1998.

Reference:
Moeller Fine Art Ltd. *Private Views*. New York: Achim Moeller Fine Art Ltd., 1990; n.p., no. 32 (repro.).

JARED FRENCH
American, 1905–1988

Plate 45: *Woman*, 1941
Egg tempera on gessoed panel, 17 ½ x 15 inches (44.5 x 38.1 cm)
Signed, lower right: *Jared French*
Collection of C. K. Williams, II

Provenance:
Margaret French, the artist's wife; DC Moore Gallery, New York, by 2001; purchase from DC Moore Gallery, November 9, 2003.

Exhibitions:
The Museum of Modern Art, New York. *Americans 1943: American Realists and Magic Realists*. February 10–March 21, 1943. Exh. cat. by Dorothy C. Miller and Alfred H. Barr, Jr., with an introduction by Lincoln Kirstein; p. 64, no. 97 (no repro.). Traveling exhibition; did not travel.

Edwin Hewitt Gallery, New York. *Paintings and Drawings by Jared French*. April 21–May 12, 1955. Exh. cat.; n.p., no. 2 (no repro.).

Academy Art Gallery, National Institute of Arts and Letters, New York. *An Exhibition of Work of Newly Elected Members and Recipients of Honors and Awards*. May 25–June 25, 1967.

Banfer Gallery, New York. *Jared French: Twenty-five Years of Paintings and Drawings from 1944 to 1969*. February 19–March 8, 1969. Exh. cat.; n.p., no. 9, misdated as 1949 (no repro.).

Midtown Galleries, New York. *Close Encounters: The Art of Paul Cadmus, Jared French, and George Tooker*. February 22–April 7, 1990. No cat.

Midtown Payson Galleries, New York. *The Rediscovery of Jared French*. April 23–June 5, 1992. Exh. cat.; no checklist (no repro.). Traveled to Mead Art Museum, Amherst College, Amherst, MA, October 2–November 29, 1992.

DC Moore Gallery, New York. *Interwoven Lives: George Platt Lynes and His Friends*. September 6–29, 2001. No cat.; no. 90.

DC Moore Gallery, New York. *The Way They See It*. September 6–27, 2003. No cat.; no. 12.

DC Moore Gallery, New York. *Endless Love*. January 7–February 7, 2004. Curated by Mark Greenwold. Exh. cat.; no checklist.

Portland Museum of Art, ME. *Monet to Matisse, Homer to Hartley: American Masters and Their European Muses*. June 24–October 17, 2004. Exh. cat., *European Muses, American Masters, 1870–1950*; pp. 129, 148, no number (repro.).

References:
Grimes, Nancy. *Jared French's Myths*. San Francisco: Pomegranate Artbooks, 1993; n.p., no. 17 (repro.), misdated as 1947.

Cole, Mark. "Jared French (1905–1988)." Ph.D. diss., University of Delaware, 1999; p. 384, no. D1941.4.

ALBERTO GIACOMETTI
Swiss, 1901–1966

Plate 46: *Chiavenna Bust I*, 1964
Bronze, 16 x 8 x 6 ⅛ inches (40.6 x 20.3 x 15.6 cm)
Cast 3/6 by Susse Fondeur, Paris
Signed, along base, proper left: *Alberto Giacometti*
Philadelphia Museum of Art. Promised gift of C. K. Williams, II

Provenance:
Pierre Matisse Gallery, New York, December 1965–April 2, 1966; Paul Borman, Birmingham, MI, April 2, 1966–2003; Phyllis Hattis Fine Arts, Inc., New York; purchase from Phyllis Hattis Fine Arts, Inc., February 11, 2003.

Reference:
Possibly Bonnefoy, Yves. *Alberto Giacometti: A Biography of His Work*. Translated by Jean Stewart. Paris: Flammarion, 1991; pp. 521, 523, 533 (repro.).

MORRIS GRAVES
American, 1910–2001

Plate 47: *Ceremonial Bronze Taking the Form of a Bird II*, 1947
Tempera on paper on illustration board, 23 x 27 ½ inches (58.4 x 69.9 cm)
Signed, lower right: *mgraves*
Collection of C. K. Williams, II

Provenance:
Willard Gallery, New York; private collection, NJ; DC Moore Gallery, New York, 2001–2; purchase from DC Moore Gallery, May 15, 2002.

Exhibition:
Contemporary Arts Center, Cincinnati, 1956.

WILLIAM GROPPER
American, 1897–1977

Plate 48: *Shouting Senator*, c. 1950
Oil on Masonite, 12 x 14 inches (30.5 x 35.6 cm)
Signed, lower right: *GROPPER*
Collection of C. K. Williams, II

Provenance:
Morton R. Goldman, New York, by c. 1960–2001; by descent in the family, 2001–3; ACA Galleries, New York, 2003; purchase from ACA Galleries, April 1, 2003.

GEORGE GROSZ
German, 1893–1959

Plate 49: *Two Women Walking*, 1929
Watercolor on paper, 29 ¾ x 23 inches (75.6 x 58.4 cm)
Signed, lower right: *Grosz*
Collection of C. K. Williams, II

Provenance:
Bella Fishko, New York; Forum Gallery, New York, c. 1985–95; purchase from Forum Gallery, April 12, 1995.

Plate 50: *The Theatergoers (The Couple)*, 1933
Watercolor on paper, 25 ¼ x 18 ¼ inches (64.1 x 46.4 cm)
Signed and dated, lower left: *Grosz 33*
Collection of C. K. Williams, II

Provenance:
Bernard Danenberg Galleries, New York; Sotheby's, New York, "Important American Paintings, Drawings and Sculpture," December 5, 1985, lot 112A (repro.); Graham Gallery, New York; Sotheby's, New York, "American Paintings, Drawings, and Sculpture," September 14, 1995, lot 216 (repro.); purchase from Sotheby's auction, September 14, 1995.

References:
Grosz, George. *George Grosz: An Autobiography*. Translated by Nora Hodges. New York: Macmillan, 1983; p. 271, no number (repro.).

Möckel, Birgit. *George Grosz in Amerika, 1932–1959*. Frankfurt am Main: Peter Lang, 1997; p. 475, no. 60 (no repro.).

PHILIP GUSTON
American, 1913–1980

Plate 51: *Portrait of Theresa Lewensohn*, 1940
Tempera on Masonite, 32 ⅛ x 20 inches (81.6 x 50.8 cm)
Signed and dated, lower left: *PHILLIP GUSTON '40*
Collection of C. K. Williams, II

Provenance:
Theresa Lewensohn; by descent to 2007; purchase from McKee Gallery, New York, March 2007.

MARSDEN HARTLEY
American, 1877–1943

Plate 52: *Composition*, 1913
Oil on board, 19 ½ x 15 ½ inches (49.5 x 39.4 cm)
Collection of C. K. Williams, II

Provenance:
Hamilton Easter Field, Brooklyn Heights, NY; Robert Laurent (his adopted son), Ogunquit, ME, c. 1920–70; Paul and Margery Laurent, 1970; Parke-Bernet Galleries, Inc., New York, "Modern European and American Paintings, Sculpture and Drawings," February 11, 1971, lot 51 (no repro.); Henry M. Reed, Montclair, NJ; Sotheby's, New York, "American Impressionist and Twentieth Century Paintings, Drawings, Watercolors, and Sculpture," December 4, 1980, lot 133 (repro.); Hirschl & Adler Galleries, Inc., New York; Helen Serger, La Boetie, Inc., New York; Thomas Solley, Bloomington, IN; Robert Schoelkopf Gallery, New York; Meyer and Vivian Potamkin, Philadelphia, 1985–2003; Sotheby's, New York, "American Paintings, Drawings, and Sculpture from the Collection of Meyer and Vivian Potamkin," May 21, 2003, lot 17 (repro.); purchase from Sotheby's auction, May 21, 2003.

Exhibitions:
The Fine Arts Gallery of San Diego. *Color & Form: 1909–1914.* November 20, 1971–January 2, 1972. Exh. cat. by Henry G. Gardiner; pp. 58, 94, no. 22 (repro.). Traveled to Oakland Museum, January 25–March 5, 1972; Seattle Art Museum, March 24–May 7, 1972.

Whitney Museum of American Art, New York. *Synchromism and American Color Abstraction, 1910–1925.* January 24–March 26, 1978. Exh. cat. by Gail Levin; pp. 43, 78, 140, pl. 34. Traveled to The Museum of Fine Arts, Houston, April 20–June 18, 1978; Des Moines Arts Center, July 6–September 3, 1948; San Francisco Museum of Modern Art, September 22–November 19, 1978; Everson Museum of Art, Syracuse, NY, December 15, 1978–January 28, 1979; Columbus Gallery of Fine Arts, OH, February 15–March 24, 1979.

Helen Serger, La Boetie, Inc., New York. *Herwarth Walden and Der Sturm.* February 27–May 31, 1981. Exh. cat.; p. 41, no number (repro.).

Pennsylvania Academy of the Fine Arts, Philadelphia. *American Art from the Collection of Vivian and Meyer P. Potamkin.* June–October 1989. Exh. cat.; p. 10, no number (no repro.).

EDWARD HOPPER
American, 1882–1967

Plate 53: *Corn Hill*, c. 1930
Watercolor over graphite on watercolor paper
Sheet 13 ¹⁵/₁₆ x 20 inches (35.4 x 50.8 cm)
Signed, lower right: *Edward Hopper / Corn Hill*
Inscribed, on verso, top right: *Corn Hill*
Philadelphia Museum of Art. Gift of C. K. Williams, II, in honor of the 125th Anniversary of the Museum. 2003-63-1

Provenance:
Frank K. M. Rehn Galleries, New York; Keith H. Baker, until 1986; Hirschl & Adler Galleries, Inc., New York, 1986; Shearson Lehman Hutton Collection, 1986–91; Hirschl & Adler Galleries, 1991–92; purchase from Hirschl & Adler Galleries, January 6, 1992; gift to the Philadelphia Museum of Art, 2003.

Exhibitions:
Whitney Museum of American Art, New York. *Edward Hopper Retrospective Exhibition.* September 29–November 29, 1964. Exh. cat. by Lloyd Goodrich; p. 67, no. 106 (no repro.). Traveled to The Art Institute of Chicago, December 18, 1964–January 31, 1965.

Hirschl & Adler Galleries, Inc., New York. *Edward Hopper: Light Years.* October 1–November 12, 1988. Exh. cat.; pp. 24, 27, no. 19 (repro.).

Mary and Leigh Block Gallery, Northwestern University, Evanston, IL. *The Modernist Tradition in American Watercolors: 1911–1939.* April 5–June 22, 1991. Exh. cat. by Marilyn Kushner; pp. 25, 36, 69, no. 27 (repro.).

Philadelphia Museum of Art. *Gifts in Honor of the 125th Anniversary of the Philadelphia Museum of Art.* September 29–December 8, 2002. Exh. cat.; p. 185, no. 183 (no repro.).

Philadelphia Museum of Art. *Andrew Wyeth in Context.* May 11–June 16, 2006. No cat.

Reference:
Levin, Gail. *Edward Hopper: A Catalogue Raisonné.* New York: Whitney Museum of American Art, in association with W. W. Norton & Company, 1995; vol. 2, p. 216, no. W-247 (repro.).

EARL HORTER
American, 1880–1940

Plate 54: *Newcastle, Delaware*, c. 1932
Watercolor on paper
Sheet (irregular) 13 ¹⁵/₁₆ x 21 ¹³/₁₆ inches (35.4 x 55.4 cm)
Signed, lower right: *E. Horter*
Inscribed, lower right: *Newcastle, Del.*
Inscribed, on verso: *Property of Earl Horter / 2219 delancy* [sic] *St. Phila / Pointelist* [sic] *Water Color Painting / "Newcastle Delaware"*
Philadelphia Museum of Art. Gift of C. K. Williams, II. 1999-27-1

Provenance:
Estate of the artist; Mrs. Elizabeth Lentz Horter, Doylestown, PA; Hahn Gallery, Philadelphia, c. 1978; Philip Jamison, West Chester, PA; Richard York Gallery, New York; purchase from Richard York Gallery, October 7, 1996; gift to the Philadelphia Museum of Art, 1999.

Exhibitions:
Philadelphia Art Alliance. *Earl Horter: Watercolors, Oils, Drawings, Prints.* December 2, 1954–January 2, 1955. Exh. cat.; n.p., no number (no repro.).

Hirschl & Adler Galleries, Inc., New York. *American Drawings and Watercolors.* October 6–29, 1979. Exh. cat.; n.p., no. 62 (no repro.).

Philadelphia Museum of Art. *Mad for Modernism: Earl Horter and His Collection.* March 7–May 16, 1999. Exh. cat. by Innis Howe Shoemaker with Christa Clarke and William Wierzbowski; pp. 45–46, fig. 40.

Philadelphia Museum of Art. *Andrew Wyeth in Context.* May 11–June 16, 2006. No cat.

Reference:
Richard York Gallery. *An American Gallery, Vol. 4.* New York: Richard York Gallery, 1988; n.p., no. 19.

Plate 55: *Abstraction—Still Life #6*, 1939
Watercolor on paper, 16 x 17 ½ inches (40.6 x 44.5 cm)
Signed and dated, lower right: *E Horter / 39*
Label, handwritten in ink, on verso: *Abstraction / #6 / Still Life*
Collection of C. K. Williams, II

Provenance:
Estate of the artist; Mrs. Elizabeth Lentz Horter, Doylestown, PA, to 1986; her niece, Janet Maher; Schwarz Gallery, Philadelphia, 1997; purchase from Schwarz Gallery, October 8, 1997.

Exhibition:
Philadelphia Art Alliance. *Memorial Exhibition of the Work by Earl Horter.* November 8–30, 1940. Checklist; no. 178 (no repro.).

Reference:
Schwarz Gallery. *One Hundred Fifty Years of Philadelphia Still-Life Painting.* Philadelphia: Schwarz Gallery, 1997; p. 123 (repro.).

HENRY KOERNER
American, born Austria, 1915–1991

Plate 56: *The Arcades*, 1950
Oil on Masonite, 30 x 37 ¾ inches (76.2 x 95.9 cm)
Signed and dated, lower right: *Koe 1950*
Collection of C. K. Williams, II

Provenance:
Henry Koerner, Pittsburgh; June Koerner, Pittsburgh; Sam Berkovitz, Pittsburgh; Michael Rosenfeld Gallery, LLC, New York; purchase from Michael Rosenfeld Gallery, LLC, May 16, 2008.

327

Exhibitions:
Circle Gallery, Cleveland (per label on verso).

Midtown Galleries, New York. *New Paintings by Henry Koerner.* March 1950.

Pennsylvania College for Women, Pittsburgh. *Retrospective Exhibition of the Work of Henry Koerner.* November 1952. Traveled to Des Moines Art Center, IA, December 3, 1952–January 4, 1953; Oklahoma Art Center, Oklahoma City, through February 22, 1953; M. H. de Young Memorial Museum, San Francisco, March 19–April 19, 1953 (brochure entitled *Henry Koerner: Exhibition of Paintings and Drawings*, no. 29); Birmingham Museum of Art, AL, October 15–31, 1953.

Museum of Art, Carnegie Institute, Pittsburgh. *Henry Koerner: From Vienna to Pittsburgh; The Art of Henry Koerner.* May 28–July 31, 1983. Exh. cat.; p. 53, no. 56 (repro.).

Michael Rosenfeld Gallery, LLC, New York. *Body Beware: 18 American Artists.* May 18–July 27, 2007.
Reference:
Cozzolino, Robert, Marshall N. Price, and M. Melissa Wolfe. *George Tooker.* London: Merrell, in association with Columbus Museum of Art, 2008; pp. 93–94, fig. 13.

JACK LEVINE
American, born 1915

Plate 57: *Woodstock Pastorale*, 1949
Oil on canvas, 25 x 31 inches (63.5 x 78.7 cm)
Signed, lower left: *JLevine*
Collection of C. K. Williams, II

Provenance:
Downtown Gallery, New York; California Palace of the Legion of Honor, San Francisco (as of 1972, The Fine Arts Museums of San Francisco), 1952–December 9, 1999; DC Moore Gallery, New York, 1999–2000; purchase from DC Moore Gallery, April 5, 2000.

Exhibitions:
Boris Mirski Art Gallery, Boston, in cooperation with Downtown Gallery of New York. *Jack Levine.* January 17–February 17, 1950. Exh. cat.; n.p., no. 8 (no repro.).

California Palace of the Legion of Honor, San Francisco. *Fifth Annual Exhibition of Contemporary Painting.* January 24–March 2, 1952. Exh. cat.; n.p., no number (repro.).

California Palace of the Legion of Honor, San Francisco. *Three Centuries of American Painting.* December 19, 1970–February 7, 1971. Exh. cat. by F. Lanier Graham; pp. 64–65, no. 78 (repro.).

The Jewish Museum, New York. *Jack Levine, Retrospective Exhibition: Paintings, Drawings, Graphics.* November 8, 1978–January 28, 1979. Exh. cat. by Kenneth W. Prescott; pp. 55, 83, no. 26 (no repro.). Traveled to Norton Gallery and School of Art, West Palm Beach, FL, February 17–April 8, 1979; Brooks Memorial Art Gallery, Memphis, April 30–June 17, 1979; Montgomery Museum of Fine Arts, AL, July 9–August 26, 1979; Portland Art Museum, OR, September 17–November 4, 1979; Minnesota Museum of Art, St. Paul, November 26, 1979–January 13, 1980.

References:
Howe, Thomas C., Jr. "Paintings Recommended for Purchase from the 5th Annual Exhibition of Contemporary American Painting." *Bulletin of the California Palace of the Legion of Honor*, vol. 9, nos. 10–11 (February–March 1952), n.p. (repro.).

Handbook of the Collections. San Francisco: California Palace of the Legion of Honor, 1960; p. 51 (repro.).

Getlein, Frank. *Jack Levine.* New York: Harry N. Abrams, 1966; p. 5, pl. 46.

Freedman, Henry. "Jack Levine: Painter and Protester." Ph.D. diss., Johns Hopkins University, 1974; p. 50 (no repro.).

Jones, Marvin. "Jack Levine." *New Common Good* (October 1986), p. 3. Unlocated.

Levine, Jack, with introduction by Milton W. Brown. *Jack Levine.* New York: Rizzoli, 1989; p. 47 (repro.).

MARTIN LEWIS
American, born Australia, 1881–1962

Plate 58: *Rail Yards from Weehawken, New Jersey*, 1913–15
Oil on panel, 10 x 8 inches (25.4 x 20.3 cm)
Collection of C. K. Williams, II

Provenance:
By gift to Patricia Lewis, to 1994; Newman Galleries, Philadelphia, 1994; purchase from Newman Galleries, October 28, 1994.

LOUIS LOZOWICK
American, born Russia, 1892–1973

Plate 59: *Factory Buildings, New Jersey*, c. 1930
Watercolor and gouache, with pen and brush and ink, on laid paper; 18 1/16 x 25 1/4 inches (45.9 x 64 cm)
Signed, lower right: *LOUIS LOZOWICK*
Collection of C. K. Williams, II

Provenance:
Possibly Thomas Segal Gallery, Boston; Schwarz Gallery, Philadelphia, by 1985; purchase from Schwarz Gallery, October 2, 1991.

Exhibition:
Schwarz Gallery, Philadelphia. *Fine American and European Paintings.* 1991. Exh. cat.; n.p., no. 41 (repro.).

MAN RAY (EMMANUEL RADNITZKY)
American, died Paris, 1890–1976

Plate 60: *Wood Interior*, 1914
Oil on canvas, 18 x 21 inches (45.7 x 53.3 cm)
Signed, titled, and dated, on verso on stretcher: *17 "Wood Interior" 1914 Man Ray*
Collection of C. K. Williams, II

Provenance:
Juliet Man Ray and by descent in the family; Sotheby's, London, "Man Ray Paintings, Objects, Photographs," March 22, 1995, lot 11 (repro.); Timothy Baum, New York, 1995–2000; purchase from Timothy Baum, April 26, 2000.

Exhibitions:
Possibly Daniel Gallery, New York. *Man Ray.* Through November 23, 1915. Exh. cat.; n.p., no. 30 (no repro.).

Frank Perls Gallery, Inc., Hollywood, CA. *Man Ray: Paintings, Watercolors, Drawings, Photographic Compositions.* March 1–26, 1941. Exh. cat.; n.p., no. 2 (no repro.).

Pasadena Art Institute, CA. *Retrospective Exhibition, 1913–1944: Paintings, Drawings, Watercolors, Photographs by Man Ray.* September 19–October 29, 1944. Exh. cat. by Jarvis Barlow and Man Ray; n.p., no. 5 (no repro.).

Frankfurter Kunstverein, Steineres Haus am Römberg, Germany. *Man Ray: Inventionen und Interpretationen.* October 14–December 23, 1979. Exh. cat. by G. Bussmann; p. 185, Gemälde und Collagen, no. 6 (no repro.). Traveled to Kunsthalle, Basel, Switzerland, January 20–February 24, 1980.

Montclair Art Museum, NJ. *Conversion to Modernism: The Early Work of Man Ray.* February 16–August 3, 2003. Exh. cat. by Francis M. Naumann; pp. ix, 86–88, fig. 106. Traveled to Georgia Museum of Art, Athens, September 20–November 30, 2003; Terra Museum of American Art, Chicago, January 23–April 4, 2004.

Reference:
Naumann, Francis M. "Man Ray and America: The New York and Ridgefield Years, 1907–1921." Ph.D. diss., City University of New York, 1988; vol. 1, p. 137, vol. 2, pp. 508, 556, 748, no. 172 (repro.).

Plate 61: *Female Figure (Femme figure)*, 1923
Oil on panel, 13 3/4 x 10 1/2 inches (34.9 x 26.7 cm)
Frame designed by the artist
Signed and dated, lower right: *man Ray 1923*
Collection of C. K. Williams, II

Provenance:
André Breton, 1923–66; estate of André Breton, 1966–2003; Calmels-Cohen Auctioneers, Hôtel Drouot, Paris, "Collection André Breton," April 15,



328

2003; private collection, New York, 2003; purchase from Menconi & Schoelkopf Fine Art, LLC, New York, October 22, 2003.

Exhibitions:

La Galerie Surréaliste, Paris. *Tableaux de Man Ray et objets des îles.* March 26–April 10, 1926. Exh. cat.; n.p., no. 16 (no repro.).

Galeria de Arte Mexicana, Mexico City. January–February 1940. *Exposición internacional del surrealismo.* Exh. cat.; n.p., no. 78 (repro.).

JOHN MARIN
American, 1870–1953

Plate 62: *Grain Elevators at Weehawken*, c. 1910
Oil on canvas, 20 x 24 inches (50.8 x 61 cm)
Collection of C. K. Williams, II

Provenance:

Estate of the artist; purchase from Meredith Ward Fine Art, New York, May 2007.

Reference:

Reich, Sheldon. *John Marin: A Stylistic Analysis and Catalogue Raisonné.* Tucson: University of Arizona Press, 1970; pt. 2, p. 419, no. 16.18 (repro.).

Plate 63: *Weehawken Sequence #3*,
c. 1916 (1903–4?)
Oil on canvas board, 9 ½ x 12 ¼ inches
(24.1 x 31.1 cm)
Signed, lower right: *Marin*
Signed and dated, on verso, at a later date: *Painted between 1903–1904 / J Marin*
Collection of C. K. Williams, II

Provenance:

Estate of the artist; purchase from Richard York Gallery, New York, April 1, 1998.

Exhibitions:

An American Place, New York. *John Marin: Oils—1903–1950.* 1950. Unillustrated checklist.

American Academy of Arts and Letters and the National Institute of Arts and Letters, New York. *John Marin, 1870–1953.* January 15–February 14, 1954. Exh. cat.; n.p., no. 72 (no repro.).

Kennedy Galleries, Inc., New York. *John Marin: Between Realism and Abstraction.* October 4–November 1, 1997. Exh. cat.; n.p., no. 4 (no repro.).

References:

Helm, MacKinley. *John Marin.* Boston: Pellegrini & Cudahy, in association with the Institute of Contemporary Art, 1948; p. 9 (no repro.).

Reich, Sheldon. *John Marin: A Stylistic Analysis and Catalogue Raisonné.* Tucson: University of Arizona Press, 1970; pt. 2, p. 439, no. 16.118 (repro.).

Plate 64: *Weehawken Sequence #41*,
c. 1916
Oil on canvas board, 9 ½ x 12 ¼ inches
(24.1 x 31.1 cm)
Collection of C. K. Williams, II

Provenance:

Estate of the artist; purchase from Richard York Gallery, New York, April 1, 1998.

Exhibitions:

An American Place, New York. *John Marin: Oils—1903–1950.* 1950. Unillustrated checklist.

Los Angeles County Museum of Art. *John Marin, 1870–1953.* July 7–August 30, 1970. Exh. cat. by Larry Curry; p. 23, no. 7 (no repro.). Traveled to M. H. de Young Memorial Museum, San Francisco, September 20–November 7, 1970; The Fine Arts Gallery of San Diego, November 28, 1970–January 3, 1971; Whitney Museum of American Art, New York, February 18–March 28, 1971; National Collection of Fine Arts, Washington, DC, April 23–June 6, 1971.

Jersey City Museum, NJ. *John Marin: The Weehawken Sequence.* September 9–November 11, 1985. Pamphlet by Robert Ferguson; no checklist (repro.).

References:

Helm, MacKinley. *John Marin.* Boston: Pellegrini & Cudahy, in association with the Institute of Contemporary Art, 1948; p. 9 (no repro.).

Reich, Sheldon. *John Marin: A Stylistic Analysis and Catalogue Raisonné.* Tucson: University of Arizona Press, 1970; pt. 2, p. 426, no. 16.57 (repro.).

REGINALD MARSH
American, born Paris, 1898–1954

Plate 65: *Gayety Burlesk (Gayety Burlesque)*, 1932
Tempera on paper, mounted on panel,
24 x 30 inches (61 x 76.2 cm)
Signed and dated, lower right: *REGINALD MARSH 1932*
Collection of C. K. Williams, II

Provenance:

Grace Eistis, Washington, DC; by descent to Moira Simonds (her granddaughter), Freeport, ME; Barridoff Galleries, Portland, ME, "American and European Art," August 1, 1990, lot 42 (repro.); Midtown Payson Galleries, New York; purchase from Midtown Payson Galleries, March 24, 1992.

Exhibitions:

Frank K. M. Rehn Galleries, New York. Reginald Marsh exhibition. April 1933. No cat.

Thomas J. Walsh Art Gallery, Fairfield University, CT. *Human Conditions: 20th Century Paintings and Drawings.* February 7–March 7, 1992. No cat. Traveled to Midtown Payson Galleries, Hobe Sound, FL, March 24–April 3, 1992.

Possibly Portland Museum of Art, ME. *The Elegant Auto: Fashion and Design in the 1930s.* July 30–November 8, 1992. Exh. cat.; no checklist.

Pennsylvania Academy of the Fine Arts, Philadelphia. *In Private Hands: 200 Years of American Painting.* October 1, 2005–January 8, 2006. Exh. cat. by Lynn Marsden-Atlass, Nicolai Cikovsky, Jr., and Robert Rosenblum; pp. 42, 137, 249, pl. 46.

References:

Blossom, Frederick Augustus. "Reginald Marsh as Painter." *Creative Art*, vol. 12 (April 1933), p. 261 (repro.).

"Reginald Marsh's Bowery." *New York Sun*, April 8, 1933, p. 8 (repro.).

Salpeter, Harry. "The Roar of the City." *Esquire* (June 1935), p. 48 (repro.).

"'Gaiety Burlesque' by Reginald Marsh." *Yale Record*, vol. 64, no. 1 (September 25, 1935), p. 14 (repro.).

Sasowsky, Norman. *The Prints of Reginald Marsh.* New York: Clarkson N. Potter, 1976; p. 182.

Sleeper, Frank. "$231,000 Painting Sets Maine Record." *Portland Press Herald*, August 2, 1990, p. 36.

Miller, Michele L. "'The Charms of Exposed Flesh': Reginald Marsh and the Burlesque Theater." Ph.D. diss., University of Pennsylvania, 1997; pp. xi, 74, 213 (repro.).

JAN MATULKA
American, born Czechoslovakia, 1890–1972

Plate 66: *The White Oak*, c. 1923
Watercolor on paper, 18 x 12 inches (45.7 x 30.5 cm)
Signed, lower left: *Matulka*
Collection of C. K. Williams, II

Provenance:

Estate of the artist, 1923–99; Thomas McCormick Gallery, Chicago; Richard York Gallery, New York; purchase from Richard York Gallery, October 14, 1999.

Reference:

Adams, Henry. *Jan Matulka.* Chicago: Thomas McCormick Gallery, 1999; p. 50, no. 53 (repro.).

Plate 67: *View from Ship*, c. 1932
Oil on canvas, 36 x 30 inches (91.4 x 76.2 cm)
Signed, lower left: *Matulka*
Collection of C. K. Williams, II

Provenance:

Estate of the artist; Mr. and Mrs. Raymond Learsy, New York, c. 1979–92; Robert Schoelkopf Gallery, New York; Marshall Henis Stepping Stone Gallery, Great Neck, NY, 1992–99; Hirschl & Adler Galleries, Inc., New York; purchase from Hirschl & Adler Galleries, Inc., December 14, 1999.

Exhibitions:
Whitney Museum of American Art, New York. *Jan Matulka, 1890–1972*. December 18, 1979–February 24, 1980. Exh. cat.; pp. 68–69, 97, no. 22, fig. 72. Traveled to The Museum of Fine Arts, Houston, April 3–June 1, 1980; Birmingham Museum of Art, AL, June 15–October 1, 1980; National Collection of Fine Arts, Washington, DC, November 21, 1980–February 8, 1981.

Museum of Art, Carnegie Institute, Pittsburgh. *Abstract Painting and Sculpture in America, 1927–1944*. November 5–December 31, 1983. Exh. cat. by John R. Lane and Susan C. Larsen; pp. 191, 242, no. 96 (repro.). Traveled to San Francisco Museum of Modern Art, January 26–March 25, 1984; The Minneapolis Institute of Arts, April 15–June 3, 1984; Whitney Museum of American Art, New York, June 28–September 9, 1984.

References:
"Jan Matulka (1890–1972) through February 8 at the National Museum of American Art." *Antiques & the Arts Weekly*, January 16, 1981, p. 47 (repro.).

Adams, Henry. *Jan Matulka*. Chicago: Thomas McCormick Gallery, 1999; pp. 30, 35, no. 36 (repro.).

KENNETH HAYES MILLER
American, 1876–1952

Plate 68: *Waiting for the Bus*, 1931
Oil on Masonite, 30 x 20 ⅛ inches (76.2 x 51.1 cm)
Signed and dated, lower right: *Hayes Miller 31+*
Titled, on verso on stretcher
Collection of C. K. Williams, II

Provenance:
Estate of the artist; private collection, 1970s; Zabriskie Gallery, New York; Sotheby's Arcade, New York, "American Paintings, Drawings and Sculpture," September 12, 1994, lot 235 (repro.); private collection; purchase from Marissa G. Boyescu Arts, Miami, 1995.

Exhibitions:
Possibly Frank K. M. Rehn Galleries, New York. *Exhibition of Paintings by Kenneth Hayes Miller*. November 16–December 5, 1931. Exh. cat.; n.p., no. 2 (no repro.).

Whitney Museum of American Art, New York. *Annual Exhibition of Contemporary American Paintings*. November 13, 1948–January 2, 1949. Exh. cat.; n.p., no. 100 (no repro.).

References:
Burroughs, Alan. *Kenneth Hayes Miller*. New York: Whitney Museum of American Art, 1931; p. 22 (repro. p. 23 of an earlier version of the painting).

Rothschild, Lincoln. *To Keep Art Alive: The Effort of Kenneth Hayes Miller, American Painter (1876–1952)*. Philadelphia: Art Alliance Press; Cranbury, NJ:

Associated University Presses, 1974; p. 100, no. 39 in Appendix B, "Catalogue of Other Known Paintings" (no repro.).

ELIE NADELMAN
American, born Poland, 1882–1946

Plate 69: *Wounded Stag*, c. 1915
Bronze and natural golden patina,
13 ⅜ x 20 ¾ x 7 ¼ inches (34 x 52.7 x 18.4 cm)
with original onyx base
Collection of C. K. Williams, II

Provenance:
Collection of the artist; given to Mr. and Mrs. Charles Wright Guthridge (Nadelman's stepdaughter Viola and her husband) on their marriage in 1919; by descent in the family until 1997; Richard York Gallery, New York; purchase from Richard York Gallery, October 8, 1997.

Exhibitions:
Scott and Fowles, New York. *Catalogue of an Exhibition of Sculpture and Drawings by Elie Nadelman*. 1917. Exh. cat. by Martin Birnbaum; no. 7 (no repro.).

Hirschl & Adler Galleries, Inc., New York. *Six American Modernists*. November 9, 1991–January 4, 1992. Exh. cat.; pp. 20, 27, no. 45 (repro.).

Hirschl & Adler Galleries, Inc., New York. *Call of the Wild: A Sportsman's Life*. June 2–August 12, 1994. Exh. cat.; n.p., no. 39 (no repro.). Traveled to Meredith Long & Co., Houston, September 8–29, 1994.

Richard York Gallery, New York. *Modernism at the Salons of America, 1922–1936*. October 19–December 8, 1994. Exh. cat.; pp. 7, 21, no. 53 (repro.).

Whitney Museum of American Art, New York. *Elie Nadelman: Sculptor of Modern Life*. April 3–July 20, 2003. Exh. cat. by Barbara Haskell; pp. 88–89, 131, fig. 100.

LOUISE NEVELSON
American, born Ukraine, 1899–1988

Plate 70: *Rain Forest Column XXIV*, 1964
Wood (painted black) and iron, 91 ½ x 16 x 16 inches (232.4 x 40.6 x 40.6 cm)
On base, in white: *XXIV*
Collection of C. K. Williams, II

Provenance:
Pace Gallery, New York, c. 1967–76; Fribourg Collection, New York; purchase from Marissa G. Boyescu Arts, Miami, February 1, 2002.

Exhibition:
The Museum of Fine Arts, Houston. *Louise Nevelson*. October 23–December 14, 1969. Exh. cat.; p. 42,

no. 58 (no repro.). Traveled to University of Texas, College of Fine Arts, Austin, January 15–February 15, 1970.

EMIL NOLDE
German, 1867–1956

Plate 71: *Red Poppies (Roter Mohn)*, c. 1920
Watercolor on Japanese tissue
Sheet 13 ½ x 18 ⅞ inches (34.3 x 47.9 cm)
Signed, lower right: *Nolde*
Signed, on verso, lower right: *Nolde*
Philadelphia Museum of Art. Gift of C. K. Williams, II. 2006-49-1

Provenance:
M. Knoedler & Co., Inc., New York; John T. Dorrance, Jr., Gladwyne, PA; Moeller Fine Art Ltd., New York; Leonard Hutton Galleries, New York; purchase from Leonard Hutton Galleries, January 7, 1995; gift to the Philadelphia Museum of Art, 2006.

Exhibition:
Galerie Ferdinand Möller, Berlin. *Emil Nolde: Blätter der Galerie Ferdinand Möller*. February 1930. Exh. cat.; p. 11, no. 33 (no repro.).

Reference:
Moeller, Achim. *Private Views*. New York: Achim Moeller Fine Art Ltd., 1990; n.p., no. 33 (repro.).

GEORGIA O'KEEFFE
American, 1887–1986

Plate 72: *Nude Series V*, 1918
Watercolor on paper, 11 ⅞ x 8 ¾ inches (30.2 x 22.2 cm)
Collection of C. K. Williams, II

Provenance:
Estate of the artist; private collection, 1986–94; purchase from Marissa G. Boyescu Arts, Miami, October 29, 1994.

Exhibitions:
Anderson Galleries, New York. *Alfred Stieglitz Presents One Hundred Pictures, Oils, Water-Colors, Pastels, Drawings, by Georgia O'Keeffe, American*. January 29–February 10, 1923. Pamphlet; no checklist.

Whitney Museum of American Art, New York. *Pioneers of Modern Art in America*. April 9–May 19, 1946. Exh. cat. by Lloyd Goodrich; p. 25, no. 109 (no repro.).

Downtown Gallery, New York. *O'Keeffe: Exhibition, Watercolors*. February 25–March 22, 1958. Exh. cat.; n.p., no. 35 (no repro.).

References:
Bry, Doris, and Nicholas Callaway, eds. *Georgia O'Keeffe: The New York Years*. New York: Alfred A. Knopf, in association with Callaway, 1991; pp. 13, 131, no. 13 (repro.).

Lynes, Barbara Buhler. *Georgia O'Keeffe: Catalogue Raisonné*. New Haven: Yale University Press, in association with the National Gallery of Art and the Georgia O'Keeffe Foundation, 1999; vol. 1, p. 109, no. 184 (repro.).

ALTON PICKENS
American, 1917–1991

Plate 73: *Game of Pretend*, 1944
Oil on burlap, 18 x 23 ½ inches (45.7 x 59.7 cm)
Signed and dated, lower right: *A. PICKENS / 9 / 44*
Collection of C. K. Williams, II

Provenance:
Buchholz Gallery, New York; private collection, NJ; DC Moore Gallery, New York; purchase from DC Moore Gallery, April 16, 2001.

Exhibitions:
The Museum of Modern Art, New York. *Fourteen Americans*. September 10–December 8, 1946. Exh. cat., ed. Dorothy C. Miller; pp. 49, 79, no. 96 (repro.). Traveled to Vassar College, Poughkeepsie, NY, January 5–26, 1947; Society of the Four Arts, Palm Beach, FL, February 7–March 7, 1947; Cincinnati Modern Art Society, OH, March 20–April 17, 1947; San Francisco Museum of Modern Art, May 1–June 1, 1947; Louisiana State University, Baton Rouge, June 15–30, 1947.

ACA Galleries, New York. *Alton Pickens: Paintings and Drawings*. April 23–May 12, 1956. Exh. cat.; n.p., no. 3 (no repro.).

References:
Louchheim, Aline B. "The Favored Few Open the Modern Museum's Season." *Art News*, vol. 45, no. 7 (September 1946), p. 17 (repro.).

Pickens, Alton. "There Are No Artists in Hiroshima." *Magazine of Art*, vol. 40 (October 1947), p. 236 (repro.).

MAURICE B. PRENDERGAST
American, 1859–1924

Plate 74: *Bathers, New England*,
c. 1916–19
Watercolor and pastel with graphite on heavy wove paper
Sheet 15 ¾ x 22 ⁷/₁₆ inches (40 x 57 cm)
Signed, lower left: *Prendergast*; lower center: *Prendergast*
Inscribed, on verso, upper right: *Bathers, New England*
Sketch in black crayon of bathers on verso
Philadelphia Museum of Art. Gift of C. K. Williams, II, in honor of the 125th Anniversary of the Museum. 2003-63-2

Provenance:
Charles Prendergast, 1924–48; Mrs. Charles Prendergast, 1948–87; private collection, 1987; Coe Kerr Gallery, New York, by 1991; purchase from Coe Kerr Gallery, March 22, 1991; gift to the Philadelphia Museum of Art, 2003.

Exhibitions:
Possibly Whitney Museum of American Art, New York. *Maurice Prendergast Memorial Exhibition*. February 21–March 22, 1934. Exh. cat.; p. 10, no. 6 (no repro.).

Coe Kerr Gallery, New York. *The Unknown Pastels: Maurice Brazil Prendergast*. November 4–December 5, 1987. Exh. cat.; pp. 16–17, pl. 20.

Coe Kerr Gallery, New York. *American Impressionism II: An Exhibition and Sale of Paintings, Watercolors, and Pastels*. May 19–June 23, 1989. Exh. cat.; n.p., fig. 33.

Philadelphia Museum of Art. *Gifts in Honor of the Museum's 125th Anniversary*. September 29–December 8, 2002. Exh. cat.; p. 185, no. 181 (repro.).

References:
Adelson Galleries, Inc. *Maurice Prendergast: Paintings of America*. New York: Adelson Galleries, 1987; pp. 66, 74–75, no. 22 (repro.).

Langdale, Cecily. "The Late Watercolors/Pastels of Maurice Prendergast." *Magazine Antiques*, vol. 132, no. 5 (November 1987), pp. 1085, 1089–91, pl. 2.

Clark, Carol, Nancy Mowll Mathews, and Gwendolyn Owens. *Maurice Brazil Prendergast, Charles Prendergast: A Catalogue Raisonné*. Williamstown, MA: Williams College Museum of Art; Munich: Prestel-Verlag, 1990; p. 525, no. 1304 (repro.).

ODILON REDON
French, 1840–1916

Plate 75: *Sea Monster (Monstre sous-marin)*, c. 1895
Pastel on paper, 21 ⁷/₈ x 18 ½ inches (55.6 x 47 cm)
Signed, lower left: *Odilon Redon*
Collection of C. K. Williams, II

Provenance:
Andries Bonger, Almen, Netherlands; Mrs. F.W.M. Bonger, baroness van der Borch van Verwolde, Almen, Netherlands; Erven Ph. Mees, Rotterdam; Galerie G. J. Nieuwenhuizen Segaar, The Hague; private collection, London, c. 1959; Wally Findlay Gallery, Chicago, c. 1965; Jean-Pierre Durand, Geneva, c. 1975; Annette Cross Murphy, New York; Christie's, New York, "Impressionist and Modern Drawings and Watercolors," May 16, 1990, lot 119 (repro.), did not sell; Christie's, New York, "Impressionist and Modern Drawings and Water-colors," November 15, 1990, lot 124 (repro.), did not sell; purchase from Jonathan Greenberg, Inc., New York, April 3, 1998.

Exhibitions:
Galerie Barbazanges, Paris. *Exposition rétrospective d'oeuvres d'Odilon Redon (1840–1916)*. May 18–June 15, 1920. Exh. cat.; no. 93 (no repro.).

Galerie Georges Giroux, Brussels. *Odilon Redon*. December 18, 1920–January 8, 1921. Exh. cat.; no. 51 (no repro.).

Stedelijk Museum De Lakenhal, Leiden, Netherlands. *Tentoonstelling kunstbezit van oud-alumni der Leidse Universiteit*. June 1950. Exh. cat. by E. Pelinck; p. 42, no. 129 (no repro.).

Gemeentemuseum, The Hague. *Odilon Redon*. May 3–June 23, 1957. Exh. cat.; p. 47, no. 136 (no repro.).

Matthiesen Gallery, London. *Odilon Redon, 1840–1916: A Loan Exhibition of Paintings and Drawings in Aid of Corneal Graft and Eye Bank Research*. May–June 1959. Exh. cat.; n.p., no. 43 (repro.).

The Art Institute of Chicago. *Odilon Redon, Gustave Moreau, Rodolphe Bresdin*. March 2–April 15, 1962. Exh. cat.; p. 173, no. 25 (no repro.). Traveling exhibition; shown only in Chicago.

References:
Berger, Klaus. *Odilon Redon: Phantasie und Farbe*. Cologne: M. DuMont Schauberg, 1964; p. 207, no. 343 (no repro.).

Berger, Klaus. *Odilon Redon: Fantasy and Color*. Translated by Michael Bullock. London: Weidenfeld and Nicolson, 1964; p. 206, no. 343 (no repro.).

Wildenstein, Alec. *Odilon Redon: Catalogue raisonné de l'oeuvre peint et dessiné*. Vol. 2. *Mythes et légendes*. Paris: Wildenstein Institute, La Bibliothèque des Arts, 1994; p. 296, no. 1293 (repro.).

Plate 76: *The Boat (La Barque)*, c. 1900
Oil on panel, 11 ¾ x 6 ⅜ inches (29.8 x 16.2 cm)
Signed, lower left: *ODILON REDON*
Collection of C. K. Williams, II

Provenance:
Marquis de Gonet, 1908–9, from the artist; by descent; Christie's, New York, "Impressionist and Modern Paintings, Drawings, and Sculpture (Part One)," November 11, 1997, lot 136 (repro.); purchase from Christie's auction, November 11, 1997.

Reference:
Wildenstein, Alec. *Odilon Redon: Catalogue raisonné de l'oeuvre peint et dessiné*. Vol. 4. *Études et grandes décorations, Supplément*. Paris: Wildenstein Institute, La Bibliothèque des Arts, 1998; pp. 284–85, no. 2657 (repro.).

HUGO ROBUS
American, 1885–1964

Plate 77: *The Accordionist*, c. 1917
Oil on canvas, 36 x 32 inches (91.4 x 81.3 cm)
Collection of C. K. Williams, II

Provenance:
Mr. and Mrs. MacDonald Deming; by descent; Sotheby's, New York, "American Paintings, Drawings, and Sculpture," December 3, 1998, lot 283 (repro.); purchase from Sotheby's auction, December 3, 1998.

Exhibitions:
Grand Central Palace, New York. *First Annual Exhibition of the Society of Independent Artists*. April 10–May 6, 1917. No. 68 (as *Accordion Player*) (no repro.).

National Collection of Fine Arts, Washington, DC. *Hugo Robus (1885–1964)*. November 30, 1979–March 2, 1980. Exh. cat. by Roberta K. Tarbell; pp. 11, 54, no. 24 (no repro.). Traveled to Allentown Art Museum, PA, July 13–September 14, 1980; Columbus Museum of Art, OH, October 21–November 30, 1980.

Reference:
Tarbell, Roberta K. "Hugo Robus' Pictorial Works." *Arts Magazine*, vol. 54, no. 1 (March 1980), p. 140 n. 2.

Plate 78: *Supplication*, c. 1925, cast 1954
Bronze, 18 1/2 x 9 1/2 x 14 inches (47 x 24.1 x 35.6 cm)
Cast 2/3 by Roman Bronze Works, Inc., New York
Signed, back of proper right shoulder: *HUGO ROBUS*
Stamped, back of proper left shoulder: *ROMAN BRONZE WORKS INC. N.Y.*
Collection of C. K. Williams, II

Provenance:
America-Israel Cultural Foundation, New York, to 1976; Forum Gallery, New York, 1976–2002; purchase from Martin du Louvre, Paris, October 9, 2002.

Exhibitions:
Forum Gallery, New York. *Hugo Robus: Sculpture, Paintings and Drawings*. December 1–29, 1979. No cat.; checklist no. 1.

Park Avenue Armory, New York. *Art at the Armory*. November 17–20, 1994. Exh. cat. by Sanford L. Smith & Associates, Ltd.; no checklist (no repro.).

Reference:
Tarbell, Roberta K. *Hugo Robus (1885–1964)*. Exh. cat. Washington, DC: Smithsonian Institution Press, for the National Collection of Fine Arts, 1980; pp. 66, 167–68, no. 11 (repro.).

MORGAN RUSSELL
American, 1886–1953

Plate 79: *Synchromist Nude*, 1913
Oil on canvas, 25 1/8 x 19 3/4 inches (63.8 x 50.2 cm)
Signed and dated, on verso: *Morgan / Russell '13*
Collection of C. K. Williams, II

Provenance:
Jean Dracopoli, France, probably acquired directly from the artist; Mrs. Milliner, France; her descendants;

private collection, c. 1985; Christie's, New York, "Important American Paintings, Drawings, and Sculpture," November 29, 2001, lot 88 (repro.); Menconi & Schoelkopf Fine Art, LLC, New York; purchase from Menconi & Schoelkopf Fine Art, LLC, October 30, 2004.

Plate 80: *Synchromy No. 8, Part II*, 1916
Oil on panel, 12 3/4 x 9 1/2 inches (32.4 x 24.1 cm)
Signed, titled, and dated, on verso: *Morgan / Russell / Part II #8 1916*
Collection of C. K. Williams, II

Provenance:
Rose Fried Gallery, New York, by 1956; Solomon Ethe, New York, by 1960; Vance Jordan Fine Arts, Inc., New York; purchase from Vance Jordan Fine Arts, Inc., October 12, 1999.

Exhibitions:
Rose Fried Gallery, New York. *Morgan Russell, 1884–1953: An Exhibition in Memoriam*. October 26–November 1953. Exh. cat.; n.p., no. 9 (no repro.).

Atlanta Public Library. *Pioneers of American Abstract Art*. December 1–22, 1955. Exh. cat.; p. 11, no. 36 (no repro.). Circulated by American Federation of Arts, New York. Traveled to Louisiana State Exhibit Museum, Shreveport, January 4–25, 1956; J. B. Speed Art Museum, Louisville, February 8–March 1, 1956; Lawrence Museum, Williamstown, MA, April 19–May 10, 1956; George Thomas Hunter Gallery, Chattanooga, May 24–June 14, 1956; Rose Fried Gallery, New York, December 19, 1956–January 9, 1957.

Dallas Museum for Contemporary Arts. *American Genius in Review No. 1*. May 11–June 19, 1960. Exh. cat.; n.p., no. 38 (no repro.).

Possibly ACA Heritage Gallery, Inc., New York. *Commemorating the 50th Anniversary of "The Forum Exhibition of Modern American Painters," March 1916*. March 14–April 9, 1966. Exh. cat.; p. 31, no. 33 (no repro.).

JOHN SINGER SARGENT
American, born Florence, died London, 1856–1925

Plate 81: *A Waterfall*, c. 1910
Oil on canvas, 44 1/2 x 28 1/2 inches (113 x 72.4 cm)
Signed, lower right: *John S. Sargent*
Philadelphia Museum of Art. Partial and promised gift of C. K. Williams, II. 2004-5-1

Provenance:
M. Knoedler & Co., Inc., New York, 1911; Mr. and Mrs. Samuel T. Peters, New York, 1911–43; estate of Mrs. Samuel T. Peters, New York; Parke-Bernet Galleries, New York, "Paintings of Many Schools Including American, English, and French Canvases Comprising Property of the Estate of the Late Mrs. Samuel T. Peters," October 14, 1943, lot 62 (repro.); George T. Nelson; International Business Machines

International Foundation, by 1948–95; Sotheby's, New York, "American Paintings, Drawings, and Sculpture from the IBM International Foundation," May 25, 1995, lot 21 (repro.); purchase from Sotheby's auction, May 25, 1995.

Exhibitions:
Royal Academy of Arts, London. *The Exhibition of the Royal Academy of Arts: The One Hundred and Forty-third*. May 1–August 7, 1911. Exh. cat.; p. 10, no. 94 (no repro.).

National Academy of Design, New York. *Winter Exhibition*. December 20, 1913–January 18, 1914. Exh. cat.; no. 203 (no repro.).

Pennsylvania Academy of the Fine Arts, Philadelphia. *One Hundred and Ninth Annual Exhibition*. February 8–March 29, 1914. Exh. cat.; p. 43, no. 412 (no repro.).

Grand Central Art Galleries, New York. *Painters of the United States, 1720 to 1920: From the Permanent Collection of the Fine Arts Department, International Business Machines Corporation*. November 15–December 8, 1951. Exh. cat.; n.p., no. 44 (no repro.).

Florida State Fair, Tampa. January–February 1953. No cat.

American Embassy, The Hague. *U.S. Department of State Art and Embassies Program*. October 1958–December 1962.

IBM Gallery, New York. *Realism: An American Heritage*. January 14–February 1, 1963. Exh. cat.; n.p., no. 48 (no repro.).

Corcoran Gallery of Art, Washington, DC. *The Private World of John Singer Sargent*. April 18–June 14, 1964. Exh. cat. by Donelson F. Hoopes; n.p., no. 82 (no repro.). Traveled to The Cleveland Museum of Art, July 7–August 16, 1964; Worcester Art Museum, MA, September 17–November 1, 1964; Munson-Williams-Proctor Institute, Utica, NY, November 15, 1964–January 3, 1965.

IBM Gallery, New York. *American Painting: 1900–1950*. June 9–July 25, 1969. Exh. cat. by Paul Rand; n.p., no number (no repro.).

American Embassy, Dublin. *U.S. State Department Art in Embassies Program*. May 1978–July 1981.

IBM Gallery of Science and Art, New York. *American Images: Selections from the IBM Collection*. June 19–July 28, 1984. No cat.; checklist; no number.

IBM Gallery of Science and Art, New York. *Selected Works from the IBM Collection*. November 5, 1985–January 4, 1986. Pamphlet; checklist no. 77 (no repro.).

IBM Gallery of Science and Art, New York. *Fifty Years of Collecting: Art at IBM*. September 12–November 25, 1989. No checklist.

Philadelphia Museum of Art. *American Marine Paintings and Prints*. February 15–May 31, 2004. No cat.

Society of the Four Arts, Palm Beach, FL. *American Cornucopia: Treasures from the Philadelphia Museum of Art*. January 20–February 26, 2006. No cat.

References:

"Fine Arts and the Royal Academy (First Notice)." *Atheneum*, no. 4357 (April 29, 1911), p. 483.

"The Royal Academy: Third Notice, Landscape." *Times (London)*, May 8, 1911, p. 10.

Downes, William Howe. *John S. Sargent: His Life and Work*. Boston: Little, Brown and Company, 1925; p. 238 (no repro.).

Charteris, Hon. Evan. *John Sargent: With Reproductions from His Paintings and Drawings*. New York: Charles Scribner's Sons, 1927; p. 291 (no repro.).

Adelson, Warren, et al. *Sargent Abroad: Figures and Landscapes*. New York: Abbeville Press, 1997; p. 109 (no repro.).

Herdrich, Stephanie L., and H. Barbara Weinberg. *American Drawings and Watercolors in the Metropolitan Museum of Art: John Singer Sargent*. New York: The Metropolitan Museum of Art, 2000; p. 273, fig. 103.

Ormond, Richard, and Elaine Kilmurray. *John Singer Sargent: Complete Paintings*. Volume on late landscapes. New Haven: Yale University Press, forthcoming.

MORTON SCHAMBERG

American, 1881–1918

Plate 82: *Landscape (with Bridge)*, 1914

Oil on canvas, 26 x 32 inches (66 x 81.3 cm)
Signed and dated, lower right: *Schamberg—1914*
Philadelphia Museum of Art. Promised gift of C. K. Williams, II

Provenance:

Maurice J. Speiser; Ellen Speiser; Mr. and Mrs. Malcolm C. Eisenberg, Philadelphia; private collection, FL; Martha Parrish & James Reinish, Inc., New York; purchase from Martha Parrish & James Reinish, Inc., October 2000.

Exhibitions:

Possibly Montross Gallery, New York. *Exhibition of Paintings, Drawings and Sculpture*. March 23–April 24, 1915. Exh. cat.; no. 49 (no repro.).

National Collection of Fine Arts, Washington, DC. *Pennsylvania Academy Moderns, 1910–1940*. May 9–July 6, 1975. Exh. cat.; p. 32, no. 35 (repro.). Traveled to Pennsylvania Academy of the Fine Arts, Philadelphia, July 30–September 6, 1975.

Whitney Museum of American Art, New York. *Synchromism and American Color Abstraction, 1910–1925*. January 24–March 26, 1978. Exh. cat. by Gail Levin; pp. 82, 143, pl. 42. Traveled to The Museum of Fine Arts, Houston, April 20–June 18, 1978; Des Moines Art Center, July 6–September 3, 1978; San Francisco Museum of Modern Art, September 22–November 19, 1978; Everson Museum of Art, Syracuse, NY, December 15, 1978–January 28, 1979; Columbus Museum of Art, OH, February 15–March 24, 1979.

Salander-O'Reilly Galleries, New York. *Morton Livingston Schamberg*. November 3–December 31, 1982. Exh. cat. by William C. Agee and Pamela Ellison; p. 9, fig. 27. Traveled to Columbus Museum of Art, OH, January 22–March 13, 1983; Peale House Galleries, The School of the Pennsylvania Academy of the Fine Arts, Philadelphia, April 15–May 6, 1983; Milwaukee Art Museum, February 11–March 27, 1984.

Marriner S. Eccles Federal Reserve Board Building, Washington, DC. *Morton Livingston Schamberg: Color and Evolution of His Paintings*. April 11–May 30, 1984. Exh. cat.; n.p., no. 23 (no repro.).

Hirschl & Adler Galleries, Inc., New York. *Modern Times: Aspects of American Art, 1907–1956*. November 1–December 6, 1986. Exh. cat.; p. 100, no. 91 (repro.).

References:

Davidson, Abraham A. *Early American Modernist Painting, 1910–1935*. New York: Harper & Row, 1981; pp. 149–50, 309, no. 82 (repro.).

Looking Back: Martha Parrish & James Reinish; 15 Years. New York: Martha Parrish & James Reinish, 2008; pp. 54, 96, no. 34 (repro.).

BEN SHAHN

American, born Lithuania, 1898–1969

Plate 83: *Study for "Jersey Homesteads Mural"* (right side), c. 1936

Tempera on paper, mounted to Masonite, 20 x 29 inches (50.8 x 73.7 cm)
Collection of C. K. Williams, II

Provenance:

Estate of the artist; Kennedy Galleries, Inc., New York; private collection, CA; DC Moore Gallery, New York, by 2006; purchase from DC Moore Gallery, October 7, 2006.

Exhibitions:

Institute of Contemporary Art, Boston. *Ben Shahn: A Documentary Exhibition*. April 11–May 31, 1957. Pamphlet; no number (no repro.); checklist no. 24 or among nos. 62–82.

Kennedy Galleries, Inc., New York. *Ben Shahn*. November 5–29, 1969. Exh. cat.; n.p., pl. 13.

National Museum of Modern Art, Tokyo. *The Exhibition of Ben Shahn*. May 21–July 5, 1970. Exh. cat.; pp. 41, 162, no. 9 (repro.).

Joe and Emily Lowe Art Gallery, Syracuse University, Syracuse, NY. *The Mural Art of Ben Shahn*. September 28–October 30, 1977. Exh. cat. by Mary H. Takach; n.p., no. 3 (no repro.).

References:

Shahn, Bernarda Bryson. *Ben Shahn*. New York: Harry N. Abrams, 1972; p. 149 (repro.).

Pohl, Frances K. *Ben Shahn: With Ben Shahn's Writings*. San Francisco: Pomegranate Artbooks, 1993; p. 59 (repro.).

Platt, Susan Noyes. "The Jersey Homesteads Mural: Ben Shahn, Bernarda Bryson, and History Painting in the 1930s." In *Redefining American History Painting*. Edited by Patricia M. Burnham and Lucretia Hoover Giese. Cambridge: Cambridge University Press, 1995; p. 302.

Chevlowe, Susan, et al. *Common Man, Mythic Vision: The Paintings of Ben Shahn*. New York: Jewish Museum; Princeton: Princeton University Press, 1998; pp. 45–46, fig. 27.

Plate 84: *Melancholia*, 1953

Gouache on paper, 19 ½ x 26 ½ inches (49.5 x 67.3 cm)
Signed, lower right: *Ben Shahn*
Collection of C. K. Williams, II

Provenance:

Private collection; Kennedy Galleries, Inc., New York, to 1991; purchase from Kennedy Galleries, Inc., October 1, 1991.

Exhibition:

Santa Fe East Gallery, NM. *Ben Shahn: Voices and Visions*. September 18–October 31, 1981. Exh. cat., comp. Alma S. King; p. 47, no. 7 (repro.).

Reference:

Shahn, Bernarda Bryson. *Ben Shahn*. New York: Harry N. Abrams, 1972; p. 83 (repro.).

CHARLES SHEELER

American, 1883–1965

Plate 85: *Water*, 1944

Tempera on paper, 7 ½ x 9 ¼ inches (19.1 x 23.5 cm)
Signed, lower right: *Sheeler*
Collection of C. K. Williams, II

Provenance:

Downtown Gallery, New York, c. 1965–66; James N. Heald II, Worcester, MA, c. 1966–February 2005; Worcester Art Museum, MA, on long-term loan from James N. Heald II, 1987–February 2005; Hirschl & Adler Galleries, Inc., New York, 2005; purchase from Hirschl & Adler Galleries, Inc., March 11, 2005.

Exhibitions:

Downtown Gallery, New York. *Sheeler (1883–1965)*. May 3–27, 1966. Exh. cat.; n.p., no number (no repro.).

Installations at the Worcester Art Museum, MA, 1987–2005.

Plate 86: *Neighbors*, 1951

Oil on canvas, 18 x 15 inches (45.7 x 38.1 cm)
Signed and dated, lower right: *Sheeler—51*
Signed and dated, on verso: *Charles Sheeler / 1951*
Inscribed, on verso: *Do not remove this board. / C.S.*
Collection of C. K. Williams, II

Provenance:

Downtown Gallery, New York, by 1953; William T. Kemper, Jr., Kansas City, MO, by 1958–89; William

T. Kemper Charitable Trust, Kansas City, MO, 1989; Christie's, New York, "Important American Paintings, Drawings and Sculpture of the 18th, 19th and 20th Centuries," December 1, 1989, lot 278 (repro.); Michael Egan, FL, 1989–2000; Martha Parrish & James Reinish, Inc., New York; purchase from Martha Parrish & James Reinish, Inc., June 2000.

Exhibitions:
Whitney Museum of American Art, New York. *Annual Exhibition of Contemporary American Paintings*. November 6, 1952–January 4, 1953. Exh. cat.; n.p., no. 126 (no repro.).

Downtown Gallery, New York. *Sheeler: Recent Paintings*. March 25–April 19, 1958. Exh. cat.; n.p., no. 16 (no repro.).

Herbert F. Johnson Museum of Art, Cornell University, Ithaca, NY. *Cornell Collects: A Celebration of American Art from the Collection of Alumni and Friends*. August 21–November 4, 1990. Exh. cat.; pp. 75, 185, no. 139 (repro.).

References:
Dochterman, Lilian Natalie. "The Stylistic Development of the Work of Charles Sheeler." Ph.D. diss., State University of Iowa, 1963; p. 485, no. 51.317 (repro.).

Looking Back: Martha Parrish & James Reinish; 15 Years. New York: Martha Parrish & James Reinish, 2008; pp. 30, 96, no. 12 (repro.).

Plate 87: *Neighbors No. 2*, 1951
Tempera on paper, 5 3/4 x 5 inches (14.6 x 12.7 cm)
Signed and dated, lower right: *Sheeler—1951*
Signed, dated, and titled, on verso: *Neighbors II / Charles Sheeler / 1951*
Collection of C. K. Williams, II

Provenance:
Downtown Gallery, New York, by 1950s; Charles Wimpheimer, New York, 1950s–90; purchase from Hirschl & Adler Galleries, Inc., New York, March 13, 1990.

Reference:
Dochterman, Lilian Natalie. "The Stylistic Development of the Work of Charles Sheeler." Ph.D. diss., State University of Iowa, 1963; p. 486, no. 51.318 (no repro.).

JOSEPH STELLA
American, born Italy, 1877–1946

Plate 88: *Study for "Battle of Lights,"* c. 1913–14
Oil on canvas, 12 x 9 1/2 inches (30.5 x 24.1 cm)
Signed, lower right: *Stella*
Collection of C. K. Williams, II

Provenance:
Sid Deutsch Gallery, New York; Mr. and Mrs. William C. Janss, Sun Valley, ID, 1984–96; Richard York Gallery, New York, 1996; purchase from Richard York Gallery, December 20, 1996.

Exhibitions:
Richard York Gallery, New York. *The Italian Presence in American Art: 1860–1920*. November 17–December 29, 1989. Exh. cat.; pp. 31, 44, no. 42 (repro.).

Whitney Museum of American Art, New York. *Joseph Stella*. April 22–October 9, 1994. Exh. cat. by Barbara Haskell; pp. 43, 53, fig. 61.

Reference:
Richard York Gallery. *An American Gallery, Vol. 6*. New York: Richard York Gallery, 1990; n.p., no. 22 (repro.).

Plate 89: *Portrait of Joe Gould*, c. 1920
Silverpoint and crayon on paper, 13 13/16 x 10 3/8 inches (35.1 x 26.4 cm)
Signed, lower center: *Joseph Stella*
Inscribed, on verso: *(Head / Joe Gould) / Silverpoint— / Price: $500.00*
Collection of C. K. Williams, II

Provenance:
By bequest to Sergio Stella, 1946; by descent in the family, to 2006; Menconi & Schoelkopf Fine Art, LLC, New York, 2006; purchase from Menconi & Schoelkopf Fine Art, LLC, October 2006.

Exhibition:
Whitney Museum of American Art, New York. *Joseph Stella*. April 22–October 9, 1994. Exh. cat. by Barbara Haskell; p. 273, no number (no repro.).

Reference:
Lancellotti, Arturo. "Un pittore di avanguardia: Giuseppe Stella." *Emporium*, vol. 71, no. 422 (February 1930), p. 69 (repro.).

Plate 90: *Palm Tree and Bird*, 1927–28
Oil on canvas, 54 x 40 1/4 inches (137.2 x 102.2 cm)
Signed, lower right: *Joseph Stella*
Signed, on verso: *Oil Painting / by / Joseph Stella*
Philadelphia Museum of Art. Promised gift of C. K. Williams, II

Provenance:
Estate of Joseph Stella, 1946–2006; purchase from Menconi & Schoelkopf Fine Art, LLC, New York, May 2006.

Exhibitions:
Whitney Museum of American Art, New York. *1930s: Painting and Sculpture in America*. October 14–December 1, 1968. Exh. cat. by William C. Agee; n.p., no. 95 (repro.).

Richard York Gallery, New York. *Joseph Stella: The Tropics*. October 1–29, 1988. Exh. cat. by Irma B. Jaffe; pp. 27, 32, no. 3 (repro.).

Whitney Museum of American Art, New York. *Joseph Stella*. April 22–October 9, 1994. Exh. cat. by Barbara Haskell; p. 156, fig. 186.

Reference:
Glueck, Grace. "The New Decade . . . at Dawn: New York Gallery Notes." *Art in America*, vol. 38, no. 1 (January–February 1970), p. 30 (repro.).

Plate 91: *Tropical Floral*, c. 1928
Oil on canvas, 23 x 16 3/8 inches (58.4 x 41.6 cm)
Signed, lower right: *Joseph / Stella*
Signed, on verso: *Joseph Stella*
Collection of C. K. Williams, II

Provenance:
Estate of the artist; Frank Stevens, New York; Gerald Peters Gallery, New York; purchase from Gerald Peters Gallery, April 14, 2003.

Plate 92: *Tropical Flowers*, c. 1929
Watercolor and casein on paper, 25 x 18 inches (63.5 x 45.7 cm)
Signed, right side just below center: *Joseph Stella*
Collection of C. K. Williams, II

Provenance:
Kennedy Galleries, Inc., New York; Mr. and Mrs. Carl D. Lobell, 1979–89; Hirschl & Adler Galleries, Inc., New York, 1989–93; purchase from Hirschl & Adler Galleries, Inc., March 19, 1993.

Exhibitions:
Minnesota Museum of Art, St. Paul. *American Drawing, 1927–1977*. September 6–October 29, 1977. Exh. cat.; pp. 14, 45, no. 89 (repro.). Traveled between 1977 and 1979 to Henry Art Gallery, University of Washington, Seattle; Santa Barbara Museum of Art; The National Gallery of Iceland, Reykjavik; Musée des Beaux-Arts, Bordeaux, France; Museo Español de Arte Contemporaneo, Madrid; Museo de Bellas Artes, Caracas; Museo Municipal de Artes Graficas, Maracaibo, Venezuela; Galeria Nacional, Dominican Republic; Museo Nacional de Artes y Industrias Populares, Mexico City.

Hirschl & Adler Galleries, Inc., New York. *A Sense of Line: American Modernist Works on Paper*. November 25, 1989–January 6, 1990. Exh. cat.; frontispiece (repro.).

Amon Carter Museum, Fort Worth. *Visual Poetry: The Drawings of Joseph Stella*. February 23–April 22, 1990. Exh. cat. by Joann Moser; pp. 113, 116, fig. 112. Traveled to Museum of Fine Arts, Boston, May 19–July 22, 1990; National Museum of American Art, Smithsonian Institution, Washington, DC, September 7–November 12, 1990.

Whitney Museum of American Art, New York. *Joseph Stella*. April 22–October 9, 1994. Exh. cat. by Barbara Haskell; p. 180, fig. 208.

Plate 93: *Golden Fall*, 1940
Oil on canvas, 26 x 20 inches (66 x 50.8 cm)
Signed, lower right: *Joseph Stella*
Signed, titled, and dated, on verso: *Golden Fall / painted in 1940 / by Joseph Stella*
Collection of C. K. Williams, II

Provenance:
Estate of the artist; by descent through the family; Sotheby's Arcade, New York, "American 19th and 20th Century Paintings," September 22, 1987, lot 314 (repro.); private collection; Spanierman Gallery, LLC, New York, 2000; purchase from Spanierman Gallery, LLC, March 27, 2000.

Exhibitions:

Associated American Artists Gallery, New York. *Joseph Stella*. January 6–25, 1941. Exh. cat.; n.p., no. 10 (no repro.).

Spanierman Gallery, LLC, New York. *In Praise of Women: Images of Leisure and Independence in American Art, 1860–1940*. February 6–March 30, 1996. No cat.

Spanierman Gallery, LLC, New York. *American Gone Modern, from the Twenties to the Sixties*. March 11–April 29, 2000. Exh. cat.; p. 42, no. 35 (repro.).

References:

Kruse, A. Z. "At the Art Galleries." Unidentified clipping, January 1941. August Mosca Papers, Archives of American Art, Smithsonian Institution, Washington, DC, reel 1576, frame 1006.

Jaffe, Irma B. *Joseph Stella's Symbolism*. San Francisco: Pomegranate Artbooks, 1994; p. xvii, no. 33 (repro.).

JOHN STORRS
American, 1885–1956

Plate 94: *Study in Form (Forms in Space)*, 1923

Oak (by eye), stained brown and partially ebonized, 20 x 12 ¼ x 2 ⅛ inches (50.8 x 31.1 x 5.4 cm)
Collection of C. K. Williams, II

Provenance:

Edith Halpert; to her descendants, to 1992; Richard York Gallery, New York, 1992–2000; purchase from Richard York Gallery, November 15, 2000.

Exhibitions:

Downtown Gallery, New York. *John Storrs*. 1965. Exh. cat.; n.p., no. 12 (no repro.).

Whitney Museum of American Art, New York. *John Storrs*. December 11, 1986–March 22, 1987. Exh. cat.; p. 138 (no repro.). Traveled to Amon Carter Museum, Fort Worth, May 2–July 5, 1987; J. B. Speed Art Museum, Louisville, August 28–November 1, 1987.

Richard York Gallery, New York. *Modernism at the Salons of America, 1922–1936*. October 19–December 8, 1995. Exh. cat.; pp. 12, 22, no. 67 (repro.).

References:

Richard York Gallery. *An American Gallery, Vol. 7*. New York: Richard York Gallery, 1992; n.p., no. 26 (repro.).

Murray, Mary E., and Paul D. Schweizer. *Life Lines: American Master Drawings, 1788–1962, from the Munson-Williams-Proctor Institute*. Exh. cat. Utica, NY: Munson-Williams-Proctor Institute, 1994; p. 99.

Richard York Gallery. *American Modernism*. New York: Richard York Gallery, 2000; p. 8 (repro.).

PAVEL TCHELITCHEW
American, born Russia, 1898–1957

Plate 95: *Pierrot*, 1930

Oil on canvas, 28 ¾ x 21 ¼ inches (73 x 54 cm)
Signed, lower right: *P. Tchelitchew*
Collection of C. K. Williams, II

Provenance:

Hammer Galleries, New York (per gallery stamp on stretcher verso); James Johnson Sweeney, New York; Sotheby's, New York, "Modern and Contemporary Paintings, Drawings and Sculpture Including the Collection of Helen W. Benjamin," June 7, 1996, lot 61 (repro.); Michael Rosenfeld and halley harrisburg, New York; purchase from Michael Rosenfeld and halley harrisburg, 2007.

Exhibitions:

Nassau County Museum of Art, Roslyn, NY. *Picasso and the School of Paris*. November 19, 2006–February 4, 2007. Exh. cat.; p. 48 (repro.).

Michael Rosenfeld Gallery, LLC, New York. *Body Beware: 18 American Artists*. May 18–July 27, 2007 (repro.).

Reference:

Riley, Charles A. II. *The Jazz Age in France*. New York: Harry N. Abrams, 2004; p. 27 (repro.).

GEORGE TOOKER
American, born 1920

Plate 96: *Voice I*, 1963

Egg tempera on gessoed panel, 20 x 18 inches (50.8 x 45.7 cm)
Signed, lower right: *Tooker*
Collection of C. K. Williams, II

Provenance:

Robert L. Isaacson, New York; Christie's, New York, "Important American Paintings, Drawings and Sculpture," May 26, 1999, lot 147 (repro.); purchase from Christie's auction, May 26, 1999.

Exhibitions:

Durlacher Bros., New York. *George Tooker*. April 28–May 23, 1964. Exh. cat.; n.p., no. 2 (no repro.).

Jaffe-Friede Gallery, Hopkins Center, Dartmouth College, Hanover, NH. *George Tooker*. August 5–September 5, 1967. Exh. cat.; front cover, no. 21 (repro.).

California Palace of the Legion of Honor, The Fine Arts Museums of San Francisco. *George Tooker: Paintings, 1947–1973*. July 13–September 2, 1974. Exh. cat. by Thomas H. Garver; n.p., no. 21 (repro.). Traveled to Museum of Contemporary Art, Chicago, September 7–October 20, 1974; Whitney Museum of American Art, New York, December 5, 1974–January 5, 1975; Indianapolis Museum of Art, January 28–March 16, 1975.

References:

Garver, Thomas H. *George Tooker*. New York: Rizzoli, 1985; front cover, pp. 77–79, 135 (repro.).

Garver, Thomas H. *George Tooker*. San Francisco: Chameleon Books / Pomegranate Communications, 1992; pp. 82–83, 147, back cover (repro.).

Baker, Susan Jane. "George Tooker and the Modern Tradition." Ph.D. diss., University of Kansas, 1994; pp. vii, 98–99, fig. 38.

MAX WEBER
American, born Russia, 1881–1961

Plate 97: *Four Figures (Sisters)*, 1912

Oil on canvas, 36 x 21 inches (91.4 x 53.3 cm)
Signed and dated, lower left: *MAX WEBER 1912*
Collection of C. K. Williams, II

Provenance:

Arthur B. Davies; estate of Arthur B. Davies, to 1929; Anderson Galleries, American Art Association, New York, "Estate of the Late Arthur B. Davies Sold by Order of Dr. Virginia M. Davies," April 17, 1929, lot 431 (no repro.); Duncan Candler, possibly via Downtown Gallery, New York, c. 1929–49; private collection, MA; Martha Parrish & James Reinish, Inc., New York, 2003; purchase from Martha Parrish & James Reinish, Inc., after January 6, 2003.

Exhibitions:

Possibly The Print Gallery, New York. *Exhibition of Paintings and Drawings by Max Weber*. February 1–18, 1915. Exh. cat.; n.p., no. 16 (no repro.).

The Art Institute of Chicago. *Arts Club Exhibitions at the Art Institute of Chicago: A Group of Paintings by Various Modern Artists; Loaned by the American Painter Arthur B. Davies*. March 19–April 25, 1926. Exh. cat.; n.p., no. 33 (no repro.).

References:

Gregg, Frederick James. "Max Weber." *Vanity Fair*, vol. 5, no. 1 (September 1915), p. 36 (repro.).

Bridgman, Edward C. "Max Weber—Modernist." *Touchstone and the American Art Student Magazine*, vol. 8, no. 4 (January 1921), p. 319 (repro.).

Looking Back: Martha Parrish & James Reinish; 15 Years. New York: Martha Parrish & James Reinish, 2008; pp. 66, 96, no. 46.

Plate 98: *The Forest*, 1912

Gouache on paper, 14 ½ x 10 ¾ inches (36.8 x 27.3 cm)
Signed and dated, lower right: *MAX WEBER 1912*
Collection of C. K. Williams, II

Provenance:

Estate of the artist; by descent in the family, to 1969; Bernard Danenberg Galleries, New York, 1969; Robert Schoelkopf Gallery, New York; Hirschl & Adler Galleries, Inc., New York; purchase from Hirschl & Adler Galleries, Inc., October 14, 2000.

Exhibitions:
Possibly J. B. Neumann's Print Room, New York. *Max Weber Exhibition: Small Paintings.* May 13–June 21, 1921. Pamphlet; n.p., no. 12 (no repro.).

Bernard Danenberg Galleries, New York. *Fifty Years of Painting by Max Weber.* April 15–May 10, 1969. Exh. cat.; p. 33, no. 45 (repro.).

GRANT WOOD
American, 1891–1942

Plate 99: *Plowing*, 1936
Colored crayons over charcoal with touches of opaque white paint on paper, 23 ½ x 29 ½ inches (59.7 x 74.9 cm)
Signed and dated, lower left: *GRANT WOOD 1936*
Signed and inscribed, on verso: *Plowing / by / Grant Wood / Made by order of / Mr. Stuart B. White / 1936*
Philadelphia Museum of Art. Promised gift of C. K. Williams, II

Provenance:
Marjorie and Stuart White, c. 1936; by descent in the family to 1995; Sotheby's, New York, "American Paintings, Drawings and Sculpture Including Property from the IBM International Foundation," May 25, 1995, lot 99 (repro.); private collection, New York, 1995–98; purchase from Hirschl & Adler Galleries, Inc., New York, November 12, 1998.

Exhibitions:
Philadelphia Museum of Art. *From Sacred Groves to Country Roads: Pastoral Themes in European and American Drawings, 1730–1980.* September 15, 2001–January 20, 2002. No cat.

Philadelphia Museum of Art. *Andrew Wyeth and the American Landscape Tradition.* May 27–July 16, 2006. No cat.

References:
Roberts, Brady M., et al. *Grant Wood: An American Master Revealed.* Exh. cat. San Francisco: Pomegranate Artbooks; Davenport, IA: Davenport Museum of Art, 1995; pp. 42–43, 61, pl. 24.

Dennis, James M. *Renegade Regionalists: The Modern Independence of Grant Wood, Thomas Hart Benton, and John Steuart Curry.* Madison: University of Wisconsin Press, 1998; pp. 173–74, fig. 95.

MARGUERITE THOMPSON ZORACH
American, 1887–1968

Plate 100: *Mountains*, 1910–11
Oil on board, 12 ¼ x 15 ½ inches (31.1 x 39.4 cm)
Collection of C. K. Williams, II

Provenance:
Daniel Gallery, New York, c. 1915–18; private collection, Albuquerque, NM; Hirschl & Adler Galleries, Inc., New York; Grogan & Company, Dedham, MA, auction, September 21, 2003, lot 84; private collection, MA; Meredith Ward Fine Art, New York, 2004; purchase from Meredith Ward Fine Art, April 2004.

Plate 101: *The Awakening*, c. 1916
Oil on canvas, 18 x 28 inches (45.7 x 71.1 cm)
Signed, lower right: *M ZORACH*
Inscribed by the artist on label, on verso: *The Awakening*
Collection of C. K. Williams, II

Provenance:
Tessim Zorach; Timothy Zorach; Barridoff Galleries, Portland, ME, c. 1984; Mr. and Mrs. William D. Hamill, Yarmouth, ME; Thomaston Auction, Thomaston, ME, August 26, 2006, lot 100; Gerald Peters Gallery, New York; purchase from Gerald Peters Gallery, January 7, 2007.

Exhibition:
Gerald Peters Gallery, New York. *Marguerite Zorach: A Life in Art.* May 3–June 8, 2007. Exh. cat.; pp. 11–12, 33, pl. 8.

WILLIAM ZORACH
American, born Lithuania, 1889–1966

Plate 102: *Yosemite Falls*, 1920
Oil on canvas, 72 x 30 inches (182.9 x 76.2 cm)
Frame designed by the artist
Signed and dated, lower right: *Zorach 1920*
Inscribed on backing: *Yosemite Falls 1920 / For Whitney Museum / show / Wz*
Collection of C. K. Williams, II

Provenance:
By gift to his son Tessim Zorach, December 25, 1957; Zabriskie Gallery, New York, to 1981; Andrew Crispo, New York, 1981–97; Sotheby's, New York, "American Paintings, Drawings, and Sculpture," December 3, 1997, lot 139 (repro.); private collection, Brooklyn Heights, NY; Meredith Ward Fine Art, New York; purchase from Meredith Ward Fine Art, October 4, 2005.

Exhibitions:
Downtown Gallery, New York. *William Zorach: A Selection, 1914–1955.* December 28, 1955–January 21, 1956. Exh. cat.; no. 8 (no repro.).

Whitney Museum of American Art, New York. *William Zorach.* October 14–November 29, 1959. Exh. cat.; n.p., no. 52 (no repro.). Traveled to Joe and Emily Lowe Art Gallery, Miami, January 1–31, 1960; Columbus Gallery of Fine Arts, OH, March 3–31, 1960; Contemporary Arts Center, Cincinnati, April 20–May 30, 1960.

Downtown Gallery, New York. *Abstract Painting in America, 1903–1923.* March 27–April 21, 1962. Exh. cat.; n.p., no. 64 (repro.).

Whitney Museum of American Art, New York. *The Decade of the Armory Show.* February 27–April 14, 1963. Exh. cat.; pp. 33, 75, no. 115 (repro.). Traveled to City Art Museum, St. Louis, June 1–July 14, 1963; The Cleveland Museum of Art, August 6–September 15, 1963; Pennsylvania Academy of the Fine Arts, Philadelphia, September 30–October 30, 1963; The Art Institute of Chicago, November 15–December 29, 1963; Albright-Knox Art Gallery, Buffalo, NY, January 20–February 23, 1964.

Brooklyn Museum, NY. *William Zorach: Paintings, Watercolors, and Drawings, 1911–1922.* November 26, 1968–January 19, 1969. Exh. cat.; pp. 14, 19, 51, no. 33 (repro.).

Probably Andrew Crispo Gallery, New York. *Paris/New York, 1910–1930s: The Influences of Paris on New York and American Artists in the 20th Century.* June–August 1977. No cat.; no. 40.

Zabriskie Gallery, New York. *William Zorach: Yosemite.* January 9–February 3, 1979. Exh. cat.; n.p., no. 34 (no repro.).

Probably Zabriskie Gallery, New York. *William Zorach.* June 10–July 10, 1981. No cat.

Probably Andrew Crispo Gallery, New York. Untitled exhibition. 1985. No cat.

Probably Canova and Rittenhouse Fine Art Gallery, New York. *A Selection of 20th Century Art: Paintings, Drawings and Sculpture.* November 1991–January 1992. No cat.; no. 44.

Probably Canova and Rittenhouse Fine Art Gallery, New York. *The Formative Years of 20th Century Art in America.* October–November 1992. No cat.; no. 9.

Portland Museum of Art, ME. *Marguerite and William Zorach: Harmonies and Contrasts.* November 8, 2001–January 6, 2002. Exh. cat.; pp. 36, 46, 110, no number (repro.).

References:
Baur, John I. H. *William Zorach.* New York: Frederick A. Praeger, for the Whitney Museum of American Art, 1959; pp. 17, 23, fig. 7.

Tarbell, Roberta K. "Catalogue Raisonné of William Zorach's Carved Sculpture." Ph.D. diss., University of Delaware, 1976; vol. 1, pp. 50–52, fig. 16.